Photoshop

For Photographers

Photoshop

For Photographers

Everything You Need to Know to Make Perfect Pictures from the Digital Darkroom

BY EDITORS OF
PhotoPlus
MAGAZINE

FOX CHAPEL
PUBLISHING

© 2012 by Fox Chapel Publishing Company, Inc., 1970 Broad Street, East Petersburg, PA 17520

Photoshop For Photographers is an original work, first published in 2011 in the United Kingdom by Future Publishing Limited in magazine form under the same title. This title printed and distributed in North America under license. All rights reserved.

ISBN 978-1-56523-721-6

To learn more about the other great books from
Fox Chapel Publishing, or to find a retailer
near you, call toll-free 800-457-9112 or visit
us at *www.FoxChapelPublishing.com*.

Note to Authors: We are always looking for talented
authors to write new books. Please send a brief letter
describing your idea to Acquisition Editor,
1970 Broad Street, East Petersburg, PA 17520.

Printed in China

First printing

Welcome

Get more from Photoshop and make more of your photos with our expert tutorials

Over the decades, Photoshop has evolved into much more than a simple photo-editor – it's now a vast, supremely powerful and very _complicated_ photo-editor! It's also a lot of other things besides, like an illustration and 3D program, so if what you want to do with it is fix and enhance your photos, then you sometimes have to search to find the tools and features you need for the task in hand. That's where this book will help.

Our focus in these pages is Photoshop strictly for photo-editing. We'll introduce you to the tools and options relevant to correcting and enhancing digital photos, show you how to get the best from them, and take you step-by-step through expert techniques for making the very best of your pictures. We'll show you how to fix common flaws from tilted horizons and colour casts to barrel distortion and exposure problems. You'll discover how to use Camera Raw to get the maximum tonal and colour detail your camera is capable of delivering, and how to bring out lost information in the highlights or shadows. We'll show you how to create magnificent black-and-white photos, and how to produce stunning HDR images that capture more depth and tonal range than any camera yet invented could hope to capture in a single exposure.

Because this is an expert guide, we won't shy away from using tools and features available only in the "full-fat" Photoshop but not in its "lite" counterpart, Photoshop Elements. However, most of the techniques and tricks we'll show you can be applied in both programs, though occasionally tools work slightly differently in Elements.

Windows or Mac?

We're mainly using Photoshop for Windows here, because that's what most people are using, but everything is applicable if you're using a Mac – where we use the Ctrl key, simply substitute the Command key (the key with an apple or "four-leaf clover" symbol on it); where we use the Alt key, for you that's the Option key. Where we right-click to open contextual menus, you can also hold down the Ctrl key and click (though right-clicking will also work!).

Whatever version of Photoshop or Elements you're using and whatever computer you're running it on, our expert tutorials and accompanying video lessons will help you get much more from your photo-editing program and make your pictures perfect.

Alex Summersby
Editor

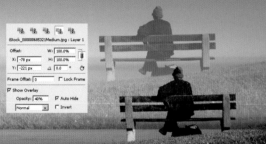

GLOSSARY

206 Key terms explained

Baffled by a phrase or term you've discovered in the pages of this book? Turn here for a quick reference guide with all the answers you need...

ON YOUR DISC

210 Using your DVD-ROM

How to use the packed DVD-ROM that accompanies this book

Watch for the badge below when reading a tutorial. It means the image we've used in the project is on your DVD, so you can try out the techniques for yourself. In most cases there's also an accompanying video tutorial!

On the disc
Try it yourself!
Start image and video on the DVD

» Photoshop basics 1

Get to know the tools and controls in Photoshop and its "budget" counterpart, Photoshop Elements, and learn how to master all the options and work more quickly

Get to know...
Photoshop's interface

There's a lot to take in, but here's an introduction to the basic layout and controls

Photoshop is a huge program, with a dazzling range of tools, commands and options. Fortunately, it's all pretty logically organised, with commands grouped in menus and a toolbox containing all the tools (some sharing a compartment with related tools). Click on a tool to activate it and you can adjust its settings and options in its options bar; click on a command with ellipsis points (…) after its name, and a dialog window pops open in which you can configure it. A variety of movable palettes (Adobe calls them "panels" in CS4 and CS5) give you access to still more options and controls; by default these are docked at the right-hand side of the screen, but you can tear them off and "float" them wherever you like, open only the ones you want, or hide them until you need them – see the box to the right. If you don't want to be distracted by your Desktop or other windows, you can press the F key on your keyboard (not a Function key, just the letter F) to switch to Full Screen mode; press it repeatedly to cycle through some further options. Finally, as well as opening the palettes you want, the Window menu includes other useful options for viewing several images at one time and synchronising what you see of each as you work.

The Photoshop interface (CS5)

Get to grips with the basic layout and controls – there's a lot on offer, and it helps if you know where to find it!

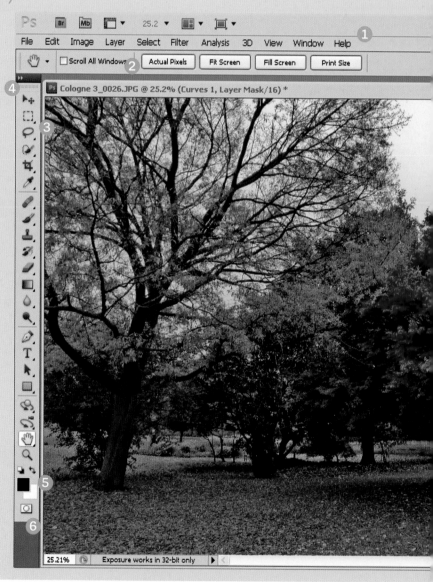

① Menus and commands
Click on a menu heading and the menu pops down; click on any of the commands within to execute it (after further input from you if it has ellipsis points after its name). Many commands have keystroke shortcuts; these are listed in the menus next to the commands, so you'll soon pick up the ones you use most often. Click the buttons in the topmost bar for extra options.

② Tool options bar
Click on any of the tools in the toolbox to activate it, and tool-specific options and settings become available in the options bar just below the main menu.

③ Toolbox
All the tools can be activated with a keystroke too; hover your mouse pointer over a tool and (if this hasn't been disabled in the Preferences) a "Tool Tip" box will appear with the name of the tool and its shortcut key.

④ Minimise button
Click the double-arrow button to show the toolbox as a space-saving single column or as two columns.

⑤ Colour swatches
The swatches display the current foreground and background colours. (Broadly speaking, the former is the colour that brushes and other tools will add; the latter is the colour that erasers will erase to.) Click the miniature swatches above (or tap D) to reset to black and white at any time; click the double-headed arrow (or tap X) to swap foreground and background colours.

⑥ Quick Mask mode
Click to enter Quick Mask mode to make or modify selections with brushes – see page 46.

Customising Photoshop
Make Photoshop look and work the way you want

Photoshop might look complex and daunting, but you can set it up in pretty much any way that makes sense to you. Want a clearer view of your image? Click the panel dock's "Collapse to icons" button (the double-arrow in the dark bar at top right). Now all the bulky palettes and panels take up almost no room at all, but you can open and close them as you need them simply by clicking on the appropriate icon. (Any floated palettes have the same dark bar at the top with the same double-arrow button, which has the same effect on that palette.) As you work, you can press the Tab key to hide the palettes temporarily, or hold down Shift and press Tab to hide all palettes except for the toolbox; you can then show hidden palettes by pressing Tab again or moving your mouse pointer to the edge of the screen. You can open just the palettes you want from the Window menu, arrange them on the screen as you like, then save this configuration by going to Window > Workspace > Save Workspace.

You can create as many of these custom workspaces as you like for specific purposes, and load them instantly by selecting them from the menu. You can even alter the appearance of many of the tools: press Ctrl-K to go to Photoshop's Preferences, then click on Cursors in the left-hand panel – or while you're there, work your way through the other Preferences screens one-by-one and configure other aspects of the program's behaviour and appearance.

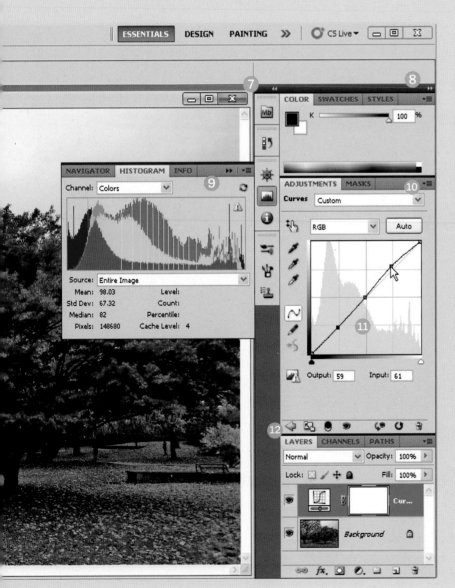

7 Panel dock
By default the palettes (panels) are docked at the right, with more palettes minimised into buttons. Hover your mouse pointer over any of these to see the name of the palette, and click to open it.

8 Expand or minimise
Click the double-arrow button at the top of either column to expand it or collapse it to buttons.

9 Pop-out palette
This palette has been opened from one of the buttons. Click the double-arrow button in its top bar, or click its name label, to collapse it to a button again. Click the name label of one of the other palettes in its group to switch to that instead.

10 Palette menu
Every palette has its own palette menu for quick access to relevant options and commands – click the "mini-menu" button at top-right. In earlier versions it's a simpler arrow button.

11 Adjustments panel
Controls and options for the current adjustment are displayed here so you can configure it. The controls for Curves are being displayed because a Curves adjustment layer is highlighted in the Layers palette below. Add a different type of adjustment and the controls will change to those relevant to that.

12 Control buttons
Buttons along the foot of each palette give you a quick way of applying certain relevant commands, typically including such options as undoing the last change you made in that palette or discarding it completely (the trashcan is the universal symbol for the latter).

Get to know...
The Elements interfaces

It's less customisable, but Elements offers three distinct screens

Elements doesn't have just a single interface; instead, you can switch between several modes depending on what you want to do – create photo books or greeting cards, share your photos on the web, and so on. You can edit your images in Full Edit, Quick Fix or Guided Edit mode. The first gives you access to all of Elements' tools and commands (see below), and is the only mode you can customise much – but not very much. You can opt to open the Project Bin at the bottom or close it and gain a little more room to work in. You can float

or dock the main image window; if you dock it, you can switch between open images using tabs at the top. You can drag palettes out over your image; if you leave them docked, you can show or hide the entire dock but not make it narrower (and it's pretty wide). That's about it.

Quick Fix mode enables you to make all the most essential fixes and adjustments using sliders. Guided Edit takes you step-by-step through basic tasks, but also gives you access to some of the most powerful options – see opposite.

Elements' Full Edit mode (Elements 9)

This mode gives you access to all of Elements' photo-editing features

① Tool options bar
The toolbox and tool options bar work just like Photoshop's. There's a more limited choice of screen modes: basically, "maximised" or not.

② Float or dock
Drag the toolbox and palettes by their top bar to "float" them where you like over your photo; drag them back to the edges of the screen to dock them again.

③ Project Bin
Any photos you have open are stored in the Project Bin, which you can hide or resize if you prefer. Double-click a shot here to open it in the main window.

④ Switch between tabs
Switch between editing modes, or go to the Create or Share modes, by clicking on the appropriate tab.

⑤ Palette menu
Click the "mini-menu" button to open the palette menu. Floating palettes have a little triangle in their top bar; click this to minimise the palette to a floating button.

⑥ Resize panels
Resize palettes within the palette bin if necessary by pulling the bar between them up or down – the mouse pointer turns into a double-headed arrow when you're in the right spot.

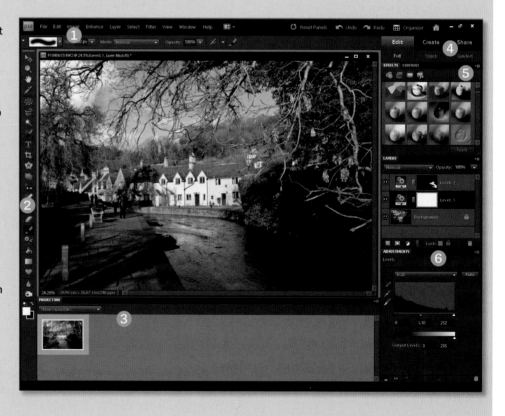

Get to know...
Quick Fix/ Guided Edit modes

Quick Fix makes photo-editing easy, and Guided mode makes it idiot-proof!

The Full Edit interface gives you access to Elements' full range of tools and commands, including layers and effects. If you don't want to add layers to a photo and just need to make a few basic corrections, Quick Fix mode may be all you need. You can apply a range of "Auto" corrections, and fine-tune them if necessary using sliders; you can also access all the adjustments under the Enhance menu and apply filters.

If you're a complete novice at image editing and want to have your hand held, you can make use of Guided Edit mode. Click the Guided tab and instead of palettes or sliders you'll see a list of common tasks in the right-hand panel, ranging from basic edits such as cropping or rotating a photo, through adjusting exposure and colour or removing blemishes, and on to creative effects such as turning a photo into a line drawing. Choose one and helpful explanatory text will guide you step-by-step and offer the sliders or tools you need. You'll also have access to the powerful Photomerge options and the automated Action Player, which will execute pre-recorded sequences of edits for you.

Quick Fix tools and features
All the essential photo fixes, in one easy-to-use panel

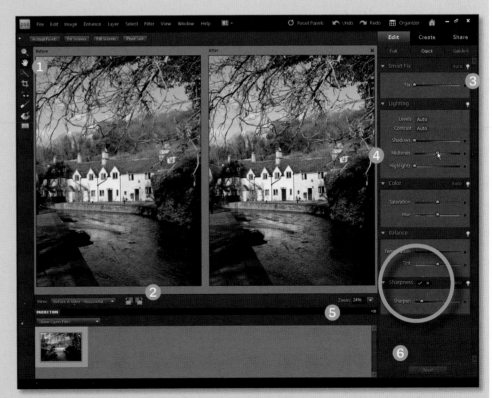

❶ Minimal toolbox
The toolbox is a pared-down version of the one in Full Edit mode, but it includes two brush-based selection tools and a handful of Smart Brush fixes you can just "paint on" where you want them.

❷ Display options
The View menu enables you to choose how an image is displayed. The Before & After options are the most useful – choose Vertical or Horizontal to suit the proportions of your image.

❸ Auto corrections
If you click any of the Auto buttons, Elements analyses the image and adjusts that aspect of it. You can correct the image yourself, or fine-tune an Auto correction, using the sliders.

❹ Sliders
The sliders offer an easy way to adjust various aspects of your image. You need to OK or reject any changes you've made in one set before moving on to the next using the tick (checkmark) or cross buttons that appear next to the group's title (circled next to Sharpness here).

❺ Zoom options
To zoom in, click and drag on the word Zoom. The slider that appears when you click the arrow is too sensitive, making it hard to zoom in or out smoothly.

❻ Reset button
Click the Reset button at the bottom to undo all your adjustments and revert the image to its unedited state.

How to...
Mastering the toolbox

Get to grips with choosing and using tools in Photoshop and Elements

Are you using the "full-fat" Adobe Photoshop or its "lite" counterpart, Photoshop Elements? (To minimise confusion, we'll refer to the former as "Photoshop" and the latter as simply "Elements".) The first thing to note is that the two have a lot in common. Both offer a dazzling array of powerful tools, commands and options, with the commands grouped in menus and the tools in a floating toolbox, some sharing a compartment with related tools. To activate a tool, you simply click on it – or, as we've mentioned, press its shortcut key. To identify which key activates a particular tool, hover your mouse pointer over its toolbox icon; a floating tool tip will appear, displaying the tool's name and the relevant key. Compartments that contain further tools have a little arrow in the lower-right corner: to see all the tools, click-and-hold (or right-click) on it. To cycle through the tools in the compartment, tap the appropriate key repeatedly. (You might find that to do this you need to hold down Shift in addition to the key required to select a tool – if you'd rather not, go to the General section of Preferences (Ctrl-K) and disable "Use Shift Key

for Tool Switch". This won't have any effect on how you activate tools in different compartments, only switching between tools that share the same compartment.)

The exact tools available vary between Photoshop and Elements, and between versions (new tools are naturally added with every upgrade); sometimes the same tools are in a different position in the toolbox. The principles remain the same, though, and so do the shortcuts.

That said, there are some significant differences between Photoshop and Elements, and in this expert guide we won't hold back from exploring options found only in the professional application. Wherever possible, however, we'll show you alternatives you can use if you have Elements or an older version of Photoshop – many features have counterparts that might have another name, look a little different or offer slightly different options but can produce much the same result.

If you want to find out more about the differences between Photoshop and Elements, visit **www.adobe.com/ products/photoshop/family**. ◻

TOP TIP! Elements variations Elements lacks some tools that Photoshop has, notably the History Brush and the Pen Tool. It has a few Photoshop doesn't have, including the Impressionist Brush (which paints with "artistic" strokes) and the Cookie Cutter (which creates frames of various shapes around images). Elements also doesn't have Quick Mask mode per se, but its Selection Brush (see page 47) does enable you to make selections using brushes.

Get more from brush-based tools
You're probably using brushes more than you realise

As we'll see in later sections, you'll use the Brush Tool to refine (and often even create) masks, which is fundamental to more flexible and "non-destructive" photo editing; and you might paint with it to colour a bland sky or pale skin. But on top of this you might find you're using brushes more than you realise. As their names suggest, the Healing Brush and Spot Healing Brush (pictured in use) are brush-based tools; but so is the Clone Stamp Tool. Elements' Selection Brush is obviously a brush, but so are the Dodge and Burn Tools, all the Eraser tools, and many more. The point is, just as you can modify or configure the Brush Tool, you can do the same with *any* brush-based tool. You can alter brush size, hardness, opacity and so on, which can mean more subtle results and more control. The Hardness setting defines how "sharp" or how "fuzzy" the brush edge is – using a soft brush will help blend your brush strokes into an image, which is vital when you're retouching. The Opacity setting controls how solid or "dense" a colour the brush lays down.

Just as importantly, the same shortcuts apply to all brush-based tools, so you can change brush size and other aspects if necessary in the middle of a tricky job with just a keystroke:
• Tap the right square bracket key on your keyboard to increase brush size in one-pixel increments up to 10 pixels, in 10-pixel increments up to 100 pixels, and in increments of 25, 50 and 100

pixels thereafter; tap the left square bracket key to reduce the brush size by the same increments.
• Hold down Shift while tapping the same keys to increase or decrease brush hardness in increments of 25%.
• In CS4/5 you can also resize a brush by holding down Alt, right-clicking and dragging to the left or the right respectively to decrease or increase brush size.
• You can change the Opacity setting for any brush-based tool using the number keys on your keyboard. Tap 1 to 0 to set the opacity in 10% increments from 10% to 100% (so for 50%, just tap 5). To set a specific value, type two numbers in quick succession – for example press 2 and then 5 for 25% (or 0 and then 5 for 5%). In Photoshop you can change the Flow setting by holding down Shift and typing numbers in the same way (there's no Flow option in Elements).

Get to know...
Tools in Photoshop's toolbox

The toolbox puts an incredible armoury within easy reach

① Selection tools
The Marquee selection tools create rectangular, elliptical, or single-pixel-wide selections. Use the Lasso tools below them to select irregular shapes; the Magnetic variant "clings" to edges as you draw.

② Retouching tools
The Healing tools and the Red Eye Tool are for retouching. Use the Clone Stamp to "brush on" pixels sampled from elsewhere, or the Pattern Stamp to brush on a preset pattern.

③ Crop Tool
To trim unwanted parts of a shot away, click-and-drag with the Crop Tool around the area you want to keep.

④ Erasers
The Eraser turns pixels the Background colour if a layer is locked, or transparent if the layer is unlocked. Its variants work selectively.

⑤ Darkroom tools
The "darkroom" tools (Blur, Sharpen, Smudge, Dodge, Burn and Sponge) are for retouching but are very destructive; using adjustment layers instead is better practice.

⑥ Vector tools
The Pen Tool and others in the same compartment, plus the compartment beneath it, are for drawing and modifying shapes and paths (vector outlines).

⑦ Notes
The Notes Tool and its Audio variant enable you to add written or spoken notes on an image canvas.

⑧ Hand Tool
Use the Hand Tool to move your image around and the Zoom Tool to magnify it.

⑨ Colour swatches
The colour swatches show the current Foreground and Background colours; click either to change it using the Color Picker, the double-headed arrow to swap them, or the mini-swatch button to reset them to black and white.

⑩ Quick Mask mode
Click this button to enter Quick Mask mode (see page 46).

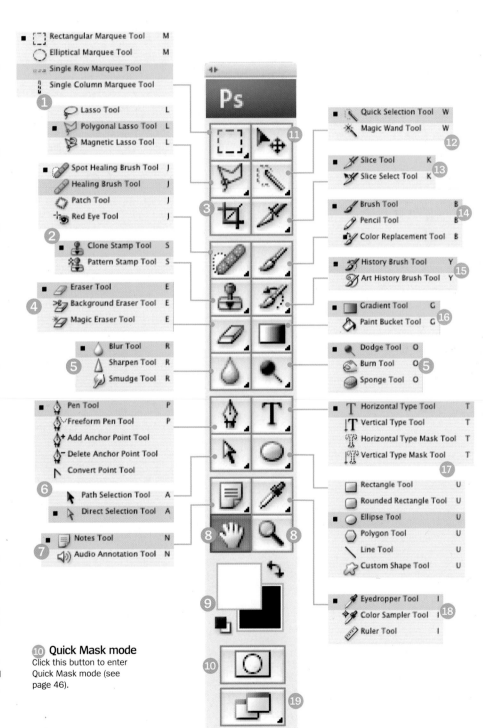

⑪ Move Tool
Use the Move Tool to move objects, selections and layers around.

⑫ Colour selections
The Magic Wand and Quick Selection tools select pixels by colour and tone.

⑬ Web slices
The Slice Tool and Slice Select Tool can be used to make and manage slices for Web images. We'll focus on photo-editing tools, so we won't be looking in detail at such specialist tools as these or the range of 3D and animation features in the Extended editions of Photoshop.

⑭ Brush tools
The Brush Tool has many uses in addition to painting colours; the Pencil Tool is a hard-edged variant. The Color Replacement Tool is a brush-based way of changing specific colours.

⑮ History brushes
Use the History Brush to paint-on past states of an image selectively without reverting the whole image. Its variant does the same with "artistic" strokes.

⑯ Fill tools
The Gradient Tool creates graduated fills; the Paint Bucket fills areas with a solid colour.

⑰ Type and shapes
The Type tools enable you to add text or text-shaped masks, while the Shape tools create vector objects of various shapes.

⑱ Sampling tools
Click in an image with the Eyedropper to set the Foreground colour; hold down Alt as you do so to set the Background colour. Place fixed markers with the Color Sampler Tool to keep track of colours as you work. Use the Ruler to make measurements within an image.

⑲ Screen Mode
Click this button (or press F) to change the Screen Mode (see page 10).

25 KEY PHOTOSHOP SKILLS

Master the essential techniques

Every photo is different, but the photo editing workflow is usually much the same. You'll tend to use the same key techniques and therefore need to master the same core skills. So to get started, here's our overview of the 25 essential Photoshop/Elements skills you'll need to take your photos to the next level. For details, follow our video tutorials on the DVD!

TOOLS YOU'LL MASTER...

✓ Levels
Levels is the first stop for tonal and colour tweaks. Its histogram is a graph of the tones in your shot, from the shadows at the left to the highlights at right.

✓ Hue/Saturation
Change colour hue (where a colour falls on the colour wheel), saturation (richness of colour), lightness, or any combination.

✓ Sharpen
The Unsharp Mask filter, Photoshop's Smart Sharpen and Elements' Adjust Sharpness all offer several options.

Essential fixes

To get started, we'll show you five essential quick fixes to improve all your pictures

WHAT YOU'LL NEED *Any version of Photoshop or Elements*
WHAT YOU'LL LEARN *How to apply essential quick fixes to any image including altering composition, correcting and boosting colour, and sharpening detail*
IT ONLY TAKES *15 minutes*

If you're just starting out in digital photography then you may not realise that most of your photos could be transformed by a few quick adjustments in Photoshop or Elements. For most people, the first foray into using either version of Adobe's photo editing suite can be a little daunting, but all you need to know initially are a few basic techniques – which can be learnt in minutes – and the rest will quickly follow. It's only once you've made the leap into the digital darkroom and started processing your own images that you'll realise how much better your pictures could look.

Here we'll introduce you to five essential image-enhancement fixes that will form the basis for most of your digital darkroom work. Then, over the next few pages, you'll see some more of the fundamentals in action, before we explore Photoshop's tools in detail in the rest of this book.

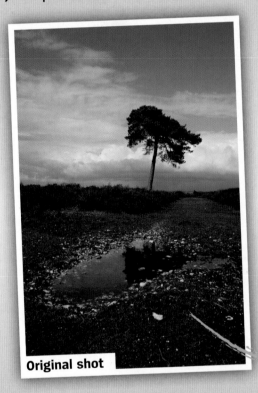

Original shot

OUR TOP SKILLS!

Do your images lack the impact you're after? Don't worry – get to grips with these basic skills to help you transform your shots

01 Cropping to compose
A little cropping can help to tighten up almost any composition. Wonky horizons can also be fixed at the same time. Use the Crop Tool (C) with a preset size of 5x7, then after you've defined the crop area click-and-drag just outside a corner to rotate it.

02 Correcting colour
Even if you're not sure why the colours don't look quite right in an image, Levels will correct it for you. Add a Levels adjustment layer, click the Set Gray Point eyedropper (the middle one in the dialog) and click on a spot that should be a colour-neutral grey.

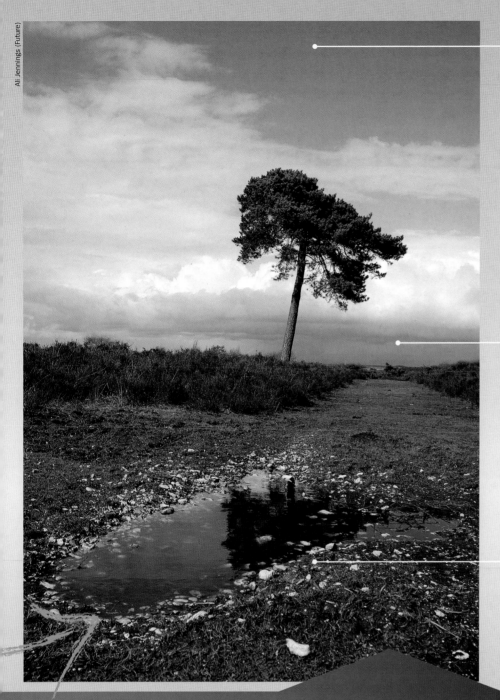

Ali Jennings (Future)

Enhance colour
Images can often suffer from colour casts, but these can often be quickly corrected using Levels.

Correct horizons
At the same time as you crop to improve the composition you can level tilted horizons.

Sharpen detail
Images straight from the camera can look soft, so a little sharpening will help to bring out the detail.

Increasing contrast
Use Curves to increase an image's impact. Add a Curves adjustment layer in Photoshop, or go to Enhance > Adjust Colour > Adjust Colour Curves in Elements, choose the Increase Midtones preset and use the sliders to fine-tune, then click OK.

Boosting colour
Increasing the colour saturation will help to boost an image's vibrancy. Add a Hue/Saturation adjustment layer and boost the colours in your shot by pushing the Saturation slider to the right to about +15. Click OK to apply.

Sharpening
To finish, go to Filter > Sharpen > Smart Sharpen in Photoshop or Enhance > Adjust Sharpness in Elements and try an Amount of 70% and Radius of 1.5. If the image starts to look painterly or haloes appear, reduce the Radius to 1.0 and click OK.

TOOLS YOU'LL MASTER...

Layers can be made to interact in different ways using blending modes, which can be quickly accessed using the drop-down menu at the top of the Layers palette. The modes are split into six different types of blend...

Normal Dissolve	*Standard* In Normal mode, layers just lie on top of each other. Dissolve produces a grainy effect if you reduce the top layer's opacity.
Darken Multiply Color Burn Linear Burn Darker Color	*Darkening* Blend the top layer's pixels with the underlying layer's in various ways, with a darkening effect.
Lighten Screen Color Dodge Linear Dodge (Add) Lighter Color	*Lightening* Blend the top layer's pixels with the underlying layer's in various ways, with a lightening effect.
Overlay Soft Light Hard Light Vivid Light Linear Light Pin Light Hard Mix	*Contrast* These all boost contrast in a range of different ways.
Difference Exclusion	*Comparative* These compare layer content and subtract the brightness of one from the other.
Hue Saturation Color Luminosity	*Colour influencing* Uses the specified component of the top layer's colours plus the others of the base layer.

On the disc
Try it yourself!
Start image and video on the DVD

Working with layers

How to work "non-destructively" and more flexibly, as well as achieve striking results

WHAT YOU'LL NEED *Any version of Photoshop or Elements*
WHAT YOU'LL LEARN *How to use layers and blending modes to replace a background, create a new one and improve contrast*
IT ONLY TAKES *20 minutes*

Layers are vital to most Photoshop work and basically enable you to stack one digital image or effect on top of another. So, for instance, if you paste a cutout object from one image into another, it will sit on its own layer on top of the underlying image; areas around the object or "holes" in it remain transparent, so you'll be able to see through them to the image below. Likewise, you can add effects in the form of adjustment layers, which work like sheets of coloured Cellophane: if you add a blue sheet, then the image will appear blue (but you can remove the effect again at any time, or change it from blue to red). Using a series of layers in this way, you can build up almost any style, effect or enhancement. Photoshop has several different types of layers, including Shape and Type layers, but here we'll look at the two most common: image layers and adjustment layers. Using this portrait we'll show you how to replace the background and increase the contrast.

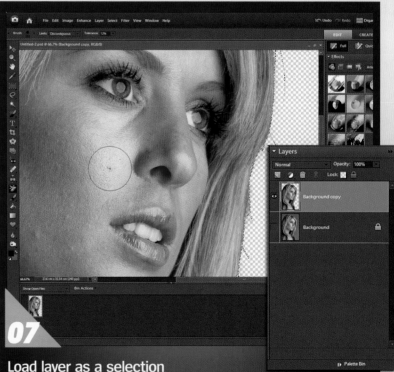

06

Image layers
Display the Layers palette by going to Window > Layers. An image straight from the camera has just a Background layer. Right-click this and choose Duplicate Layer. Click the eye icon to the left of the Background layer thumbnail to switch the visibility of the layer off. In the toolbox, click and hold on the Eraser Tool until the tool compartment pops open. Select the Background Eraser. In the options at the top of the screen, set Limits to Discontinuous and Tolerance to 12%. Carefully erase the background.

07

Load layer as a selection
Hold down Ctrl on your keyboard (Command if you're using a Mac) and then left-click the Background copy layer's thumbnail in the Layers palette. This is a quick way to select the content within an image layer. You should now see the "marching ants" selection marquee around the model. Now that we have the model selected, any effects we apply will affect only the selected area rather than the whole image. When we create our first adjustment layer in the next step, the selection will automatically convert into a mask, which prevents the effect from being applied to the masked area. A thumbnail of the mask will appear next to the layer thumbnail.

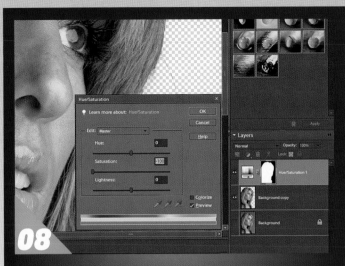

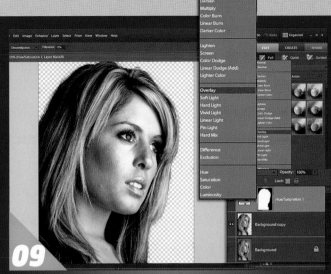

08 Add an adjustment layer

We want to improve the contrast of the model, but rather than using Levels or Curves we'll use an alternative technique involving a blending mode. This gives us more flexibility for later adjustment and a more refined contrast boost. Go to Layer > New Adjustment Layer > Hue/Saturation and pull the Saturation slider down to –100 to remove all colour. Click OK. You can now see the new adjustment layer in the Layers palette. You'll also see the mask that's been created out of the selection we made in the last step – its thumbnail appears to the right of the layer thumbnail. White areas on the mask are affected by the adjustment, black areas unaffected or masked, and any grey areas partially affected.

09 Blending modes

Now go to the blending modes menu at the top of the Layers palette (it reads Normal by default). Change the blending mode to Overlay and you'll see an instant boost in the contrast and colour of the model. In Overlay mode, the Hue/Saturation layer we've added doesn't just have its normal effect; instead, the blending mode blends the tonal information of the desaturated layer with the colour layer beneath. You can now use the layer's Opacity slider to adjust the effect – try clicking-and-dragging on the word Opacity to see the difference it makes. To compare the image with and without the effect, click the layer's visibility eye icon to hide it and then click the same box again to reveal it again.

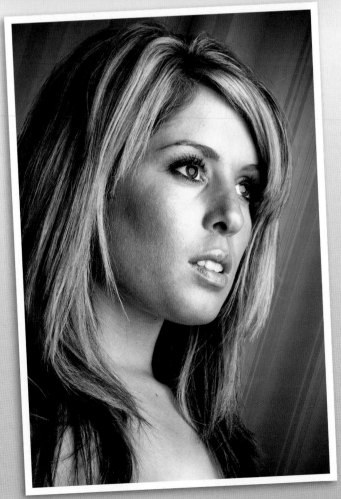

10 Filters and effects

We're now ready to create the new background. Click the Background layer thumbnail and then go to Layer > New > New Layer. Tap the D key on your keyboard to reset the toolbox colours to black and white, then go to Filter > Render > Clouds. Now go to Filter > Pixelate > Mezzotint and select Long Lines, then go to Filter > Blur > Motion Blur and set the angle to 90 and distance to 999. Repeat the Blur about 15 times by tapping Ctrl-F. We now need to scale and rotate the backdrop to suit the image. Go to Image > Transform > Free Transform (Ctrl-T) and in the tool options bar at the top of the screen set the angle to 20 and scale to 160% – only the currently targeted layer will be affected. To colour the backdrop, add a new Hue/Saturation adjustment layer; it will be added above the currently targeted layer and affect only layers beneath it. Click the Colorize box in the dialog, move the Hue slider to 220 to colour the background blue, and click OK. 📷

Get started with Raw

On the disc
Try it yourself!
Start image and
video on the DVD

Want to get the best from your camera? Here's how to do so with Camera Raw – and add a cross-processed polish

TOOLS YOU'LL MASTER...

✓ *Histogram*
You can gauge the effect of your edits by keeping an eye on the histogram at the top right of the Adobe Camera Raw interface.

✓ *Clipping warnings*
Avoid clipping the shadows or highlights by switching on the clipping warnings. Hit U for shadows and O for highlights.

✓ *Zoom*
Tools such as the Zoom and Hand Tools are essential when checking the edits you've made in the preview window.

WHAT YOU'LL NEED *Any version of Photoshop or Elements*
WHAT YOU'LL LEARN *How to get maximum quality images by processing in ACR, how to apply creative colour enhancement with Levels to produce a cross-processed look*
IT ONLY TAKES *15 minutes*

Image editing can seriously improve the quality of your photos, but it cannot create tonal and colour detail that isn't there to start with. If detail has been lost in blown highlights or underexposed shadows, you're not going to be able to rescue it. If you make extensive edits with Levels, say, your JPEGs are also going to start degrading – smooth gradations of tone and colour will become posterised, details may become "blocky", and so on. Shoot Raw files, though, and you'll be able to take the unprocessed image data captured by your camera straight to your computer, which means you'll have more tonal and colour information to work with right from the start and more headroom for editing.

Unlike JPEGs, which open directly into Photoshop/Elements, a Raw file must first be processed, but the Adobe Camera Raw plug-in, which works with Photoshop and Elements, makes this easy. Here we'll introduce the techniques needed to produce the best possible image from ACR and then look at a quick creative project to give images a cross-processed finish within Photoshop.

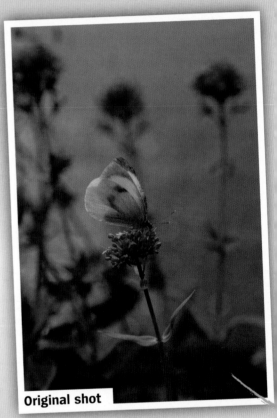

Original shot

OUR TOP SKILLS!

For the best quality images, you need to work with Raw files, but before you enhance them you'll need to process them in ACR

11

Correcting colour
Open ACR_Before.tif. Using the rotate buttons at the top of the ACR window, rotate the image 90 degrees anti-clockwise. Click the White Balance Tool and click into the grey background. The slight blue cast should instantly disappear.

12

Basic Raw adjustment
Push the Exposure slider to about 1.6 to lighten the image and the Recovery slider to 50 to rescue the highlights and remove the clipping warnings. Ramp up blacks to 15 and contrast to 40. You'll have a full histogram with loads of tone and detail.

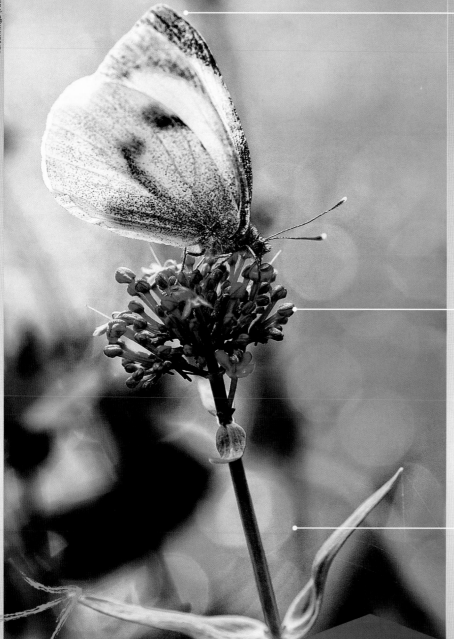

Ali Jennings (Future)

Draw out details
Making the basic
adjustments in Raw
enables you to pull back
detail that would have
been lost if you were
working on a JPEG file.

Subtle colour boost
Vibrance boosts the colour
of more subtly coloured
areas to a greater degree
than already-saturated
areas, helping prevent
an "overblown" look.

Playing with colour
Using the Channel menu
in Levels enables you to
adjust colour channels
separately and change the
colour mix in the image.

13

Increasing vibrancy
To boost the colour without overblowing the
already-rich colours in the shot, use the Vibrance
slider, which enhances less-saturated colours to
a greater degree than already-intense ones. Push
the slider to about 45.

14

Cropping in ACR
To crop, click-and-hold on the Crop Tool and select
5 to 7 in the menu to set the proportions of the
crop box. Click-and-drag to draw the frame; drag
within it to reposition it. Click Open Image to open
the processed image in Photoshop/Elements.

15

Cross processing
Add a Hue/Saturation layer, set Saturation to 30
and the blending mode to Hard Light. Add a Levels
layer, select Red in the dialog's Channel menu and
set the values to 0/81/241. Select Green and
make them 0/0.96/241, then Blue 0/1.37/239. 📷

25 PHOTOSHOP SKILLS

OUR TOP SKILLS!

ADVANCED SELECTIONS
Use the Quick Selection Tool and the Lasso tools to make complex selections. Your initial selection can be refined and saved for use later.

OUR TOP SKILLS!

PERFECT CUT-OUTS
To combat haloes and light lines, use the Lasso to select an edge and then adjust the colours and brightness without losing edge detail.

OUR TOP SKILLS!

ADDING TEXT
A caption is a great way to finish an image, and Photoshop includes a wealth of Type tools that give you a variety of different fonts and styles.

Ed Godden - Small hut in Snowdonia

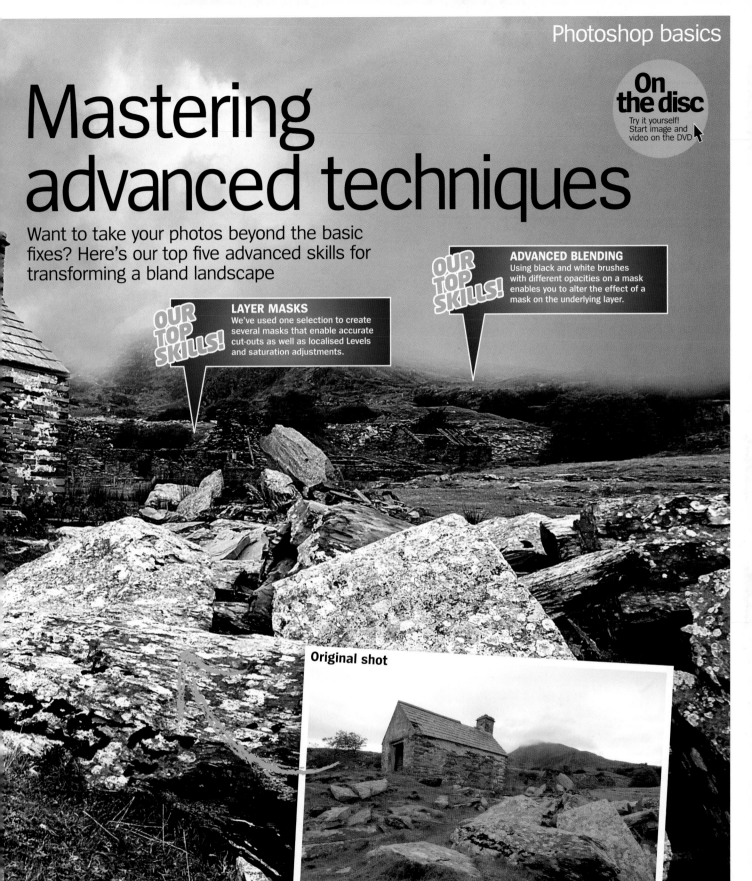

Mastering advanced techniques

Want to take your photos beyond the basic fixes? Here's our top five advanced skills for transforming a bland landscape

On the disc
Try it yourself! Start image and video on the DVD

OUR TOP SKILLS!

LAYER MASKS
We've used one selection to create several masks that enable accurate cut-outs as well as localised Levels and saturation adjustments.

OUR TOP SKILLS!

ADVANCED BLENDING
Using black and white brushes with different opacities on a mask enables you to alter the effect of a mask on the underlying layer.

Original shot

Turn the page for the techniques... »

TOOLS YOU'LL MASTER...

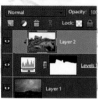

✓ *Tools for top cut-outs*
Selection tools and refinements used with masks enable you to get near-perfect cut-outs every time.

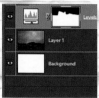

✓ *Blending brushwork*
Use masks and different-opacity brushes to paint in the new clouds, so they blend in with the existing foreground.

✓ *Adding text*
Add a simple white border and use the Text tools and options to add the finishing touch.

Ed Godden - S...

WHAT YOU'LL NEED *Any version of Photoshop or Elements*
WHAT YOU'LL LEARN *How to blend different images using layers, masks, blending modes and advanced selection techniques, and finish with a border and caption*
IT ONLY TAKES *30 minutes*

You can't rely on the weather to give you the ideal mix of light that illuminates the perfect landscape shot, and shots taken in misty or glary conditions will often look flat and washed-out. However, the digital darkroom gives you all the tools you need to transform a well composed but flat landscape into a colourful, high-impact scene. In this tutorial we'll take things a step further by showing you how to make complex selections, create perfect cut-outs, make the most of layer masks and use advanced blending tips to combine two images seamlessly together. Finally, we'll take a look at how to add a simple border and text title to give your picture the perfect finish.

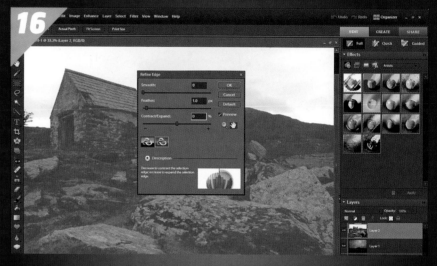

Refining your initial selections
Open the sky and foreground shots from the Skills 4 folder on the DVD. Go to the foreground shot, Select > All and Copy. Now go to the Sky shot and Paste. Using the Quick Selection Tool, select the sky, then switch to the Lasso Tool. You'll see there are a few areas that have been missed out. Hold down the Shift key so the tool works in "Add to selection" mode and draw around any areas you want to add to your selection. When done, click Refine, and Feather the edge by 2, leaving the other two sliders at 0. Click OK, then go to Select > Save Selection, save as "Sky" and click OK.

Perfecting your cut-outs
Creating perfect cut-outs is one of the toughest challenges in photo editing, but a handy trick is to refine the cut-out after you've created a composite and transformed the selection into a mask.

In Photoshop, with your Sky selection active and the foreground layer highlighted, click the "Add layer mask" button in the Layers palette. In Elements, add a new Levels adjustment layer and OK it without making any changes, drag this layer below the foreground layer in the layer stack, then hold down Alt and click the line between the Levels and foreground layers. The Levels layer's mask will now act as a mask for the image layer.

In both programs, click the mask thumbnail and press Ctrl-I to invert the mask, revealing the foreground and removing the sky.

If you now look around the cut-out edge you'll see a light line surrounding the building and a little chromatic aberration. Use the Lasso Tool to select the edge and then go to Hue/Saturation. Use the dialog's Edit menu to select the colour of the aberration and then the Saturation and Lightness slider to remove any haloes or outlines.

18 Using layer masks

Now to boost the colour and contrast. Drag the foreground layer thumbnail onto the "New layer" button in the Layers palette to duplicate the layer, press Ctrl-Shift-U to desaturate the copy, then set its blending mode to Overlay to boost the foreground contrast. Go to the Select menu and load the saved Sky selection but click the Inverse box first. Alt-click the "Create adjustment layer" button and select Levels in the list. Click Group with Previous Layer in the dialog and click OK. In the Levels dialog, hold down Alt and slide the White Point slider inwards until you see the clipping warning; repeat for the Black Point slider. Load an inverted Sky selection again and add a Hue/Saturation layer in the same way. Select Red in the dialog's Edit menu, boost Saturation to taste, then repeat for other foreground colours.

Advanced blending

To help blend the layers, we want some of the clouds from the sky to overlap the foreground. Click the foreground layer's mask thumbnail (or the mask of the Levels layer beneath it in Elements) and switch to the Brush Tool. Tap D (then X if need be) to make the foreground colour black, and set the brush opacity to 10-20%. Paint over the edges of the horizon to reveal some of the sky layer. If you go too far, tap X to flip the brush colour to white. Click the Sky layer thumbnail and add a Levels layer above it, then move the midtones slider to the right to darken the sky. Click the foreground layer thumbnail, then add a Levels layer and a Hue/Saturation layer, and make any necessary tweaks to the overall contrast and colour.

Ed Godden - Small hut in Snowdonia

20 Adding a border

The image should now have that added impact. Save a copy in case you want to revisit your layers, then flatten so you can sharpen. As a final step we'll add a border, so go to Canvas Size (under Image in Photoshop or Image > Resize in Elements). We want to print on A3 paper with at least 15mm all round for mounting, so increase the canvas to a width of 42cm and height of 29.7cm. Check that the Canvas Extension Color is set to White in the dialog and click OK. Now switch to the Text Tool, choose a suitable font, set the foreground colour to black, click just below the image and type in your text. Use the handles to resize it if necessary, and click the green tick in the tool options bar to finish.

Create large-scale prints

On the disc
Try it yourself! Start image and video on the DVD

Taken a great panorama shot? We reveal the five steps to creating stunning large-scale prints

TOOLS YOU'LL MASTER...

✔ **Layout options**
For most panoramas the Auto option is fine, but Interactive Layout enables you to position the images perfectly.

✔ **Refining the edge**
After making a selection, the Refine Edge dialog enables you to adjust the edge of the selected area.

✔ **Selecting the range**
Use the Dodge Tool on highlights and the Burn Tool on shadows. Occasionally use both in the midtones.

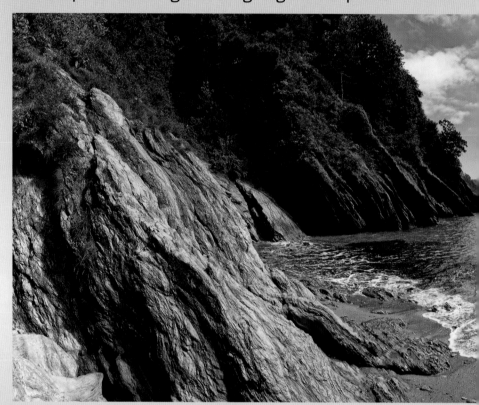

OUR TOP SKILLS!

Automated features within Photoshop give you access to techniques that would take hours manually. These do save time, but a little background know-how will make all the difference

21

22

Photomerge Panorama
In Photoshop or Elements, go to File > New> Photomerge Panorama, click Browse and select the images you want. In the panel on the left select Interactive Layout. In the Photomerge window position the images so they align perfectly. Zoom in to check the horizons. Once you're happy, click OK, then crop and flatten the layers.

Quick selections
We want to boost the sky to help draw out the clouds. With the Quick Selection Tool, drag across the sky to select it. Click the Refine button in the options bar, and Feather by a few pixels to smooth the transition of the effect. Add a new Levels layer and, holding down Alt so you can see the clipping warning, pull the Black Point slider in to about 70.

Original exposures

WHAT YOU'LL NEED *Any version of Photoshop or Elements*
WHAT YOU'LL LEARN *How to use the built-in Photomerge feature to blend together a sequence of images into an awe-inspiring panoramic scene*
IT ONLY TAKES *20 minutes*

With Photomerge, it couldn't be easier to create large-scale panoramas. For good results, you need to take a sequence of images – at least three of them, with about a 25% to 50% overlap (but not more than

70%) – so a good strategy is to locate a fixed point in the right-hand third of your first shot, then turn so it's in the left-hand third of the next, and repeat with another reference point for each subsequent shot. Then it's back to the digital darkroom to let Photomerge do the tricky blending work by attempting to match the shots' content and adding layer masks to blend them as it finds necessary. Note that any imperfections in the blending or enhancements can really show, so you may find that a little manual adjustment is necessary.

23
Boost colours selectively
Deselect (Ctrl-D) and add a new Hue/Saturation adjustment layer. In the dialog's Edit menu, select Cyans so the layer affects greens and blues. Push the Saturation slider to 15 to boost the colour of the sea. Then select Greens followed by Yellows, boosting the Saturation of each by 15.

24
Revealing shadow detail
To boost some of the details in the shadows and increase the midtone contrast, go to Shadows/Highlights (under Image > Adjustments in Photoshop or Enhance > Adjust Lighting in Elements). Set the Shadows and Highlights sliders to 5% and the Midtone Contrast to 10%. Keep your adjustments moderate to avoid spoiling the image.

25
Dodging and Burning
The Dodge and Burn tools need to be used in moderation to lighten and darken areas. Take the Dodge Tool and set the Exposure to 5% and Range to Highlights. Carefully paint over areas of the sea and rocks to lighten them, then switch to the Burn Tool, set it to Shadows and use it to darken areas. To finish, flatten the image and sharpen.

On the disc
Try it yourself!
Start image and
video on the DVD

How to...
Import and organise

Save time and trouble by letting Photoshop's
built-in organisational tools take the strain

Even if you know where all the tools are, and even if you're familiar with all their settings and options, you're still not guaranteed to get the best from Photoshop/Elements. Our 20 tips will help you get more at every step of the workflow.

Okay, you want to spend your time improving your images, not organising your hard disk. But following these four tips will take you just a few minutes and yet potentially save you hours of wasted effort and frustration later on. You might already be using Bridge, the file-management utility that comes with Photoshop, to preview and organise your photos, but our tips will show you four sure-fire ways to get even more out of it and make your life easier. We're using Photoshop CS4 on a PC here, but the same techniques will also work in Elements' Organizer, in other versions of Photoshop, and on a Mac (substitute the Command key – the key with an apple or "four-leaf clover" symbol – for Ctrl).

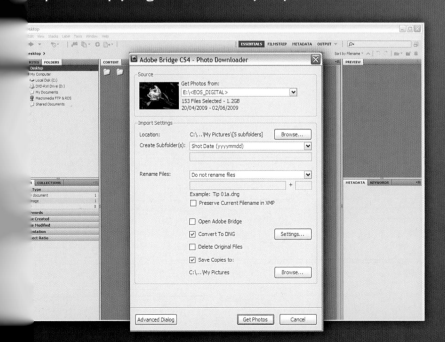

1 Get organised instantly

Ever lost a digital photo? Ever tried to recover a corrupted or accidentally deleted image? Ever wasted time just trying to find the shot you wanted? The solution is easy – and almost entirely automated. When you're ready to import your photos from your camera or memory card, go to "Get Photos from Camera" in Bridge or Elements' Organizer. This launches Adobe Photo Downloader. Enable both Convert to DNG and Save Copies To, set the locations and options for both, and click Get Photos. All your original images will be filed in your selected backup location; copies will be converted to DNG files and saved to a folder you specify (or, if you wish, to a new sub-folder labelled with the shoot date, the import date or a custom name of your choice). You can even opt to have your shots renamed and numbered in sequence for you. Result: instant filing system, instant backup!

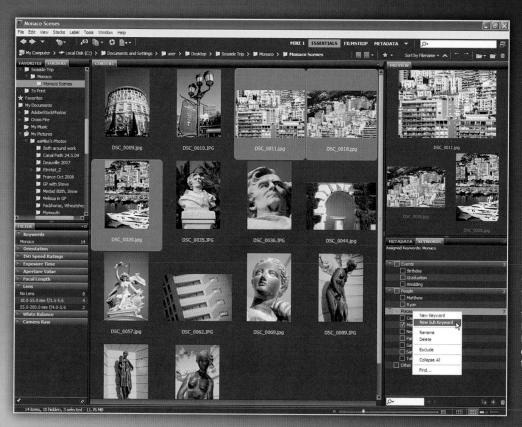

2 Use tags for faster finds

How good is your memory? If you're organised, you'll probably import your shots into folders marked with the date of each shoot or possibly the name of the occasion (such as "Egypt Trip" or "Ali's Wedding"), but are you going to remember every location six months later? ("Was that Aswan or Luxor?") Are you going to recognise who's who in every shot? What if you want to find "before" and "after" pictures of Ali? You need an easy, reliable method for labelling your images, and Bridge gives you exactly that in the form of Keywords. After importing your images into Bridge or Elements' Organizer, take a few moments to tag them with relevant keywords. Simply click once on an image thumbnail to highlight it (then optionally Ctrl-click on others to highlight them in addition, or Shift-click to highlight a range of adjacent images), go to the Keywords palette, and click the words that apply to the selected image(s). Want a new tag? Just right-click in the Keywords palette and select New Keyword or New Sub Keyword to add one. Now you'll be able to find the shots you want days or months later simply by right-clicking in the Keywords palette and choosing Find.

3 Speed up searches with ratings

Shooting digital eliminates the costs of processing film, but you might now have several memory cards full of hundreds of shots to assess. To save you having to wade through all those images repeatedly, use Bridge's star rating system in addition to keywords. On your first look through, start by giving any acceptable photo an initial two stars by simply hitting Ctrl-2. Then filter by rating, take a closer look, and increase the rating of the best shots by simply tapping Ctrl-> (the key with the full stop or period on it). If you wish, you can reduce any image's rating by hitting Ctrl-< (the key with the comma on it). After you've given all your shots ratings, you can now filter by rating at any time in the future to view only the best of your photos.

4 Automatic ACR processing

The Adobe Camera Raw (ACR) editor makes it easy to bring out the best in every shot or add a personal style, such as "high contrast, low saturation". If you've hit upon a particular formula you like, save it as a Setting in ACR (using the palette menu at the top-right of each tab). You can then apply this Setting to any other image without even opening it in ACR: simply right-click on the shot (or multiple highlighted shots) in Bridge and select Develop Settings from the menu that pops open. (You can also apply the Camera Raw Defaults or your last-used ACR settings, even if you didn't save them.) What's more, because all ACR edits are "non-destructive", you can adjust any effects at any time by opening the image in ACR, or remove them without affecting the original file.

On the disc
Try it yourself!
Start image and
video on the DVD

How to...
Get more from Raw

Make more of the powerful tools in the Adobe
Camera Raw editor and improve Raw processing

The Adobe Camera Raw (ACR) editor is a fantastic option for perfecting the exposure and white balance of your images, and newer versions of the editor also include some superb tools for further adjustments and effects, from removing lens artifacts to split colour toning. It's designed for Raw files, of course, which contain the full tonal and colour information captured by the camera sensor; but you can also use it on your JPEGs: go to File > Open As, navigate to your image, and choose Camera Raw in the Open As menu; or in Bridge, right-click and then choose Open in Camera Raw from the menu.

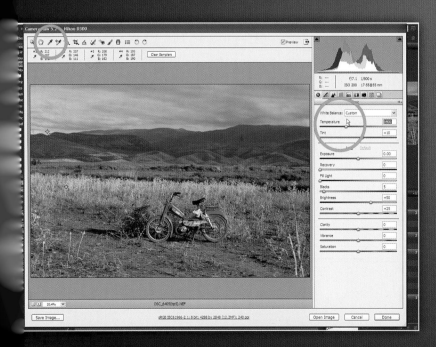

5 Get it white

Correcting white balance is one of the primary functions of ACR. If you open a Raw file (though not if you're using ACR on a JPEG), there will be a range of presets on offer in the White Balance menu at the top of ACR's Basic tab. Each preset will have the same effect as selecting that setting in-camera would have done, so pick the one that best represents the lighting conditions when you took the shot, then fine-tune with the Temperature slider if necessary. Even simpler is the White Balance Tool: click with it on a spot in your image that should be a colour-neutral grey – light greys or diffuse whites work best (avoid the brightest highlights). As a check, there's the Color Sampler Tool (next to the White Balance Tool, but not available if you're running ACR under Elements). Use this to place a few markers in any spots that you think should be a colour-neutral grey: once you've corrected the white balance, these spots should have "equal" R, G and B values (such as R120,G120, B120 or R30,G30,B30, though one or more values might be a couple of units out because of rounding).

7 Fix tricky exposures

In bright conditions, capturing a perfect exposure can be all but impossible: expose for the sky, and the ground will end up deep in shadow; expose for the foreground, and the sky will be blown out. If you don't have a graduated ND lens filter with you, one solution is to try ACR's targeted tonal sliders back in the digital darkroom: Exposure and Recovery to adjust highlights and brighter midtones, then the Blacks and Fill Light sliders for the shadows. The latter two sliders are relatively blunt instruments, though, and ACR's Tone Curve (available if you're running ACR under Photoshop) is a much more precise way of adjusting parts of the tonal range selectively.

1 Shape the Curve
Click the Tone Curve tab, then Point rather than Parametric. The curve works just like Photoshop's own Curves dialog: click on the line and pull the curve upwards to lighten tones in the image, or pull it down to darken.

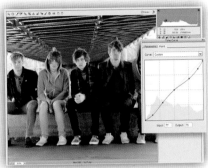

2 Target points
To target specific tones in your image, hold down Ctrl (Command on a Mac) and click on the area you want to adjust in the image. A control point will appear at the corresponding point on the curve.

3 Targeted Adjustment Tool
Under CS4/5, this is a quick way to apply local Curve and other adjustments: select the tool, right-click in the area you want to adjust, pick an adjustment type, then simply click and drag left or right to adjust those tones.

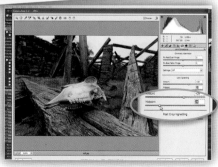

6 Rescue highlight detail

Digital cameras are much more sensitive to highlight information than film was and often capture detail even in areas that seem burnt-out. You can often pull back detail from blown highlights using ACR's Recovery slider. First enable the highlight clipping display by pressing O (for "overexposed"): clipped highlights will show up in the image as red, but they might be clipped in only one or two channels, with detail you can rescue in the remaining channel(s). Make any larger-scale exposure correction with the Exposure slider, then nudge the Recovery slider to the right and watch for any remaining red overlay to disappear. Take it gently, though – Recovery adjustments can darken other, correctly-exposed highlight tones, dulling the image down and causing it to look flat, so you might just need to live with some highlight clipping.

8 Give your shots an edge

Vignetting is very common when you're using wide-angle lenses, particularly at their widest angles of view. Although vignetting is often regarded as a flaw, it's also sometimes added as a popular creative effect to "frame" an image and draw attention where it's wanted (in wedding portraits, for example). The problem is, it can be just as tricky to control in-camera as it is difficult to avoid when you're out shooting a sweeping landscape. The digital darkroom gives you much more control, so whether you want to remove the effect or add it, try the sliders under ACR's Lens Corrections tab – the Post Crop variant, new in CS4, gives you extra control over the vignette shape and extent.

1 Vignetting controls
Push the Lens Vignetting Amount slider to the right to lighten the edges of the shot, or to the left to darken them. Use the Midpoint slider to control how far into the shot the effect extends.

2 Creative framing
Pull the Amount slider hard to the left to really darken the frame edges, then use the other sliders under Post Crop Vignetting to adjust the extent, shape and fade of the effect.

3 Fix that fringing
The Lens Corrections tab also includes tools to tackle the colour fringing you often get along high-contrast edges. Zoom in close to identify the problem colours so you can target them.

How to...
Add impact to your images

Take greater control of your edits, from tonal and colour adjustments to mono conversions

Whether you want to adjust colours or tones in your image or convert it to black-and-white, we'll show you how to do so with more precision and more flexibility. Key to this is using adjustment layers, which enable you to apply a wide range of adjustments and effects to an image without irretrievably altering its pixel content, which means you can hide or remove the effect at any time. Click the black-and-white "half-moon" button in the Layers palette and select an adjustment type to apply from the list.

9 Removable adjustments

If you apply an adjustment or command from the Image > Adjustments menu (or the Enhance menu in Elements), you'll permanently alter the pixel content of the image: if you change your mind, the only way to undo is to step back in the History. The "non-destructive" alternative is to use adjustment layers, which enable you to apply Levels, Hue/Saturation and many other edits on separate layers. Just as a red Cellophane overlay will make a photo print appear red without actually recolouring it, adjustment layers "lie on top" of an image and change its appearance without altering it permanently – which means you can discard the adjustment at any time, hide it temporarily, or even revisit it to tweak its settings, even after you've closed and reopened the file. (The History vanishes when you close the file.) If you want to try out alternative effects, you can group adjustment layers and hide or show whole groups at a time to help you decide between them.

10 Mono with impact

A great black-and-white image isn't just a colour shot with the colour removed. Each of the colour channels within the photo contains a slightly different version of the image – there might be more contrast in the blue channel, for example, or a greater tonal range in the green. The secret to a great mono conversion is to make the most of this tonal richness by mixing the information from the various channels to suit the image or the result you have in mind. Photoshop's Channel Mixer was the traditional tool for this, but there's now the option of a Black & White adjustment Layer. You can use the sliders to add or subtract information from each channel or pairs of channels, apply a selection of presets and then fine-tune them, or click in your image to pinpoint the exact tones you want to adjust and then drag left or right to lighten or darken them.

11 Master tone control

The Curves dialog in Photoshop is almost identical to the version in ACR but has one distinct advantage. In the top-left corner of the Curves dialog in CS4 and newer you'll see a button with a small hand-and-arrow icon, the "On-Image adjustment" tool. Click this and you can move your mouse pointer over the image to instantly see where the tones in the image relate to the curve; click-and-drag the mouse up or down, and those tones will lighten or darken. You can place up to 14 separate control points on the curve to adjust different parts of the tonal range, but two or three is usually enough.

1 Spot that tone
In CS4/5, to see where on the tone curve a particular area lies, click the button to activate the "On-image adjustment" tool and hover your mouse pointer over your image.

2 Place a point
Now simply click in the image and drag up or down to adjust all similar tones in the photograph – you'll see the curve change shape as you do so.

3 Anchor points
To prevent other tones being affected, click on the curve to place anchor points. Here we anchored the midtones so we could tweak the shadows without affecting midtone contrast.

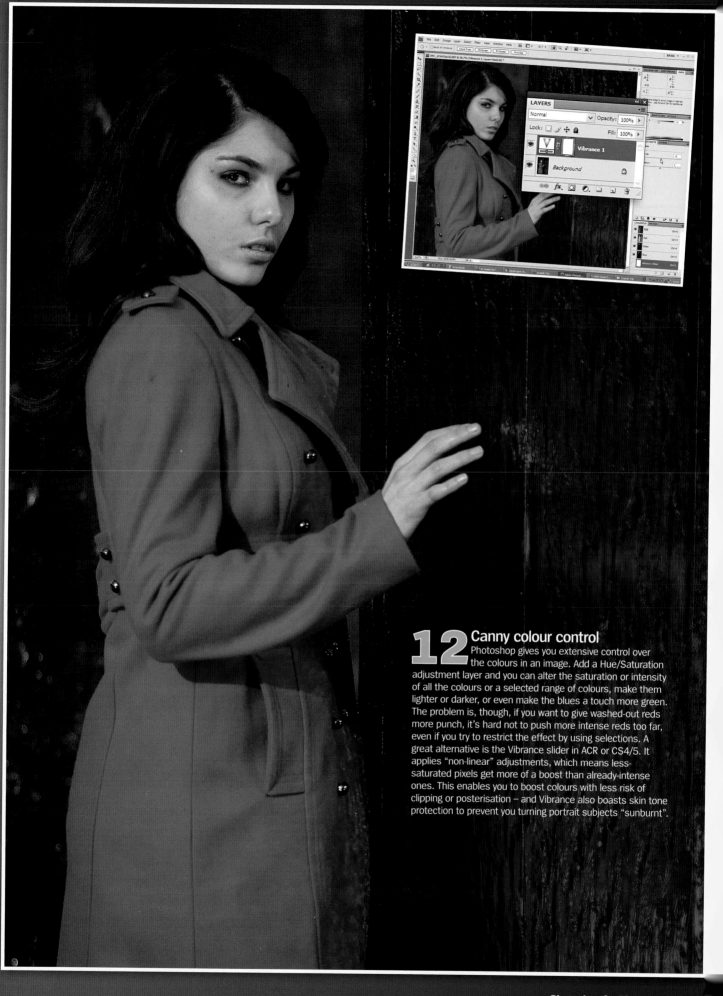

12 Canny colour control

Photoshop gives you extensive control over the colours in an image. Add a Hue/Saturation adjustment layer and you can alter the saturation or intensity of all the colours or a selected range of colours, make them lighter or darker, or even make the blues a touch more green. The problem is, though, if you want to give washed-out reds more punch, it's hard not to push more intense reds too far, even if you try to restrict the effect by using selections. A great alternative is the Vibrance slider in ACR or CS4/5. It applies "non-linear" adjustments, which means less-saturated pixels get more of a boost than already-intense ones. This enables you to boost colours with less risk of clipping or posterisation – and Vibrance also boasts skin tone protection to prevent you turning portrait subjects "sunburnt".

How to...
Retouch creatively

Improving your images can take more than just tweaking the tones and colours. Here are the secrets of successful retouching

Retouching is the first thing that leaps to many people's minds when they hear the word "Photoshop", but as so often, there's more than one way to re-skin a virtual cat. The handiest tip to remember is always to retouch on a separate layer: either make a selection around the area you want to work on and float it to a new layer by pressing Ctrl-J, or simply add a new blank layer and enable your retouching tools' Sample All Layers or Current & Below option. Instead of irrevocably altering the image, your retouching will then lie on a layer of its own, making it easier to fine-tune – you can reduce its opacity to help it blend with the original image below, mask it to alter where it shows, or change its blending mode for more subtle or creative results.

13 Make more of masks

The options for applying and using masks have changed in CS4, making them even more powerful, but the principles remain the same: black areas of a mask conceal corresponding areas of the image content of that layer (or the adjustment, in the case of an adjustment layer), and white areas reveal them. For more subtle effects, bear in mind that grey areas of the mask partially conceal the image content or adjustment – the darker the grey, the more they conceal it. Want to check how your image looks with and without the mask? Hold down Shift and click the mask thumbnail to toggle it off temporarily; Shift-click it again to reactivate it. Alt-click on the mask thumbnail to view the mask itself instead of the image in the main window – great for working on detail or fine-tuning, particularly touching-up grey partially-masked areas.

Original shot

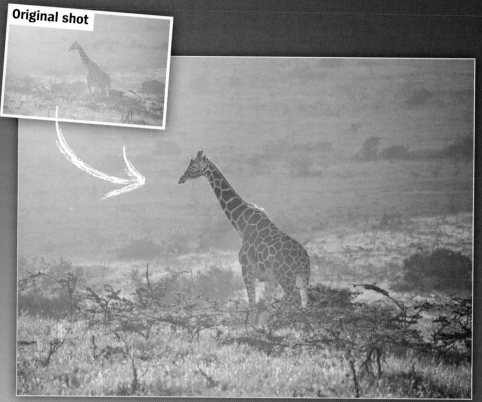

14 Self blends

In summertime landscape photos, the distant background often looks hazy and "washed out". Here's a simple but highly controllable alternative to separate exposure and contrast adjustments. Duplicate the Background layer and change the blending mode of the new layer to Overlay – this adds contrast and boosts the colours. The effect can be a little extreme, though, so reduce the Layer opacity as necessary. Alternatively, add a Levels adjustment layer, OK the dialog without touching any settings, and change the layer blending mode to Multiply to darken the image, or Screen to lighten it. Adjust opacity to fine-tune – if you're used to thinking in photographic terms and want to be very precise, an opacity of exactly 38% has the same effect as adjusting exposure by a full f-stop; 19% is equivalent to a half-stop adjustment, about 13% one-third of a stop, 76% two stops (as here), and so on. To localise the effect, click the layer's mask thumbnail to target the mask, then paint with a black or grey brush to conceal or partially conceal the effect respectively.

16 Smarter dodging and burning

Photoshop's Dodge and Burn Tools can be invaluable for those localised contrast tweaks that give an image more punch and depth, but before you get stuck in with either tool, make sure you set the Exposure to no more than 5% or 10% at the very most – any more and you'll quickly see a marked loss in image quality. Work carefully – the effects of these tools are cumulative, so avoid going over the same area repeatedly. For gentle changes, avoid working in the midtones: if you're using the Dodge Tool, set Range to Highlights so you lighten only light tones; if using the Burn Tool, set Range to Shadows so you darken primarily dark tones. For a non-destructive alternative, try adding a new, blank layer and using the Brush Tool set to Soft Light mode and a low Opacity (say 10%): paint with a large, soft brush using any colour lighter than 50% grey to lighten (dodge) areas, and any colour darker than 50% grey to darken (burn).

15 Preserve detail by cloning, not healing

The key to success in retouching is often knowing when to clone and when to heal. Both sets of tools lay down pixels sampled from elsewhere, but the healing tools then additionally blend these pixels into their new surroundings, and this invariably has the effect of blurring or distorting detail, so if preserving detail is important then the Clone Stamp is your best bet. The Spot Healing Brush is usually the fastest option for removing dust spots and similar blemishes from areas of relatively uniform colour and tone such as clear blue skies, but even with this tool, clicking instead of brushing will often help preserve subtle tones and detail. Bear in mind too that not only layers but also brush-based tools can be set to different blending modes, altering their behaviour: set the Clone Stamp to Lighten mode, for example, and it will replace only pixels that are darker than the colours you've sampled. This is fantastic for cloning away distractions behind a blonde-haired portrait subject: sample areas darker than the hair and the tool won't affect the hair, even if your brush should inadvertently stray over it.

20 WAYS TO GET FASTER WITH PHOTOSHOP

On the disc
Try it yourself!
Start image and
video on the DVD

How to...
Get a perfect finish

All your photo-editing efforts will be wasted if your final prints aren't sharp. Learn how to apply those critical finishing touches...

Have you ever taken some time, and possibly quite a bit of trouble, to get a photograph spot-on, only to then face having to adjust another dozen or more from the same shoot? If you're using ACR, you can open multiple images in Filmstrip mode and then (under Photoshop) click Synchronize to copy any or all of the adjustments you've made on one image and apply them to the others.

(Under Elements you can apply them all by selecting Previous Conversion in the Settings menu.) In Photoshop or Elements you can drag adjustment layers from one image onto another. Alternatively, you can record a sequence of edits as an Action in Photoshop and then apply them to other images, one by one or all together using the File > Automate > Batch commands.

17 Automated edits

Photoshop offers automation options to save you time, avoid tedious repetition or ensure consistent adjustments to multiple images: you can record a sequence of edits and commands as an Action. Simply click the Create New Action button in the Actions palette, give the Action a name (or double-click it afterwards to do this), hit Record, work through the edits, and click Stop when done. You can then "play" the Action at any time to apply the edits to any image (but do be wary – don't record a Save As, for instance, or you'll save over the same file every time you run the Action). You can assign a keystroke shortcut to play your Action, either when you create it or afterwards by selecting Action Options in the Actions palette menu. In Elements 7 and newer you can apply pre-recorded Actions using the Action Player (available in the Automated Actions tab in Guided Edit mode) but not record your own.

18 Pin-sharp pictures

Digital photos often turn out a bit less sharp than you expect – particularly Raw files, which are not sharpened in-camera, though some mild sharpening is applied by default when you open a Raw file in ACR. You might not notice anything on-screen, though, unless you zoom in to 100% (or more) and check specifically – most images will probably look a little soft. Photo-editing can have a further softening effect, so it's good practice to apply some sharpening as the final step in the editing process. All sharpening risks exacerbating (or even introducing) image noise, but Unsharp Mask's Threshold control can help offset this, making this filter still a great first option. Smart Sharpen lacks a Threshold control; but conversely, if you click the Advanced button, it does enable you to "fade" or pull back the sharpening effect in Shadow areas, where noise is likely to be lurking, or apply different settings in the Highlights to make them "pop".

19 Save those trees!

As well as new tools and features, Photoshop CS4 introduced some pretty fundamental changes, such as a completely new way of adjusting tone or other characteristics of an image by clicking and dragging left and right. Oddly, though, as if to offset these new gains, some of those extras that we've been used to for years are now omitted from the standard install. Some will go unmissed, but others are pretty useful and well worth taking the trouble to restore. Among the latter group is Picture Package. To get this back you'll need to dip into the Goodies folder on your Photoshop install disc or locate the files in the Adobe Downloads website (**www.adobe .com/downloads**). Once installed, Picture Package enables you to arrange multiple images (or a single image repeated) on one sheet of paper. This is not only a smart way of getting the most economical use out of a sheet of expensive photo paper; it's also great if you want to print the same photo in a variety of different sizes – with a family portrait, say, you might want a large print to frame, a small one for your wallet, plus mid-size copies you can send to far-flung relatives.

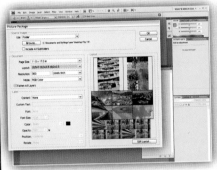

1 Pick your pictures
Go to File > Automate > Picture Package, and select your photo(s) in the Source Images section of the dialog, or click an image preview to replace it.

2 Change the layout
Set the page size and layout; drag the previews around to rearrange shots on the page, or click the Edit Layout button to customise it.

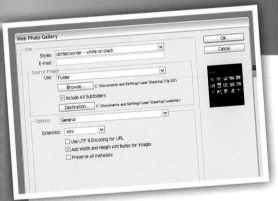

20 Put it all online

These days you're just as likely to want to share your photos electronically as on paper. Photoshop can help you create a complete photo gallery site of your own from scratch (if you reinstate the Web Photo Gallery option, also missing from the standard CS4 install). Start by putting copies of all the images you want to include in a folder or highlighting them all in Bridge, then go to File > Automate > Web Photo Gallery (or Tools > Photoshop > Web Photo Gallery in Bridge). Choose a basic layout for your site from the Styles pop-up menu, and your choice will be previewed at the right of the dialog (though only at thumbnail size). Select a location for your site files, then work your way through the Options panels one by one; finally, click OK to have Photoshop create your site for you.

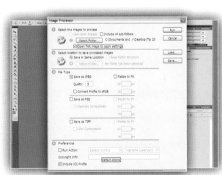

1 Leave it to Photoshop
Once you've specified all the settings and options, Photoshop will chug through your photos pretty efficiently, generating every element of the website.

2 Simple sites
The small previews of the site designs can make it tricky to choose between them. So if uncertain, select just a few images in Bridge first for a trial run of some of the designs.

3 Things to do yourself
For more control, you can specify image size and colours for each scheme. If you need web-safe colours, check out the Image Processor in the File > Scripts sub menu. ◖

Get to know...
Using layers

You *can* edit photos without them, but they're very useful things...

Matt Henry

Layers are an invaluable part of digital darkroom work. At their simplest, layers contain objects you've pasted in from other images; or you can make a selection around an area and then "float" it to a new layer within the same image by pressing Ctrl+J. (If there's no selection active, this creates a duplicate of the entire layer.) Think of layers as clear sheets of acetate stacked on top of your image, transparent apart from the object on them. This makes them great for "stacking" cutout objects behind one another.

There's another kind of layer, too: one that doesn't contain pixels but simply applies an editing effect, with the option to remove or adjust the content whenever you like. Many of the most common and most useful edits can be applied using adjustment layers, including Levels, Hue/Saturation, and more – click the "half-moon" button in the Layers palette to see the list. Their benefit is that, like a red acetate overlay laid on top of a print, they alter the appearance of your image but don't actually alter it, so you can hide or discard the edit later. You can also double-click the layer thumbnail in the Layers palette to reopen the adjustment dialog and make fine tweaks at any time. Here's a quick example... 📷

What you can see

This is how you see the composite image on screen, complete with "overlaid" adjustments. You can hide or discard any or all of the layers at any time if you change your mind or want to experiment.

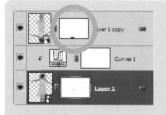

Masked layer

This layer is a duplicate of the pasted-in girl ("Layer 1"), flipped to create her reflection in the water. To make the reflection fade out, we added a mask to the layer (circled) – more about masks overleaf.

Adjustment layer

To give our pasted-in girl more "punch" and help her match the tonal depth of the background image, we added a Curves adjustment layer and created this "S-shaped" curve to boost contrast – see page 76 for more on Curves. (Elements' counterpart, Adjust Color Curves, can't be added as an adjustment layer, so you'll need to apply the command directly to a duplicate image layer or use an alternative type of adjustment layer such as Brightness/Contrast.) Adjustment layers usually affect all the layers beneath them, but this one is "clipped" to the cut-out girl layer (note how its thumbnail is indented in the Layers palette) so that it affects only the girl layer and not any other layers.

Image layer

The girl (complete with her stepping stones) has been cut out from another image and pasted in to create this composite image. Like any pasted-in object, she appears on her own layer; the rest of this layer is transparent and allows the background layer to show through.

Background layer

Pixels in the original image are unaltered by adjustment layers, and the pasted-in objects remain separate; only if you merge layers or flatten the image (Layer > Flatten Image) are the component layers combined together and any changes applied permanently. Up till then, you can move layers independently and hide or show them separately.

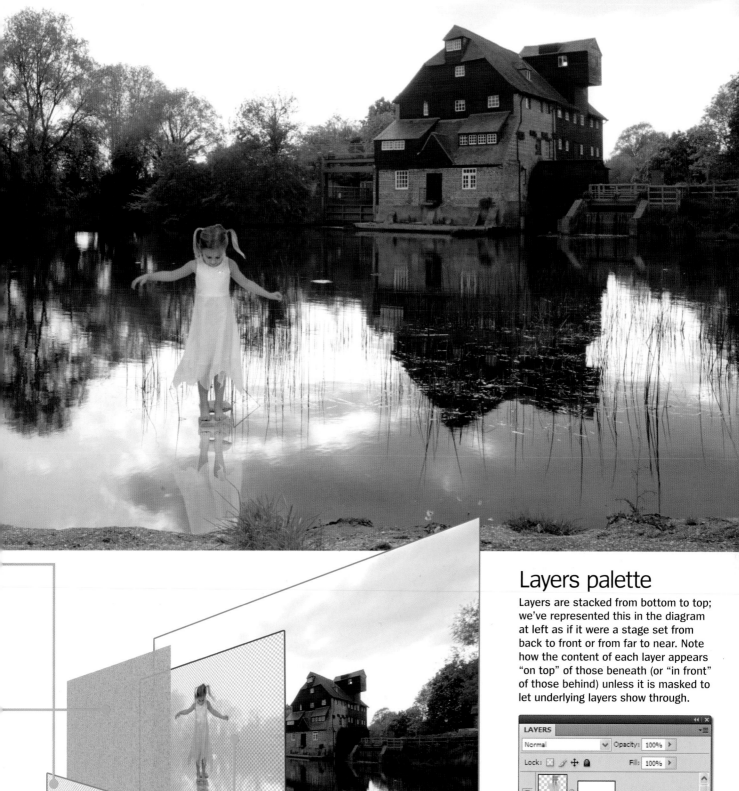

Layers palette

Layers are stacked from bottom to top; we've represented this in the diagram at left as if it were a stage set from back to front or from far to near. Note how the content of each layer appears "on top" of those beneath (or "in front" of those behind) unless it is masked to let underlying layers show through.

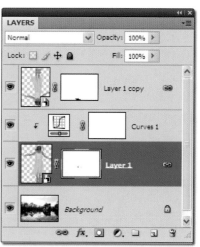

Get to know...
Working with layers

The Layers palette isn't as scary as it may at first seem. Keep this page handy when you're editing in the digital darkroom for quick reference.

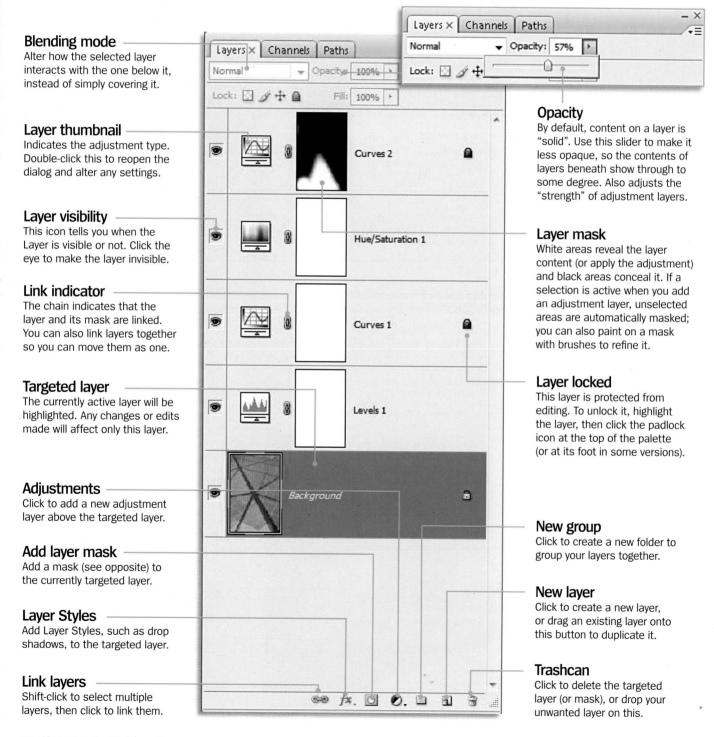

Blending mode
Alter how the selected layer interacts with the one below it, instead of simply covering it.

Layer thumbnail
Indicates the adjustment type. Double-click this to reopen the dialog and alter any settings.

Layer visibility
This icon tells you when the Layer is visible or not. Click the eye to make the layer invisible.

Link indicator
The chain indicates that the layer and its mask are linked. You can also link layers together so you can move them as one.

Targeted layer
The currently active layer will be highlighted. Any changes or edits made will affect only this layer.

Adjustments
Click to add a new adjustment layer above the targeted layer.

Add layer mask
Add a mask (see opposite) to the currently targeted layer.

Layer Styles
Add Layer Styles, such as drop shadows, to the targeted layer.

Link layers
Shift-click to select multiple layers, then click to link them.

Opacity
By default, content on a layer is "solid". Use this slider to make it less opaque, so the contents of layers beneath show through to some degree. Also adjusts the "strength" of adjustment layers.

Layer mask
White areas reveal the layer content (or apply the adjustment) and black areas conceal it. If a selection is active when you add an adjustment layer, unselected areas are automatically masked; you can also paint on a mask with brushes to refine it.

Layer locked
This layer is protected from editing. To unlock it, highlight the layer, then click the padlock icon at the top of the palette (or at its foot in some versions).

New group
Click to create a new folder to group your layers together.

New layer
Click to create a new layer, or drag an existing layer onto this button to duplicate it.

Trashcan
Click to delete the targeted layer (or mask), or drop your unwanted layer on this.

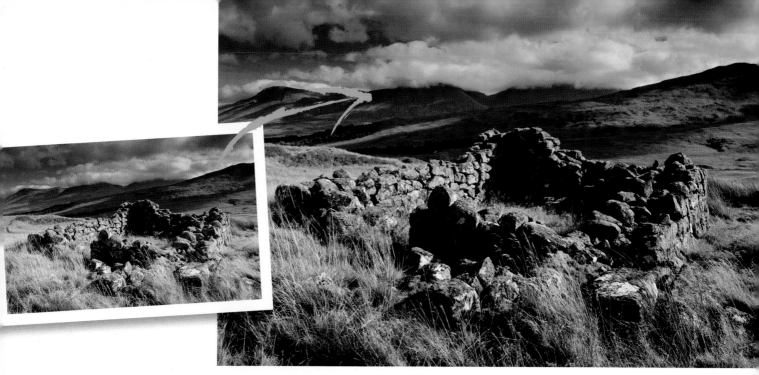

Masking and blending

Hide and reveal layer content or adjustments exactly where you want

Layer masks are extremely powerful editing tools because they enable you to apply edits or effects to specific parts of the image. If there's a selection active when you add an adjustment layer or click the "Add a mask" button in Photoshop's Layers palette, the mask will reflect the selection: selected areas will be white on the mask, revealing the layer content or effect in these areas; unselected

areas will be black, hiding the content or adjustment; grey areas on the mask partially hide and partially reveal it – the darker the grey, the more they hide it. The real power of masks is that you can refine the mask at any time by clicking the mask thumbnail and painting on your image with black, white or grey brushes to hide or reveal areas; in fact, you can also use gradients and many other tools to

modify a mask, as we'll see. There's no button for adding layer masks in Elements 8 or earlier; instead, add any adjustment layer (such as Levels) that doesn't apply an instant effect, drag it immediately beneath the layer you want to mask in the stack, then hold down Alt and click on the line between the two layers. The adjustment layer's mask will now act as a mask for the image layer. �‬

Using masks and blending modes

We'll show you how to use layer opacity and blending modes later, but here's a quick example. We wanted to add a "tobacco grad" effect to this shot and boost the contrast of the foreground. If

you make all these changes using adjustment layers, a mask is automatically created at the same time, which you can always return to and fine-tune later.

1 Levels
Always start with good contrast as close as possible to where you want it to be. We added a Levels adjustment layer to increase contrast by pulling the Black Point slider (the left one) towards the centre. The highlights needed no adjustment.

2 Gradient
We added a Gradient layer, and faded it top to bottom. We changed the blending mode to Overlay, which has the effect of boosting contrast, then used a large soft black brush to paint on the layer mask and hide the effect over the foreground.

3 Curves
To darken the foreground we added a Curves adjustment layer and set the blending mode to Multiply (a darkening mode). We dropped the layer opacity to 65% then painted black over the sky area on the layer mask so that the sky wasn't affected.

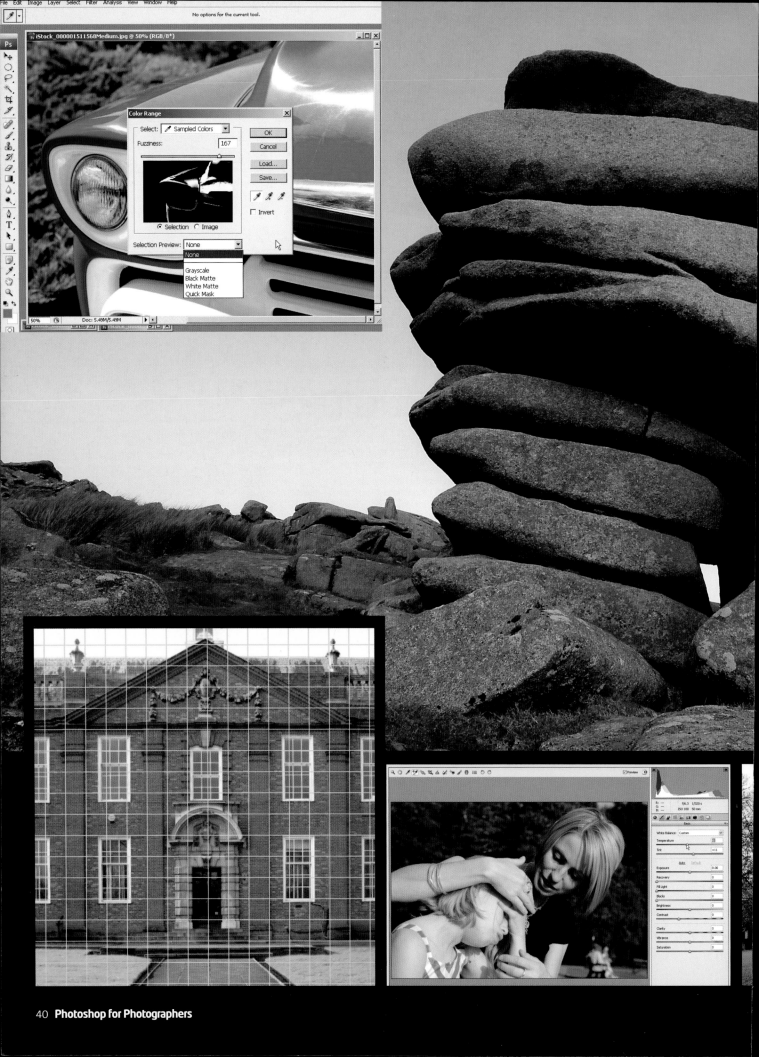

» Tools and Techniques 2

Explore the range of tools available for all the essential photo-editing tasks, from levelling-out an off-kilter shot to retouching, adjusting exposure and correcting colour casts

How to...
Make a basic selection

The simplest way to make a selection is just to draw a shape on your image

You'll often want to make "global" changes to photos, for example to correct a general exposure problem or colour cast. But just as often, you'll want to make "selective" or localised changes. There are some tools that enable you to brush adjustments on where you want them, like the Dodge and Burn Tools, but most often, when you want to restrict your edits to specific parts of an image, you'll need to make a selection. You'll certainly need to do so when you want to cut an object out. The Rectangular and Elliptical Marquee tools are the most basic selection tools: you simply click-and-drag to draw a rectangular or elliptical selection. To constrain the marquee to a perfect square or a circle respectively, hold down Shift as you drag. Hold down Alt to draw the

marquee out from a central point instead of from corner to corner. If you hold down both keys, you can draw a constrained selection out from a central point (useful, for example, if you want to select a subject's eye), although you may need to move the selection (see below) or modify its shape to accurately select the desired area.

To create a shape with a specific aspect ratio other than 1:1, select Fixed Aspect Ratio from the Style menu in the tool options bar in Photoshop (it's the Mode menu in Elements) and type values in the Width and Height fields. If you select the Fixed Size option, the default units are pixels (px), but you can specify others by entering "7in" for inches, "20mm" for millimetres and so on.

Moving selection marquees
To move a marquee, don't use the Move Tool

If you've drawn a selection marquee which is the right size and shape but isn't quite in the right position, you can click-and-drag inside the marquee to move it; if you want to make more precise adjustments, tap the cursor keys to nudge the marquee up, down, left or right one pixel at a time. Make sure one of the Marquee tools or a Lasso tool is active when you do either of these, though – if you use the Move Tool, you'll move the selected pixels instead of the marquee. Make sure "New selection" mode is enabled too (see opposite) – if one of the other options is enabled, you'll modify the selection instead. You can also alter the size and shape of a selection, and modify it in other ways – see pages 48 and 51.

How to...
Use the Lasso tools

The Lasso Tool and Polygonal Lasso Tool enable you to make simple selections fast

The Lasso tools are great for selecting more complex or irregular shapes. The Lasso Tool itself enables you to draw freehand selections around objects – you simply click and drag to draw with the tool, and when you release the mouse button the selection will be closed. The tool is really useful only for making quick, rough-and-ready selections, although if you have a graphics tablet you'll be able to make more precise selections than if you're using a mouse. Grouped with the Lasso Tool is the Polygonal Lasso Tool, which we'll look at below, and the Magnetic Lasso Tool, which we'll look at opposite.

By default, every selection tool (except the Quick Selection Tool – see page 50) creates a new selection each time you click-and-drag, and any existing selection is abandoned. For more intricate selections, however, you can set any selection tool to "Add to selection" mode, so that you can draw several shapes to build up a more complex shape, or "Subtract from selection", or "Intersect" to select only areas where two or more marquees overlap. You can do this by clicking one of the buttons that appear at the left of the tool options bar at the top of the screen, or using keyboard shortcuts: hold down the Shift key as you use a selection tool to add to a selection, Alt to subtract, or both Shift and Alt to intersect. (The Quick Selection Tool by default works in "Add to selection" mode, though you can hold down Alt to make it subtract instead.)

The Polygonal Lasso Tool
This tool enables you to select straight-edged objects

With the Polygonal Lasso, you click to place corner points, which are automatically joined by straight lines; when you get close to the start point, a small circle will appear next to the cursor, indicating that your next click will close the selection. If you go wrong, hit the Delete or Backspace key to delete the last point – you can delete as many points as necessary before continuing with the selection. While using either the Lasso or the Magnetic Lasso, you can also temporarily switch to the Polygonal Lasso to trace a straight edge: hold down the Alt key, then release the mouse button and click to place corner points; to return to the Lasso or Magnetic Lasso, hold down the mouse button, then release Alt and resume dragging.

How to...
Use the Magnetic Lasso Tool

On the disc
Try it yourself! The start image is on the DVD

Use this tool if there's good contrast between subject and background

Instead of just drawing with the Lasso Tool, try the Magnetic Lasso where you want to select a subject or object with a reasonably distinct outline. As you trace the outline, the tool "snaps" to its edges – you can control how sensitive it is to edges by adjusting the Width and Contrast settings in the tool options bar. Keep both settings low unless the object has very well defined edges. The tool places anchor points as it goes: setting a high Frequency value in the options bar means it places more points, which is great for intricate edges but can result in a "jaggy" outline; a low Frequency usually means a smoother outline but won't suit complex shapes.

1 Start **Activate the tool**
Open Magnetic.jpg from the Selection Tools folder on your DVD and press L to activate the Magnetic Lasso. (You might need to press this a few times to step through the Lasso tools, which share a toolbox compartment. Depending on your setup, you may also need to hold down the Shift key to do so. If you'd prefer not to, press Ctrl-K to go to the Preferences and disable "Use Shift key for tool switch".)

2 **Configure the settings**
The Magnetic Lasso works by identifying edges based on contrast between pixels. Because the subject's dark suit doesn't stand out from the background very well in some areas, leave Contrast set to 10% – at a high setting, the tool will detect only high-contrast edges. To prevent the tool from straying too far from our subject's outline, set the Width option to 5 pixels.

3 **Trace the outline**
Engage Caps Lock to turn your pointer into crosshairs, so you can trace the outline more accurately. Click to place an anchor point at the bottom-left of the subject, then release the mouse button and trace around him as closely as you can. Hold down the spacebar to switch temporarily to the Hand Tool to scroll around; hold down Ctrl as well and click to zoom in to work close-up, or Alt and click to zoom out.

4 Finish **Add or delete points manually**
The tool will place anchor points as it goes. If it has to take a sharp turn (to select the edge of the flower, for example), you can click to place additional anchor points manually, to stop it going astray. If it goes wrong, press Delete or Backspace to delete the last point (or as many as necessary) and resume tracing. Don't worry if the selection isn't perfect – we'll look at refining selections shortly. ◘

How to...
Use Photoshop's Quick Mask mode

On the disc
Try it yourself! The start image is on the DVD

Make or modify selections with brushes rather than drawing outlines

Often, outlining an area or object can't produce a perfect selection – it won't if, for example, the object doesn't have distinct edges. In Photoshop you can create or modify selections in Quick Mask mode using brushes, the advantage being that you can adjust the brush size, hardness or opacity to suit. Use a soft brush, for example, for gently-graduated selections. Tap the left or right square bracket key on your keyboard to decrease or increase brush size respectively. Hold down the Shift key as you do so to decrease or increase brush hardness instead in increments of 25% – so hold Shift and tap the left square bracket key four times for a soft brush, whatever the original setting.

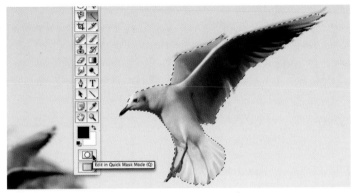

1 Start Open the Options dialog
How Quick Mask mode works depends on the settings in the Quick Mask Options dialog. To open this, double-click the "Edit in Quick Mask Mode" button below the colour swatches in the toolbox. (Note that if you're already in Quick Mask mode, doing this reverts you to Standard Edit mode, with a "marching ants" selection marquee. After setting the options, click the button again or tap Q for Quick Mask mode.)

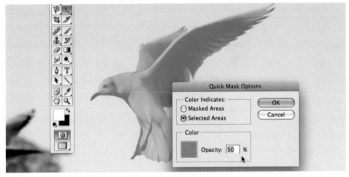

2 Paint on or paint off
Setting Color Indicates to Selected Areas is usually more intuitive: with this setting, you paint with a black brush to colour the areas you want to select (switch to the Brush Tool, tap D to reset the colours to black and white, and tap X if necessary to make black the foreground colour), or use a white brush to remove the colour and thus remove areas from the selection. You can "feather" a selection (give it a soft edge instead of a hard outline) by using a soft brush.

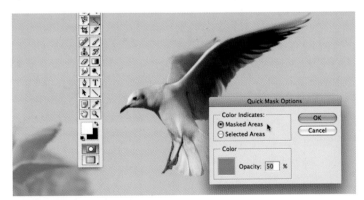

3 Further options to set
If Color Indicates is set to Masked Areas, a black brush still applies the colour overlay and a white brush still removes it, but the coloured areas will be the *un*selected areas. The Options dialog also enables you to change the overlay colour to suit the image you're working on (if it contains a lot of red, for instance, choose a different colour), as well as adjust the opacity of the overlay.

4 Finish Use grey for partial selections
For even subtler or more graduated effects, you can also partially select areas by using a grey brush or by reducing brush opacity. Using grey tones is generally the better option – brushing over the same area more than once with a reduced-opacity brush has a cumulative effect, so you could end up with a patchwork of different levels of selection. You can make the brush a specific shade of grey by clicking on a grey swatch in the Swatches palette. ◘

How to...
Use Elements' Selection Brush Tool

In Elements, you can use this brush-based tool to create or fine-tune selections

Photoshop's "lite" counterpart, Photoshop Elements, lacks some of the features of its big brother (but then it does cost less than one-tenth as much, so that's not really very surprising). Often, though, Elements has its own versions of Photoshop's tools (though these may work a little differently) – and sometimes Elements has some useful tools or options that Photoshop lacks. (Elements had a Quick Selection Tool first, for example, though recent versions of Photoshop now have it too.) Here's a case in point. Elements doesn't have Quick Mask mode, but it has its own specialised tool for creating or modifying selections with brushes...

1 Start Paint with "marching ants"
Elements' Selection Brush Tool enables you create selections or modify existing ones with a brush. Set Mode to Selection and you can "paint on" marching ants to define a selection. The "Add to selection" option is enabled by default in this mode; if you switch to "Subtract from selection" (or hold down the Alt key), then any selected pixels you brush over are removed from the selection.

2 Mask mode
If you set Mode to Mask, the tool works just like Photoshop's Quick Mask mode with Color Indicates set to Masked Areas. In this mode, "Subtract from selection" is enabled by default. If a selection is active, painting over selected areas applies colour and removes those areas from the selection. (If there's red in your image, you can change the overlay colour and opacity.) If no selection exists, painting in this mode creates a mask, so areas you leave unpainted will be selected.

3 Selection strategies
A good strategy is to start in Selection mode and fill in the bulk of the object you want to select. Reduce the brush size (tap the left square bracket key to do this quickly) to brush around the edges, then switch to Mask mode to preview the selection. You can use a soft-edged brush to feather the edges of the selection – the larger the brush, the more gradual the feathering will be.

4 Finish Select the inverse instead
Switch between modes to fine-tune the selection. You may find it easier to paint over areas you want to select with the overlay colour, rather than with the marching ants, particularly when working on detailed areas – if so, switch to Mask mode, invert the selection (by pressing Ctrl-Shift-I), paint over areas you want to select with "Subtract from selection" enabled, then invert the selection again. ◘

Get to know...
The Magic Wand Tool

On
the disc
Try it yourself!
The start image
is on the DVD

The Magic Wand is ideal for making colour-based selections – here's how to use it

Rather than selecting a shape or object in an image, you'll often want to select a specific range of colours – an example is when you want to select the dull or washed-out sky in a landscape shot, so that you can boost its colours or tones without affecting the rest of the image. One of the easiest ways of doing this is with the Magic Wand Tool (the shortcut for activating it is W), which works by selecting pixels of a similar colour to the one you click on. You can configure the tool to select a narrower or wider range of colours by adjusting the Tolerance setting in the options bar, and you can fine-tune a selection by adding pixels to the selection or subtracting pixels from it, or by taking your initial selection into the Refine Edge dialog (see page 51 for this).

Magic Wand settings

Like all selection tools, the Magic Wand can add to an existing selection, subtract from one, and so on. Hover your pointer over the buttons to see which is which.

Anti-aliasing smooths the jagged, "stepped" edges that can appear when you select objects with rounded or diagonal edges.

If you have a multi-layered image, you can select pixels on all the visible layers (but note that adjustments will affect only the targeted layer or layers at any one time).

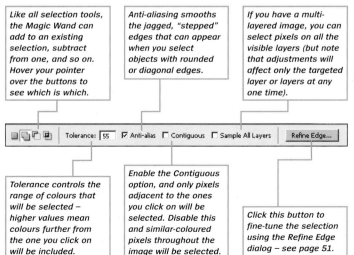

Tolerance controls the range of colours that will be selected – higher values mean colours further from the one you click on will be included.

Enable the Contiguous option, and only pixels adjacent to the ones you click on will be selected. Disable this and similar-coloured pixels throughout the image will be selected.

Click this button to fine-tune the selection using the Refine Edge dialog – see page 51.

How to...
Modify your selections

You don't have to get a selection spot-on first time. There are many ways to refine it

You'll find several options for fine-tuning your selections in the Select menu and its Modify sub-menu. Press Ctrl-Shift-I to invert a selection – the current selection will be deselected, and the rest of the layer will be selected instead. Feathering makes the edges of a selection transparent, softening the transition between selected and unselected areas. Expand can give you a bit more leeway for feathering, while Contract can help remove a "halo" of background pixels clinging to the edges of a selection. Border in effect creates a second selection around an existing one. Smooth will tidy up colour-based selections; Grow and Similar will expand them, based on the Magic Wand's Tolerance setting (Grow works like Contiguous, Similar works throughout the image).

Transforming selections
If a selection isn't quite the right shape, transform it

As we've seen, you can move a selection marquee by clicking-and-dragging it (making sure a Lasso or Marquee tool is active, not the Move Tool) or tapping the cursor keys to nudge it in smaller steps. If you want to change the size and/or shape of an active selection marquee in Photoshop or Elements 8/9, choose Transform Selection from the Select menu or the contextual menu that pops up when you right-click on the canvas. (Don't use Free Transform, which transforms the selected *pixels*, not the marquee.) To scale the marquee up or down, drag a corner handle (in Photoshop, hold down Shift as you do so if you want to preserve its proportions); you can also adjust its height or width by dragging a side handle, or rotate it by clicking-and-dragging outside the box. To skew the shape, hold down Ctrl as you drag a side or corner handle; hold down Shift as well to constrain the skew horizontally or vertically. Hold down Alt in addition to the other keys mentioned to make any transformation apply symmetrically.

Get to know...
Color Range

This Photoshop tool gives you more control over colour-based selections

The Magic Wand Tool is great for quickly selecting pixels of a similar colour. However, the tool can sometimes fail to select every pixel you want – some pixels which are a slightly darker or lighter shade of the colour you want may fall just outside the specified range, and you can easily miss a small cluster of marching ants tucked away in the corner of the image that indicates unselected pixels. Another tool that makes selections based on colour is Photoshop's Color Range command (Select > Color Range). Its advantage over the Magic Wand is that it gives you more visual feedback regarding your selection (with a variety of preview options to choose from), and it's also easier to fine-tune the selection to capture all the pixels you want (because Fuzziness works differently from the Magic Wand's Tolerance, it's better at including shades of a colour). If a selection is active when you open the Color Range

dialog, the tool will work within the selection (but if you hold down the Shift key before you go to the Select menu and keep it held down as you choose Color Range, it will work in "Add to selection" mode).

When the Color Range dialog opens, your pointer turns into an eyedropper with which you can click on a colour or colours in the image; you can then use the Fuzziness slider to increase or decrease the range of colours selected, as well as Shift-click to add colours or Alt-click to subtract them. You can also hold down Shift and *drag* to quickly select lots of colours, which you can't do with the Magic Wand, or Alt-drag to deselect a range.

(Elements doesn't have a Color Range dialog, but the most common reason for selecting colours is to change them, and Elements does have Replace Color, the selection part of which works exactly the same as Color Range.)

The Color Range dialog
Photoshop's tool gives you more options than the Magic Wand

① Adjust the colour range
Fuzziness is similar to the Magic Wand's Tolerance option, making the tool more or less sensitive, but you can adjust the slider on-the-fly.

② Small preview
Click here for a small greyscale preview of the selection – white indicates selected colours, black unselected colours.

③ Large preview
From this menu, you can choose one of four options for previewing your selection in the main image window. If you choose Black Matte, for instance, unselected areas will appear black and selected areas will appear in colour.

④ Using the selection
When your desired colour range shows up as a strong white in the preview window, click OK. A "marching ants" border will indicate the selected pixels in the image.

⑤ Modify your selection
Use the left-hand eyedropper to make your initial selection, then the Add and Subtract eyedroppers, in conjunction with the Fuzziness slider, to add colours to the selection or subtract colours from it.

⑥ Select the inverse
If you want to invert your selection, so that the selected pixels are deselected and vice-versa, click this box.

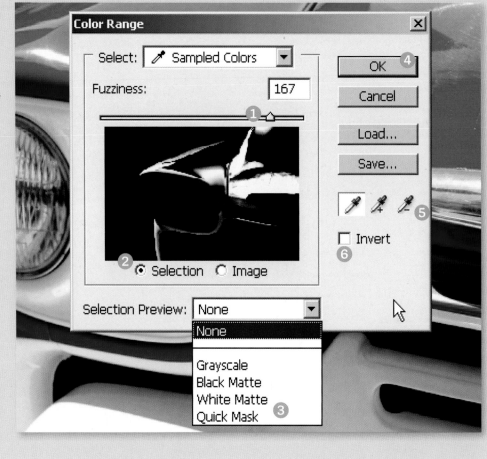

How to...
Use the Quick Selection Tool

On the disc
Try it yourself!
The start image is on the DVD

Quickly select areas of similar colour against a contrasting backdrop

The Quick Selection Tool combines the colour-selecting ability of the Magic Wand with the edge-detecting ability of the Magnetic Lasso. Like Elements' Selection Brush, it paints-on "marching ants", but these snap to object edges – the better-defined these edges, the better it works; there's no Tolerance setting to adjust, but the tool seems more sensitive in "Subtract" mode, so you can make it refine a selection pretty well, though you'll probably want to fine-tune afterwards too (see step 4). The Auto-Enhance option reduces blockiness at the edges of selections, but its effectiveness depends on what you're trying to select, and most of the time you won't see much difference.

1 Start Activate the tool

Open quickselection.jpg from the Selection Tools folder on your DVD. We want to select the flowers in this shot without selecting the greenery, and the perfect tool for the job is the Quick Selection Tool. To select an area with the tool you simply paint over it – the tool works on both colour and tone, and the selection border "snaps" to any defined edges based on the areas over which you brush.

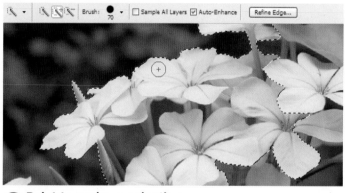

2 Paint to make a selection

For this image, start by setting the brush size to around 40 pixels in the options bar, and click and drag to select most of the flowers. You don't have to try to select all the flowers in one go – when you release the mouse button, the tool switches automatically from "New selection" mode to "Add to selection" mode, and you can add more areas to the selection, regardless of whether or not they're adjacent.

3 Add and subtract

To remove pixels from the selection, click the "Subtract from selection" button in the tool options bar or hold down the Alt key, and brush over the unwanted areas. Switch between Add and Subtract modes to build up the selection, reducing brush size for more detailed areas – tap the right and left square bracket keys on your keyboard to increase or decrease the size of your brush as you work.

4 Finish Fine-tune as necessary

You'll be able to select most of the flowers easily, but the tool will struggle in areas where there isn't such good contrast between the flowers and the greenery. To fine-tune the selection, switch to Quick Mask mode in Photoshop (page 46) or the Selection Brush Tool in Elements (page 47), or click the Refine Edge button (see opposite); you can also use a small, soft-edged brush on indistinct areas. ◘

Get to know...
The Refine Edge dialog

Powerful options to fine-tune any selection

On the disc
Try it yourself!
The start image
is on the DVD

The Refine Edge dialog combines several options for modifying your selections in one interface, along with a choice of preview options, enabling you to perform all your fine-tuning in one go. Many selection tools have a button in their options bar that takes you straight to Refine Edge, or you can use it on a selection made with any tools by choosing

it in the Select menu or pressing Ctrl-Alt-R. The dialog is enhanced in CS5 with incredible new options for refining a selection edge in specific areas – invaluable if you need to select wisps of hair (or our tiger's whiskers) – and a Decontaminate Colors control for removing any last vestiges of old background colour clinging to the edge of a selection.

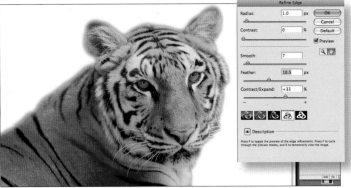

1 Start Feather and Expand/Contract

Open refine.jpg from the Selection Tools folder on your DVD and make an initial selection, as crude as you like – we used the Quick Selection Tool, which produced a very jaggy outline because it couldn't cope with the tiger's wispy fur. In Refine Edge we then expanded the selection and feathered heavily, using the 'On White' preview option to make the feathering easy to see.

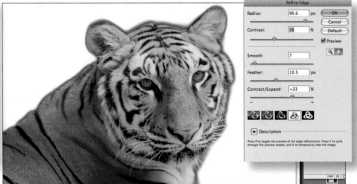

2 Radius and Contrast

Lots of background pixels are now selected, but the tiger's fur no longer looks "clipped off". The Radius slider determines how far around the selection gets refined; increase the value if the subject has fine edge detail. Contrast sharpens selection edges; if the Radius setting makes the edges of your subject look noisy, you can use Contrast to restore some definition. You'll often need to adjust the two in tandem.

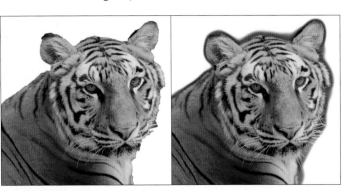

3 Refinement strategies

Compared to the initial cut-out, our refined one is almost ready to use, at least on a dark background (though the whiskers need work). For images with good contrast between subject and background, try increasing Radius, boosting Contrast to sharpen edges, then adjusting the Contrast/Expand slider. If colour contrast is poorer, try smoothing first to reduce blockiness, then feathering, then Contrast/Expand (contract if a "halo" of the old background will show against the new).

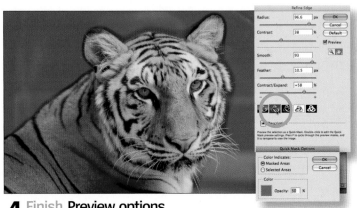

4 Finish Preview options

In Photoshop, you can choose between several preview options to help you assess the results; in Elements the choices are more limited. As with Quick Mask mode and Elements' Selection Brush Tool, you can change the mask colour in both if your image contains tones that are similar to the default red. To do so, double-click the Quick Mask button in Photoshop (circled) or the Custom Overlay Color button in Elements. ◘

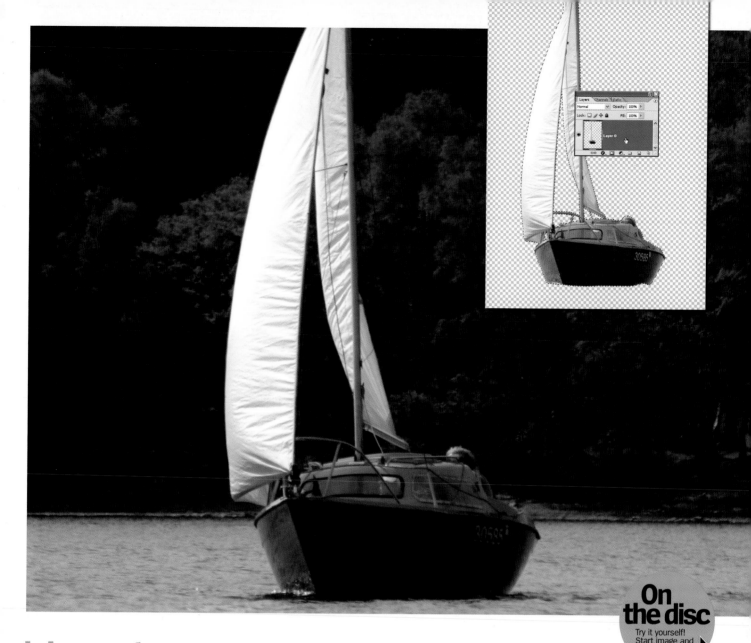

How to...
The Pen Tool and Paths

Photoshop's Pen Tool is ideal for tracing around shapes that have both straight and curved lines and would be tricky to select with other tools

We've seen how different selection strategies might suit different jobs, and the Pen Tool comes into its own when you want to select an object made up of both straight lines and smooth curves (which includes many manufactured objects and some natural ones such as boulders). The Pen Tool starts out like the Polygonal Lasso – you click to place anchor points, which are joined by straight lines – but, by dragging the mouse as you click, you can curve the line or Path in any direction, enabling you to trace large curved areas more quickly than you could with other selection tools, especially if they're set against a busy background with variable contrast, which would cause problems for "edge-detecting" tools. The real benefit is that you can

adjust the shapes of the curves, the number of anchor points and their positions in order to fine-tune the Path before turning it into a selection.

If you want to draw Paths "freehand" rather than by placing and manipulating points, you can do so using the Freeform Pen Tool, which is grouped with the Pen Tool. As you draw a Path, editable corner and curve points are placed automatically. Unless you're a skilled artist using a graphics tablet, however, this tool can be very tricky to use effectively. If you enable the Magnetic option, though, the Freeform Pen will behave like the Magnetic Lasso Tool, snapping to edges; click the arrow next to the Magnetic box to configure Frequency, Width and Contrast options. Here we'll use the usual Pen Tool options to select a complex shape.

Tools and techniques

Modifying Paths
Getting the curves right does take practice!

To adjust the contour of a Path curve, switch to the Direct Selection Tool in the toolbox (press A, or if you're using the Pen Tool, hold down Ctrl to activate it temporarily), click on one of the curve's handle points and manipulate it.

Moving a curve handle tends to curve the Path lines on both sides of the anchor point. If you want to adjust the curve only on one side of the point, click the curve handle to select it, then hold down the Alt key. This enables you to tweak the curve on one side of the point without affecting the curve on the other side.

To add extra points for more precision in intricate areas, click with the Add Anchor Point tool; use the Delete Anchor Point tool to remove unwanted points; or enable Auto Add/Delete in the Pen Tool's options bar and the tool will behave "intelligently", adding points if you click on a line segment or deleting them if you click on an existing point.

To select and move an entire Path, click on any anchor point or line segment with the Path Selection Tool (if the Pen Tool is active, hold down Ctrl-Alt to activate it temporarily) and drag. To reopen a Path, click with the Direct Selection Tool on a point or line segment, hit Delete, then switch to the Pen Tool, click on an end point, and resume drawing.

Master the Paths palette
Control and modify Paths just as you would layers

When you draw a Path with the Pen Tool, it appears in the Paths palette as the Work Path. Once you finish working on a Path and deselect it, the Path disappears from view in your image, but unlike an ordinary selection it isn't lost. It's still there in the Paths palette – click on it and it becomes active and visible in the image once more. Once you start drawing another Path, however, the new Path replaces the previous Work Path. If you want to save the current Work Path first, the simplest way is to rename it: double-click on its thumbnail in the Paths palette, and type a name in the Save Path dialog that appears.

Other functions in the Paths palette work like their Layers or Channels palette counterparts: to duplicate a Path, drag it onto the "Create new Path" button, or click the Path thumbnail and choose Duplicate Path in the palette menu; to delete a Path, drag its thumbnail to the palette's trashcan icon.

Like selections, Paths can modify each other: use the Add, Subtract, Intersect and Exclude buttons in the Pen Tool's tool options bar to set how a new Path will affect existing ones. Click the arrow button at the right-hand end of the row of tool buttons in the options bar and enable the Rubber Band option: you'll then see each line segment previewed as you draw it.

1 Start Begin drawing your Path
Open pen_tool.jpg from the Pen Tool folder on the DVD. Switch to the Pen Tool (P), and make sure it's set to draw Paths and not Shapes – click the middle button of the three at the far-left of the tool options bar. For straight edges, the tool works just like the Polygonal Lasso: click (and release the mouse button) to place an anchor point, move along, click again to place another, and a straight line will join the two.

2 Curve the Path
To create curves, click to place one anchor point, then, as you click to place a second point, hold down the mouse button and drag in the direction you want the curve to follow. Use a combination of curves and straight lines around the sails. You don't need to be too precise, because you can fine-tune the Path later by moving points, adding new ones, and changing lines to curves. »

3 Zoom and scroll shortcuts

Keep clicking to outline the body of the boat. You'll need to zoom in close and place quite a few anchor points around the person's head to trace it, but you can't switch tools to do so without losing the Path, so instead, hold down Ctrl and the spacebar and click to zoom in; hold Alt in addition and click to zoom out. Hold down just the spacebar to activate the Hand Tool temporarily to scroll around the image.

4 Close the Path

Don't worry about any gaps – we'll subtract these from the selection next. Complete the Path by clicking back on your starting point (watch for the small circle appearing next to the pointer to signal that the next click will close the Path, just as it does when you're using a Lasso tool). Once you complete the Path, the anchor points will vanish. Open the Paths palette (if you haven't already done so) to see the Work Path.

5 Subtract unwanted areas

Now to remove areas of background from within the boat's outline. With the Pen Tool still active, go to the tool options bar and click the "Subtract from Path area" button. Draw new Paths around the areas of background between the sails and the areas enclosed by the railings; you'll see corresponding grey holes appear in the Path's thumbnail in the Paths palette.

6 Fine-tune the Path

Before you turn the Path into a selection, you need to fine-tune it. Zoom in to take a closer look at the Path; you're likely to find that some lines don't follow the outline of the boat precisely. To adjust the position of an anchor point, go to the toolbox compartment showing the Path Selection Tool by default, and click and hold to switch to the Direct Selection Tool (or press A twice).

Turning a Path into a selection

This is the usual use for Paths in photo-editing

Why base selections on Paths? Well, if what you want is a soft-edged, graduated selection, Paths are *not* the ideal way to go. Paths are vectors, and you can't beat vectors for precise lines and smooth curves, so they're ideal for sharp, accurate selections. In addition, of course, you can return to a saved Path and make minute adjustments at any time, which makes Paths more flexible than most other types of selection. To turn a Path into a selection, click the Path thumbnail, then click the "Load Path as a selection" button at the foot of the Paths palette or choose Make Selection from the Paths palette menu – the latter command offers some additional options for creating the selection (pictured). Once you've turned a Path into a selection, it behaves like any other selection, so you can expand it, feather it or refine it in all the usual ways. You can turn any selection into a Path by clicking the "Make work path from selection" button in the Paths palette, but note that any feathering will be lost and intricate shapes might subtly change.

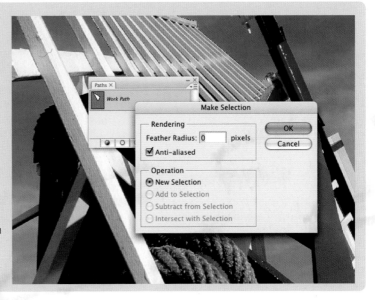

7 Reposition anchor points

Click on a Path line with the Direct Selection Tool to activate it. You can now manually reposition anchor points by clicking and dragging them to change the length and direction of the lines, and you can also manipulate a point's curve handles to alter the shape of curved lines – see the box on page 53 for more on both these operations.

8 Add anchor points

If you're having trouble selecting some areas accurately, you can use the Add Anchor Point Tool to place additional points. Simply move the tool over the Path and a plus sign will appear beside the tool icon. Click to add an anchor point, or hold down the mouse button and drag if you want to create a curve, then edit the point as before using the Direct Selection Tool.

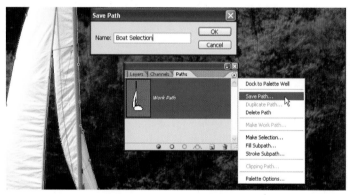

9 Save the Work Path

Before turning a Path into a selection, it's good practice to save it in case you want to revisit it. To turn your temporary Work Path into a permanently stored Path, open the Paths palette menu by clicking the arrow or "mini-menu" button at the top-right of the palette, select Save Path and give the Path a name. The Path will be stored with the image, and you'll be able to reactivate it and edit it at any time.

10 Turn the Path into a selection

To turn the Path into a selection, go to the palette menu again and choose Make Selection. The Make Selection dialog appears, giving you the option to feather the edge of the selection – a value of 1 pixel should do. Make sure that Anti-aliased is enabled too, so that the selection's curves and diagonals won't look too jagged when converted to pixels. Click OK to create a selection with a "marching ants" border.

11 Using the selection

Now you can use the selection in the normal way. Go to the Layers palette and double-click the Background layer to unlock it, then click the "Add layer mask" button. The background will be hidden, leaving the checkerboard pattern that represents transparency. (Masking instead of deleting the background gives you more flexibility to fine-tune the selection once you can see how it's working.)

12 Finish Create a composite

Press Ctrl-D to deselect. You can now place a new image behind the boat – perhaps, as here, to display it in more exotic surroundings. The feathering around the edges of the selection will help to blend the boat's pixels with the new background, creating a more convincing composite, but you can fine-tune the mask as needed and adjust tone and colour as required for a better match. ◘

How to...
Crop your images

Crop out distracting areas to improve a composition or help focus the viewer's eye

Many of your photos will need to be cropped in some way. The standard image produced by most digital cameras tends to be quite long and thin, so you may well need to crop to match standard print sizes such as 10x8 inches; or you might wish to crop simply to improve the composition and focus attention where you want it. Click the Crop Tool in the toolbox (or press C) and simply click-and-drag to define the crop, or enter a fixed ratio, such as 10 and 8 for Height and Width, in the tool options bar to constrain the crop to that ratio. You can also choose from a selection of preset crop ratios, but bear in mind that these are based on resolution too (in Photoshop, 300 pixels per inch) – if you specify a greater resolution (density of pixels) than the cropped area of the image contains, which may happen if you're cropping in to a small slice of your image, then Photoshop will interpolate new pixels to reach that resolution. It can't create detail that the camera didn't

capture – the new pixels will simply be averaged from the surrounding pixels – so as a rule, you should avoid this; if you need to add pixels, it's better to do so after you've made any other edits and to take a little more control of the process yourself (see page 110).

Once you've drawn a crop frame, you can drag the handles to resize it (if you've specified an aspect ratio, this will be preserved as you do so), or move the whole crop frame to perfect the composition. In the full Photoshop you can also alter the colour and opacity of the "shield" area outside your crop frame once you've drawn it: dark grey or black are ideal; you can reduce the opacity to see whether you've included all you wanted, then increase it to 100% so you can judge whether the composition works on its own terms. In CS5, you can superimpose a "rule of thirds" grid that resizes with the crop frame, so you can see how well your crop fits this classic principle of pleasing composition.

Advanced crop options
You can rotate an image as you crop it, or even alter its perspective

The Crop Tool can do more than just draw a rectangle or square to define a crop area. You can also use it to rotate the cropped area: after you've drawn a crop marquee, click outside the marquee and drag to rotate it, then press Return (or click the tick button in the options bar) to rotate the image and apply the crop at the same time. (Note, though, that there are more precise ways to rotate or level an image – see opposite.)

In the full Photoshop, you can opt to hide rather than delete the cropped area, which gives you the option to restore the image to its original state later if you change your mind about the crop. You'll need to unlock the Background layer first by double-clicking its thumbnail in the Layers palette. Now, when you've drawn your crop frame, you can select Hide instead of Delete in the options bar. You can reveal the cropped area at any later time by going to Image > Reveal All.

There's yet another option in Photoshop: you can also alter the perspective of an image as you crop. Drag a marquee around the area you wish to crop, then click Perspective in the tool options bar. (Note that you can't use both the Perspective and Hide Cropped Area options at the same time.) Drag the corner handles of the marquee so the edges of the crop follow the horizontal and vertical lines in the image, and hit Return to apply the perspective transformation as well as the crop. The

advantage of this over options such as the Lens Correction filter (see page 60) is that you can make different adjustments on every side to cope with the most asymmetrical distortions, which the filter can't do (though note that reshaping a layer with Free Transform (Ctrl-T) works just as well and

is less destructive because, unlike cropping, it doesn't discard the extraneous pixels permanently). If the effect isn't quite right, you can undo and move the image's centre point, from which the transformation is extrapolated, by simply clicking-and-dragging the centre marker (circled here).

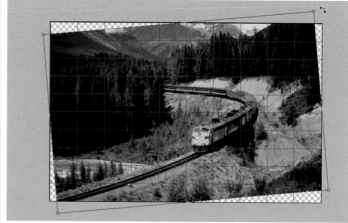

How to...
Level tilted photos

On the disc
Try it yourself! The start image is on the DVD

Level off-kilter images by simply drawing along a line that should be horizontal

You have several options for levelling off-kilter shots, but if a photo contains a clearly defined horizon or any line that you know should be horizontal, such as part of a building, the simplest solution is to use the Straighten Tool. You'll find this in the Lens Correction filter's interface in Photoshop CS2 onwards, or in the main toolbox in Elements. To use the tool, click and drag to draw along a line that should be horizontal; when you release the mouse button, the image is rotated accordingly. Photoshop and Elements offer different options for dealing with the transparent "wedges" that appear in the corners – see below.

In Photoshop, you can use the Ruler Tool as an alternative: click and drag along a line you know should be horizontal, then go to Image > Rotate Canvas > Arbitrary. When the dialog opens you'll see a value in the Angle field – this is the angle by which the image needs to be rotated in order for the line you've drawn to be horizontal. Click OK to level the image.

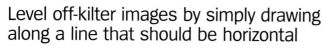

Edge options
After levelling a shot, get rid of the corner "wedges"

If you use the version of the Straighten Tool in Photoshop's Lens Correction filter, you can use the Scale slider to scale up the levelled image to fill the canvas and hide the transparent corner "wedges" that the correction will have created; the options under the Edge menu – Edge Extension, Transparency and Background Color – aren't much use for photos. Alternatively, you can OK the filter and then crop the image. In Elements the Canvas Options menu in the tool options bar gives you three choices, of which the most useful is "Trim Background" ("Crop to Remove Background" in versions before Elements 7). Select this option before using the Straighten Tool (you can't apply it afterwards) and the image will be levelled and cropped at the same time.

(The name "Straighten Tool" is a little misleading, because the one thing it won't do is straighten lines that are curved because of lens distortion. For this, see page 60.)

How to...
Level shots with Transform

How can you level an image that doesn't contain obvious horizontal features?

While images that contain horizons or other obviously horizontal elements will benefit most from being levelled, you might also want to level shots that don't contain such features but do have vertical features such as trees or telegraph poles that you can use as a guide. In most such cases the best method is to unlock the Background layer (double-click its thumbnail in the Layers palette, then OK the New Layer dialog) and go to Edit > Transform > Rotate in Photoshop, or Image > Rotate > Free Rotate Layer in Elements; alternatively, you can hit Ctrl-T to initiate Free Transform. See below for more.

ACR also has a Straighten Tool, with which you can draw along a line that should be horizontal *or vertical*, and a crop box rotated to that angle will appear; it will have the aspect ratio selected in the ACR Crop Tool's options menu. Under CS4, Elements 7 or newer, you can press Enter to apply the correction; in older versions it will be applied when you open the image in Photoshop/Elements.

Rotating an image
Use the grid to help you judge when a shot is level

With the Transform box active, you simply click and drag anywhere outside the box to rotate your image. If necessary, you can tap Ctrl-0 (zero) to zoom out so you can see the corners of the box. For fine adjustments, click in the angle field in the options bar and then tap the arrow keys on your keyboard to rotate in steps of 0.1 degrees. You can judge the correction by eye – or if, as is the case in our shot above (Tilted2.jpg from the DVD), the image contains vertical features, you can activate the grid to help you rotate the shot accurately. If you're using Photoshop, make sure Grid is selected in the View > Show sub-menu, then press Ctrl-H to show or hide it. If you're using Elements, go to View > Grid. When you're happy that the image is level, hit Return to apply the transformation; in Elements you can also click the green tick button that's superimposed on the transform box. As before, you'll need to crop away the transparent corner "wedges" that appear.

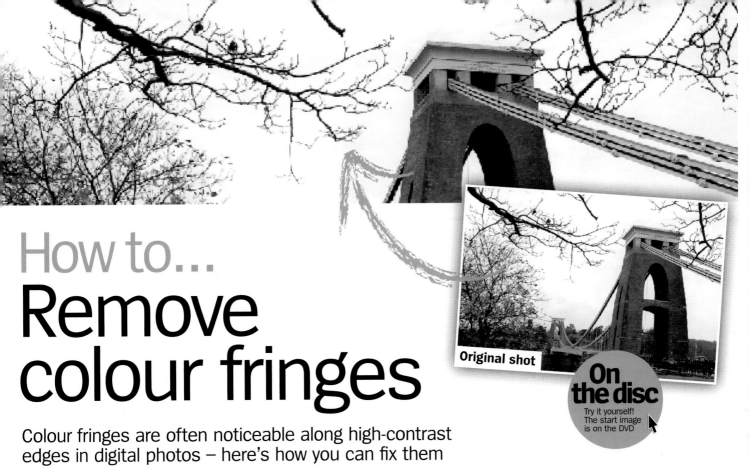

Original shot

On the disc
Try it yourself!
The start image is on the DVD

How to...
Remove colour fringes

Colour fringes are often noticeable along high-contrast edges in digital photos – here's how you can fix them

Colour fringing along high-contrast edges is common in photos of buildings or objects shot against bright skies. It's routinely put down to "chromatic aberration" (the inability of the lens to focus different wavelengths of light at precisely the same point) and most of the tools for tackling the phenomenon use this term, but it can also be caused by sensor "blooming" (light overspill from the individual colour receptors on the sensor). The fringes are most often purple, but they can also be red, cyan, blue, yellow or green, and not all the solutions on offer will be equally effective at dealing with all the possible colours.

If you're running it under Photoshop, ACR includes two sliders under the Lens Corrections tab that enable you to subdue colour fringes by reducing the saturation of individual colour channels: one targets red/cyan, the other blue/yellow. You may need to tweak both, particularly

in the case of purple fringing, and you'll need to zoom in to at least 100% to see the effects of your adjustments. Under CS3 and newer the sliders are supplemented by a Defringe menu which enables you to more precisely target the effects of your adjustments on the edges where they're needed; it's particularly effective for coloured fringing around specular hotspots caused by extreme light exposure hitting the sensor rather than lens-induced chromatic aberration.

The Lens Correction filter in CS2 and newer also has sliders for removing fringes. These tools will generally be able to fix simple cases of fringing, where you have obvious fringes along one or two edges, but won't be any use for the widespread fringing we're tackling here. Our technique here is also a more controllable alternative if you find that attempting to remove red fringes adds cyan ones or vice-versa!

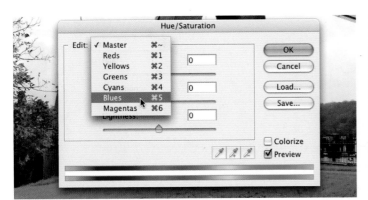

1 Start **Target the fringe colours**
Open fringing.jpg. You'll see purple fringes caused by chromatic aberration clinging to the edges of the bare branches. As we've noted, there are several possible solutions, but this one is great for extensive fringing involving multiple colours. Add a Hue/Saturation adjustment layer and select Blues from the dialog's Edit menu; we'll be adding a second adjustment layer later, so rename this one "blues".

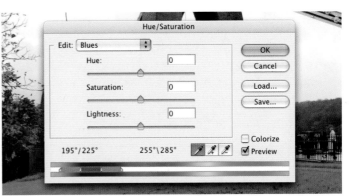

2 **Tweak the target range**
You'll see four small markers appear between the colour bars at the foot of the dialog. The inner markers control the range of colours which are selected and will be adjusted when you move the Hue, Saturation or Lightness sliders. The outer sliders enable you to feather the selection at the edges of the range for a subtle transition between adjusted and unadjusted colours.

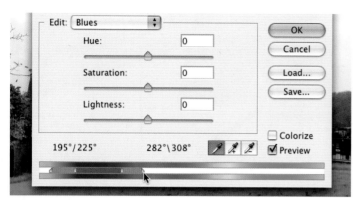

3 Expand the range

The colour fringes in our image include magenta tones as well as blues, so drag the right-hand colour slider to the right a little to add magentas to the selection, and drag the right-hand feathering slider to the right as well. You don't need to worry too much about selecting a precise range at this point – if necessary you can refine the range after you've altered the selected colours.

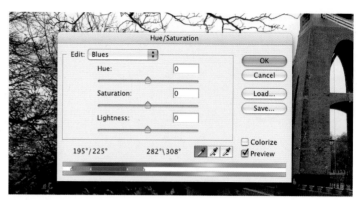

4 Shift the colours

An easy way of removing fringes is to desaturate the selected colours by moving the Saturation slider all the way left to –100. However, in the case of our image this would mean discarding much of the colour information in the branches, which aren't that colourful to begin with. Instead we'll shift the colours of the fringes to make them a similar colour to the branches.

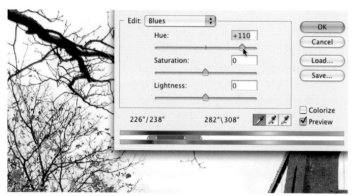

5 Fine-tune the adjustment

Zoom in on an area of severe fringing and drag the Hue slider to the right to about +110: this turns the blue and magenta tones red and orange. The colours in the lower bar will change, showing you how the colours are being shifted. If the pale blue sky pixels change colour, nudge the left-hand range and feather sliders to the right to remove those tones from the selected range.

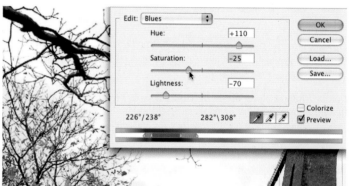

6 Check further colours

Drag the Lightness slider to the left to around –70: this turns the yellows and reds to shades of brown. Drag the Saturation slider to the left to around –25 so that the browns more closely match the colours in the branches. If necessary move the colour and feathering sliders again to further fine-tune the range of colours on the upper colour bar that are affected by the adjustment.

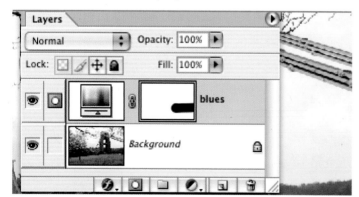

7 Mask unwanted changes

Zoom out and you'll see that blues and magentas have been turned brown throughout the image – depending on how you tweaked the range, the blue van may have changed colour, and some blues in the sky may have shifted. Click the adjustment layer's mask to target it, and paint over any such areas with a black brush to remove the colour adjustment from those parts of the image.

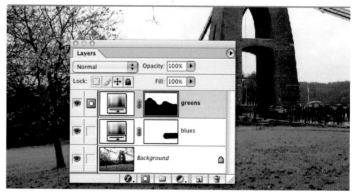

8 Finish Repeat for other fringe colours

If you zoom in on the top-right corner of the image you'll notice green fringes as well. Add a second Hue/Saturation layer to deal with these – this time select Greens from the dialog's Edit menu, and adjust the sliders as before to turn the green fringes dark brown. The grass and green leaves will turn brown as well, so target the layer mask and paint out the adjustment in those areas. ◘

How to...
Correct lens-induced distortions

Use the dedicated filters to fix a host of lens-related problems

On the disc
Try it yourself!
The start image
is on the DVD

Some lenses or camera settings can cause distortions: a zoom lens set to its widest angle of view, for example, often causes "barrel distortion", where vertical lines at the sides of a shot bow outwards; the opposite, "pincushion" distortion, is common with telephoto lenses. If you point the camera upwards to shoot a building from ground level, you'll get a problem known as perspective distortion or converging verticals, whereby the lens exaggerates the perspective and vertical lines in the image lean inwards. You can fix these and other camera-induced flaws with the Lens Correction filter (under Filter > Distort) in Photoshop or the Correct Camera Distortion filter in Elements. We'll use the former on Distort.jpg from your DVD, which as you'll see suffers from both barrelling and converging verticals.

Correcting distortions

Fix a range of lens-related flaws in one place with the Lens Correction filter

❶ Optional tools
Photoshop's version of the filter includes a Remove Distortion Tool (which does the same job as the slider), a Straighten Tool and a Move Grid Tool, which you can use to align the grid with lines in your image.

❷ Remove Distortion
Drag the Remove Distortion slider to the right, to around +2, to counter the slight barrelling in the shot.

❸ Vignetting and fringing
Use the Vignette sliders to counter the darkening that some lenses create around the edges of shots, or to add a vignette effect. The Photoshop filter also has sliders for fixing colour fringing.

❹ Perspective Distortion
Straighten the building's converging vertical lines by dragging the Vertical Perspective slider to the left, to around −20.

❺ Level tilted shots
You can use the Angle dial to level a shot, but in the Photoshop version of the filter it's easier to draw along a line that should be horizontal with the Straighten Tool (this tool is in the toolbox in Elements).

❻ Adjust the grid
You can change the grid colour so it stands out better from the colours in your image. In the Photoshop filter you can also adjust the size of the grid.

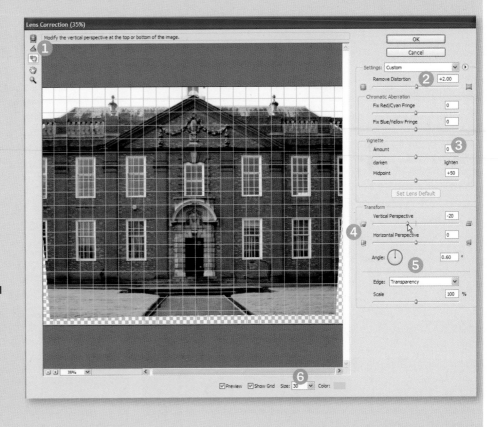

How to...
The Clone Stamp Tool

Configure the options for this pre-eminent retouching tool to get the best results

On the disc
Try it yourself! The start image is on the DVD

The Clone Stamp Tool enables you to sample (or copy) pixels from one part of an image and paint them into another part. It's ideal for removing unwanted objects, or for close-up retouching work in areas where the blending properties of the Healing tools would blur detail (see page 64). To avoid creating repeating patterns that will betray your editing, use only short strokes and resample regularly. You also need to make sure that your sample point doesn't "catch up" with the point from where you started cloning – if it does, you'll see pixels that you've just cloned over reappearing in another part of your image. There are more retouching tips on the next few pages.

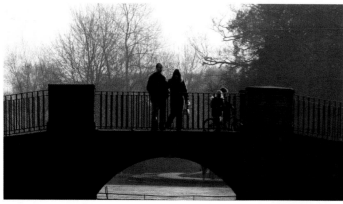

1 Start **Work non-destructively**
Open clone.jpg from your DVD. Start by adding a new blank layer – cloning on this layer will ensure that you don't lose any of the original image information, and also gives you extra options for blending your repairs better with the image beneath. Switch to the Clone Stamp Tool (or press S) and in the options bar set the Sample menu to "All Layers" or "Current & Below" (or click "Sample All Layers" in Elements).

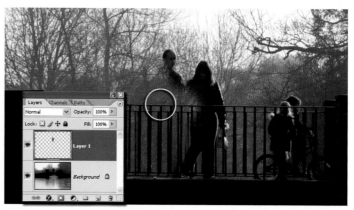

2 **Configure the tool**
Set the brush to about 125 pixels in size, then hold down Shift and tap the left square bracket key four times to set it to 0% hardness. Now Alt-click to sample some of the railings to the left of the figures on the bridge. Zoom in close, engage Caps Lock to turn your pointer into crosshairs for greater precision, and position the brush at a spot where the railings match the sample point as closely as possible.

3 **Paint over unwanted areas**
Now paint over the figures. The key is to align the copied railings with the ones being replaced – you may need to undo and try again a few times to get it spot-on. Don't try to clone out the figures in one go – and keep an eye on where you're sampling from, or you can end up sampling some areas you want to remove and shifting them from one part of the image to another.

4 Finish **Cover repeating patterns**
One of the tell-tale signs that often gives away the use of cloning is the appearance of repeated objects or patterns. In step 3 you can see that a recognisable tree trunk on the left has been used to cover the figures. Alt-click to sample a more random, less recognisable area of branches, and use this to hide the unwanted tree trunk. To finish, clone away the reflections of the figures in the water as well. ◘

Get to know...
Clone Source palette

Make use of the Clone Stamp Tool's helpful additional features

When you're using the Clone Stamp in Photoshop, you can optionally open the Clone Source palette (WIndow > Clone Source). This gives you several useful options, including the option to see a preview of the pixels you've sampled (the "clone source") superimposed on the image, which moves around as you move the mouse pointer and can help you align your cloned pixels more accurately than just the pointer (even the precision version you see if you engage Caps Lock). You may find it less confusing to enable the Auto Hide option, so the overlay disappears when you begin brushing. You can even use the five buttons along the top of the palette to store multiple sample points for easy access later.

1 View the overlay preview
Once you've Alt-clicked to define a sample point, you can view an overlay of the sampled pixels by enabling Show Overlay in the Clone Source palette. In Elements 7 and newer, click the button at the right of the options bar to open the Overlay options panel and enable Show Overlay. In CS4, Elements 8 and newer, enable Clipped and the overlay appears only within the brush, which can be less confusing.

2 Rotate options
Photoshop's Clone Source palette also enables you to rotate the clone source by clicking and dragging on the angle icon or typing a value in the field. Here we're changing the time on the clock in clone_source.jpg from the DVD by clicking in the dead centre of the face and entering an angle value of 60°. The entire preview is rotated, and using the overlay as a guide we can carefully clone in just the hands.

3 Cleaning up
Click the icon to the right of the angle box to clear the transform fields; hide the overlay and use the Clone Stamp in the conventional way to remove the original hands, then tidy up around the edges of the cloned hands. To work faster, hold down the spacebar to switch to the Hand Tool temporarily to scroll around; hold down Ctrl as well and click to zoom in; hold down the spacebar and Alt and click to zoom out.

4 Advanced options
You can also scale your cloned pixels up or down by typing a value in either the height or width field; the proportions are constrained by default (you can click the chain button to change one without affecting the other). In CS5 you can also flip the sampled pixels horizontally or vertically by clicking the tiny icons that appear to the left of the width and height fields (not visible in this shot of an older version).

How to...
Cloning and healing tips

Which retouching tool is right for the job? We'll help you choose and get better results

Retouching takes practice to master, but you can also get better results by knowing how to get more from the retouching tools. For example, you'll usually use the Clone Stamp in Normal mode, but in Lighten mode it will replace pixels only if they are darker than the pixels you've sampled, leaving already-lighter pixels intact; Darken mode does exactly the opposite (we'll look at a handy application for this, removing glare "hotspots" on skin, on page 83). The Healing Brush has a Replace mode, which enables you to preserve noise, film grain and texture at the edges of your brush stroke – ideal if you're working on very "grainy" images. Here are some more tips for better retouching.

1 Heal or clone?
The Healing Brush, Spot Healing Brush and Photoshop's Patch Tool are known as the healing tools: they don't just clone areas but also blend cloned pixels into their new surroundings afterwards. This makes them ideal for removing blemishes in areas of otherwise uniform tone and texture such as spots on the skin, but the blending effect will blur detail, so they're not suitable if you need to preserve detail.

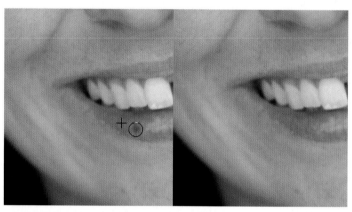

2 Using the Healing Brush
To use the Healing Brush, make the size just a bit larger than the blemish, Alt-click on a "clean" area nearby, then drag over the blemish – or better for small areas, just click. The repair is blended when you release the mouse button. A hard brush usually works best, but if the blend isn't perfect, undo and try a softer one – this makes the tool take more account of the surrounding colour and shading.

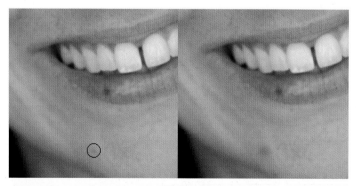

3 Spot Healing Brush tips
For removing small blemishes, the Spot Healing Brush is faster, because you don't have to set a sample point, just click on the blemish – in its default Proximity Match mode, it analyses surrounding pixels and bases the repair on these. However, if the surrounding detail isn't even in tone, the Healing Brush may be a better choice. Or, if you're working on a more textured area such as clothing instead of skin, set the Spot Healing Brush to Create Texture in its options bar, and it will create a repair that incorporates the texture of the surrounding pixels.

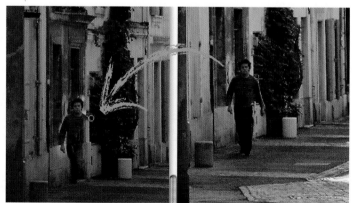

4 Clone between images
Both the Clone Stamp and the Healing Brush (though not the Patch Tool) can not only clone onto a new blank layer, but also clone *from* another layer – or even another image, such as another photo taken in the same shoot as a flawed image. Simply open both shots, switch to the appropriate tool, and Alt-click on the "clean" area you want to sample, then go to the other image and paint as normal.

How to...
The Patch Tool

Photoshop's Patch Tool is handy for covering up larger blemishes such as eyebags

The Patch Tool (Photoshop only) is a bit different from the other retouching tools. It's like a combination of a selection tool and the Healing Brush, but confusingly it can work in two completely opposite ways. In Source mode, you draw a patch around the blemish and drag this over a "clean" area. In Destination mode, you draw around a clean area and cover the blemish with it. Source mode is useful if you're not sure which area you want to use for the patch: as you drag the patch area around your image, the original selection area will change to preview the result; release the mouse button when you get a good match. Note that once you've created a patch, it will remain active (just like a selection) until you deselect it using Select > Deselect or Ctrl-D. Here are some tips on using the Patch Tool.

1 Start Covering large areas
Using brushes to repair large areas can be very fiddly. If you're using the full Photoshop, the Patch Tool enables you to repair larger blemishes by lassoing a "clean" area and then dragging this over the blemish, or vice-versa. Either way, the patch is then blended in, just as with the Healing Brush. It's ideal for fixing larger facial blemishes such as wrinkles and eyebags. Try it on patch.jpg from your DVD.

2 Create a selection
The Patch Tool doesn't have an All Layers option and won't work on a new empty layer, so create a duplicate of the image layer to work on. You can draw a patch freehand with the Patch Tool itself – it works just like the Lasso Tool – or you can use any selection tool you like. Here we've created an eyebag-shaped selection on the cheek in Quick Mask mode, using a very soft brush to create nicely-feathered edges.

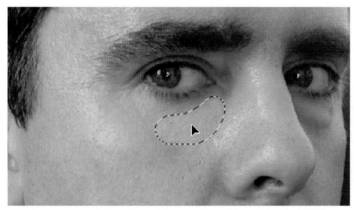

3 Drag the patch into place
With the selection active, switch to the Patch Tool, and click on Destination mode in the options bar. Click inside the selection and drag it over the eyebag; when you release the mouse button, the patch will cover the eyebag, and its tonal and colour information will be blended with that of the underlying area to create a seamless repair.

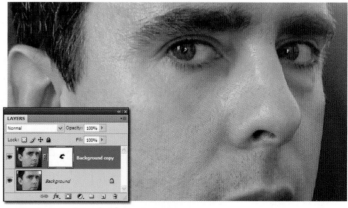

4 Finish Mask if necessary
If you don't get a perfect result first time, undo, modify your selection and try again. Alternatively, if the patched area mostly looks okay but edge detail such as the eyelashes has been blended and blurred, you can add a mask to the copy layer and paint out the edges of the patched area with a soft black brush. ◘

How to...
Photomerge
Scene Cleaner

On the disc
Try it yourself!
The start images
are on the DVD

Can't get a clear shot of a scene? If you're using Elements,
take multiple shots and let Photomerge clear away the crowds

**Many of the tools and features unique to Elements are designed to
make tasks easier or more "automatic" than in Photoshop, and the
Photomerge features fall squarely into this group.** As we'll see a little
later, Photoshop has Photomerge Panorama, but Scene Cleaner is
unique to Elements. Its aim to is to make it simpler to combine several
shots of the same scene, revealing or hiding just the areas you want.
Scene Cleaner doesn't do anything you couldn't do manually with
layers and masks, given enough time and patience, but is easy and
fun to use. It also does a very good job of aligning the content of your
images and blending replacement areas into their new surroundings

relatively seamlessly – our shots were taken hand-held and don't
match up precisely at all, but the results are very good. Doing it
manually would be a very fiddly and time-consuming job.

The options in Scene Cleaner are like those in the other Photomerge
tools. If your shots don't align well and this causes problems in the
blend, you can manually place Alignment markers on points that should
match between shots. You can use the Eraser to fine-tune the areas
being blended, much like adjusting a mask. Finally, the Pixel Blending
option may create a more seamless blend, though in our case the Final
image looks slightly better with this turned off.

1 Start **Copy the start images**
We've already seen a couple of ways to remove unwanted objects
or passers-by from a scene. The Photomerge Scene Cleaner option
in Elements 7 and newer is another way to remove people, traffic and
other moving objects from a series of shots of the same scene to
produce a clutter-free composite image. To start, copy the "Scene
Cleaner" folder from the DVD to your computer's hard disk.

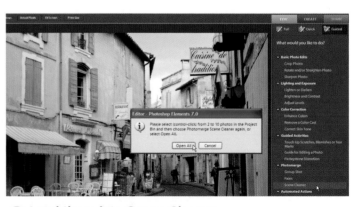

2 **Load them into Scene Cleaner**
Open scene_1.jpg, scene_2.jpg and scene_3.jpg, either via
Organizer or by going to File > Open. Then go to File > New >
Photomerge Scene Cleaner, or else switch to Guided Edit mode and
select Scene Cleaner from the list of Photomerge options. When a
dialog appears prompting you to select the photos you want to use,
click Open All to launch the Scene Cleaner interface.

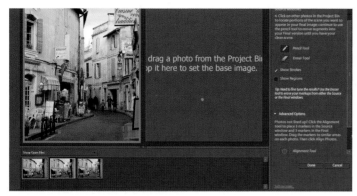

3 Let it align the images

The dialog contains two windows: the Final window will contain your composite image, and the Source window displays the currently selected shot from which you'll select areas for inclusion in the composite. By default scene_1 will be displayed in the Source window, and if you click on each of the other images in turn you'll see that Photomerge has attempted to analyse their content and align them.

4 Choose the "base" image

We'll use scene_1 as the "base" image for the composite, so drag its thumbnail from the Project Bin into the Final window. Now click the scene_2 thumbnail to display that image in the Source window. Hold down Ctrl and the spacebar and click where the street disappears round the corner to zoom in – both images will be zoomed to the same magnification. Hold down the spacebar and drag to scroll around.

5 Scribble out unwanted areas

You can now use the Pencil Tool (it's active by default) to remove the people from the Final image, either by drawing over them in the Final window or by drawing over corresponding "clean" parts of the image in the Source window. We'll use the former option, so start by drawing over the family in front of the open doorway, as shown.

6 And they're gone!

Each source image is colour-coded – the scene_2 image is highlighted with a yellow border, so your Pencil Tool strokes will be yellow. When you release the mouse button, the figures will be replaced with the unobscured doorway and surround from the scene_2 image. Move your cursor off the Final window to hide the brush strokes so you can see the cleaned-up area.

7 Tidy up

You'll see that the couple to the right of the family have also been removed, even though you didn't draw over them, and replaced by the two figures who were in a similar position in scene_2. This is because Scene Cleaner defines tonal "regions" based not only on your Pencil Tool strokes but on the contrast between surrounding tones – click the Show Regions option to view these. You'll have a little tidying-up to do...

8 Finish Add areas from the other shot

To remove the figures in front of the blue door, click the scene_3 thumbnail to display that image in the Source window, then draw over the figures in the Final window. As long as you draw over just the couple, you won't see the figure to the right of the door appear in the Final image, because there's good contrast between that figure and the "clean" area to his left. ◘

Original shot

How to...
Content-aware scaling

If you're using Photoshop CS4 or CS5, you can transform an image's composition without distorting its important features

Ordinarily, when you scale an image or layer using Free Transform, all elements are scaled by the same amount. The Content-Aware Scale command (CS4/5 only) focuses scaling on areas that don't contain important detail, such as skies (or specific areas you define in the shot); this enables you to scale images selectively to improve composition, to change their orientation, or to fit a photo frame or page layout. Open Scaling.jpg from your DVD. We'll show you how to use Content-Aware Scale to create a tighter composition by moving the parasols that are the focus of the shot closer together and remove some of the sky, sea and sand at the edges without distorting the parasols.

Unless your image consists of well-defined subjects against a fairly plain background, content-aware scaling will inevitably involve some compromises. It's generally most effective if you keep the scaling modest – for example if you wanted to fit an image with an aspect ratio of 4 x 3 inches into a 10 x 8 frame. For more dramatic scaling you may find conventional retouching tools are a better solution – in the case of

our shot, we could clone the left-hand parasol to move it closer to the right-hand one and then clone out the original fairly easily.

The Amount setting specifies the ratio of content-aware scaling to normal scaling. If you have people in an image that you want to scale, you don't need to go through the hassle of selecting them so that you can protect them from being distorted. Clicking the figure icon at the left of the options bar enables a "protect skin tones" option, which limits the extent to which objects containing those tones will be distorted.

When you're making selections for use with the Protect option, make sure you select a good bit of information around the area you want to protect, and try to keep the edges of your selections away from areas of detail or you may see "creases" appear when you scale the image. We've selected the sky outside the outer edges of the parasols in step 4 – this ensures that some sky is preserved at the edges of the shot, which helps to create a pleasing composition. If a particular selection doesn't produce a good result, undo, refine the selection and try again.

1 Start **From landscape to portrait**
Open Scaling.jpg in Photoshop, and unlock the Background layer by double-clicking its thumbnail. Go to Edit > Content-Aware Scale, and drag the left side handle to the right to scale the shot down to 50%. Photoshop detects the difference between the parasols and other elements. The beach, sea and sky are distorted but the parasols remain relatively undistorted. Hit Escape to cancel the transformation.

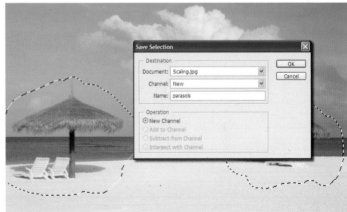

2 **Make a selection to protect**
Content-aware scaling will usually do a good job of working out which features should be protected, but the results aren't always perfect. To minimise any risk of distortion, you can specify the particular areas you want to be protected. Use the Lasso tool to make a selection around the parasols, then go to Select > Save Selection and name the selection "parasols".

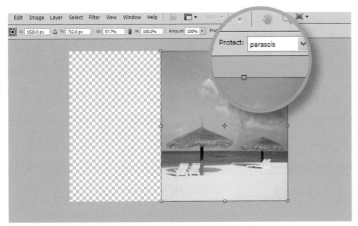

3 Scale with the selection protected

Press Ctrl-D to deselect the selection – make sure you don't miss out this step. Now go to Edit > Content-Aware Scale again – but this time, before scaling the shot, go to the Protect menu in the options bar and choose "parasols". If you now scale the image again you'll find that the parasols and the area around them are barely distorted at all. Hit Escape to cancel the transformation once again.

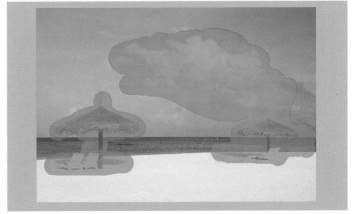

4 Finish Create an extended selection

At present the clouds in the shot are being distorted along with the sea and sand, which isn't ideal because they're a nice feature. You can protect only one selection, so make a new selection like the one shown using Quick Mask mode, then scale the image with this new selection protected. You may still need to tidy up small details using conventional retouching methods, or else undo and add them to your selection. ○

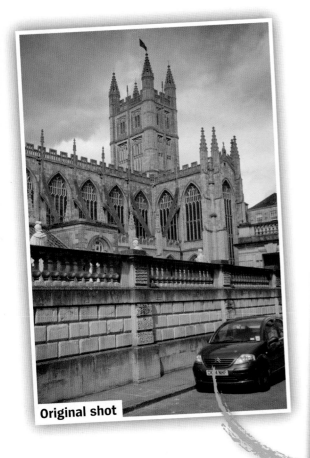

Original shot

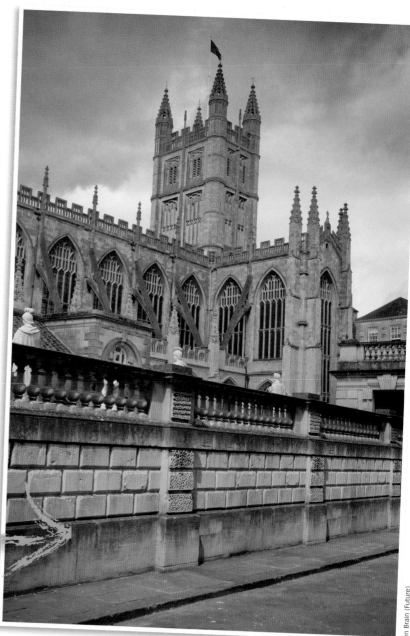

Ben Brain (Future)

How to...
Retouch an image
in perspective

On the disc
Try it yourself!
Start image and
video on the DVD

Photoshop's intelligent Vanishing Point filter helps you to maintain an image's
perspective when cloning out background objects with foreground pixels

WHAT YOU'LL NEED *Photoshop CS3 or newer*
WHAT YOU'LL LEARN *How to master the Vanishing Point filter, how to
patch in perspective, and how to perform advanced cloning*
IT ONLY TAKES *15 minutes*

**Sometimes a photo opportunity can be spoiled by distractions, such
as the parked car in the otherwise historical shot above.** We could
have waited around until the car was driven away before taking the
photo, but this option isn't always practical.

You could remove the car by using the Polygonal Lasso tool to select a
clear patch of foreground wall, copying this selection and pasting it over

the car. But you'd then have to use Free Transform to try to scale the
patch down and make it match the bricks in the photo's background.
Photoshop's Vanishing Point filter, on the other hand, enables you to
teach Photoshop about a shot's depth. If you then copy and paste a
selection, it will automatically be scaled down and transformed to match
the shot's perspective when you move it over a more distant area. The
same applies if you sample pixels using Vanishing Point's version of the
Clone Stamp: as you paint them on, they will automatically be scaled
down to match the size of the pixels in the area where you're painting.
Vanishing Point's ability to understand depth as well as height and width
makes it much easier to retouch a perspective shot.

1 Start Open Vanishing Point

Open vanish_start.jpg from the DVD, duplicate the Background layer, then go to Filter > Vanishing Point. Click the filter's Zoom Tool to zoom in (or use the usual shortcuts – hold down Ctrl and the spacebar and click to zoom in, or hold down Alt and the spacebar and click to zoom out. To scroll around, hold down the spacebar to activate the Hand Tool).

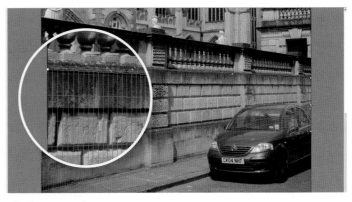

2 Draw a plane

Click with the filter's Create Plane Tool to define the four corners of a frame that matches the perspective of the wall. If the box outline is red or yellow, you'll need to adjust it using its corner handles until the grid turns blue, indicating that Photoshop considers it a viable perspective plane. Extend the box to ensure it includes plenty of "clean" areas.

3 Make a selection

You can now use the filter's Stamp Tool (which works just like the Clone Stamp) or, since we want to clone a large area of wall, its Marquee Tool: drag over an area of wall at the left of the shot, and the marquee's perspective will automatically be adjusted as required. Now hold down Alt and drag the marquee to the right. The selected area will be copied and rescaled as you move it to match the image's perspective.

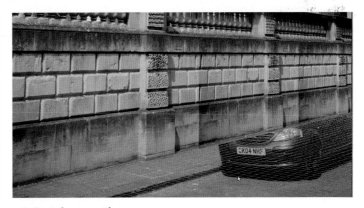

4 Patch over the car

Try to match up the stonework with that of the target area precisely; tap the arrow keys on your keyboard to "nudge" the patch into place if need be. Once you've got it aligned, the marquee stays active in its new location, so instead of having to draw a new marquee, you can simply Alt-drag to create a new patch from the existing one. Drag this over the rear of the car; once again, it will be scaled to match the image.

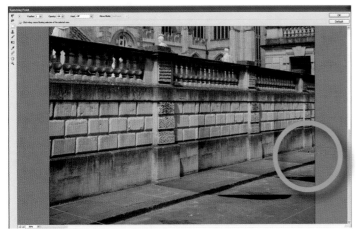

5 Patch over the road

Now for the road. Switch to the Create Plane Tool again and draw a new plane over the ground, then use the Marquee Tool to select a clear patch of road. Hold down Alt and drag this over as much of the remaining parts of the car as it will cover. Repeat as in step 4 to patch over more of the car – we'll tackle any gaps in the next step.

6 Finish Clone to fine-tune

To plug the gaps (see previous step) and blend the hard edge of the patches with the rest of the shot, switch to the filter's Stamp Tool, Alt-click to sample a suitable "smooth" area, and brush over the gap or uneven edge. The sampled pixels will automatically be scaled to match the perspective. When done, click OK to apply all the filter effects. 📷

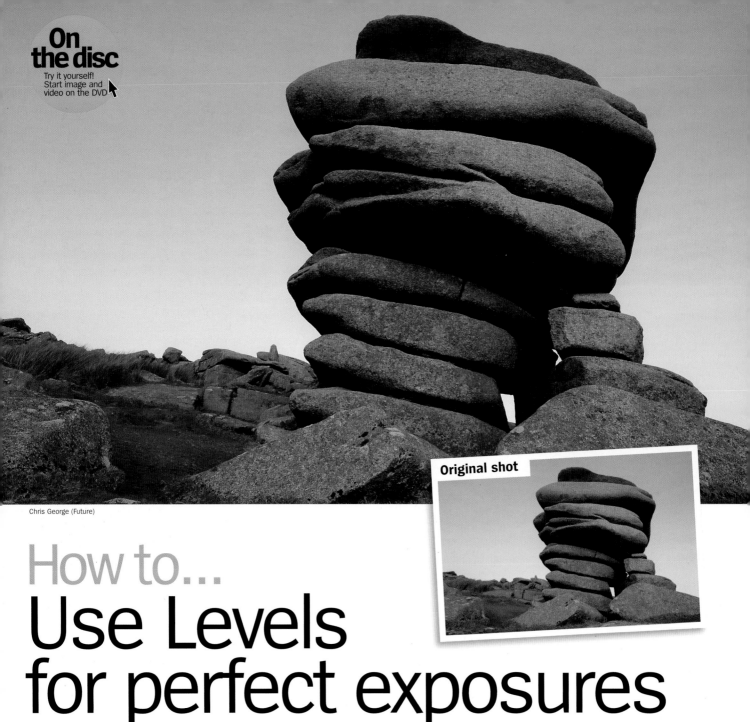

Chris George (Future)

Original shot

How to...
Use Levels
for perfect exposures

Are your pictures too dark or too bright? Or do they just look flat?
Photoshop's Levels dialog should be your first port of call...

WHAT YOU'LL NEED *Any version of Photoshop or Elements*
WHAT YOU'LL LEARN *How to use a Levels adjustment layer to improve
the exposure and contrast in a photo, how to work out what's wrong
with a picture from its histogram*
IT ONLY TAKES *10 minutes*

**When editing your photos in Photoshop or Elements, you should
always adjust the exposure and contrast first.** However good you
are as a photographer and whatever camera you use, most shots will
benefit from a little more punch, and Levels is the perfect tool to help
you make these tonal adjustments. Unfortunately, the window looks
baffling – it's one of the least intuitive controls in any version of
Photoshop/Elements. But you should persevere with it, because
Levels is not only one of Photoshop's most useful tools, it's also

the first thing you should look at with any picture you edit.
 The frightening bit is the histogram – a graph-like display that shows
the distribution of tones in your image, from the darkest shadows (at
the left) to the brightest highlights (at the right). It shows the same
information as the histogram display option on the back of your D-SLR.
With practice, you can instantly see whether an image needs to be
made brighter or darker without even looking at the picture.
 A great-looking image often has a perfect-looking histogram with a
classic "bell-curve" shape (peaking near the middle and falling away at
both ends), but this is not necessarily the case, particularly if the shot
deliberately uses a small range of colours or tones. The Levels dialog
offers plenty of options for you to reshape the graph and create a
better picture but, in essence, there are only three controls you need
to worry about. Read on to find out how to make the most of them.

Get to know... the Levels dialog

① Shadows
This represents the darkest tones in the image. Pure black has a value of 0.

② Midtones
Shows the proportions of tones and colours with different intensities.

③ Highlights
Represents the lightest tones. Pure white would have a value of 255.

④ Input sliders
The left-hand slider sets the black point, the right-hand slider the white point and the middle one midtone brightness.

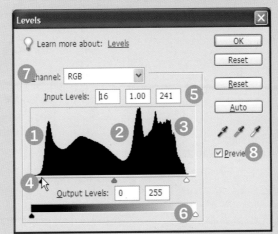

⑤ Input levels
Numerical values show where the Input sliders have been moved to.

⑥ Output slider
This can be used to decrease the overall contrast of a shot, but is best left alone.

⑦ Channels
You'll normally adjust the full-colour RGB image, but you can target the levels of the three primary colours separately.

⑧ Eyedroppers
Use these to set the black point, white point and colour balance automatically by clicking something in the image that should be pure black, white or grey.

1 Start Add an adjustment layer
You can apply a Levels adjustment directly to the image layer, but it's best practice to use it non-destructively on a separate layer. To do this, go to Layer > New Adjustment Layer > Levels or click the "half-moon" button in the Layers palette and pick Levels in the pop-up list.

2 The Auto option
A window opens showing the image's histogram (see page 75) and various slider and button options. The Auto button provides a one-click fix. This is rarely the best option, but it is worth trying, because it can show you what's possible with this image.

3 Reset the histogram
The Auto command will change the image (though its histogram won't update in the Levels dialog; to monitor changes, use Window > Histogram). To go back to the start and make your own adjustments, click the Reset button which appears in the box if you hold the Alt key.

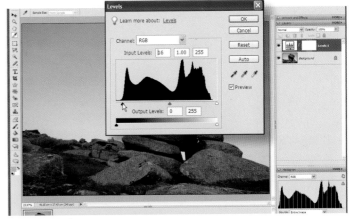

4 Move the black point
The first adjustment involves the black point input slider. Move this inwards until it lines up with the point where the histogram graph really gets going. For this shot, a setting of 10 is about right. This "remaps" the darkest tones in the image to a value of 0 or true black. »

Tools and techniques

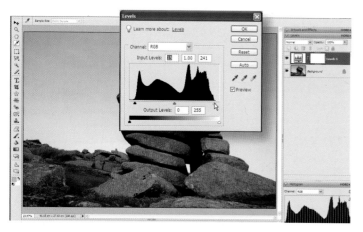

5 Set the white point

Move the white point input slider to the left until it aligns with the point where the graph ends. For this shot a setting of around 241 should do the trick. This remaps the brightest tones to white and spreads the rest of the tonal range accordingly. With black and white points remapped, the image looks less flat and has more contrast.

6 Go for accuracy

There is a more accurate way to set the input sliders. Hold down the Alt key as you move the black point slider and the screen goes white ("Threshold" view). Move the slider too far and you'll see areas appear in colours or in black. This indicates that subtle tones are being lost or "clipped" to black. Pull the slider back until the colours vanish.

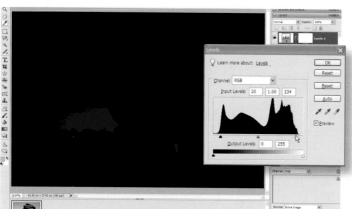

7 Threshold on the highlights

Adjust the white point input slider using the same trick. Hold down the Alt key as you move the right arrow under the histogram and the image goes black. Move the slider left until the brightest parts of the image appear, then nudge it back until they disappear.

8 Adjust the overall exposure

Setting the white and black points increases the contrast of the image. But now you'll need to adjust the overall brightness until you get a picture that you like. Do this by moving the central grey-coloured input slider. Moving it left makes the picture brighter.

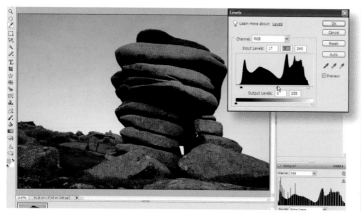

9 Dark and delightful

This picture, a shot of the Cheesewring on Bodmin Moor, needs to be darker to give the late afternoon shot a moody appearance. To create this effect, move the central slider to the right until you're happy with the way the picture looks. A value of 0.88 should be just right.

10 Finish Monitor changes

Click OK to commit to your changes. Because you've made the adjustment in a separate layer, you can go back and change the values used (double-click the adjustment layer's thumbnail in the Layers palette) or hide and reveal the effect (click the eye icon next to it).

Quick guide
How to read a histogram

Learn how to assess an image just by looking at its exposure chart

The histogram is a graph of the tones in your image, from darkest to lightest; the height of the graph at any point shows the relative number of pixels in the image with that lightness. The important thing to remember is that it's not the precise shape of the graph that counts – just as all pictures are different, so is every histogram. A well-exposed image, however, should have tones right across the range from deep shadows to bright highlights. Look out also for a histogram that looks "cut off" at either end of the graph, suggesting that tones are being "clipped" to solid black or white, with a loss of subtle tonal detail. Here are four histogram shapes to look out for and what they'll tell you.

1 Underexposed
The histogram is bunched up towards the left-hand (shadows) side of the graph. There are no bright tones in the picture, so the graph tails off before it reaches the highlights end of the scale. In an ideal graph, only very few pixels would be jet black or have a histogram value of 0, but here the number of dark tones goes off the scale.

2 Overexposed
Here, the histogram is shunted up to the right-hand (highlights) side. There are almost no dark tones in the picture, so the graph barely gets off the ground until a third of the way across the scale. It will be impossible to fully rescue the huge number of pixels at the maximum brightness value (255).

3 Well-exposed
An ideal histogram has a full range of tones, with some very bright pixels and some very black ones, so it stretches right across the width of the graph and tails off noticeably at each end. Remember, though, not every great picture has a perfect-looking histogram with this classic "bell-curve" shape, and you don't need to move the Levels sliders right in to create deep blacks or bright whites if they don't suit the image.

4 Over-processed
The more you manipulate your image, the more the histogram will distort. Using Levels will create gaps in the histogram, which tell you that tonal values have been "stretched" to fill a wider range than the shot originally had. This is perfectly acceptable as long as these gaps don't get too numerous or too large. A comb-like histogram shows that the image has been heavily processed and may appear "posterised". ○

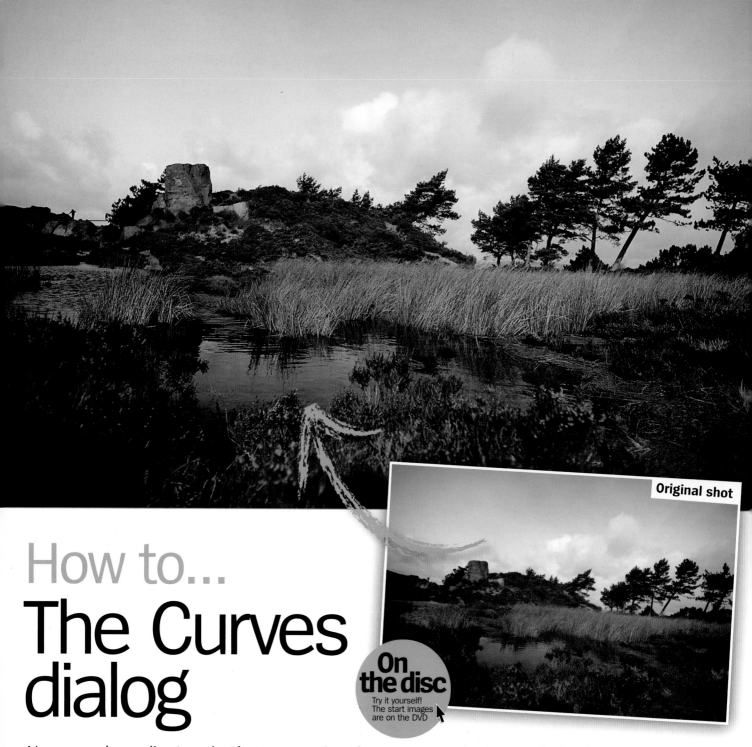

Original shot

On
the disc
Try it yourself!
The start images
are on the DVD

How to...
The Curves dialog

You can also adjust a shot's tones using the more precise controls in the Curves dialog

WHAT YOU'LL NEED *Any version of Photoshop or Elements*
WHAT YOU'LL LEARN *How to adjust an image's tonal range more*
precisely using Curves in Photoshop or Adjust Color Curves in Elements
IT ONLY TAKES *10 minutes*

Photoshop's Curves command (under Image > Adjustments, or better
as an adjustment layer) does a similar job to Levels, altering a shot's
tonal values. But where Levels lets you adjust shadows, highlights or
midtones, Curves enables you to target any parts of an image's tonal
range. This range is displayed as a line graph, representing a shot's
brightness levels from shadows at the bottom-left to highlights at top-
right. The shape of the curve shows how the image's original "input"
tonal values (represented along the horizontal axis) are adjusted or
remapped to new "output" values (along the vertical axis). It starts
as a diagonal line (so input values match output values), but you
can change its shape by placing and manipulating anchor points –

dragging a point upwards lightens the pixels in that area of the tonal
range, and dragging a point downwards darkens them. In pre-CS4
versions, you can click on the curve to place up to 14 control points,
or Ctrl-click on the area you want to adjust in your image and a control
point will appear at the corresponding tone on the curve. In CS4/5 you
can adjust specific tones using the On-Image Adjustment Tool: click the
tool's icon in the dialog, then click on a tonal area in your image that you
want to adjust, and drag upwards to lighten those tones or down to
darken them. Bear in mind that while you can target tones very precisely
with Curves, those tones will be adjusted throughout the image; if you
don't want certain areas to be affected, you'll need to mask them (using
the mask automatically created with the adjustment layer).

Elements' counterpart, Adjust Color Curves, can't be applied as an
adjustment layer, so use it on a duplicate image layer. It offers a range
of presets you can use as a starting point and then fine-tune with the
sliders, though each slider targets only a limited range of tones.

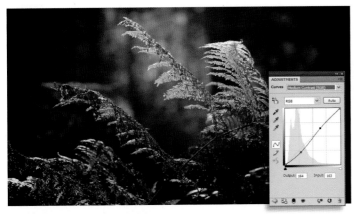

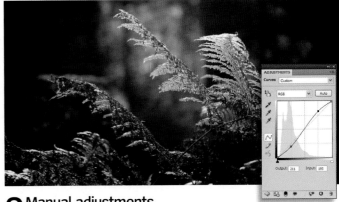

1 Using Curves presets

Open curves1.jpg from your DVD and add a Curves adjustment layer. You'll see that the image's tonal endpoints aren't far off – it's the midtones that need a contrast boost. If you're using CS3/4, the Medium Contrast preset in the dialog's Preset/Curves menu produces a nice result – see the note on the facing page if you're using Elements.

2 Manual adjustments

In pre-CS3 versions of Photoshop you'll need to adjust the curve manually. Click to place a point on the shadows quarter point (the top-right corner of the bottom-left grid box) and pull it downwards a little to darken the shadows, then place a point on the highlights quarter point (the bottom-left corner of the top-right grid box) and push it upwards to lighten the highlights.

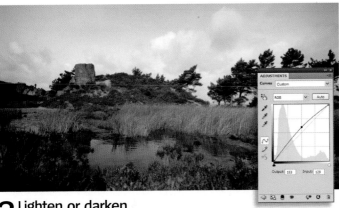

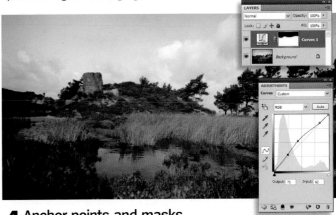

3 Lighten or darken

The contrast-boosting "S-shaped" curve in step 2 is probably the most common Curves adjustment, but it won't suit every shot. Open curves2.jpg. To lighten the image a little, click to place a point on the middle of the curve and drag this upwards. The adjustment is focused on the midtones and tapers off towards the shadows and highlights. To darken a shot, pull a point downwards from a similar area.

4 Anchor points and masks

You can refine how wide a range of tones you'll affect by placing "anchor" points on the curve. Here we've placed one point in the shadows to stop the lightening adjustment in step 3 affecting the darkest tones, and another in the highlights to anchor the lightest areas. We've also masked out the adjustment from the sky to preserve the deep blues (click the layer mask thumbnail and paint with black). ⬛

The Curves dialog
Get to know the main controls and options

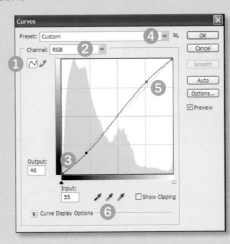

❶ Adjust the curve or draw one
You can plot a curve by adding and manipulating points, or click the pencil icon to draw a curve by hand (though this latter option is really useful only for special effects).

❷ Target separate channels
You can edit an image's red, green and blue colour channels separately by selecting them from the dialog's Channel menu.

❸ Target tones
The lower-left third of the curve controls shadows and dark midtones, the top third highlights and light midtones. Pulling the curve downwards darkens corresponding tones, pushing it up lightens them.

❹ Use presets
In CS3 or newer, the Preset menu is a quick way to apply edits, like Increase Contrast, or special effects, like Cross Processing.

❺ Placing points
Pre-CS4 (shown here), you can click directly on the curve to place a point, or Ctrl-click in your image to target a tone. In CS4/5 (see steps above), use the On-Image Adjustment tool. To delete a point, click it and hit Delete or drag it off the edge of the Curve window.

❻ Eyedroppers
Use these eyedroppers, like those in Levels, to set black, midtone and white points by clicking in the image.

How to...
Fix colour casts with Levels

On the disc
Try it yourself!
The start image
is on the DVD

Colour casts are surprisingly common. You can fix casts by adjusting the brightness levels of the colour channels, or try an "auto" option

There are a couple of reasons why the colours in your photos might look "wrong" when you view them on-screen. The first is that the screen might simply be displaying colours inaccurately. Look at all the TV screens on display in your local electrical superstore: they're all receiving exactly the same input, yet their pictures are all different. It's the same with computer displays.

If colour accuracy is important to you, it might be worth investing in a colorimeter, a small device you sit on your screen to calibrate it. Plug the device in, install its software, and run its test routine; it detects how the screen behaves and adjusts the output to get it as accurate as possible. The colorimeter will also produce a "profile" of that screen's characteristics, which Photoshop/Elements will pick up automatically and use to tweak colours on-the-fly, so that if, say, your monitor makes colours look a bit cool (as many LCD displays do), the software will subtly warm them up a bit so they look right on-screen.

A "professional" colorimeter such as the DataColor Spyder 3 will cost you less than $200, while a good mid-range unit like the Pantone Huey Pro is about $100 online. If you leave the Huey plugged in, it will also continuously monitor the ambient light and adjust your display to compensate for the changing light as the day ebbs.

If printed colour accuracy is critical, then the next step up is to profile your printer too. Until recently, the hardware required to calibrate a printer was prohibitively expensive, so the best solution was to use an online service such as www.pureprofiles.com – you download a

couple of test charts, print them out, send them off to the company, and they send you back a printer profile you install on your computer to add your printer into the colour management loop.

Colour temperature

Your colours might look wrong for another reason: a colour cast. Casts arise because different light sources have different colour temperatures – indoor light is warmer (more orange) than daylight, though daylight itself is warmer at dawn, turns cooler (more blue) in the course of the day, and warms up again towards sunset. The eye compensates automatically, and a camera's Auto White Balance function is designed to do the same, but it can be fooled in tricky lighting conditions, or overcompensate and flatten the rich hues of a sunset, for instance – or you might have manually chosen the wrong WB setting for the conditions.

Colour temperature is measured in kelvins (named after the 19th-century physicist who identified the phenomenon), and if you're editing a Raw file in ACR (see overleaf) the Temperature slider readout is in kelvins, but it's best to ignore this and work by eye; if you edit a JPEG in ACR, the slider simply runs from an arbitrary –100 to +100.

If a photo has an obvious cast, it's best to tackle it before making exposure and contrast adjustments; you can fine-tune the colour after these if need be. Here's how to do it.

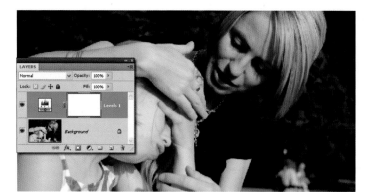

1 Start **Open your image**
Open Tinted_warm.jpg from your DVD in Photoshop or Elements. You can fix colour casts with Levels in two ways. If an image contains tones you know should be a neutral grey, you can click on these with the dialog's Set Gray Point eyedropper to neutralise colours throughout the shot – see step 8. The other option is to adjust the individual colour channels, which we'll try first.

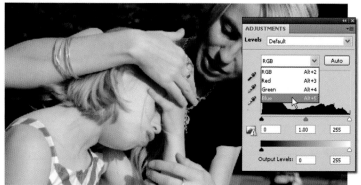

2 **Complementary colours**
Add a Levels adjustment layer, and go to the dialog's Channel menu (in the Adjustments panel in CS4/5 or Elements 8/9, it's the unnamed menu above the histogram and to the left of the Auto button). Our cast is predominantly yellow, so we'll adjust the Blue channel first – blue and yellow are complementary or "opposite" colours on the colour wheel, so adjusting the blue channel affects yellows too.

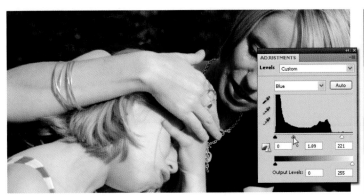

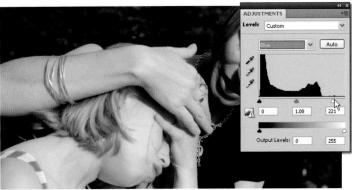

3 Test the blues

Drag the midtones slider left and right to see the effects: dragging it to the left intensifies blue and removes yellow; moving it right intensifies yellow and removes blue. For now, move the slider back to 1.00 or click the Reset button (the button next to the trash can at the foot of the Adjustments panel; in earlier versions, hold down Alt to change the Cancel button to Reset).

4 Adjust the blue/yellow balance

If you look at the histogram for the Blue channel, you'll see that it falls well short of the highlights end of the range, which tells us there's very little bright blue information in the image, and an absence of blue corresponds to a preponderance of its opposite, yellow. So rather than adjusting the midtones slider, we can remove the yellow cast by dragging the White Point input slider inwards to a value of around 220.

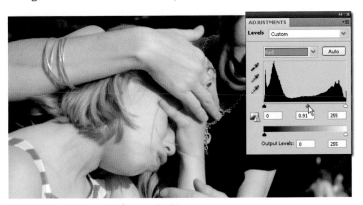

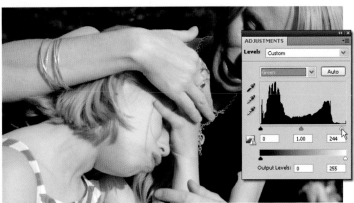

5 Adjust the red/cyan balance

In ACR (see overleaf) dragging the Temperature slider towards blue removes red from a shot as well as yellow; with Levels we need to adjust the red channel separately. Select Red in the dialog's Channel menu. This time the histogram reaches both ends of the scale, so we don't need to adjust the end points; instead, drag the midtones slider to the right, to around 0.90, to remove red and add cyan.

6 Adjust the greens

It's not very noticeable, but there's a faint green tint (like many casts, it becomes more obvious once you fix it!), so we'll fine-tune by adjusting the green/magenta information. In this case the histogram falls short of the highlights end of the range, so move the White Point slider inwards to around 245 to brighten the strongest greens in the image.

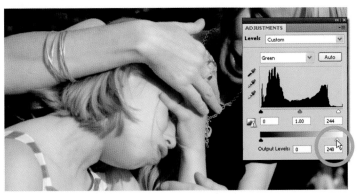

7 Fine-tune the greens

This actually makes the tint on the skin look worse, but it improves the greens in the trees and grass. Now move the White Point Output slider (the lower one in the dialog) inwards a little, to around 240 – this darkens the brightest greens in the image, which are in the skin tones, and removes the tint in those tones with minimal effect on the darker greens in the foliage.

8 Finish The one-click fix

As mentioned in step 1, you can also try neutralising colours by clicking with the dialog's Gray Point eyedropper (the middle one) on what should be a neutral grey tone. Here the only grey tones are in the small stretch of path visible behind the bench. If you click on the lighter grey, you'll find that the image is made too cool, but clicking on the shadow on the path produces a fair result. Look at the colour channels now and you'll see that they've all been adjusted; fine-tune manually if needed. ◘

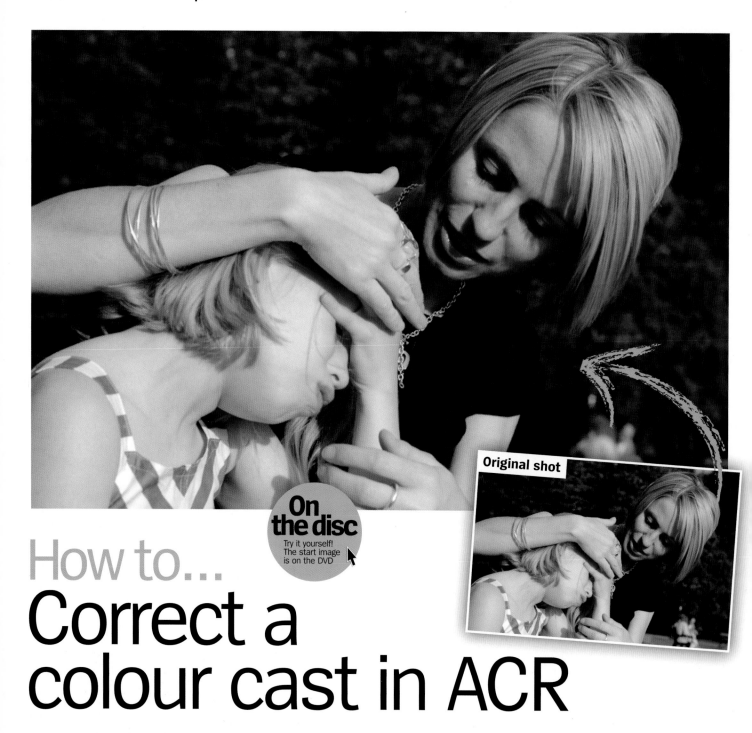

Original shot

On the disc
Try it yourself!
The start image
is on the DVD

How to...
Correct a
colour cast in ACR

The Adobe Camera Raw editor's tools enable you to correct
colour casts quickly and effectively, even if you shoot JPEGs

**There are several different options for correcting colour casts in
Photoshop, Elements and the Adobe Camera Raw editor, ranging from
tools for precisely neutralising colours to others, such as Variations
(see page 82), which enable you to take a more visual and subjective
approach.** If you're shooting Raw files, the ACR tools will produce the
best results, but if you're shooting JPEGs there's no definitive fix for
casts – you'll find that a method which works for one image may be
less successful for other shots, and you'll need to experiment to find
the most effective solution for each.

That said, and despite the fact that we started our look at correcting
colour casts with Levels, it's worth trying ACR first even if you're shooting

JPEGs – its colour correction tools are unmatched, yet almost as easy
to use as the Variations thumbnails. We'll look in detail at Camera Raw
in Part 4 (see page 112), but here we'll just mention that one of the
strengths of the Camera Raw editor is that it enables you to adjust
almost every aspect of a photo post-shoot, and among the most
important of those is White Balance. Here's how to use it.

As you move your cursor around a shot you'll see the brightness
values for the RGB channels displayed beneath ACR's histogram (or in
the Info palette in Photoshop/Elements). You can use these readings to
help you gauge corrections: if for example a spot's R, G and B values
are close to each other, you'll know you're close to a neutral grey.

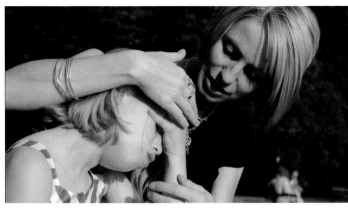

1 Start Open your image in ACR

If you're using CS3, Elements 5 or a newer version of either program, you can edit your JPEGs in ACR: go to File > Open As (Open on a Mac), navigate to Tinted_warm on your DVD, then select Camera Raw (*not* Photoshop Raw) from the Open As menu (the Format menu on a Mac) and click Open. The shot has a fairly strong yellow cast, and if you look closely you'll see that the skin has a green tinge too.

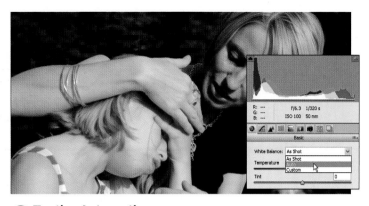

2 Try the Auto option

The first step is to try the Auto option in the White Balance menu – "As Shot" (the default) is the camera setting, and selecting "Custom" reapplies the last settings you configured yourself. If the file is a Raw file, the menu contains additional options that correspond to camera White Balance settings, and selecting one has the same effect on the shot as using that setting in-camera would have done – Tungsten, for example, will cool down a shot taken under warm indoor lighting.

3 Switch to ACR's White Balance Tool

In this case the Auto adjustment makes the image look much too cool – you'll see that the Temperature slider has shifted left towards blue, to a setting of −25. The Tint slider has also shifted left, to a setting of −2, which adds green – this isn't what we want either. We'll see if we can get a better result with the White Balance Tool. Click on it in ACR's toolbar at the top of the screen.

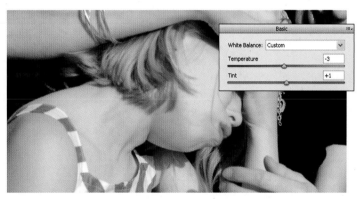

4 Click in a neutral area

To use this tool you need to click on an area that should be a colour-neutral light grey or diffuse white (the tool won't work on bright highlights, since they contain little colour information). Click on different tones in the white stripes of the girl's dress and you'll get similar results: the Temperature slider is shifted towards blue by a few points, and Tint moves a point or two either way.

5 Fine-tune with the Temperature slider

If you toggle the preview on and off, you'll see that the cast is reduced, but we can take things further using the sliders. (If you're correcting shots of your own taken on a sunny day, say, you might prefer them to retain a slight warm tint.) The sliders are very easy to use: the Temperature slider simply makes shots more blue or more orange; the Tint slider adds green or adds magenta.

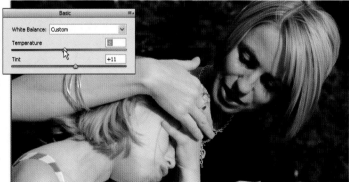

6 Finish Refine with Tint if necessary

Depending on where you clicked with the White Balance Tool, the Temperature setting shouldn't be too far off, but it won't hurt to experiment with the slider; in this case somewhere between −6 and −8 removes the yellow cast effectively. You'll find that the green cast is now more noticeable; to neutralise this, move the Tint slider to the right to a value of around +12. ◘

How to...
Adjust colours with Variations

Remove casts or adjust a shot by adding or removing specific colours

On the disc
Try it yourself! The start image is on the DVD

The Variations dialog in Photoshop (Color Variations in Elements) isn't exactly the most sophisticated colour correction tool, but it takes a uniquely visual approach, which some users will find more intuitive. It displays a set of thumbnails, each of which previews how your image will look should you apply the adjustment it represents. To adjust a photo, you click the thumbnails repeatedly to add or remove particular colours until you get the result you want; all the thumbnails update each time you click, so you can see what effect each will now have, and you simply keep clicking them until you get a result you're happy with. To try it out, open Warm.jpg from your DVD and go

to Image > Adjustments > Variations in Photoshop or Enhance > Adjust Color > Color Variations in Elements.

Elements' Color Variations dialog works in the same way as Photoshop's Variations dialog, but it's laid out a little differently. The thumbnails enable you to add or remove red, green and blue; decreasing blue, for example, has the same effect as adding yellow. (It helps to understand the colour wheel here – search on the Web or in the Photoshop/Elements Help Pages for "color wheel".) The Amount slider works like the Photoshop dialog's Fine/Coarse slider, but the Load, Save and Show Clipping options are absent. ◻

The Variations dialog (Photoshop)

The point-and-click approach: "Make my colours more like *this*"

❶ Colour wheel layout
Variations works on the principles of the colour wheel: click a thumbnail to boost a colour, or subdue a colour by adding more of the opposite colour.

❷ Before and after
Your original shot is displayed at top-left; click it to revert to this. The "Current Pick" thumbnails (next to this and centre) show the image with the changes you've made.

❸ Targeted adjustments
You can target your adjustments at an image's shadows, midtones and highlights, and adjust the saturation of the image.

❹ Fine-tuning
Drag the Fine/Coarse slider to the left if you want to make adjustments in more subtle increments, or right to apply bigger colour shifts with each click.

❺ Tonal adjustment
As well as adjusting colour, you can also lighten or darken your image by clicking the Lighter or Darker thumbnails (though Levels or Curves will be more precise).

❻ Quick fix
The cast in Warm.jpg is mostly red, so you can remove it pretty effectively by clicking once on the More Cyan/Decrease Red thumbnail with the Fine/Coarse or Amount slider at the default setting.

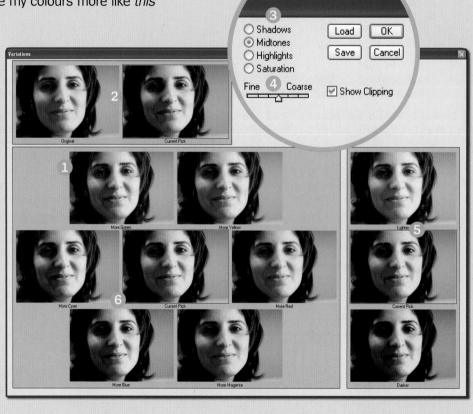

How to...
Remove hotspots

On the disc
Try it yourself!
The start image
is on the DVD

Glare from strong sunlight or a flash can ruin portraits. Here's how to tone it down

"Hotspots" caused by harsh lighting such as bright sunshine or an undiffused flash are partly an exposure problem and partly a colour problem, but you'll rarely be able to eliminate them using either the exposure or the colour tools in Photoshop/Elements. Instead, the most effective approach is usually to treat them as a retouching challenge. In fact, this is a particularly good example of the benefits

of being able to change the retouching tools' blending mode (see page 64 for more about this). Note that we're talking here about tool blending modes, set in the tool options bar, not layer blending modes. The latter apply to an entire layer; tool blending modes can apply to individual brush strokes – you can change from one stroke to the next if you wish. Here's how you can use this to tone down skin glare.

1 Start Create a cloning layer
Open glare.jpg from your DVD. The sunlight hitting the subject's face has created harsh highlights with no detail, so we'll tone them down a bit by cloning nearby areas of normal skin tone. Add a new layer, switch to the Clone Stamp Tool, and enable the All Layers option.

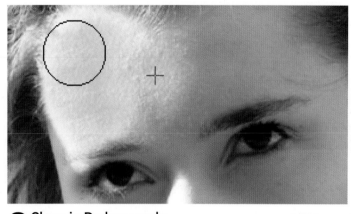

2 Clone in Darken mode
Set the tool to Darken mode, so that only areas lighter than the tones you sample (that is, the glare) will be affected. Set the brush size to about 60 pixels, the hardness to 25% and opacity to 60%. Alt-click in the middle of the forehead to sample medium skin tones that contain some visible texture, and click to dab these pixels over the highlights – don't drag, because the area you're sampling is small.

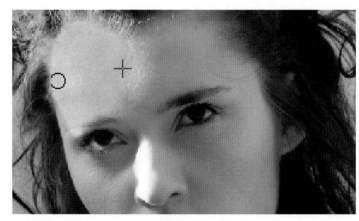

3 Preserve tonal variation and detail
Go over the right half of the highlight area more than the left half to create a smooth transition from midtone to lighter areas. Reduce the brush size and opacity to work close to the edges – you don't want to blur the detail of the hairline or eyebrows. If you do affect these areas by mistake, you can remove the cloned pixels with the Eraser Tool set to the same hardness and opacity as the Clone Stamp.

4 Finish Fine-tune as required
Sample from the centre of the forehead to retouch the nose, adjusting the brush to suit and tidying up with the Eraser Tool. To soften the edges of the shadows, create another new layer (so you can fine-tune this area separately if you decide to alter the opacity of the main cloning layer later), and set the Clone Stamp to Normal mode so you can both darken and lighten areas. 📷

» Using Photoshop 3

Time to get stuck in and discover what Photoshop can do for you! We'll show you how to tackle real-world photo-editing tasks and reveal expert techniques for great results

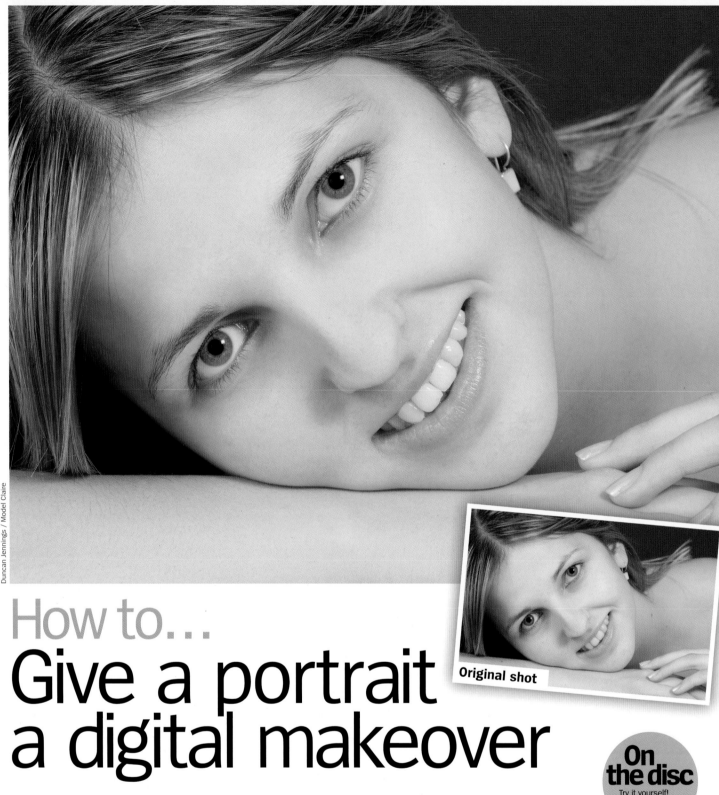

Original shot

How to...
Give a portrait
a digital makeover

On the disc
Try it yourself!
Start image and
video on the DVD

Polish a portrait to perfection by banishing blemishes, whitening
teeth and creating a healthy complexion. We'll show you how!

WHAT YOU'LL NEED *Any version of Photoshop or Elements*
WHAT YOU'LL LEARN *How to boost colour and contrast; enhance skin tone;
remove blemishes, wrinkles and shiny hotspots; brighten eyes and whiten teeth*
IT ONLY TAKES *15 minutes*

**A high-resolution digital camera that's equipped with a decent lens has
the potential to capture stunning looking high-quality portraits, but even
the professionals need to spend some time tweaking colour and tone in
Photoshop to make the shot look perfect.** Odds are the contrast might be a
little flat and the shot may need a bit of sharpening to bring out finer details like
hair and eyelashes. (As a rule, every image, no matter how well focused, will

benefit from some degree of sharpening to counteract the inherent softening
effect of digital capture.) The colours may also need to be tweaked to create
a more natural-looking skin tone.

As well as technical issues with the photo, the subject of the shot may be
having a bad skin day, so the image may need some subtle retouching to make
her look her best. By shooting in Raw format you can give yourself the edge in
the battle for quality, so we'll kick off by doing as much image enhancement as
we can in the Adobe Camera Raw editor before popping into the standard editor
to make use of its extra image-enhancing tools – for more about ACR, see Part 4.
Follow our comprehensive step-by-step guide to making a good portrait look even
better using a variety of photo-enhancing tips, tricks and techniques.

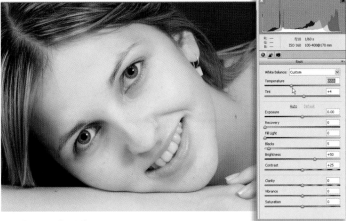

1 Start Getting warmer

Open the unprocessed Raw file, MakeOver_Before.CR2. The image straight from the camera looks a little too cold – because of the camera's white balance setting, there's a slightly blue colour cast. Warm up the shot a little by dragging the Temperature slider to the right (to about 5550 on the scale should do it).

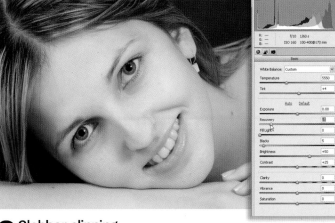

2 Clobber clipping

To check the portrait's exposure, click the highlight clipping warning triangle at the top right above the histogram. A few specks of the overlay colour alert us to blown-out highlights on the skin. Drag the Recovery slider to the right to around 15 to restore more detail to these flash-induced shiny hotspots.

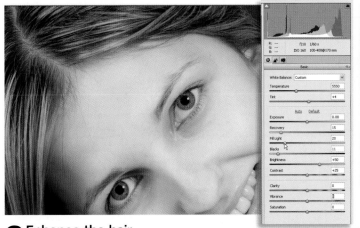

3 Enhance the hair

To reveal more hair detail, pull the Fill Light slider up to 20. This brightens up the darker midtones without messing with the correctly exposed highlights. It also boosts the shot's saturation a little. For a wider contrast, drag Blacks up to 11. This offsets the Fill Light adjustment and darkens the shadows a bit more.

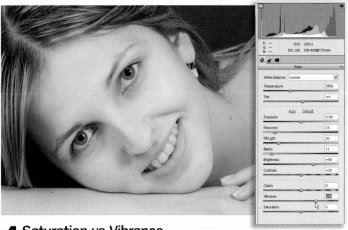

4 Saturation vs Vibrance

The shot still looks a little desaturated, making our model look rather pale. You could try boosting the Saturation but this will tint our model's skin tones a fake-tan orange. For a subtler and more natural colour enhancement, drag the Vibrance up to +40 – this boost less-saturated colours without overdoing things.

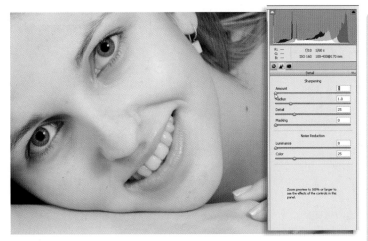

5 Finish Remove the default sharpening

By default ACR applies some gentle sharpening to Raw files, which aren't sharpened in-camera. We're going to do some retouching later and will need to sharpen after that, so to avoid sharpening multiple times (which entails a high risk of creating artifacts), click on the Detail tab and take Amount down to 0. »

Expert tip
Retouch Raw files in the ACR editor

In our project we'll use the Photoshop/Elements Spot Healing Brush to remove moles, freckles and skin blemishes. If you're using the full Photoshop you can also retouch unwanted spots without leaving the comfort and quality zone of the Adobe Camera Raw editor. Click its Spot Removal Tool (called the Retouch Tool in older versions of ACR – the shortcut in any version is B) and set it to a diameter that's big enough to cover any spots. Set Type to Heal. Click on a blemish with the tool's red overlay circle. Drag the adjacent green overlay circle onto a clear patch of skin, and Photoshop will replace the unwanted spot with clear skin.

Original shot | Finished shot

Master retouching tools

Banish blemishes and send acne packing with the Spot Healing Brush

Our skin tends to change on a day-to-day basis. Spots can spring up at a moment's notice, in spite of the fact that we're having our portrait taken. A bit of make-up can absorb sweat but skin can still look shiny under the glare of a studio flash. We'll tackle hotspots shortly but first let's look at ways of removing spots to make our subject's skin look its best. We can also reduce moles and freckles without resorting to surgery thanks to Photoshop's ability to graft clean skin over unwanted blemishes. Creases under the eyes can also be reduced to preserve that youthful appearance. Try not to remove every line and freckle, though – we want to enhance the portrait in subtle ways, not make the subject look like a showroom dummy with unrealistic, completely featureless skin!

1 Start **On the spot**
After editing in Raw, click Open Image to open the file in the standard Photoshop editor. Switch to the Spot Healing Brush Tool (J). For this shot, set it to a Size of around 80 pixels so that it will cover any spot or mole. Click on unwanted spots, freckles and moles to replace them with smooth skin.

2 **Remove those wrinkles**
The soft skin under the eyes creases as we age, so turn back time by switching to the Healing Brush Tool. Alt-click to sample a patch of smooth skin below the eyes. Click and drag over the shiny, creased skin, avoiding any areas of detail like the eyelashes. Photoshop blends the transplanted skin seamlessly with its new surroundings.

3 Finish **Round up strays**
Our model has a few distracting stray hairs. Reduce the Healing Brush's tip Size to 40 (tap the left square bracket key to shrink it instead of changing the Size in the Options bar). Alt-click to sample a patch of smooth skin as close as possible to an unwanted strand of hair so the tones will match, then click-and-drag over the strand of hair to remove it.

Original shot

Finished shot

Create flattering skin tones
Bring colour to your subject's cheeks and banish flash-induced hotspots

There is a multitude of expensive cosmetic products vying for our hard-earned cash. Each product claims to keep skin looking smooth, healthy and young. Photoshop's digital makeover tools can enhance skin without the need to blow your budget on cosmetics. We've already warmed up the skin's cold blue colour cast in the Adobe Camera Raw editor, as well as boosting its colour using

Vibrance. Although our blemish and wrinkle-free skin looks younger, there are still some shiny hotspots on the cheek, making our subject look a little sweaty. We can apply a virtual powder puff to reduce shine courtesy of the Brush Tool, or use Elements' unique Adjust Color for Skin Tone command to subtly enhance skin tones by boosting the skin's natural-looking browns. Try these alternatives...

1 Tweak skin tone
If you're using Elements, you can try enhancing the skin tones with Enhance > Adjust Color > Adjust Color for Skin Tone. Click with the eyedropper on a patch of pink skin. Drag the Tan slider right to gently increase the strength of the browns. This produces a delicate and natural-looking tan, giving the skin a warmer, more attractive tone. Click OK.

2 Hue/Saturation
Elements' tool will affect colour throughout the shot, and you can't mask it easily. An alternative is to add a Hue/Saturation adjustment layer, choose Yellows from the dialog's Edit menu and move the Saturation slider to about –16. Click the mask and paint with black to hide the effect where needed.

3 Virtual powder puff
Add a new empty layer. Switch to the Brush Tool (B), and set the brush size to about 200. Alt-click to sample some pink skin near the cheek. Paint with the pink brush over the cheek's shiny hotspots, then drop the layer opacity to 30% to reveal the underlying skin texture. »

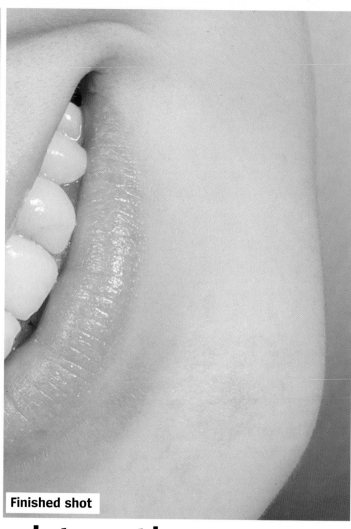

Original shot Finished shot

Whiten eyes and teeth

Digitally remove stains and even the tooth colour to create a winning smile

Real teeth can have a wide range of colours, from grey to yellowy-white and beyond, and it's usual for a person's teeth to vary quite widely in colour. We're conditioned to expect a flawless, uniform look these days, though, so we'll show you how to create a smile fit for a Hollywood star. We'll show you how to whiten teeth with a quick scrub of the Sponge Tool. Teeth aren't usually the focus of a portrait, though – the eyes are the first thing most people look at in a portrait,

so they too can benefit from a little enhancement. We'll show you how to use the Dodge Tool to lighten the whites of the eyes to give them extra impact.

When retouching the eyes, though, it's important not to go over the top and make the eyes look like they are glowing. Whenever you're retouching, think "less is more" so that you don't create an unrealistic result. If your enhancements are subtle enough, the subject won't even be able to say why the shot looks better.

1 Start The eyes have it!
Take the Dodge Tool (O) and for this shot set it to a Size of about 65 pixels. Set Range to Highlights so the tool doesn't tinker with the eye's shadows or midtones. Set Exposure to 20% for a subtler edit. Brush with smooth strokes over the white of each eye to increase the intensity of the whites gently.

2 Tackle the teeth
Use the Polygonal Lasso to draw a rough selection around the teeth, then press Ctrl-J to float the selection to a new layer. Label the new layer "Teeth." Now switch to the Sponge Tool, and set its mode to Desaturate. A size of about 70 pixels will do the trick in this case.

3 Finish Desaturate the yellow
Brush carefully in short strokes over the yellow teeth to whiten them. It won't matter if you stray over the gums, but if you inadvertently desaturate the lips, simply undo the last stroke (that's why it's worth using short strokes). Toggle the layer visibility on and off to assess the effect.

Bring out subtle details

Make your enhanced portrait print out with more punch! Follow our guide to artifact-free digital sharpening

Original shot Finished shot

It's always worth leaving the sharpening process to the very end of your portrait enhancing workflow – this process can add artifacts to the shot like grain, blown-out highlights and dark halos around edges, and these types of picture artifacts might be exaggerated if you go on tweak colours and tones after sharpening. Luckily Photoshop and Elements have all the tools you need to bring out subtle details and create a crisp, artifact-free version of your enhanced portrait with the minimum of fuss.

1 Start Merge layers
Save a copy of your image as a PSD to preserve the layers in case you want to revisit any edits later, then flatten the image (Layer > Flatten) to merge the layers – like all filters, sharpening can be applied only to an image layer, so we need to consolidate all our edits into a single image layer.

2 Unsharp Mask
Go to Unsharp Mask (in the Filter > Sharpen sub-menu in Photoshop, or the Enhance menu in Elements). Because of display anti-aliasing, you can't assess the effect properly at anything other than 100% zoom. Drag inside the dialog's preview window to view fine details like the iris. Pop Amount up to 54%. Radius alters the spread of the change, so keep it below 2 to avoid dark haloes.

3 Advanced sharpening
Click Cancel to leave Unsharp Mask. Instead, go to Smart Sharpen (or Enhance > Adjust Sharpness in Elements) – this gives you a larger preview window. Set Amount to 95% and Radius to 1.4. Click and hold down the mouse button to see the original soft shot, then release to see the sharpened version.

4 Finish Ready to print
The sharpening process has brought out a little image noise in some of the shadows. You can reduce this subtly without blurring the shot by choosing Lens Blur instead of Gaussian Blur in the dialog's Remove menu and *disabling* the More Accurate option (More Refined in Elements), which will also exaggerate noise. Click OK and you're done. ◻

George Cairns

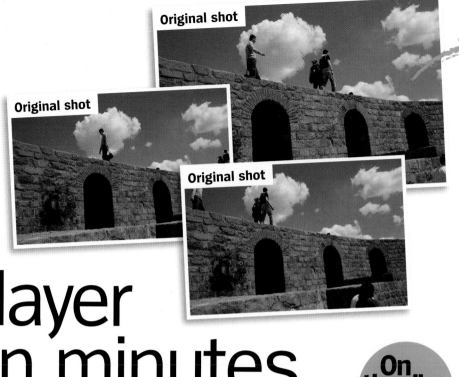

Original shot

Original shot

Original shot

How to...
Master layer masks in minutes

Layer masks may sound daunting, but they're surprisingly intuitive and can help you declutter an image with ease

WHAT YOU'LL NEED *Photoshop CS or newer*
WHAT YOU'LL LEARN *How to align several shots of the same scene, how to hide unwanted people using layer masks, how to transform layers to fix converging verticals, how to use an Adjustment Layer to convert to mono*
IT ONLY TAKES *15 minutes*

Once you get your head around the concept of working with photos on multiple layers, you can go one step further and use masks to help you pick and mix the best bits from each layer. Take our finished architectural scene for example: we could have hung around until all the

tourists had left, but this would have taken too much time. By shooting multiple exposures as people wandered by, we were able to capture every architectural detail in three different shots.

In this tutorial, we'll show you how to place the three source files onto separate layers and align them so that the building is in the same position on each of the layers.

You'll then add a see-through mask to every layer. By painting black on a layer's mask, you can effectively mask out the unwanted people on that layer, revealing a clear area of architecture from the layer below. We'll finish off by straightening up the converging verticals, and using an adjustment layer to create a striking monochrome scene.

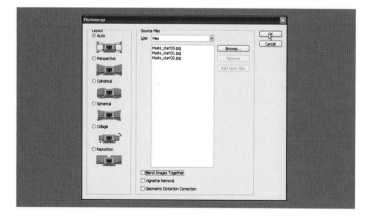

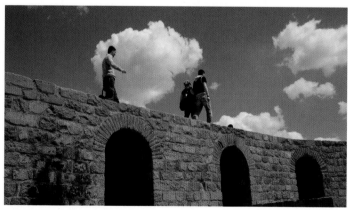

1 Start Align your shots
You could copy each photo into a single file on separate layers, but there's a quicker way which also aligns your images. In Photoshop, go to File > Automate > Photomerge. Click Browse and navigate to the Declutter folder on your DVD, then Ctrl-click the three masks_start files. Click Open. Click Auto, disable Blend Images Together, then click OK.

2 Check the layer order
Photomerge will place the shots in a single document on separate layers, and then – because they were shot by hand – reposition each layer to make sure the buildings overlap as accurately as possible. Now go to Window > Layers and drag the layer thumbnails so that masks_start1 is at the bottom of the stack and masks_start3 is at the top.

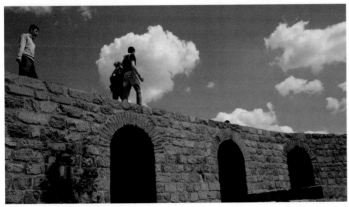

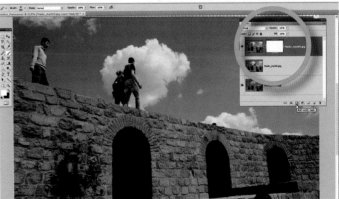

3 Alter the opacity

Click on start3, then use the opacity slider at the top of the Layers palette to drop this layer's opacity temporarily to 20%. Compare the content of the top layer with start2 below. The man on the left and the couple at the bottom almost vanish, so there are some clear patches of building and sky below, on masks_start02. Restore opacity to 100%.

4 Add a mask

Click the Add layer mask button in the Layers palette to add a mask to the start3 layer. By default it's all-white and doesn't mask out any of this layer, but painting with a black brush on the mask will conceal the areas you paint over on start3, revealing the corresponding areas of the start2 layer below. »

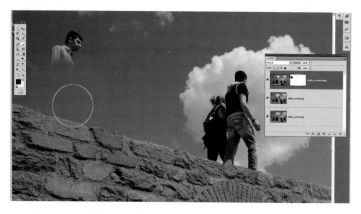

5 Paint away intruders

Switch to the Brush tool. Click the brush preview in the options bar and choose a soft brush with a diameter of 300 pixels, then set Opacity and Flow to 100%. Click on the start3 layer's mask thumbnail. Tap D, then X if need be to make the foreground colour black, then paint over the unwanted man at the top left.

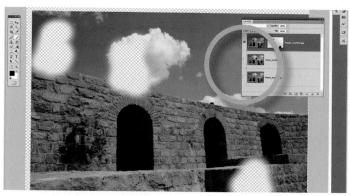

6 Check the masks

Do the same with the couple on the top of the wall. This will reveal a man on the layer below, but we'll mask him out later. Finally, paint out the couple at the bottom. To get a better idea of what your mask is doing, click the two lower layers' visibility eye icons to make them invisible. You'll see the "holes" that the mask has made in the top layer. Click the other layers' eye icons again to make them visible.

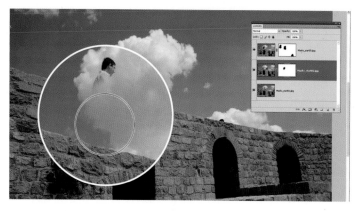

7 Vanishing act

Click the start02 layer thumbnail and add a layer mask as in step 4. Click the mask thumbnail and paint with the black brush over the remaining man. As an experiment, tap X to swap the foreground colour to white: when you brush, you'll erase the black mask to reveal the hidden man. Press X to return to a black brush and hide him again.

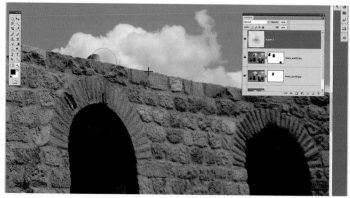

8 Send in the Clone Stamp

The top of a head remains visible, because it's in the same position in every shot. Click the start3 layer thumbnail, then click the "Create a new layer" button in the Layers palette. Switch to the Clone Stamp Tool and enable Sample All Layers. Alt-click to sample a nearby patch of wall and sky, then clone out the head.

9 Transform your image

Press Ctrl-Alt-Shift-E (Command-Option-Shift-E on a Mac) to create a new layer at the top of the stack combining the existing layers without discarding them. To fix the shot's converging verticals, go to Edit > Transform > Perspective. Pull a top corner handle out a bit to straighten the verticals, and hit Return. Go to Edit > Transform > Scale to enlarge the shot a little to hide any overlapping edges, then hit Return again.

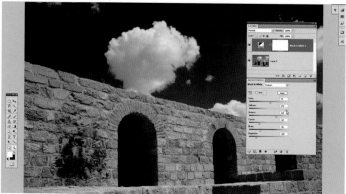

10 Finish Convert to mono

To make those fluffy clouds pop out more, add a Black & White adjustment layer. In the dialog, choose Infrared from the Presets menu. Darken the sky by dragging Blues to −56, and lighten the architecture by popping Yellows to +274 and Reds to +70. These contrasting tones make the building's shapes and textures stand out better. ◘

On the disc
Try it yourself! Start image and video on the DVD

How to...
Correct a photo's exposure

Lift flat images and help correct exposure or contrast flaws – we show you how

WHAT YOU'LL NEED *Any version of Photoshop or Elements*
WHAT YOU'LL LEARN *How to improve an image's tonal balance and boost contrast, how to lighten or darken areas of a photo selectively*
IT ONLY TAKES *15 minutes*

Photoshop and Elements have a wealth of tools to tackle almost any exposure issues. These tools vary in complexity from the very straightforward slider controls in the Adobe Camera Raw editor or in the Brightness/Contrast dialog to the subtleties of Photoshop's Curves. Depending on the problem you're tackling, which program you're using and your skill level, you might try one or several of these options. We'll start with an overview of the options for exposure and contrast adjustment, then turn to localised lightening and darkening. When global adjustments don't improve a flat image, you can localise them using masking techniques, painting with a black brush on the mask to hide the effect where it's not wanted, or else turn to the brush-based Dodge and Burn Tools, which are best used carefully on relatively small areas to build structure.

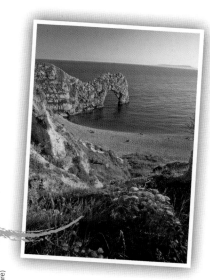

Ali Jennings (Future)

Using Photoshop

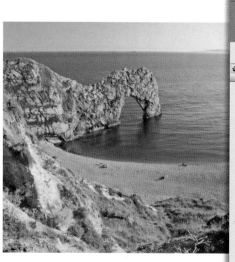
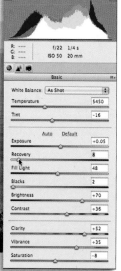

1 Adobe Camera Raw
Open DodgeBurn.dng from the Exposure folder on your DVD. It's a Raw file, so it will open in the Adobe Camera Raw editor, which is the perfect first stop to adjust the exposure and contrast of all your shots, JPEGs as well as Raw files. Its slider controls can't be beaten for precise tweaks of specific parts of the

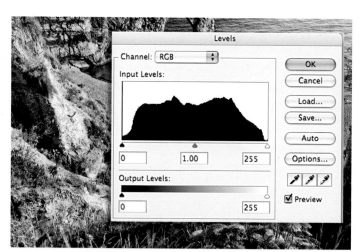

2 Levels contrast boost
This is crucial tool for assessing and correcting exposure and contrast. The histogram displays the image's tonal range from shadows at the left and highlights at the right. If the graph doesn't extend all the way from end to end, pull both the Black Point and White Point input sliders inwards to meet the histogram edge to improve contrast.

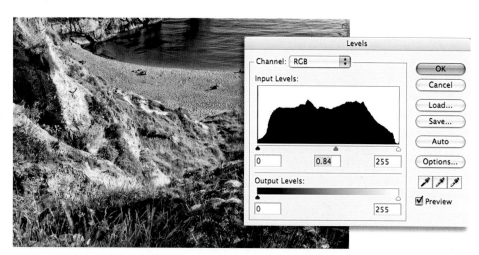

3 Adjust the midtones
Once you've set the end points, you can use the Gamma (midtones) slider to brighten or darken the image by dragging the slider to the left or the right respectively. (This seems slightly unintuitive at first, but think of moving the slider left towards the shadows as compressing the darker tones, making more room for the lighter ones, and vice-versa.)

Dodging and burning

Dodging and burning are the classic terms for selectively lightening and darkening areas of a photo respectively. In the traditional darkroom this was done by exposing areas of a print to more light or less light during the printing stage; in Photoshop/Elements the Dodge and Burn Tools are brush-based, enabling you to paint the effects where you want them. This means you have complete tonal control and can quickly lift a flat image, create paths of light, or enhance shadows and reflections. First make your global tonal corrections, then Dodge and Burn locally, setting the tools to an Exposure of no more than 5% to 10% and building up the effect very gradually.

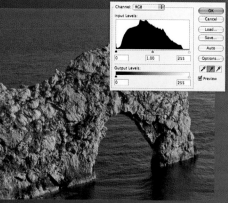
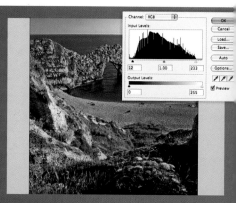

1 Start Checking the tones
Without making any changes in ACR, open DodgeBurn.dng into Photoshop/Elements and start by duplicating the Background layer. Then add a Levels adjustment layer and set the tonal end points as in step 2 above.

2 Increasing contrast
If you pull either slider in past the ends of the graph, you'll clip tones at that end of the range to solid black or white. To prevent this, hold down Alt as you move either slider, and stop just short of the point where colours appear. If you can't avoid some clipping, clip shadows rather than highlights.

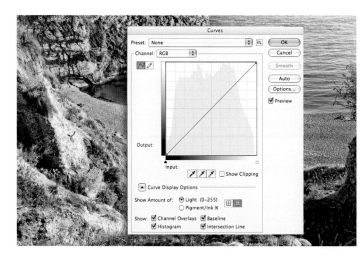

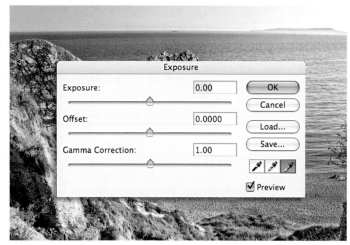

4 Curves

Curves gives you greater control over tones, so you can lighten or darken specific parts of the tonal range without affecting the end points. Elements' counterpart, Adjust Color Curves, has sliders for adjusting shadows, highlights or midtones (that is, little more than Levels), but the Photoshop version enables you to adjust up to 14 points on the curve.

5 Other options

The Brightness/Contrast dialog's sliders make tonal changes without affecting the end points (so work more like Curves than Levels), and this can be added as an adjustment layer in Elements. The sliders in Photoshop's Exposure dialog have roughly the same effect as ACR's Exposure, Blacks and Brightness sliders respectively; the eyedroppers will set the black, grey or white tonal points without affecting colours as the Levels versions do.

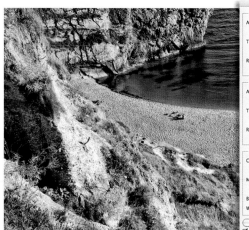

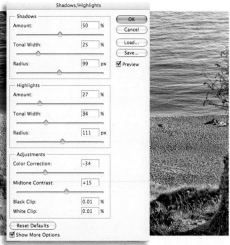

6 Shadows/Highlights

You can't use it as an adjustment layer, but this dialog enables you to lighten the shadows or darken the highlights in a shot separately, or both, as well as fine-tune exactly what tones are included in either range (Photoshop's version offers more options here than Elements'). It can help you correct exposure problems or be taken further to create striking pseudo-HDR effects.

3 Use brushes instead

To localise lightening or darkening, you'll need to mask a Levels layer, or else use the Dodge and Burn Tools. Subtlety is key, so use a large brush of 200-300 pixels in size and reduce hardness to 0 and Exposure to 5%. When dodging, set Range to Highlights; when burning, set it to Shadows.

4 Burn the shadows

In this image, the contrast in the rock needs to be boosted. Use the Burn Tool to make sweeps over the rock face and darken the shadows. The effect is cumulative, so you can brush over the same area several times to build up the effect. Be creative and use contrast to create structure.

5 Finish Dodge highlights

Use the Dodge Tool on areas you want to lighten. Apply it to the central section of rock to add impact. Use it to pick out reflections in the sea and the light edges of the greenery. Both tools can quickly destroy image quality, though, so should be used in moderation. 📷

Peter Travers (Future)

Original shot

How to...
Quickly boost individual colours

On the disc
Try it yourself!
Start image and
video on the DVD

Use Photoshop's clever Selective Color adjustment layer to
make speedy improvements to the colours in your images

WHAT YOU'LL NEED *Photoshop CS3 or newer*
WHAT YOU'LL LEARN *How to use layers, how to create a Selective Color
adjustment layer, how to enhance blue skies and green landscapes, and
how to use the Brush Tool to apply a mask*
IT ONLY TAKES *10 minutes*

**One way to boost defined colours in your photos is to add a Hue/
Saturation adjustment layer in either Photoshop or Elements.**
However, a Selective Color layer, available in Photoshop CS3 and newer,

offers an even faster and more powerful way to adjust specific colours,
keeping your colour changes consistent throughout your image.

Using Selective Color adjustment layers, you can make accurate
changes in primary colours, enhancing the cyan in the blues, for
instance, without affecting the cyan in the greens. The dialog does
this by enabling you to target the primary colour channels and pairs
of channels (Reds, Yellows, Greens, Cyans, Blues, Magentas, Whites,
Neutrals and Blacks), then providing four main adjustment sliders for
precise colour changes – Cyan, Magenta, Yellow and Black (CMYK).

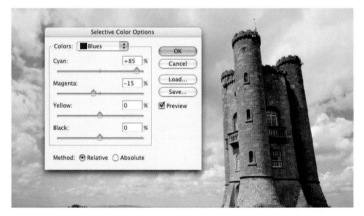

1 Start Getting started
Open selectcolour_start.jpg from your DVD in Photoshop CS3 or
newer. Go to Layer > New Adjustment Layer > Selective Color (or hold
down Alt as you click the "Create adjustment layer" button in the Layers
palette). In the next box that appears, simply click OK, so that the name
of your new layer is "Selective Color 1", Color is White, Mode is Normal
and Opacity is 100%. The Selective Color dialog will now open.

2 Boost the blues
Let's begin by selectively adjusting the blues in the sky of our
source image. To do this, choose Blues from the dialog's Colors menu.
Keep Method set to Relative, then drag the Cyan slider to the right to
around +85 and the Magenta slider left to about –15. This will create
a more vibrant blue sky.

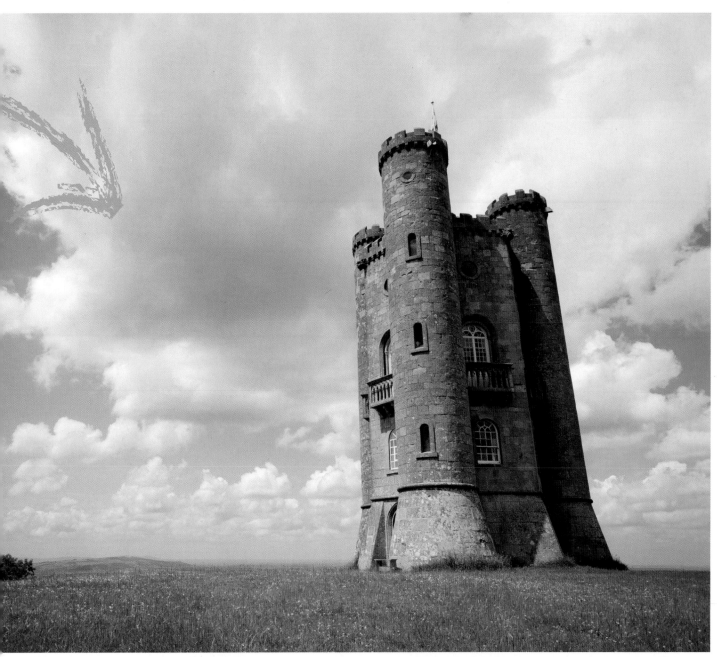

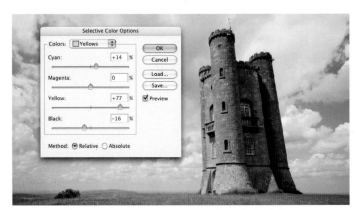

3 Green, green grass

You can also use Selective Color to enhance the greens in your landscape images. Go to Layer > New Adjustment Layer > Selective Color and click OK (so the name of your new layer is "Selective Color 2"). Again, keep Method set to Relative, and drag the sliders to something like the following settings to create richer green grass: Cyan +14, Magenta 0, Yellow +77 and Black –16.

4 Finish Mask unwanted side-effects

The adjustment in step 3 also changes the yellows in the tower's brickwork, but you can easily mask this out: click the Selective Color 2 layer's mask thumbnail, and switch to the Brush Tool. With a soft brush of around 400 pixels size and 50% opacity, brush over the tower to reveal the unaltered tower on the layer below. You don't have to be too neat with your brush – there are no yellows in the surrounding sky. ○

Matt Henry

Original shot

How to...
Professional retouching techniques

Adjustment layers and layer masks are the key to advanced portrait retouching. Learn how to unleash their full potential

WHAT YOU'LL NEED *Photoshop CS or above*
WHAT YOU'LL LEARN *How to reshape the body using Free Transform and Liquify; how to clean up skin using the Healing Brush and Clone Stamp; how to smooth skin with Gaussian Blur and lighten it using Curves; and how to remove unwanted colour using Selective Color*
IT ONLY TAKES *30 minutes*

With fashion and portrait retouching, the devil really is in the detail; you might want to enlarge the eyes a little, remove a few spots, lighten the skin, or even reduce the size of the feet! It's all work that requires you to get up close and personal, not something you can accomplish with a quick sweep of the brush at 50% zoom. And this

is what makes the use of layers and layer masks crucial: if you make a mistake, you can easily delete or edit the layer and have another go. Do that same work on the original background layer and you might find, 20 minutes down the line, that you've got a wonky arm, one eye bigger than the other and skin that looks like a Botox accident. It's not until you see all the elements working together that you can really decide whether something looks right or needs a little tweak here and there – which is easily done when everything sits on separate layers.

In this project, we'll cover subtle body slimming and reshaping, skin smoothing and colouration, and background lightening, all on different layers. If at any point you feel one of your alterations isn't quite right, a little tweak is a cinch!

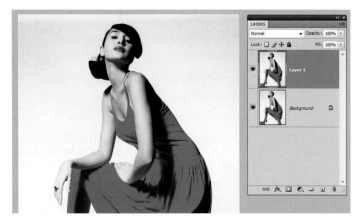

1 Start Instant slimming
We're going to start with an old trick to slim our model a touch – not that she needs it, but just to show you how it's done. Open retouch_start.jpg from the Liquify folder on your DVD in Photoshop and duplicate the original Background layer by pressing Ctrl-J. Next press Ctrl-T to initiate a Free Transform. In the options bar at the top of the screen type 97% in the Width box and hit Enter twice.

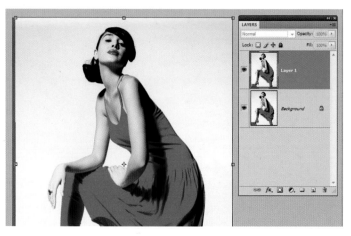

2 Crop out the left edge
We need to crop out the left edge of the shot, where the chair now looks skewed – the right side is fine because it's just white background. Press C for the Crop Tool, zoom in using Ctrl and + and line up the bottom-left edge so you don't lose more than you have to before extending the crop around the picture. When you're happy, hit Return. »

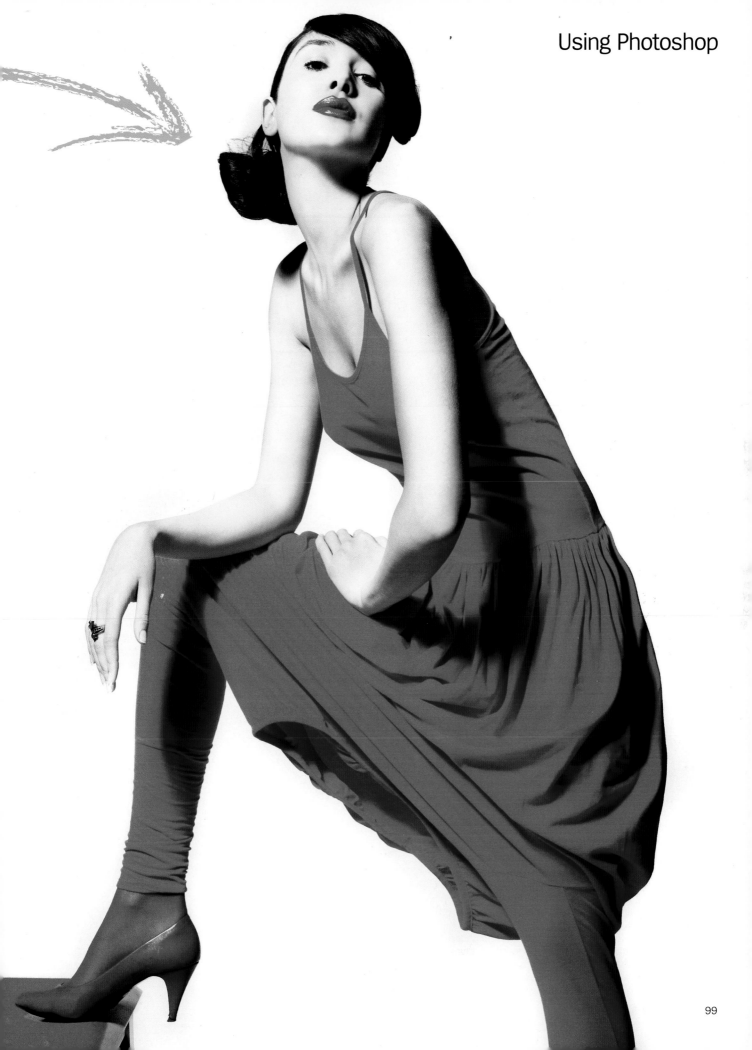

Using Photoshop

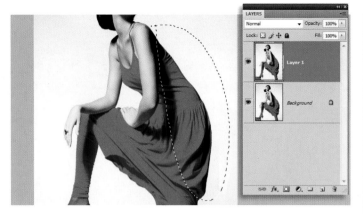

3 Select the rear
Next we'll slim down a part of the model's body. Switch to the Lasso Tool (L) and draw a rough selection freehand around her back and bum, as shown. Float this selection to a new layer by pressing Ctrl-J and then go to Filter > Liquify. Adjust the brush size until it's about one-sixth of the size of the selection.

4 Liquify the body
Now carefully work down the edge of the dress, using your mouse to drag inwards from the very edge of the clothing towards the body. Try to get the back looking straight and uniform, switching to a smaller brush to iron out little kinks if required. Hit Enter when you're happy.

5 Check the joins
Zoom in close to check that any reshaped fabric creases and patterns line up with any areas of the dress that we didn't liquify. You can blend those that don't by adding a layer mask, clicking it to target the mask and brushing over the join with a soft-edge black brush. Next zoom in to 200% and hold down to the spacebar to drag over to the face. Add a new layer (Layer > New > Layer).

6 Clean up the skin
Switch to the Spot Healing Brush (J), and make sure the tool is set to Sample All Layers in the options bar at the top. Now work around the face clicking on blemishes, using a brush size just slightly bigger than the blemish at hand in each case. Switch to the Clone Stamp Tool when near edges of the mouth and nose to avoid blurring the features. In the options bar, set the Sample menu to Current And Below.

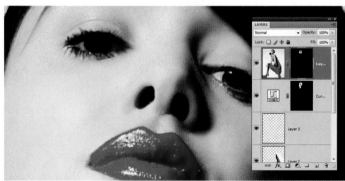

7 Smooth out rough areas
Add a Curves adjustment layer and drag a point in the shadows sector upwards to lighten the shadows on the skin. Click OK, target the layer's mask and press Ctrl-I to hide the effect. Tap D, then X if need be to set the foreground colour set to white, and use a soft brush to paint over the neck to lighten the shadows. To smooth the skin a touch, target Layer 3, then press Ctrl-Alt-Shift-E to create a new layer that merges all of the existing layers. Go to Filter > Blur > Gaussian Blur and set Radius to 3 pixels. Hit OK, then add a mask to this layer by clicking the "Add layer mask" button at the foot of the Layers palette.

8 Paint in this smoothing
To turn the mask black and hence mask out your new blurred layer, click the mask thumbnail to target the mask and then press Ctrl-I. Now tap X if need be to set the foreground colour to white. Using a soft-edged brush of around 50 pixels in size, paint onto areas of the skin that look a little rough, to effectively cut a hole in the black mask and reveal the smoothed skin, avoiding facial features or areas of detail.

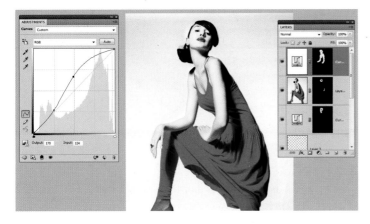

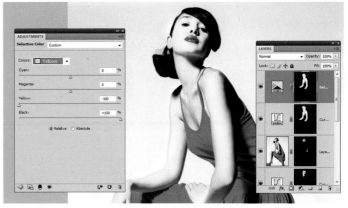

9 Lighten the skin

We want to tone down the model's tan too, so add another Curves adjustment layer, then reshape the curve roughly as shown above. Click OK, target the mask and then press Ctrl-I to conceal this adjustment. With the foreground colour set to white, use a soft-edged brush to paint over the skin, cutting a hole in the mask to apply the Curves adjustment to these areas. Avoid painting over the red dress!

10 Finish Adjusting skin colour

Holding down the Ctrl key, click the Curves layer's mask to load it as a selection. With the selection active, add a Selective Color adjustment layer: the layer's effect will be limited to the same areas. Choose Yellows from the dialog's Colors menu and set Yellow to −100% and Black to +100%. Click OK and save the image as a PSD to preserve all the layers so you can revisit them later if you want to tweak them. ◘

How our layers stack up...

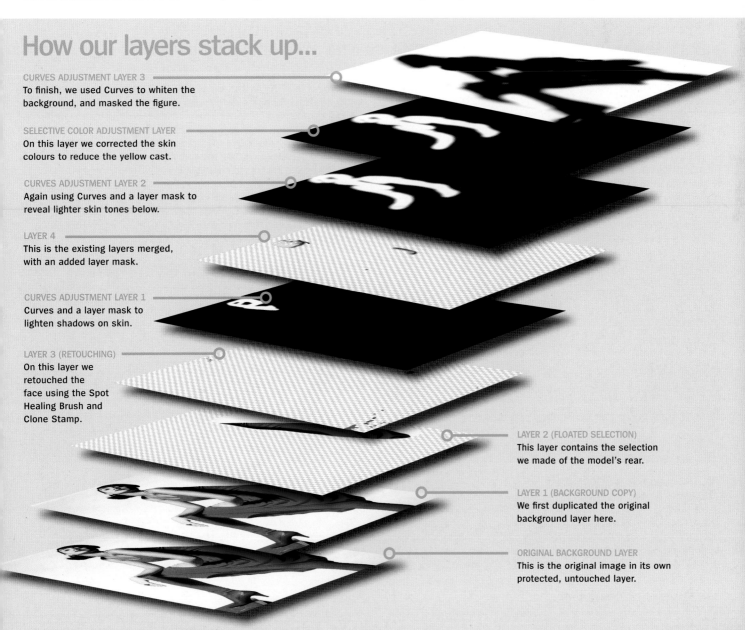

CURVES ADJUSTMENT LAYER 3
To finish, we used Curves to whiten the background, and masked the figure.

SELECTIVE COLOR ADJUSTMENT LAYER
On this layer we corrected the skin colours to reduce the yellow cast.

CURVES ADJUSTMENT LAYER 2
Again using Curves and a layer mask to reveal lighter skin tones below.

LAYER 4
This is the existing layers merged, with an added layer mask.

CURVES ADJUSTMENT LAYER 1
Curves and a layer mask to lighten shadows on skin.

LAYER 3 (RETOUCHING)
On this layer we retouched the face using the Spot Healing Brush and Clone Stamp.

LAYER 2 (FLOATED SELECTION)
This layer contains the selection we made of the model's rear.

LAYER 1 (BACKGROUND COPY)
We first duplicated the original background layer here.

ORIGINAL BACKGROUND LAYER
This is the original image in its own protected, untouched layer.

Chris George (Future)

Original shot

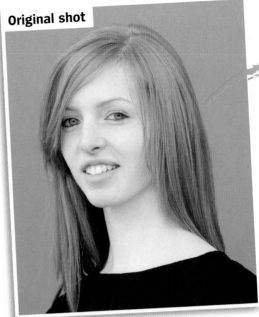

On the disc
Try it yourself!
Start image and
video on the DVD

How to...
Fast and
effective sharpening

If you want to give your images a really professional finish, try revealing
extra detail using Photoshop's Unsharp Mask filter. We show you how

WHAT YOU'LL NEED *Photoshop CS, Elements 5, or a newer version
of either program*
WHAT YOU'LL LEARN *How to reveal hidden detail, how to avoid adding
artifacts, how to give shots added impact*
IT ONLY TAKES *15 minutes*

**Sharpening is an essential Photoshop adjustment that, if done well,
is guaranteed to enhance your photos.** As well as providing a number
of automatic commands that spruce up colour and tone, Photoshop
also has an Auto Sharpen option, but this is better left alone. Photoshop
creates a sharper-looking shot by increasing the contrast along the
edges of features in your photograph. However, Auto Sharpen doesn't

take into account the size of your image, so it could make too large
or too little an adjustment, with disastrous results. To sharpen a shot
quickly and effectively, you need to be able to control the amount of
contrast adjustment and how far it extends, so that this matches the
image's pixel dimensions and resolution. You can do this quickly and
easily with Photoshop's simple yet effective Unsharp Mask filter.

However, there's an art to sharpening and it's important to take
care not to over-sharpen your pictures. Push the effect too far and you
run the risk of adding unwanted artifacts, such as blown-out highlights
and perceptible haloes that cling to the subject's outline. Here we'll
demonstrate a really simple way to ensure that you get it right every
time. Read on to find out more.

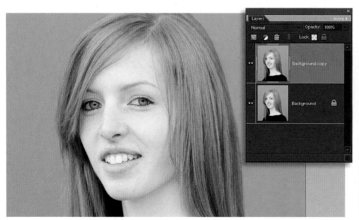

1 Start **Make a duplicate**
Open Sharpen_start.jpg from the Sharpen folder on your DVD.
Before editing, it's best to make a copy so that you can compare the
edited file with the original (or start again if things go wrong). To do this,
open the Layers palette (Window > Layers) and drag the Background
layer thumbnail onto the "Create a new layer" button. A new layer called
Background copy will appear at the top of the layer stack.

2 **Tweak the tones**
Our shot's contrast looks a little flat. To create a wider range of
tones, click the Background copy layer thumbnail to target it, and add a
Levels adjustment layer. The shadow pixels to the left of the histogram
don't stretch as far left as they could, indicating that the shot's
shadows are a little washed out. Pull the Black Point input slider to
about 13 to make the darkest shadows darker, then click OK. »

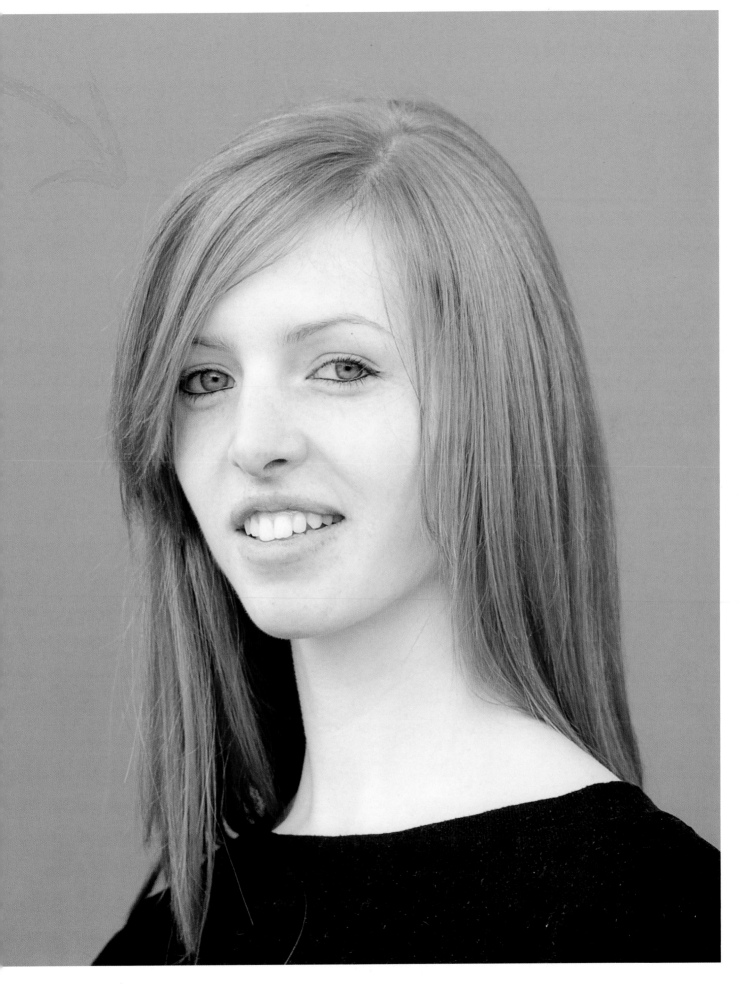

3 Try Auto Sharpen

Click the Background copy layer thumbnail. You can reveal more detail in the eyes by going to Filter > Sharpen > Sharpen in Photoshop or Enhance > Auto Sharpen in Elements. They'll now look sharper, but the Auto setting will also add extra grain, so you'll need to take manual control. To do this, first undo the adjustment we've just made.

5 Know your enemy

It's easy to ruin shots by over-sharpening. To recognise typical sharpening artifacts, move Amount to 120%, Radius to 7 pixels and Threshold to 0. Enable the Preview so you can see the effect of these changes. The contrast change has created dark haloes around the eyes, and highlights on the skin have also blown out, making it look blotchy. Hold down the Alt key and click the Reset button that appears.

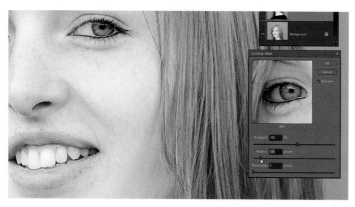

7 Increase Radius

Finer details, such as the eyelashes, already look sharper because of the increased contrast. But you can give these even more impact by increasing the spread of the tonal change. Drag the Radius slider to 1.8 to do this. For most shots it's best to stick to a maximum Radius of 2.0 pixels for natural results.

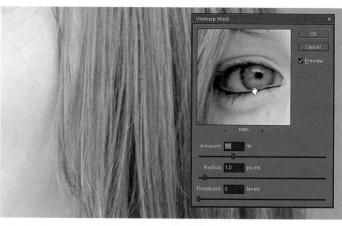

4 Before and after

Now go to Unsharp Mask in the same menu, move the square cursor over one of the model's eyes and click to centre the preview window on it. Click in the preview window and hold down the mouse button to see a "before" version. Let go to view the sharpened version.

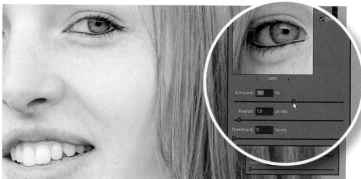

6 Adjust the Amount

Now move the Radius down to 1.0 pixels and Amount to 100%; leave the Threshold at 0 levels. This reveals finer details in delicate areas such as the eyelashes, but also shows a little grain around the whites of the model's eyes. You can target and reduce this unwanted noise later. For now, toggle the Preview on and off to see before-and-after versions of the entire sharpened shot.

8 Finish Use Threshold to tidy up

Unsharp Mask's Amount and Radius sliders perform a balancing act between revealing fine detail and creating unsightly haloes. The Threshold slider helps to fine-tune that balance. Our settings brought out picture noise in the whites of the eyes. A Threshold value of 3 reduces the strength of the other settings to preserve fine details and banish noise. Click OK to apply the changes. ◘

High Pass sharpening

Use filters and blending modes to take more control

Photoshop is well known for giving you multiple ways to achieve a given result, and true to form it provides you with a variety of different ways to sharpen your shots. The Unsharp Mask filter we've just looked at can be used to increase the contrast around details like the eyes and hair to create more impact. Here we'll show you another handy trick you can use to sharpen shots, combining the High Pass filter with layer blending modes. The High Pass filter is usually used for artistic effects, but it also enables you to pick out the edges you want to enhance. You can then limit the sharpening to these isolated edges and avoid sharpening skin or other areas of flat tone where noise would be exacerbated, keeping unwanted artifacts to a minimum. This trick enables you to sharpen more precisely and effectively.

1 Start Duplicate the layer
Open Sharpen_start.jpg and duplicate the Background layer as before. We'll use this duplicate layer to sharpen the layer beneath it. This time, though, instead of using a sharpening command, go to Filter > Other > High Pass and the duplicate image will turn grey – but you'll notice that some of the shot's edges will become visible.

2 Adjust the Radius
You can adjust the clarity of the edges with the filter's Radius slider. Don't go too far beyond 2 pixels or you risk adding dark haloes around the eyes and face when you apply the High Pass layer to the main image later on. Click OK. Now press Ctrl-Shift-U to desaturate the layer, turning it monochrome.

3 Change the blending bode
Click on the drop-down Blending Mode menu in the Layers palette and choose Overlay. This blending mode hides all of the neutral grey pixels in the High Pass filtered layer while leaving the fine edges around the face, eyes and hair visible. These edges give corresponding details on the layer below more impact and make the image look sharper.

4 Finish Fine-tune the effect
Click the High Pass layer's visibility eye icon to hide it, then click the box again to reveal it again and see the difference it makes. If the sharpening effect is too strong you can reduce the opacity of the High Pass layer to 90% to reveal more of the original layer. This performs a similar role to the Threshold slider in the Unsharp Mask dialog. 📷

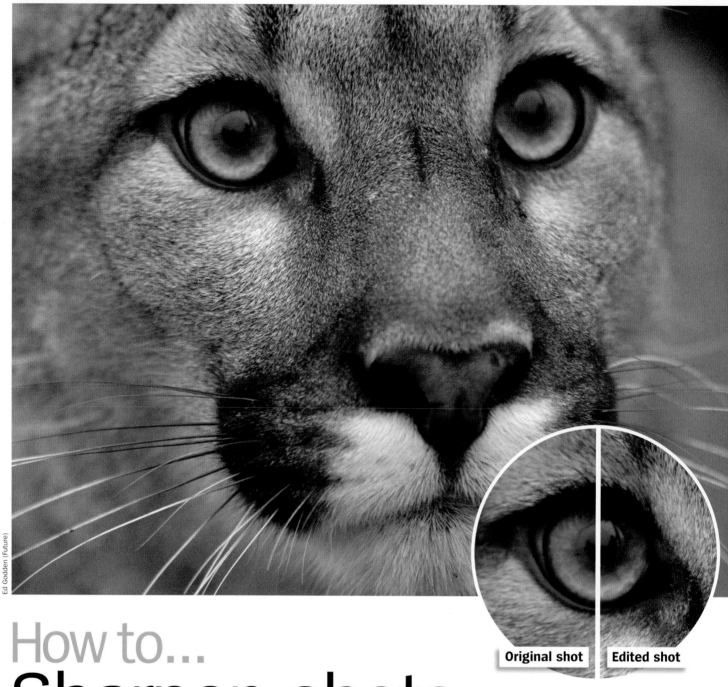

Ed Godden (Future)

Original shot | **Edited shot**

How to...
Sharpen shots the smart way

In addition to the well-established Unsharp Mask, Photoshop offers a more advanced sharpening option with the none-too-subtle name Smart Sharpen

WHAT YOU'LL NEED *Photoshop CS2 or newer*
WHAT YOU'LL LEARN *How to sharpen your photos using Smart Sharpen, how to use the dialog's options to target sharpening more accurately*
IT ONLY TAKES *15 minutes*

Unsharp Mask is still the best place to start when a shot is suffering from general "softness", especially if it's also noisy – the Threshold slider will help minimise the impact of sharpening on noise, and only Unsharp Mask has this slider. Here we'll look at the Smart Sharpen

alternative, which is designed to target specific types of blurring and, if used properly, can produce better results especially on shots that need sharpening because they're suffering from motion blur.

Elements' counterpart, Adjust Sharpness, offers the same basic controls but lacks the fine-tuning options under the Photoshop filter's Advanced tab (steps 4 and 5). You should always sharpen your shots last of all, after any colour correction and retouching work, because some edits can blur detail or conversely exacerbate noise, so it's only at the very end that you can tell how much sharpening is really needed.

1 Start Create a duplicate layer

Open Sharpen_Before.NEF from the Smart folder on your DVD. It's a Raw file, so will open in ACR. Make any necessary changes to the shot's contrast, then click Open Image to open it in Photoshop. Now duplicate the Background layer and go to Filter > Sharpen > Smart Sharpen.

2 Choose your Blur

You can choose to target Motion Blur to reduce the effects of camera shake – provided it's not too severe, this can be quite effective if you adjust the Angle to match the direction of the blurring. Lens Blur detects the edges and detail in an image, providing finer sharpening of detail. Gaussian Blur corrects contrast below a certain threshold that's become blurred; its effect is much like that of the Unsharp Mask filter.

3 Apply basic sharpening

Enable More Accurate. Adjust the Amount slider to 60% (any higher causes over-sharpening). This increases the contrast between edge pixels. Adjust the Radius to no higher than +1.3 pixels. This determines the number of pixels surrounding the edge pixels that are affected.

4 Add advanced sharpening

Click Advanced to adjust the degree of sharpening applied in the highlights and shadows separately – handy to prevent highlights being blown out or noise appearing in the shadows as a result of sharpening. Use the Tonal Width slider to control the range of tones modified. Lower values restrict the effect to the darker regions for shadow correction and the lighter regions for highlight correction. Use around 40%.

5 Fade Amount and Radius

These control how much the sharpening effect is reduced in either shadows or highlights and, confusingly, the radius used to determine whether a pixel is a highlight or a shadow (*not* the extent of the effect, like the previous Radius slider). Use them sparingly in conjunction with basic sharpening. Set Fade Amount to around 30% and keep Radius at +10 pixels. These controls help reduce haloes that may have appeared.

6 Finish Fine-tune the effect

Go back over the image and readjust the sliders as necessary to fine-tune the effect. Ensure the zoom is set to 100% – you can't judge sharpness at any other magnification because of on-screen anti-aliasing. If you plan to print the image, it will need a touch more sharpening than for viewing on-screen, because inkjet printing has a further softening effect. If the image has been over-sharpened, haloes will appear. ◘

Original shot

How to...
Enlarge a
small subject

Want to make a big print of a small photo? Here's all you need
to know about image resolution, resampling and enlargement

WHAT YOU'LL NEED *Any version of Photoshop or Elements*
WHAT YOU'LL LEARN *How to check whether your image will print at
adequate quality at the size you want; how to resample it using Image
Size if it won't*
IT ONLY TAKES *10 minutes*

**It's always fascinating to photograph small animals and insects – if
only they weren't quite so tiny.** Even with a macro lens, you're unlikely
to get a subject such as our spider to fill the frame, so you'll probably
want to crop your photo in the digital darkroom. Doing this, however,
means you're discarding part of the image, which may well become

a problem when you come to print. Cropping in tight on the spider in our
shot has left us with only around 900x750 pixels. Conventional wisdom
says that for photo-realistic quality you need to print at a resolution of at
least 240ppi (pixels per inch), which means our cropped image can't be
printed at bigger than about 4x3 inches. Even if we push it and print at
150ppi, we won't get bigger than about 5x4 inches without risking the
image becoming grainy, blocky or indistinct.

If you want to print a similarly hard-cropped photo at 10x8 or A4 size,
what you need is some way to enlarge the cropped photo for printing that
preserves its crispness and detail – some way of increasing the density
of pixels in the image. You need to not just enlarge but resample.

1 Start Crop to size
The Crop Tool gives you the option to specify Height, Width and Resolution for your crop. If you have a size in mind, feel free to enter it; this will constrain the crop frame to the correct proportions, even if you resize it. Draw the crop frame, drag a corner handle to resize it if need be, then drag within it to reposition it as desired.

2 Don't specify Resolution
However, leave the Resolution field blank, and *don't* select a preset size. Presets are based on resolution (in Photoshop, 300ppi) as well as size. If you pick one or enter a value in the Resolution field but there aren't enough pixels in the image, then Photoshop will interpolate (add pixels) to reach that resolution, but for more control, do this separately.

3 Test Image Size
Go to Image Size (in the Image menu in Photoshop or under Image > Resize in Elements). *Disable* the Resample Image option, set inches as the unit in the pop-up, and type in the print Width or Height you want (if Constrain Proportions is enabled, one will change with the other). You'll also see the Resolution figure change. If it's now below about 180ppi, you're spreading the image pixels too thinly for a crisp print.

4 Configure Resampling
Enable Resample Image, and pick Bicubic in the pop-up. (Ignore the others: Bicubic Smoother is *not* necessarily "best for enlargement" – the smoothing it adds can blur the fine detail in macro shots. Bicubic Sharper adds sharpening, which risks creating edge haloes.) Enable Constrain Proportions, specify a Width or Height and an adequate Resolution, and Photoshop will generate new pixels to plug the gaps.

5 Finish Sharpen for output
The interpolated pixels are based on existing pixels – in an area of brown, for example, Photoshop will just add an average brown. The process cannot create new detail, so you can't enlarge beyond about 1.5x or 2x at most without the image becoming unacceptably indistinct and blurred. You'll also need to sharpen before printing. 📷

Expert tip
Play the percentages for better enlargements
If you need to resample, you might get better results if you stick to relatively even multiples of the image size, so try choosing "percent" in the units pop-up in the Image Size dialog and specifying not a new Width but "150 percent" or the nearest to what you want. If you're enlarging by a big factor, some experts recommend resizing in steps of 10 percent at a time – select "percent" in the pop-up units menu, enter 110, and repeat till the image reaches your desired size. Even if you're using resampling, though, enlarging too much will make the image become indistinct and blurred.

» Camera Raw

4

Want to get the best from your D-SLR and produce photos with much more depth and richer colour? Raw files are the answer! Here's our complete guide to using Camera Raw

Get to know...
Adobe Camera Raw

Raw files are like "digital negatives" containing all the tonal and colour detail captured by your camera, with no in-camera processing. Here's the lowdown on using Raw.

Today's digital cameras have remarkably good auto focus and auto exposure features, and using them can make it hard to take a bad photo. Taking a *great* photo, though, usually requires the photographer to take control. And yet, it's likely that you're letting the camera keep charge of certain key settings that can have just as much impact on the quality of the image you get as focus, aperture or shutter speed. If you've set your camera to save shots as JPEGs, then you're letting the camera's built-in, "one-size-fits-all" algorithms process the image data captured by the sensor. Even if you've set it to maximum quality, your camera is discarding most of that precious image information before you even get to see it.

JPEG limitations
The fact is, the JPEG file format simply isn't capable of recording all the information that your camera sensor captures. (In a nutshell, JPEGs can record only 256 levels of light intensity in each of the three colour channels, while your camera is detecting at least 4,096 levels per channel or more. If you set it to save shots as JPEGs, it's just throwing all that extra detail away.) If you want to take control and produce the best-quality images possible, you need to save your shots as Raw files. All digital SLRs and many quality compacts give you this option, though "Raw" isn't a single file type like JPEG – different camera makers (and often different models) use their own proprietary Raw formats, such as .CRW or .CR2 for Canon, .NEF for Nikon and .ORF for Olympus.

With all that extra data, Raw files are much bigger than JPEGs and therefore take longer to save, so shooting Raw is not the best option if you need to take a sequence of shots to capture fast-moving action. Another limitation is that you can't open Raw files directly in Photoshop

or Elements. Most camera makers supply their own Raw processing software optimised for their own cameras; or you can use the Adobe Camera Raw editor (ACR), a free plug-in which works with Photoshop/Elements and not only processes Raw files so you can open them but also gives you all the tools you need to perfect your shots' exposure, contrast and colour, plus sharpening, noise removal and much more.

The non-destructive advantage
As well as their greater tonal and colour detail, there's another benefit of Raw files: like "digital negatives", they can't be overwritten and remain untouched when you create images from them using ACR – when you click Open Image, ACR generates a *copy* of the image with your edits applied. This means you can even process the same file multiple times and produce different interpretations of the same original, like producing different prints from the same negative.

ACR's deceptively simple tools take advantage of Raw files' greater dynamic range and detail to deliver maximum image quality every time. ACR can also offer many subtle adjustments that can't be replicated in Photoshop/Elements – for example, you'll be hard-pressed to match the ACR White Balance slider's ability to fine-tune colour temperature, or the Recovery slider's ability to pull back highlights, or Fill Light's ability to rescue shadows, and many others. For this reason, ACR is a great first resource for adjusting the exposure or colour of JPEGs too – and it works non-destructively on them as well. You can make all your basic tonal and exposure adjustments in ACR, and more, then optionally open the image for printing or further work in Photoshop or Elements using features that ACR doesn't have, such as layers, masks or filters. Here's a quick introduction to the ACR tools and options. ◘

ACR's toolbar (ACR 5.4 under Photoshop)

TOP TIP!
Edit JPEGs in ACR
If you're running ACR under CS3, Elements 5 or a newer version of either program, you can edit your JPEGs and TIFFs in ACR: go to File > Open As (Open on a Mac), navigate to your image, then select Camera Raw (not Photoshop Raw) from the Open As menu (the Format menu on a Mac) and click Open. If you're using Bridge, you can also right-click the image and select Open in Camera Raw from the contextual menu.

The Zoom and Hand Tools work just like their counterparts in Photoshop and Elements, and the same shortcuts work too.

Localise edits using the Targeted Adjustment Tool (under CS4/5 only). ACR's Crop Tool works like its Photoshop/Elements counterpart.

The Spot Removal Tool is really only for eliminating small blemishes. The Red Eye Removal Tool does what it says.

Click the 'menu' icon to go to ACR's Preferences. Click the next two icons to rotate your image 90° anti-clockwise or clockwise.

The White Balance Tool offers a one-click fix for colour casts. Use the Color Sampler (in ACR under Photoshop only) to keep track of the colour values of specific points as you work.

Photo off-kilter? To level the shot, draw with the Straighten Tool along any line in the image that should be horizontal or vertical.

The Adjustment Brush and Graduated Filter (both CS4/5 only) also enable you to localise ACR adjustments.

Mark the currently selected image for deletion (Filmstrip mode only). The image won't be deleted until you click Done, Save or Open.

Get to know... the ACR editor

1 Filmstrip mode
Ctrl-click on multiple Raw files in Bridge, Elements' Organizer or the File > Open dialog, then open them all and they'll open in Filmstrip mode. Under Photoshop you can apply edits to one and then click Synchronize to apply some or all of those edits to the others highlighted in the filmstrip; under Elements, highlight them first and then make your edits to apply to all.

2 Mark for deletion
In Filmstrip mode, hit the Delete key to mark the highlighted shot for deletion; press it again to unmark it. All marked files will be deleted when you click Open, Save or Done. Click Cancel and no files will be deleted.

3 ACR toolbar
In addition to its slider controls, ACR has its own toolbar (see facing page), though which tools are included here varies between versions and you won't see all of them if you run ACR under Elements. Tools for making localised edits are available only under CS4/5; in other versions, ACR's edits affect the whole image (or to a specific range of tones throughout it).

4 Preview
Toggle the Preview on and off to view the image with and without the edits in the current tab. The button to the right of this toggles Full Screen mode on or off.

5 Histogram
The histogram displays the image's tonal range – see page 75. The little triangle buttons above the histogram enable ACR's clipping displays – click the left-hand one (or press U for "underexposed") to view shadow clipping or the right-hand one (or press O for "overexposed") to view highlight clipping.

6 Shooting information
EXIF (shooting) data is displayed here for Raw files and even for most JPEGs. To its left is a continuously updated readout of the colour beneath the cursor at every moment – use this to check colours in ACR under Elements, where you don't have the Color Sampler Tool.

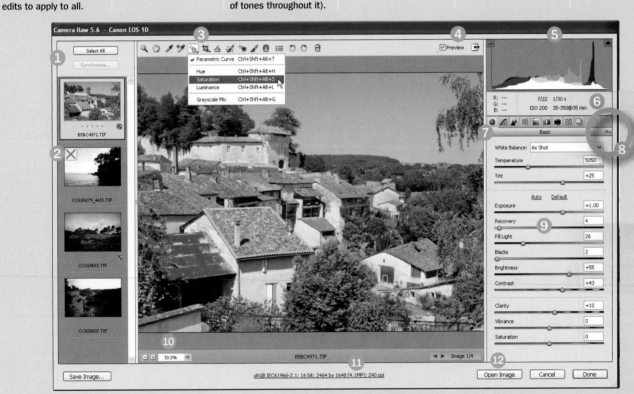

7 Tabbed interface
You make all the key adjustments in ACR using deceptively simple slider controls grouped under the tabs in this panel. Under both Photoshop and Elements, ACR has Basic, Detail and Camera Calibration tabs; the rest, which appear only if you run ACR under Photoshop, include advanced controls such as Tone Curve, Hue/Saturation/Lightness and others.

8 Settings menu
Click this little button to open the Settings menu, from which you can apply specific combinations of slider values at a click and switch between them quickly to try them out. You can revert the image to its untouched state or reapply the settings you used on the last Raw file you edited, among other options.

9 Slider controls
The Basic tab tonal sliders target parts of the tonal range: Recovery the highlights, Fill Light the shadows, Blacks the deepest shadows, and so on. As a rule, you'll work through them in order but revisit them as others have a knock-on effect. Double-click a slider to reset it to its default; click once to return it to the point where you click (so if you don't move your mouse, you can toggle one slider on and off in this way).

10 Zoom presets
Pick a preset zoom level from the pop-up menu at the foot of the image preview, or click the + and – buttons to jump between presets. For custom zoom levels, draw a marquee with the Zoom Tool around the area you want to view.

11 Workflow options
Click the link at the foot of the window to open the Workflow Options dialog: the settings here – bit depth, colour mode and so on – will apply to every image when you click Open Image. If you're running ACR under Elements, there's just a pop-up Depth menu here.

12 Finishing options
When you've processed and edited your Raw files, you can click Open Image to open a copy of the image (with your edits applied) for further work in Photoshop/Elements; Done to save the details of your edits but not open the image; Save Image to save a copy with a new name; or Cancel to abandon your edits. Hold down the Alt key for further options.

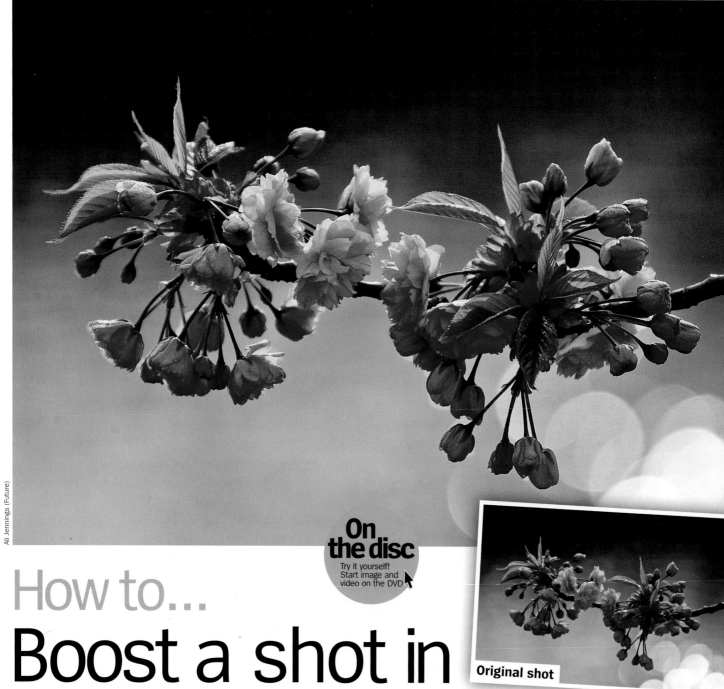

On the disc
Try it yourself!
Start image and
video on the DVD

Original shot

How to...
Boost a shot in
Adobe Camera Raw

We reveal how to use the powerful Camera Raw editor to gently
boost tone and colour without destroying the subtle details

WHAT YOU'LL NEED *Any version of Photoshop or Elements*
WHAT YOU'LL LEARN *How to boost colour, tone and contrast in the Adobe
Camera Raw editor*
IT ONLY TAKES *5 minutes*

**As we've mentioned, Raw files contain all the tonal and colour information
captured by your camera sensor, without any in-camera processing.** When
you first start working with Raw files, though, you might think they're a little
disappointing. They might not look as crisp, bright and colourful as the JPEGs
you're used to. That's quite likely, because the in-camera processing that
produces JPEGs almost invariably involves sharpening, boosting colour and

pumping up the contrast. With a Raw file, you have to do these things yourself –
and though some default adjustments (the Camera Raw Defaults settings) are
applied when you first open a Raw file in ACR, these are very mild compared with
the much more brash and brassy settings typically applied to JPEGs.

The good news is that there's much more tone and colour hiding within your
Raw files to be brought out, and ACR makes it delightfully easy. It has everything
you need, and in this tutorial we'll show you how easy it is to get the very best
out of your shots in ACR. You'll learn how to boost the colour, tone and contrast
of a seasonal flower shot, before recovering the apparently burnt-out highlights,
reducing the noise and even applying some basic sharpening to enhance the
flower's delicate detail. Read on to find out how it's done.

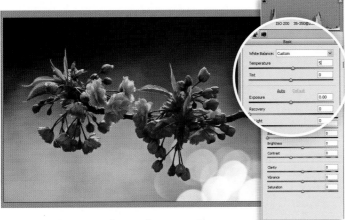

1 Start Correct the colour cast

Open RAW_before.dng from the Boost folder on your DVD. As a Raw file, it will open in ACR. Correcting the colour cast with ACR's White Balance tool is tricky with this shot, because there aren't any obviously neutral areas to click on. Instead, use the manual Temperature slider: moving it to 5 will remove the slight blue cast and warm the image up.

2 Recover the highlights

Switch on the shadow and highlight clipping warnings by tapping U and O respectively. A blue overlay will appear over any small patches of underexposure, and a red overlay in overexposed spots. Move the Exposure slider to –0.80 and the Recovery slider to 55. The amount of highlight clipping should now be reduced.

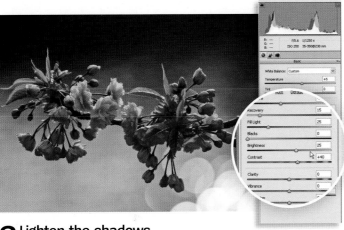

3 Lighten the shadows

To boost the delicate detail in the flower's petals, lighten these areas by bumping the Fill Light slider up to 25. Next, set Brightness to 25 and Contrast to +40. Although you'll see that these adjustments have lightened the darker details, they've also left the whole image looking a little flat. This is easily fixed...

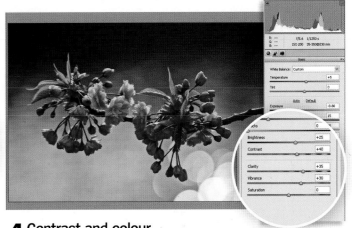

4 Contrast and colour

To gently boost the contrast and help to bring out the definition in the petals, increase the Clarity slider to 35. You can use the Vibrance slider to gently boost the overall colours. Vibrance is better than Saturation in this situation, because it will leave already-saturated colours untouched. Move Vibrance to 30.

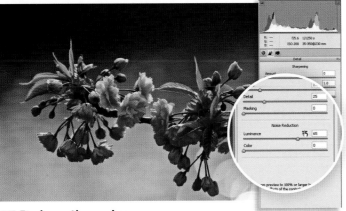

5 Reduce the noise

The main adjustments to the image are now done, and you'll see a noticeable improvement to the image as a whole. However, you'll also notice that your changes have introduced unwanted noise into the flat tones of the background. To reduce this, click on the Detail tab and push the Luminance noise reduction slider to 65.

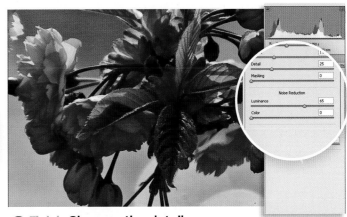

6 Finish Sharpen the details

To sharpen the image, zoom the preview in to 100% using the drop-down menu at the bottom left of the ACR preview screen. Now push the sharpening Amount to 65 and Radius to 1.2. To finish, click Open Image to open the shot in Photoshop/Elements, go to File > Save and save the processed image in the format of your choice. ◘

Camera Raw

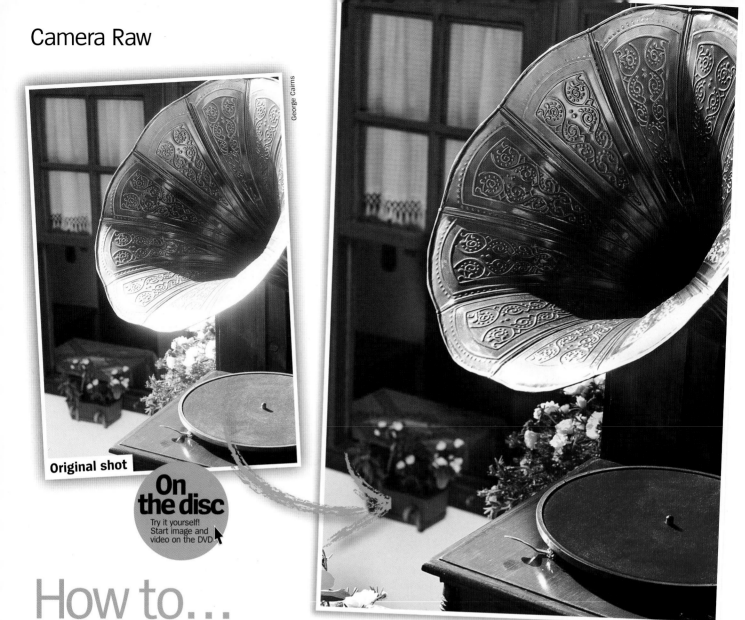

George Cairns

Original shot

On the disc
Try it yourself!
Start image and
video on the DVD

How to...
Make selective tonal adjustments in ACR

Thanks to Adobe Camera Raw's new Adjustment Brush, you can target
and improve specific areas in your photos without switching to Photoshop

WHAT YOU'LL NEED *Photoshop CS4 or CS5*
WHAT YOU'LL LEARN *How to "burn in" detail using the new Adjustment
Brush in ACR, how to make different tonal adjustments in different
areas, how to edit or undo your brush strokes using Pins*
IT ONLY TAKES *10 minutes*

On the DVD you'll find a Raw file named Adjustment brush_start.CR2.
The shot suffers from dramatically blown-out highlights – you can see
them on the gramophone horn's reflective metal surface. If you tried to
restore detail in the highlight areas simply by decreasing the exposure in
the usual way in Adobe Camera Raw, you'd underexpose the rest of the
shot. Instead, you need to make a targeted adjustment, altering only the
affected areas and leaving the rest of the image untouched.

To do this, you could open the Raw file in Photoshop or Elements'
standard editor and use the Burn Tool to selectively darken those blown-
out highlights. However, ACR's new Adjustment Brush (introduced in
version 5 of the Adobe Camera Raw editor if you run it under Photoshop
CS4 or CS5) means you can make all your image adjustments, both
global and selective, in one place.

Among other things, the Adjustment Brush gives you all the
functionality of Photoshop's Burn Tool, and can be used to target and
restore detail in our shot's blown-out highlights without making unwanted
exposure changes to the image as a whole. You can also tweak the
intensity of the tool's tonal adjustments with ease, and use masks to
fine-tune the edited areas until you're happy with the overall effect. Read
on to find out how it works...

1 Start Open the source file

Open the Raw file in the Brush folder on the DVD, then turn on the highlight clipping warning by tapping O. The red patches indicate blown-out highlights. Dragging Recovery to 100 fails to restore all the detail, and reducing Exposure to –1.95 underexposes most of the shot. Press Alt and click Reset. Reduce Exposure to –0.25 and set Clarity to +80.

2 Set up the Adjustment Brush

Click on the Adjustment Brush icon. This opens up the Adjustment Brush panel, where you can configure both the brush and the adjustment it applies, such as Exposure and Saturation. Set Exposure to –2.00 and Size to 7. Next, give the brush a soft edge by setting Feather to 68, then set Flow to 50 and Density to 59. This will help to blend the corrected highlight details more effectively with their unedited surroundings.

3 Reveal the detail

Press Ctrl and the + key to zoom in on the gramophone's horn. Now brush over the clipped highlights; this will reduce the red clipping warning patches and reveal more highlight detail in the shot. To view the restored highlight details appearing as you brush, turn off the clipping warning. Try to avoid painting over any of the darker tones.

4 Modify your adjustment

Click on the Mask Overlay Color swatch at the foot of the Adjustment Brush panel and choose red. Click Color Indicates Affected Areas, then click OK. Move your cursor over the grey Pin icon that the Adjustment Brush has left in the image. The areas affected by the stroke now appear in red. You can darken the exposure adjustment further by dragging the Exposure slider down to –2.75.

5 Darken the shadows

Once these changes have been made, click on the New button in the Adjustment Brush panel and set Exposure to –2.80. Set Size to 20 and then paint over the horn's shadows to darken them. This creates a wider range of tones and makes the image look less flat. A new Pin appears, enabling you to fine-tune the selective shadow exposure at a later point independently of the highlight-altering brush strokes.

6 Finish Finishing touches

Click on New once more. Set Exposure to –3.10 and paint carefully over the turntable and the blown-out flowers just behind it to darken them. Click on the Zoom tool to leave the Adjustment Brush panel and return to the usual ACR interface. Here, move the Vibrance slider up to +55 to bring out the shot's striking colours and give it added impact. ◘

How to...
Make selective adjustments

Paul Grogan (Future)

How to fine-tune ACR's selective Adjustment Brush

In this start image, our subject is backlit, so the points of interest – the child and the cereal on the table – are underexposed. You could try boosting the Exposure slider's value, but this would also blow out the background highlights. As we saw on the previous page, ACR's selective Adjustment Brush (available if you're running ACR 5 or newer under CS4 or CS5) enables you to lighten the child's midtones without

altering the background highlights. It works much like the Dodge Tool in Photoshop's standard editor, but the advantage of targeting and tweaking exposure in Camera Raw is that you can undo or edit your changes at any time. We'll show you how to do this, and how to add and refine separate adjustments for different parts of the image, something you can't do in ACR under Elements or in earlier versions.

1 Start Open the start image
Open selective_start.CR2 from your DVD; it's a Raw file, so it will open in ACR. To turn the shot the right way up, click once on the Rotate Image 90° Counter Clockwise button. Now click the Adjustment Brush in the ACR toolbar. In the Adjustment Brush panel, configure the effect it will apply by setting Brightness to +120 and Contrast to +72.

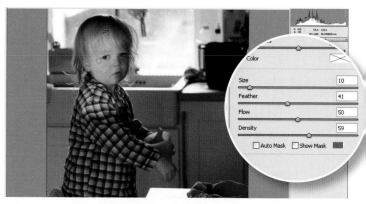

2 Set up the Adjustment Brush
To configure the brush itself, set colour to white, Size to 10, and Feather to 41 to give the brush a softer edge and ensure that the lightened areas blend in with the rest of the shot. Brush over the child to reveal more midtone detail. You can refine the effect by moving any of the sliders while the current adjustment is active.

3 Add a new adjustment
Now click the New button in the Adjustment Brush panel and set Brightness to +101 and Contrast to +53. Brush over the cereal to make it stand out from the rest of the scene. To remove the effect, click the Erase button and paint it out where it's not wanted. The Eraser will use the current brush settings; to change this, click the mini-menu icon at the top right of the panel and choose Separate Eraser Size, then set the Size, Feather, Flow and Density you want just for the Eraser.

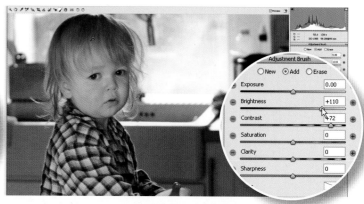

4 Finish Fine-tune the adjustments
You'll now see two Pin icons on the image, representing the two separate adjustments. You can fine-tune them separately. Click the Pin icon on the child. A red mask will show you which areas of the shot this particular adjustment affects. Drag the Brightness slider down to +100 to produce a more subtle effect. Press V if you want to hide the Pins to assess the image. To remove one adjustment, click its Pin to activate it, then press the Delete key. The other won't be affected. 📷

How to...
Update ACR

Download and install the latest version of the Adobe Camera Raw plug-in

The Adobe Camera Raw (ACR) editor is a plug-in – a separate "mini-application" that runs on top of Photoshop or Elements (or Bridge, if you opt to host it there). The ACR plug-in is updated from time to time in order to add support for the specific Raw file formats used in the latest camera models, and occasionally to add new features too, so it's well worth checking to make sure you're using the most recent version of ACR compatible with your version of Photoshop or Elements (see table below, correct as we go to press). This is particularly true if you buy a new camera, to ensure that you can open the Raw files it's giving you – but note that if you're still using an older version of Photoshop or

Elements, you might also need to upgrade the program to a newer version that can run the version of ACR required. (If you've bought a Canon EOS 550D [Digital Rebel T2i], for example, you'll need ACR 5.7 or newer, and ACR 5.7 won't run under anything older than Photoshop CS4 or Elements 8.) You'll find the ACR version number at the top of the main ACR screen (at the left of the title bar on a PC, in the middle on a Mac). As a rule, Photoshop and Elements use the same plug-in (though this seems to have changed with ACR 6.2), but you won't get all the features under Elements. Whatever version you use, though, the download and installation procedure is basically the same.

1 Start **Download the update**
Check our table for the newest version of ACR compatible with your version of Photoshop/Elements. If there's one newer than you're using, quit Photoshop/Elements and launch your Web browser. Go to www.adobe.com, select Updates from the Downloads menu, choose Camera Raw Windows or Mac as appropriate in the Product menu, and click Go. Read the details, click on Proceed to Download, then click Download Now. If given a choice to Open or Save, choose Open.

2 **Unzip the files**
Once the download is finished, a new window will open. Double-click on the Windows .exe file and choose Extract All. Now follow the Wizard, which will open the unzipped files in a new window (or on a Mac, open the .dmg). Next, go to My Computer, double-click on the C drive and navigate to Program Files (or on a Mac, your Applications folder) > Adobe > Photoshop (Elements) > Plug-Ins > FileFormats.

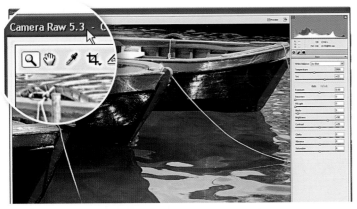

3 Finish **You're up-to-date!**
Drag the original Camera Raw plug-in icon from the FileFormats folder onto your Desktop (in case you ever need access to the older ACR editor) and then drag your newly downloaded Camera Raw plug-in file into the FileFormats folder. Relaunch Photoshop/Elements and open a Raw file. You'll now see the new version number at the top-left of the ACR editor window on a PC, or in the middle on a Mac. 📷

Photoshop / Elements version	Latest compatible ACR version
Photoshop CS5	6.2
Photoshop CS4	5.7
Photoshop CS3	4.6
Photoshop CS2	3.7
Elements 9	6.2 (for Elements)
Elements 8	6.2 (for Elements)
Elements 7	5.6
Elements 6	5.6
Elements 5 (Windows)	4.6
Elements 4.01 (Mac)	4.6
Elements 4 (Windows)	3.7

Chris George (Future)

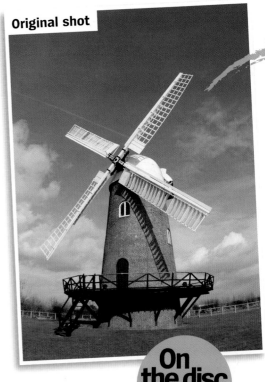

Original shot

On the disc
Try it yourself!
Start image and
video on the DVD

How to...
Tackle lens-
related problems

Correct the effects of vignetting and chromatic aberration in Adobe Camera Raw

WHAT YOU'LL NEED *Photoshop CS or newer*
WHAT YOU'LL LEARN *How to get rid of colour fringing in ACR, how to remove (or add) vignetting, how to counteract lens distortion*
IT ONLY TAKES *10 minutes*

Raw files contain much more tonal and colour detail than JPEGs, but they're not immune from lens-related flaws or artifacts. High-contrast objects (the white sails on our windmill, for example) can be affected by chromatic aberration – where red or cyan fringes appear along bright edges. This occurs when a lens fails to focus different wavelengths of

light on the same part of a camera's sensor. Shooting with wide-angle lenses can produce side-effects such as curved horizons or "barrelling" caused by lens distortion, as well as vignetting (dark areas in the corners of your shots), which occurs when the front edge of your lens (or filter) limits the amount of light entering the lens. Vignetting is most common at wide apertures in SLRs with full-frame sensors, and can be removed by lightening the corners in Photoshop (or added for creative effect by darkening them). Here we'll show you how to banish each of these common artifacts using ACR and Photoshop's Lens Correction filter, plus how to add a touch of vignetting to creatively frame your shots.

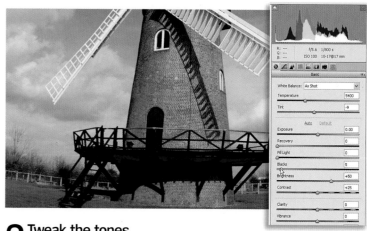

1 Start Getting started
Open raw_start.CR2 from the Lens folder on your DVD in Photoshop. It's a Raw file, so it will open in the Adobe Camera Raw (ACR) editor. As well as lens-induced barrelling and colour fringes along the edges of the windmill's sails, you'll notice that the shot tilts a little to the right, so there's plenty of work to be done.

2 Tweak the tones
The histogram reveals a broad spread of shadows, midtones and highlights, so the shot's exposure is relatively healthy. Click the shadow clipping warning button (the white arrow) at the top-left of the histogram and the darkest parts of the shot will appear as blue patches. To reveal a little more detail in these areas, drag the Blacks slider to about 2. »

3 Level the shot

The windmill is tilting slightly to the right. Click the Straighten Tool in the toolbar and use it to draw a line along the windmill's horizontal wooden rail. This tells Photoshop which features should run parallel with the bottom edge of the frame. A rotated crop box will appear. Drag the crop handles in a little to lose some of the curved fence and sky.

4 Chromatic aberration

Switch to the Zoom tool in the toolbar and click a few times on the top-right sail to zoom in to 300%. You'll see that there's a fringe of red clinging to the top edges of the white struts. This example of chromatic aberration is quite subtle, but it would still be enough for the file to be rejected if you submitted it to a stock photo library.

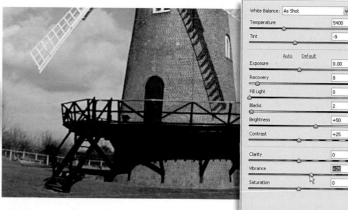

5 Remove the fringe

Click on the Lens Corrections tab, then drag the Fix Red/Cyan Fringe slider left to a value of around –22. This erases the red fringe, leaving a clean, white wooden sail. Zoom out to see the entire shot. You could use the Lens Vignetting slider to darken the corners, but since we're going to crop the edges when we remove the barrelling, we'll add a vignette later.

6 Tweak the colours

To create richer-looking blues and greens, click on the Basic tab and push the Vibrance slider up to +25. If you're running ACR under CS3, Elements 6 or older, you won't see the levelled horizon; to do that you need to open the edited image in Photoshop, which also has the tools you need to banish the barrelling at the bottom of the image.

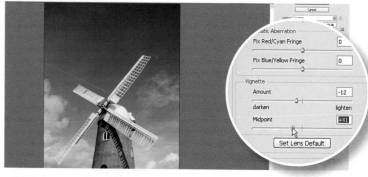

7 Banish the barrelling

Click Open Image to view it in Photoshop. Go to Filter > Distort > Lens Correction and a grey grid will appear. This will help you straighten out the curved horizon. Move the Remove Distortion slider to +23.00 to reduce the barrelling, then drag the Scale slider to 119% to lose the transparent edges produced by the lens correction procedure.

8 Finish Add a vignette

The horizontal distortion has been eliminated. This image doesn't suffer from unwanted vignetting, but you can add a vignette to give texture to a bland blue sky and help draw attention to your subject. Drag Vignette Amount to –12 and push the effect to the corner edges by changing Midpoint to +41. Click OK and you're done. (Under CS4/5 there are Post Crop Vignetting sliders you can use to add a vignette in ACR, but correcting the barrelling afterwards will distort the effect.) ◘

How to...
Blend two versions of a single Raw file

Combine two exposures of the same image to reveal shadow detail

Deep shadows can be a frustrating problem when it comes to getting exposures spot-on. Particularly if you're shooting into the sun, the strong, dark shadows can leave your backlit subject underexposed. One solution is to expose for the subject, but this can result in an overexposed background. Another is to add a quick burst of fill-flash to lighten the darkest shadows without blowing out any highlights in the

background. But what if you forget to fire your flash, or you want to avoid the harsh light it can produce? Shooting Raw can capture enough detail in both highlight and shadow areas, but you need to bring them out separately. We'll show you how to combine two versions of the same shot, processed in ACR first to get the right exposure for the foreground and then once again to get it right for the background.

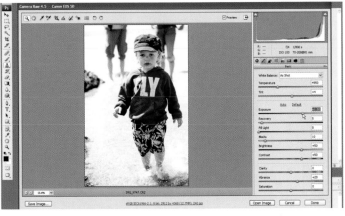

1 Start Lighten up!
Open Merge_start.cr2 from the Shadows folder on your DVD. The file will open in the Adobe Camera Raw editor. To adjust the image so that the toddler is correctly exposed, drag the Exposure slider to +1.5, the Recovery slider to 5, the Contrast slider to +50 and the Vibrance slider to +20. Ignore the background for now, and click Open Image.

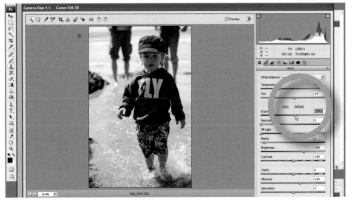

2 Brighten the background
Now open the Raw file again (if you're using Elements, you'll need to Save As and give the opened file a different name before you can do this). Click on Default in the panel on the right (circled) to restore the shot's default settings. To give the background a bright, summery feel, drag the Exposure slider to around +0.25. Keep the Vibrance slider at +20 and click on Open Image to open this version of the shot too.

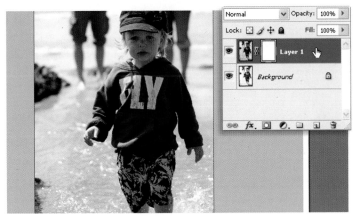

3 Combine the exposures
Next, go to Select > All, then Edit > Copy. Switch to the toddler exposure you opened in step 1 and then go to Edit > Paste. The background exposure will appear as a new layer on top. Make sure that the top layer is targeted, and add a mask to this layer. Tap D on your keyboard and then X if need be to set the foreground colour to black.

4 Finish Paint in the detail
Take the Brush Tool and configure a soft-edged brush of around 300 pixels. Set Opacity to 60% and Flow to 20%. Carefully paint over the toddler, starting with his face and hat, and then moving down. This will reveal the toddler from the layer below. If you go wrong, tap X to change the brush colour to white and paint the top version back in. ◖

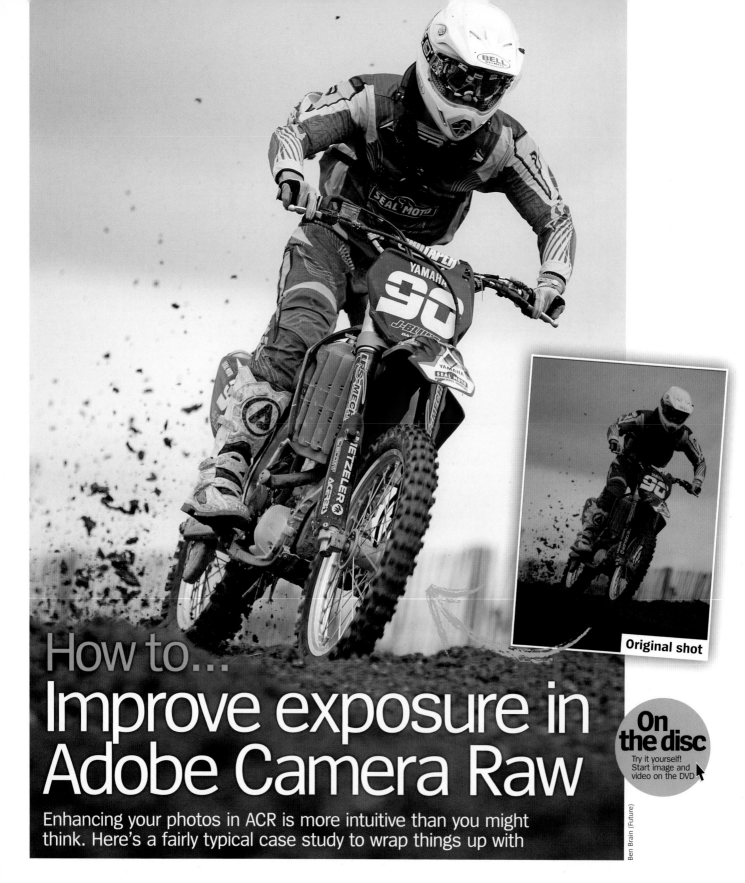

Original shot

Ben Brain (Future)

How to...
Improve exposure in Adobe Camera Raw

Enhancing your photos in ACR is more intuitive than you might think. Here's a fairly typical case study to wrap things up with

WHAT YOU'LL NEED *Any version of Photoshop or Elements*
WHAT YOU'LL LEARN *How to use ACR to tweak tone and boost colour and contrast, how to appraise your adjustments using the histogram*
IT ONLY TAKES *5 minutes*

Many people find the whole idea of shooting and editing in Raw a bit daunting. But once you get the hang of it, it's surprisingly intuitive. If anything, it's easier than using your standard image editor – partly

because the most important controls can be found in one simple interface and partly because Raw images contain so much more information than JPEGs. A Raw file contains every last scrap of colour and tonal information captured by your camera's sensor. This makes Raw files much more forgiving when it comes to fine-tuning exposure or boosting colour and contrast. In this concluding case study, we'll show you how to use the controls in ACR's Basic tab to tweak a shot's tones to perfection, and how to boost colour and contrast in a matter of seconds.

1 Start Evaluate the exposure

Open Exposure_before.dng from the Exposure folder on your DVD. It's a Raw file, so will open in Adobe Camera Raw. If you look at the histogram you'll see that the graph doesn't stretch all the way to the right, indicating our source file is underexposed and has no bright highlights. This is why the "white" of the helmet looks grey.

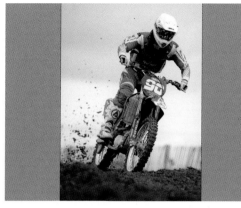

2 Tweak the tones

Press O to activate the highlight clipping warning, then drag the Exposure slider to the right until red patches appear on the helmet. Nudge the slider back to the left until they disappear. The shot now boasts a full range of shadows, midtones and highlights. Toggle the Preview on and off to see the change.

3 Boost the Blacks

Adjusting the exposure has shifted the histogram to the right and flattened it, weakening the shadows slightly. To deepen the shadows and improve contrast, press U to activate the shadow clipping warning too, then drag the Blacks slider to the right until blue patches start to appear. Now nudge it back to the left until they disappear.

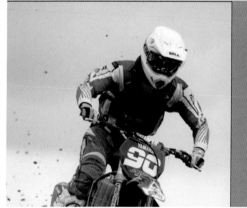

4 Brighten it up

To brighten the image and bring out detail in the shadows without losing all texture in the clouds, move the Brightness slider to +40. This works on the midtones rather than the shadows or highlights, so the tonal extremes should be unaffected. The contrast is already quite strong, so leave Contrast and Clarity as they are.

5 Correct the colours

The colours still look a bit flat, so drag Vibrance to +40 to boost the blues and browns and Saturation to +20 to boost reds and yellows. Vibrance affects only less-intense colours but Saturation boosts them all, even those that are already quite rich like the reds and yellows, so don't be tempted to go any further or the shot will start to look garish.

6 Finish Reveal shadow detail

As a final tweak, push the Fill Light slider to about +15 to reveal detail in the shadows without blowing out the highlights. Zoom in and scroll around the shot to check for areas of clipping or details that look flat – increasing the Clarity will boost midtone contrast and help offset the latter. Revisit the other sliders and tweak them as need be, keeping an eye on the histogram to judge the impact of your adjustments. ◘

» Black-and-White 5

The appeal of black-and-white is timeless, but a great mono picture isn't just a colour shot with the colour taken out. Here's how to produce really stunning mono images

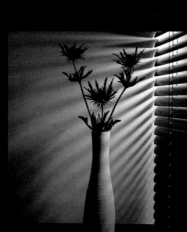

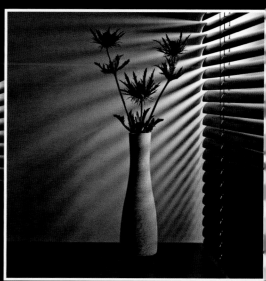

How to...
Go mono

On the disc
Try it yourself!
Start image and
video on the DVD

Transform colour photos into powerful black-and-white
images using our expert digital darkroom techniques

Unless you're using your Raw converter to
turn a colour image into black-and-white
(see overleaf), to get the benefits you must
first process your Raw images properly,
optimising exposure, brightness and
contrast and then saving as a colour TIFF.

You can then perform your mono conversion
inside Photoshop or Elements using one of
the options below. Sharpening can introduce
artifacts and colour noise reduction can
soften details, so these tweaks are best left
until just before you save ready to print.

Photoshop's Black & White dialog

The Channel Mixer (see overleaf) was once regarded as the ultimate
in mono conversion tools, but it has now been superseded by the
Black & White dialog, which offers a simpler, more intuitive and
more flexible way of working. It works by letting you independently
vary the luminance levels of eight individual colour ranges and

thereby control their influence in the final conversion. It's best to
use the Black & White dialog in the form of a non-destructive
adjustment layer (Layer > New Adjustment Layer > Black & White, or
click the "Add adjustment layer" button in the Layers palette and
pick Black & White) so you can tweak the adjustment afterwards.

WARNING!

Messing about with colour
channels without restraint can
quickly lead to serious image
quality issues such as haloes,
"blocking" and picture noise.
For this reason it's vitally
important to keep an eye
on your image at 100%
magnification when you
make changes.

1 Using the sliders
Dragging a colour slider from left to right
makes the grey tones of that colour range
darker or brighter. The strip above the slider
shows how light the tone will be.

2 Being more precise
Click within your image and drag to the
right or the left to lighten or darken those
tones. Click the Preset Options button to save
your greyscale mix to re-use on other images.

The Black & White conversion dialog

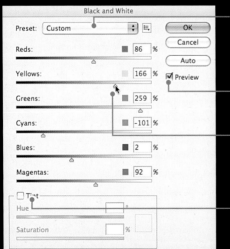

Photoshop offers ten ready-made
mono conversion recipes in the drop-
down Preset menu.

To reveal your image's original
colouring, toggle the Preview off.

You can adjust the colour sliders
manually or click-and-drag on the
image to adjust the slider for that
particular colour range.

Add a pro-style tint to your mono pics
– just click the Tint box, choose a
colour via the Hue slider and set the
intensity via the Saturation slider.

Black and White in Elements

Like Photoshop, Elements has a built-in
Black and White tool, and although it's lite
in comparison and can't be applied as an
adjustment layer, it's still a powerful asset.
To use it, go to Enhance > Convert to Black
and White. In the dialog you can select
from a set of preset conversions, use the
sliders to alter the channel mix, or both.

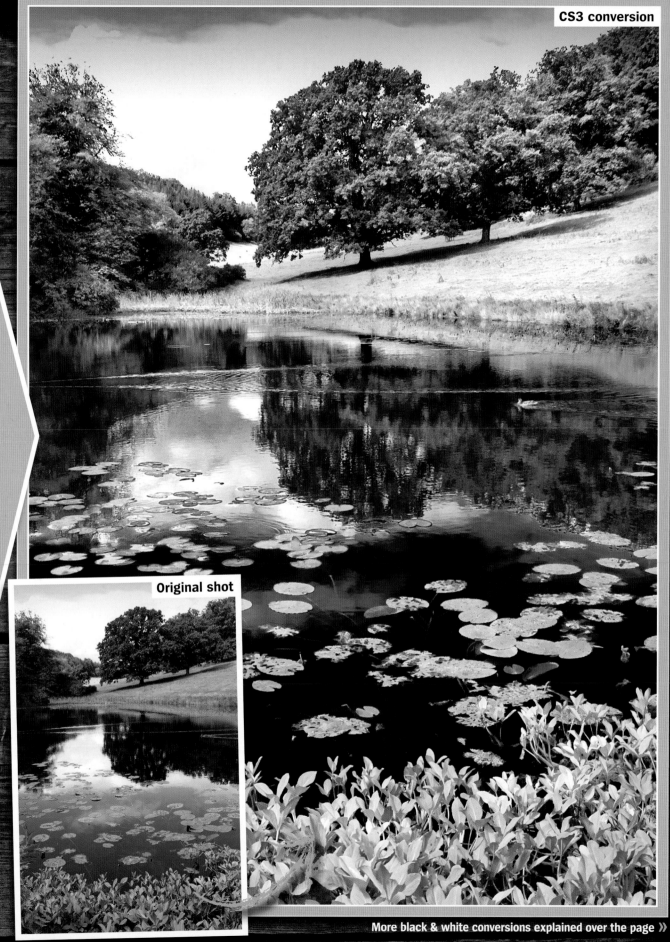

CS3 conversion

Original shot

More black & white conversions explained over the page »

Alternative conversion methods
Which one suits you?

There are many ways to skin a cat in Photoshop, and converting to mono is no exception. Here we examine eight more methods

On the disc
Try it yourself!
Start image and video on the DVD

Grayscale mode

Simply changing the Mode of your image from Color to Grayscale actually offers a pretty reasonable mono conversion. Click Image > Mode > Grayscale, then click OK when asked if you want to discard colour information. The problem is that you have no control over the result. Switching to Grayscale also blocks many adjustments and filters, and you need to convert back to RGB (Image > Mode > RGB Color) to use them again. If you're really pressed for time, though, this might be just the job.

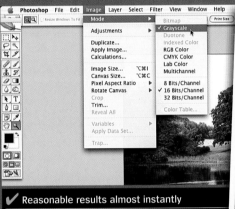

✔ Reasonable results almost instantly

✗ No control over result

Lab Color

This is another quick and easy conversion technique. Again there's no control, but it does generate a particularly light, airy and smooth-looking result that's well suited to delicate subjects and/or high-key or low-contrast treatments. In Photoshop only, choose Image > Mode > Lab Color. Now go to Window > Channels and click on the Lightness channel. To finish, go to Image > Mode > Grayscale and click OK.

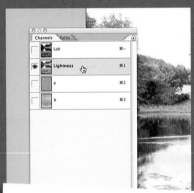

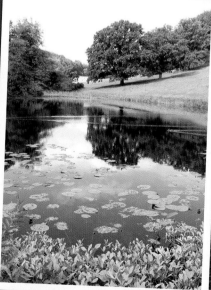

✔ Creates smooth, airy results quickly

✗ No control over result

Desaturation

Using Image > Adjustments > Desaturate (Enhance > Adjust Color > Remove Color in Elements) is just as fast, but the result is slightly rougher and again you have zero control. Desaturating using a Hue/Saturation adjustment layer, however, provides much more control and more pleasing results. First drag the Saturation slider to –100, then use the drop-down Edit menu to selectively adjust the Lightness of the Reds, Yellows, Greens, Cyans, Blues and Magentas to taste.

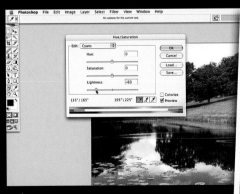

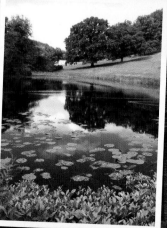

✔ Lightness control over individual channels

✗ Limited control compared with Camera Raw

Calculations

Photoshop's Calculations dialog (Image > Calculations) enables you blend two source channels to create a mono conversion. By default, the channel is set to Red and the blending mode to Multiply. It's worth experimenting with different combinations, but for non-portrait shots, this set-up plus a reduction in Opacity will usually produce the best results.

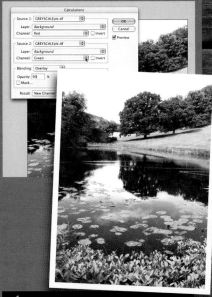

✔ A quick way to create dramatic results

✗ Limited number of conversion settings

Gradient Map

For harder, high-contrast results, try the Gradient Map. Click the "Add adjustment layer" button in the Layers palette and choose Gradient Map (not Gradient). Click the gradient preview in the dialog, then choose the Black,White preset and click OK. Refine the contrast by moving the Color Stop and Smoothness sliders.

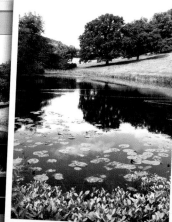

✔ Punchy results and fine-tuning available

✗ Best for mid to high contrast subjects only

Adobe Camera Raw: HSL/Grayscale

ACR's HSL/Grayscale tab (not available under Elements) is an powerful tool for converting to mono. Once you've primed your shot using the standard Camera Raw controls, click the HSL/Grayscale tab and choose Convert to Grayscale. You can then separate and enhance the individual tones using the eight Grayscale Mix colour controls, which alter the balance of channel information used in the mix.

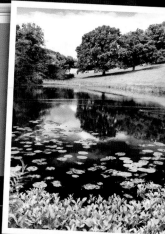

✔ Offers vast array of controls and effects

✗ Changes must be applied to entire image

Channel Mixer

The Channel Mixer is still a formidable option in Photoshop, allowing precise blending of the Red, Green and Blue channels to create a wide variety of mono effects. Go to Layer > New Adjustment Layer > Channel Mixer. Click the Monochrome box, then adjust the Source Channels sliders, ideally keeping the overall percentage total to around 100.

✔ Great control and good results

✗ Requires time and experimentation

Plug-ins

There are some fine plug-ins available that offer custom mono effects or replicate the look of classic mono film stocks, like Black & White Studio and Film Grain by Power Retouche. You could do much the same "by hand" – for example, you could track down grainy traditional 35mm films, scan them in and turn them into mono grain filters – but why do it the hard way? ◖

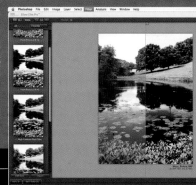

✔ Extensive new controls and effects

✗ Quality plug-ins don't come cheap

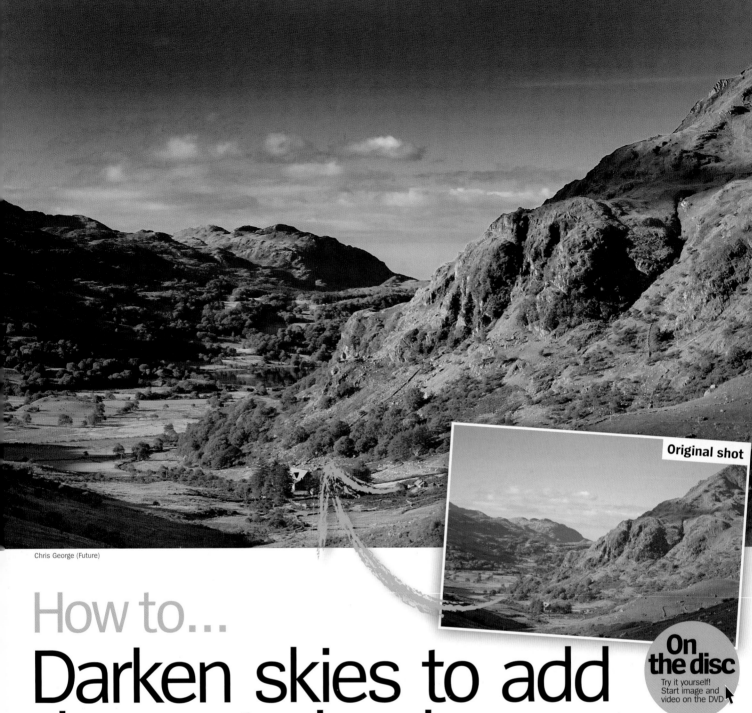

Chris George (Future)

Original shot

How to...
Darken skies to add drama to landscapes

On the disc
Try it yourself!
Start image and
video on the DVD

Photoshop's Black & White dialog enables you to get the brightness
of the land and the sky just right when converting shots to mono

WHAT YOU'LL NEED *Photoshop CS3 or newer*
WHAT YOU'LL LEARN *How to control tonal brightness when converting
to mono, how to take advantage of Black & White adjustment layers*
IT ONLY TAKES *10 minutes*

**As we've seen, there are lots of different ways to turn a colour photo
into a black and white one using Photoshop, but the Black & White
dialog in Photoshop CS3 and newer is the most powerful option for
creative custom conversions.** You can apply a Black & White
adjustment directly to the image itself, but it's much better practice to
apply it in the form of an adjustment layer. The controls and the end
result are exactly the same, but by using adjustment layers you have

much more scope to go back and refine your alterations at any
later stage in the process, because the adjustment doesn't alter
the underlying pixels in the original image.

Broadly speaking, the Black & White dialog's sliders enable you to
change the shade of grey that each colour in the image becomes. With
six different sliders available – controlling Reds, Greens and Blues, plus
Yellows (Reds + Greens), Cyans (Greens + Blues) and Magentas (Blues +
Reds) – you can be quite precise when controlling which areas are
lightened or darkened during the conversion. When you're working with
landscapes, this adjustment is brilliant for darkening blue skies while
simultaneously lightening the land to bring out detail in the foreground.
This is how it's done...

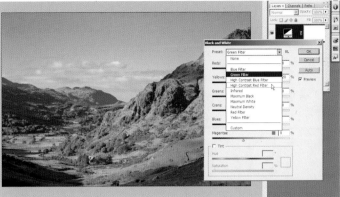

1 Start **Add your adjustment layer**
Open Dramatic_Skies_start.jpg in Photoshop CS3 or newer. Go to the Layers palette (tap the F7 key to show it if need be), click the "half-moon" button at the foot of the Layers palette, and choose Black & White from the list of adjustment layer types that appears.

2 **Pick a preset**
Click on the Preset menu at the top of the dialog, and try out each of the ten presets to see which does the best job at conversion for your scenic image. We chose High Contrast Red Filter as the best starting point for this shot of Snowdonia.

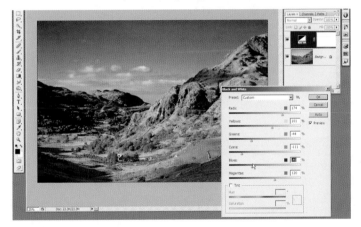

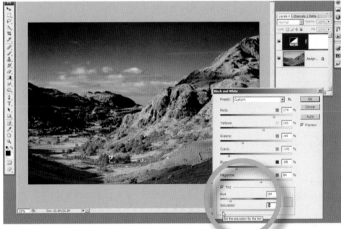

3 **Blacken the sky**
Adjust each of the sliders in turn. The Cyan and Blue sliders can be used to darken the sky, but the effects of some are less obvious – use the Yellow and Red sliders to brighten the rocky mountain slope. Push the sliders to extremes to see where they have an effect, and then set a sensible level for each one.

4 Finish **A subtle tint of sepia**
Add a toned effect by clicking the Tint box near the foot of the dialog and then adjusting the Hue and Saturation sliders to set a tint colour. Make sure the effect is subtle – a slight colour tone can help you achieve better results when printing to a colour inkjet printer. ◻

The Black & White adjustment dialog
Get to know the controls for customising your mono conversion

① **Presets**
The drop-down menu provides ten one-click options that dictate how your colour image is converted to shades of grey. The Green, Red and High Contrast Red options are the most useful for converting your landscape photos.

② **Colour sliders**
Use the sliders to manually adjust six different ranges of colour in the final mix. You can apply a Preset first and then refine it with the sliders.

③ **Personal presets**
You can save and reload your own presets. If you find a combination of slider settings you particularly like, save it for use in other shots.

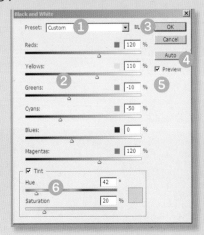

④ **Auto**
Clicking this button provides a fast, one-click conversion. The feature is worth a try, but the results are rarely as good as they'll be if you set the sliders yourself or use one of the Presets from the menu.

⑤ **Preview**
Click this on and off to toggle between your original colour image and the mono conversion.

⑥ **Tint**
Click the Tint box, then use the Hue and Saturation sliders (or click the swatch to open the Color Picker) to give your monochrome image a subtle colour wash, such as sepia.

On the disc
Try it yourself!
Start image and
video on the DVD

How to...
Get a classic mono look

Ever wanted to turn a plain colour landscape into an Ansel Adams mono masterpiece? Here's how!

WHAT YOU'LL NEED *Any version of Photoshop or Elements*
WHAT YOU'LL LEARN *How to create and apply that classic Ansel Adams black-and-white look to all your landscapes*
IT ONLY TAKES *20 minutes*

Undoubtedly the greatest 20th century master of black-and-white landscape photography is the legendary Ansel Adams. His classic style of beautifully exposed mono prints with a rich tonal range has been a source of inspiration for decades and become a benchmark for great landscape photography. Now you can apply Adams' style to all your landscapes.

To truly get the Ansel Adams look and re-create his "zone" system (see Expert Tip, page 139) you'd need to shoot large-format sheet film and process it using nasty, harmful chemicals. Fortunately, you can get very close by shooting digitally and using Photoshop/Elements, as we'll see. In the field, however, make sure you expose to retain the highlights in the scene – pay close attention to the sky – so that you'll have plenty of detail and pixel information to manipulate. Shoot bracketed Raw exposures.

Of course, Ansel Adams' other trademark was taking pin-sharp images front-to-back, so remember to shoot using the smallest aperture possible, such as f/22 – and who knows, you could become a 21st century master of mono landscapes.

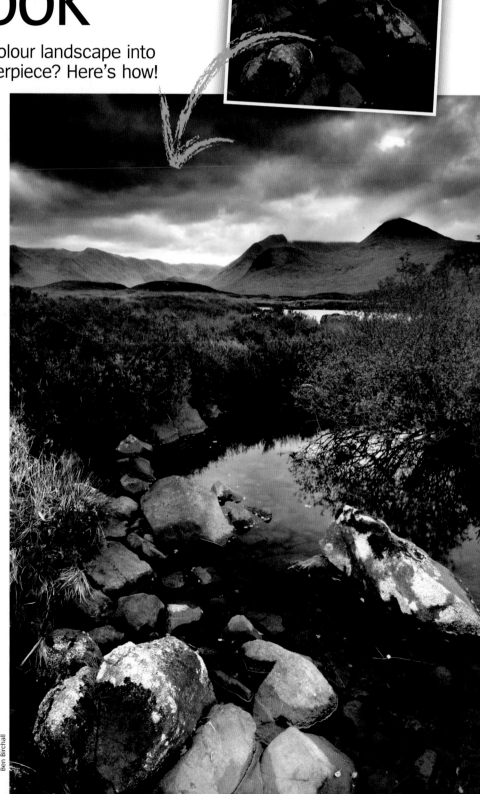

Original shot

Ben Birchall

Expert tip
Get the best from Raw

Before you can begin working your image in Photoshop, you'll need to process the Raw file using Adobe Camera Raw (ACR). But, rather than tweaking it to death using all that ACR has to offer, simply manipulate the Exposure, Fill Light and Recovery sliders to get the best histogram possible – that is, a histogram that isn't "cut off" at either the left or right edges, indicating that image information has become clipped at one or both ends of the tonal range. Tap U and O respectively to view the shadow and highlight clipping warnings, and adjust the tonal sliders until both warnings disappear (or at least are minimised as far as possible). It's okay to apply some sharpening, but avoid altering the colour values, and for this project leave the mono conversion process until Photoshop/Elements.

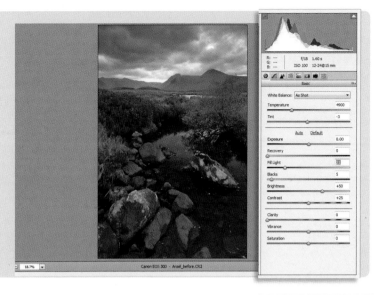

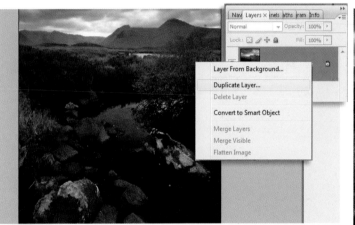

1 Start Layer up
Open Classicmono_Before.CR2, process it in ACR as above, then click Open Image to open it in Photoshop. Begin by duplicating the Background layer: right-click the Background layer thumbnail in the Layers palette, then choose Duplicate Layer from the menu.

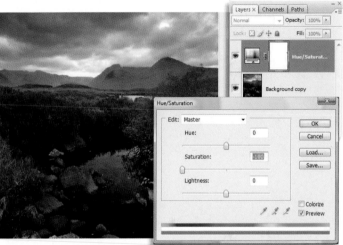

2 Lose the colour
Desaturate the image by adding a Hue/Saturation adjustment layer and dragging the Saturation slider all the way left to –100. This will preserve the underlying colour pixel information, which we'll need.

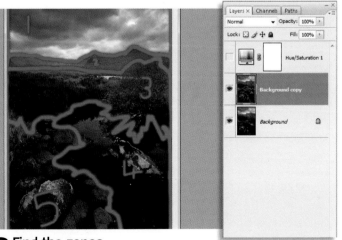

3 Find the zones
To work individually on each zone (see opposite), you'll need to split the image into imaginary areas of similar tones. Here we've decided that the photo has five areas that need to be worked on separately – the sky, distant mountains, water, bushes and rocks.

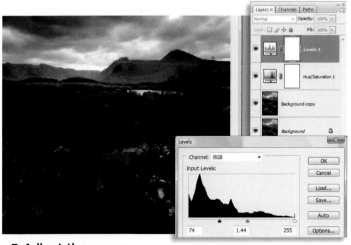

4 Adjust the zones
To work on the sky zone, add a Levels adjustment layer and drag the Black Point and White Point input sliders inwards until the sky looks dramatic, with the forms of the clouds really emphasised. Ignore the effect on the rest of the image for the time being.

Black-and-White

Expert tip
Replicate Adams' Zone system

Adams applied his Zone system to every aspect of his work from exposure in the field right through to developing and printing. It's based on a scale of 11 tones ranging from pure black to pure white. We can transfer his system to Photoshop fairly easily. Add a Curves adjustment layer in Photoshop and click the Curves Display Options box. Choose the option to display the grid with 10% increments. Each point where the curve line meets the grid intersections, as we've illustrated by placing edit points at right, represents a Zone. The bottom left-hand point is Zone 0, the next one up is Zone 1, and so on until the top right-hand point, which is Zone 10. Adjusting the curve between the Zone points, rather than the whole Curve line, alters the brightness of that Zone only, enabling finer tuning.

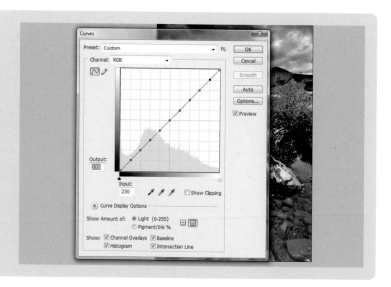

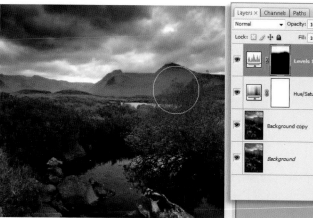

5 Mask the effect
To restore the rest of the image to normal while retaining the dramatic quality of the sky, switch to the Brush Tool, click the Levels layer's mask thumbnail, and paint with a large, soft black brush over the whole land area to mask the Levels layer and reveal the detail again.

6 Attack the next zone
Now click the Levels layer's visibility eye icon to hide it, so you can concentrate on the effect you'll apply to the next zone. Add another Levels adjustment layer and adjust the tones of the mountains, pulling both end point sliders in hard to really boost the contrast in this area.

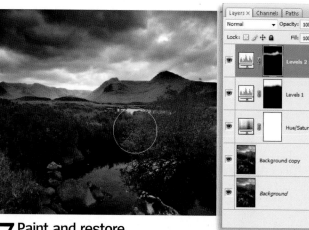

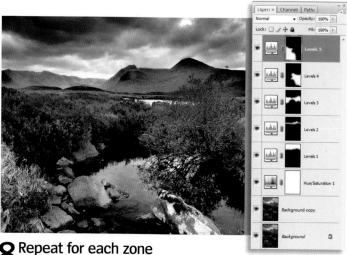

7 Paint and restore
As before, ignore the effect on the rest of the image until you're happy, then click the layer's mask and paint with black over the rest of the image, restoring the lost detail around the rocks, water, bushes and sky area. To assess the effect so far, restore the visibility of the sky layer by clicking once again in the box where its visibility eye was.

8 Repeat for each zone
Repeat the process by hiding the previous Levels adjustment layers and adding a new one for each zone in turn. At the end of the process, press Ctrl-Alt-Shift-E (Command-Option-Shift-E on a Mac) to create a new layer at the top of the stack incorporating all the other layers.

How to...
Dodge and Burn like a pro

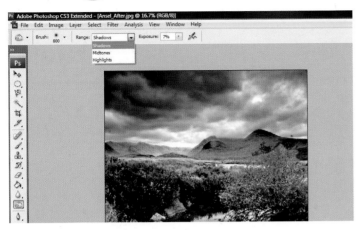

1 Brush and burn
Switch to the Burn Tool. Choose Shadows from the Range menu and set Exposure to around 7%. Make sure the brush is large and soft, then brush gently over the sky on the right-hand side to darken it.

2 Deepen the shadows
To deepen the shadows in the water in the foreground, increase the brush size to around 1,000. Make a few short, swift strokes over the water to increase the contrast in this area.

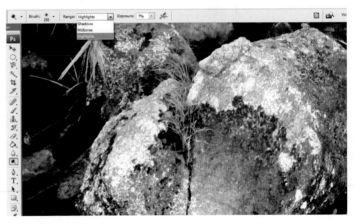

3 Dodge the midtones
To pull back and even-out the heavy tone around the bushes in the centre of the frame, we'll lighten the midtones. Switch to the Dodge Tool, set Range to Midtones, keep Exposure low and brush gently.

4 Finish Brighten the highlights
Finally, dodge a few highlights to increase overall contrast. Choose Highlights in the Range menu, and keep Exposure at 7%. Reduce brush size to 250 pixels and stroke over the naturally bright areas. ◘

Expert tip
The golden rule

Dodging and burning (selectively lightening and darkening respectively) is a simple process. The results can be stunning and even fantastical when applied creatively. However, there's one golden rule to observe: never dodge the shadows and never burn the highlights. Why? Technically, because pure shadow and highlight contain no detail, there's nothing to pull back or reveal. Creatively it will look terrible as highlights become muddy, grey, washed-out areas and shadows will become the same with horrible grey streaks. It's fine to dodge or burn midtones in an image, but the effects won't be as bold. Just burning shadows and dodging highlights will greatly improve contrast.

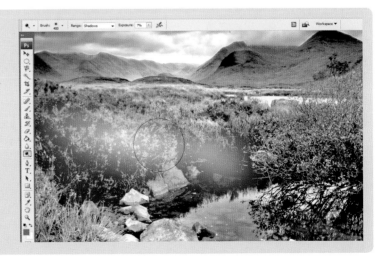

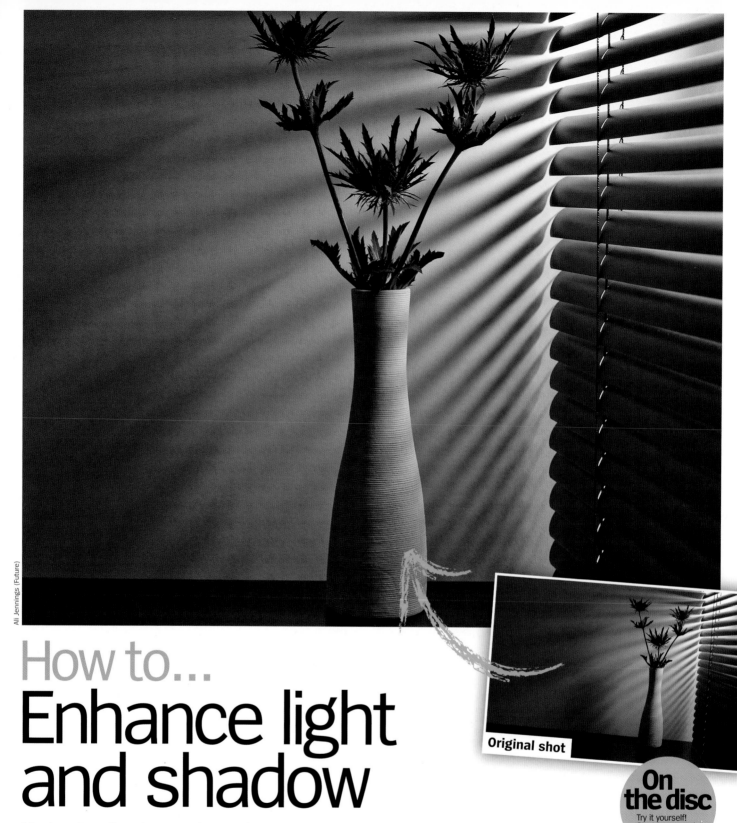

Ali Jennings (Future)

Original shot

How to...
Enhance light
and shadow

Understanding how colour relates to mono tones is key to getting good
black-and-whites. Here we reveal how to take control of your conversions

WHAT YOU'LL NEED *Any version of Photoshop or Elements*
WHAT YOU'LL LEARN *How to prepare colour images to enhance detail
in mono conversions*
IT ONLY TAKES *10 minutes*

**Converting colour photos to black-and-white is an art; it's all too
easy to make a quick conversion that looks fine on-screen but once
printed loses tone and detail.** When adjusting a colour Raw file, it's
important to remember that each colour directly relates to the lightness

or darkness of a greyscale tone. To see this, open a Raw file and pull the
Saturation slider in Adobe Camera Raw down to −100, then adjust the
Temperature and you'll instantly see areas lighten and darken. Knowing
how colours relate to a mono tone will help you get the conversion you
want. To make sure you have the maximum amount of detail in your
image, you also need to use basic tools in Camera Raw to create an
image packed with tones and with minimal clipping in the shadows and
highlights. Here we'll show you how to adjust your Raw file correctly to
eliminate lacklustre conversions, whatever method you use to convert.

138 **Photoshop for Photographers**

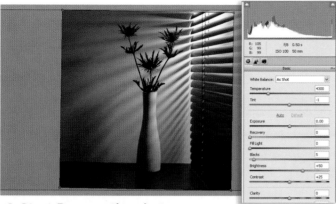

1 Start Re-crop the shot

Open StillLife_Before.dng from the Mono ACR folder on your DVD, and start off by recomposing the shot. Choose the Straighten Tool from ACR's toolbar and click-and-drag to draw a line across the top horizontal edge of the shelf. Now switch to the Crop Tool and, holding down the Shift key, draw a perfect square crop around the vase and thistle. Drag the crop box handles or click-and-drag the box itself to refine the crop.

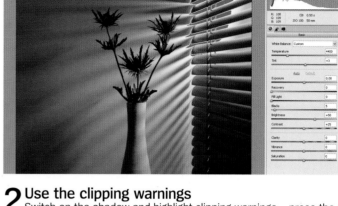

2 Use the clipping warnings

Switch on the shadow and highlight clipping warnings – press the U key for shadows and O for highlights. A red overlay will appear over any areas of clipped highlights, and a blue one over clipped shadows. Just to avoid colour complications, switch to the White Balance Tool and click with it on a colour-neutral area in the background.

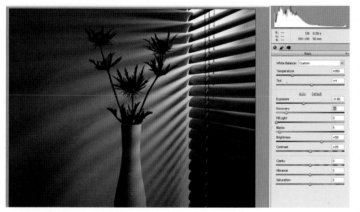

3 Remove the colour

Pull the Saturation slider at the foot of the Basic tab to –100. Next, move Exposure to –0.80. There will still be small dots of burnt-out highlights under the blind, but these shouldn't be an issue – push the Recovery slider to the right if needed to reduce these areas further.

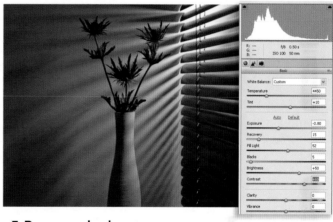

4 Recover shadows

Looking at the shadow areas, move Fill Light to 52, Brightness to 50 and Contrast to 60. You'll notice that the histogram is weighted to the left, but the bulk of the detail is moving towards the centre of the graph. However, neither the shadows nor highlights are clipped.

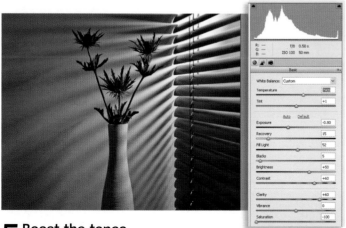

5 Boost the tones

To boost the tones, push the Clarity (midtone contrast) slider to 60. Now you can experiment with the colours' effect on the tones of the image by adjusting the Temperature and Tint sliders. Once you're happy with the result within Adobe Camera Raw, click Open Image to open the processed image into Photoshop/Elements.

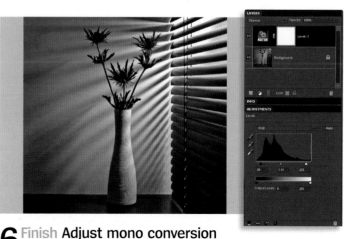

6 Finish Adjust mono conversion

Add a Levels adjustment layer. By using an adjustment layer, you have complete flexibility: if you want a high-key conversion, move both the Black Point and White Point sliders inwards to clip the histogram, then lighten or darken the conversion overall by moving the midtones slider to the right or left. 📷

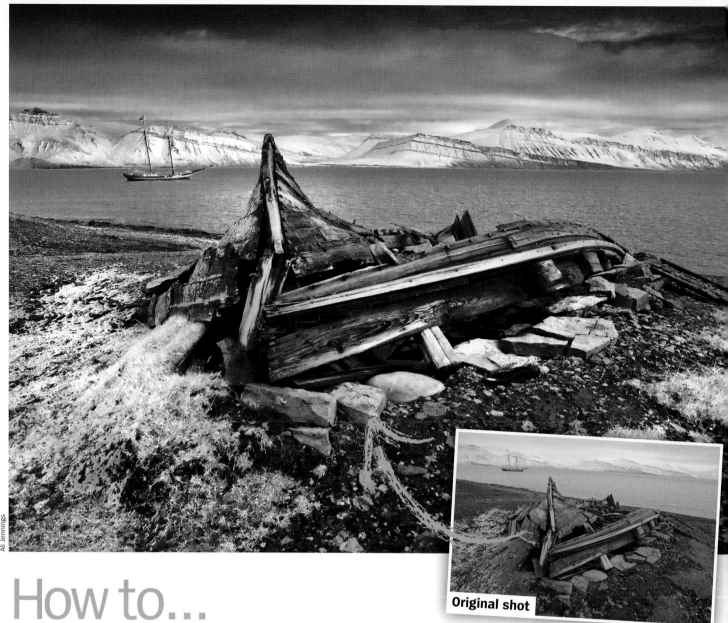

Ali Jennings

Original shot

How to...
Get better black-and-white in ACR

Discover how to use the powerful new mono conversion tools in ACR
running under CS4/5 to create a striking black-and-white landscape

WHAT YOU'LL NEED *Photoshop CS4 or CS5*
WHAT YOU'LL LEARN *How to make striking black-and-white conversions
using the tools in the latest versions of Adobe Camera Raw, how to
adjust tones locally in ACR under CS4/5*
IT ONLY TAKES *20 minutes*

Creating a mono image with real impact can be a challenge. If you
simply desaturate a shot you can end up with a bland wash of greyscale
colours and lose any distinctive shapes and textures that were proudly
visible in the original colour version.

However, thanks to the amazing localised adjustment tools in the
Adobe Camera Raw editor running under Photoshop CS4 or newer, you
can convert a shot to black-and-white and then lighten or darken specific

colours in the photo to make certain objects and textures stand out. The
controls in the HSL/Grayscale tab in ACR running under any version of
Photoshop enable you to drag colour sliders around to lighten or darken
specific colours in your image. This echoes the traditional technique of
placing coloured filters over the lens when shooting with black-and-white
film. For example, a red filter will darken blue skies and help make white
clouds stand out.

However, the latest tools enable you to do much more to alter the
tonal balance. We'll show you how ACR's new Targeted Adjustment Tool
can help you tweak the tones of specific areas, and demonstrate how to
lighten areas and emphasise certain features with the Adjustment Brush.
We'll finish off by using Tone Curves to create a more striking contrast
between black and white to really emphasise form and texture.

1 Start Brighten the highlights

Open CS4ACRMono_before.dng from the Mono CS4 folder on your DVD. You'll need to be running ACR under CS4 or CS5 to use the latest ACR features we're using here. You'll see that the histogram's brightest pixels don't reach the far right of the tonal scale, indicating that the image is slightly underexposed.

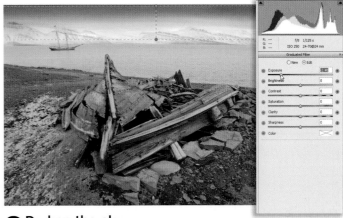

2 Darken the sky

To boost the highlights without affecting the shadows or midtones, drag the Exposure slider to the right to +40. Click on the Graduated Filter Tool icon (or press G). In the Graduated Filter panel, set Exposure to –2.40. Set everything else to 0. Click at the top of the image and draw a short vertical line downwards to gently darken the sky.

3 Make it mono

Click the Zoom tool icon to exit Graduated Filter mode. To convert the shot to mono, click on the HSL/Grayscale tab, click the Convert to Grayscale box, then move the Oranges slider to +100 to lighten the grass. Drag Reds to –50 to darken the distant boat and make it stand out. The contrast change enhances the shapes of different objects.

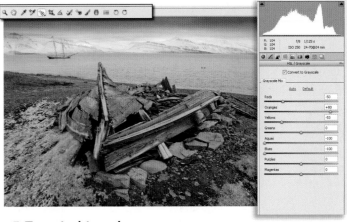

4 Targeted tweaks

Switch to the Targeted Adjustment tool. Click on a patch of dark soil, then drag the cursor left. The tool will sample the colours from the original shot and adjust the appropriate sliders to darken the sampled colours. Drag the tool to the left on the sea to darken that area too.

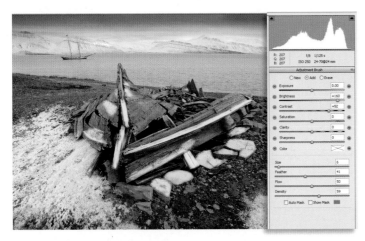

5 Selective adjustments

Click on the Basic tab, then press K to activate the Adjustment Brush. Set Brightness to +160, Contrast to +52, Size to 6 and Feather to 41. Brush over the plants to lighten them up a bit. Now reduce Size to 2 and brush again to lighten up the frosty patches on the boat.

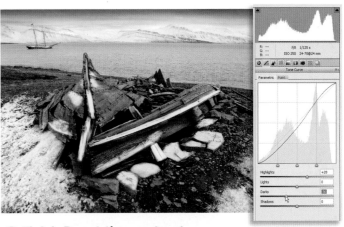

6 Finish Boost the contrast

Press the Z key to exit the Adjustment Brush mode. To widen the contrast between the dark and light areas, click on the Tone Curve tab. Drag Darks down to –30 to darken the boat and the terrain. Increase Highlights to +28 – the boosted contrast will really bring out the forms and textures in the image, making a much more striking scene. ◘

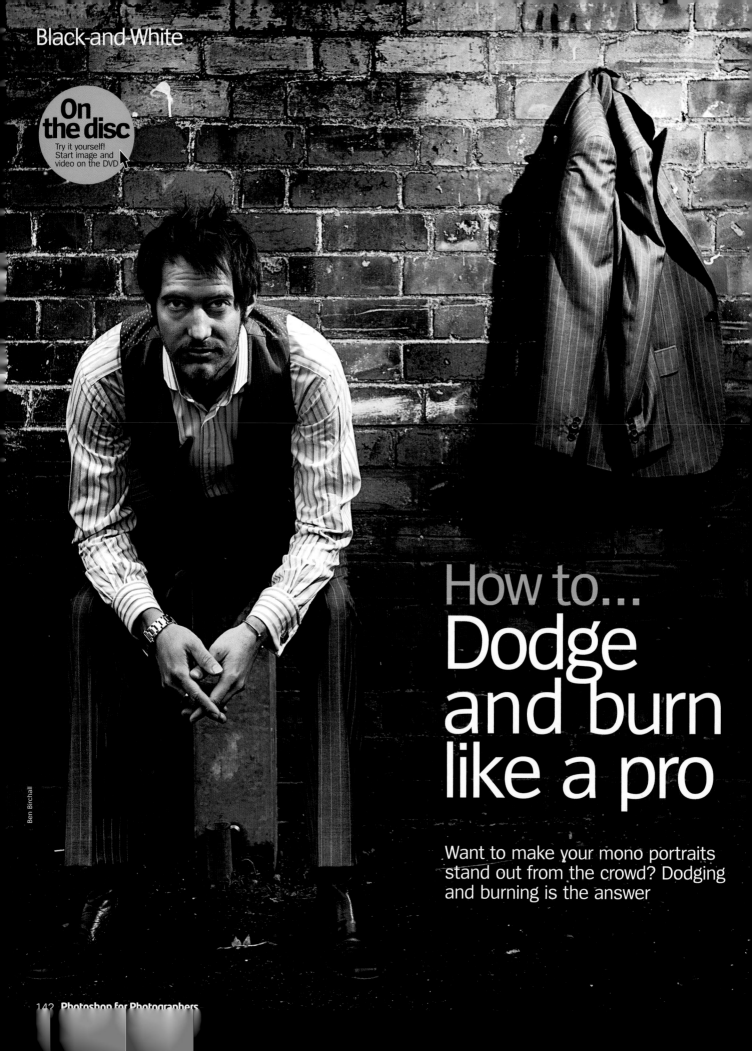

On
the disc
Try it yourself!
Start image and
video on the DVD

Ben Birchall

How to...
Dodge
and burn
like a pro

Want to make your mono portraits
stand out from the crowd? Dodging
and burning is the answer

As we've seen, the key to a great mono image is contrast and tonal depth. In traditional black-and-white prints, good-quality dodging and burning – selectively lightening and darkening areas respectively – was the secret weapon of any master printer. In this digital age of powerful software tools that can emulate (or sometimes even better) just about any traditional darkroom process, why should things be any different? Always finish off your mono images with a touch of dodging and burning.

Don't think of it as a rescue for poor exposure, but approach it with a view to enhancing your lighting and adding extra impact.

Remember that the Dodge and Burn Tools themselves are highly destructive of image quality if you overdo them, so it's a far better strategy to use adjustment layers to add your dodging and burning effects. There are plenty of methods out there, but here's a versatile method that works and feels very like the traditional tools in use.

Dodge and burn the non-destructive way

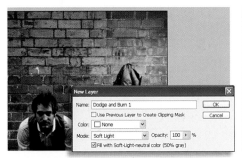

1 Start Create a grey Fill Layer
Go to Layer > New Layer or Alt-click the New layer button in the Layers palette. In the dialog choose Soft Light mode, click the "Fill with Soft-Light-neutral color" box and click OK.

2 Switch to the Brush Tool
Target the grey layer, tap B for the Brush Tool and set the brush to a suitable size. Set hardness to 0 and mode to Normal. Tap D to set the colours to the default black and white.

3 Finish Start painting
Use black to burn (darken) and white to dodge (lighten). Tap X to swap between black and white; change brush opacity for a weaker or stronger effect, starting around 20%. ◘

How we added impact
Boost contrast and bring out form and texture

① Midtones
This shot was exposed to preserve the midtones in the brickwork and clothing because the main contrast is provided by the face, shirt and jacket, drawing attention to them. We deepened the lower midtones in the bricks and brightened the highlights using the grey Fill Layer method described above.

② Highlights
We used a Curves adjustment layer to brighten the highlights across the whole of the image, then masked the layer's effect where it caused the highlights to become clipped.

③ Shadows
The natural shadows are mainly around the model, his jacket and the ground. True 100% black shadows were left alone, and the shadows around the jacket, brickwork and floor were darkened using a grey Fill Layer.

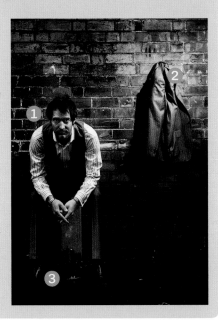

Alternative methods
Here are a couple more non-destructive approaches

It's satisfying to find a dodging and burning method that works for your photography; take a look at two more of our favourites below. Remember the golden rule of enhancing the existing lighting, so no dodging shadows to lighten them or burning-in clipped highlights!

1 Levels layers
Add two Levels adjustment layers: one for highlights with the sliders set to lighten and one for shadows that darkens. Click the mask thumbnail of each layer, press Ctrl-I to invert it to black and hide its effect, then paint in each effect with a soft white brush where wanted.

2 Color Range
Go to Select > Color Range and choose Highlights from the dialog's Select menu. Hit OK, feather the selection, then add a Levels layer to brighten those tones. Deselect, then repeat the process, selecting the shadows and darkening them. Tweak the midtones if needed.

✔ Greater contrast control and organic looking.

✘ Can be a convoluted process and easily overdone.

✔ Fast and simple without any brushwork.

✘ Can create harsh edges; no control over range selected.

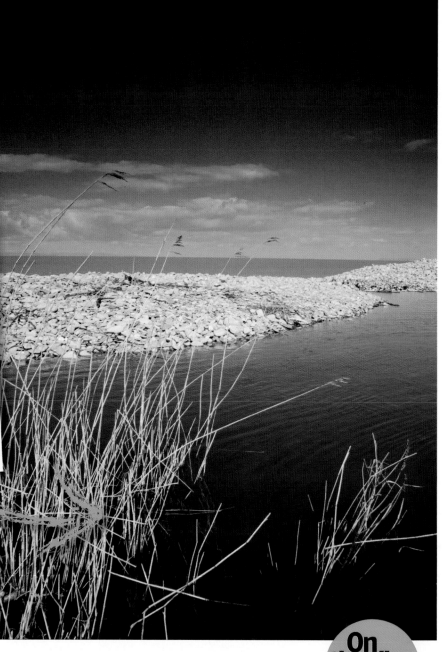

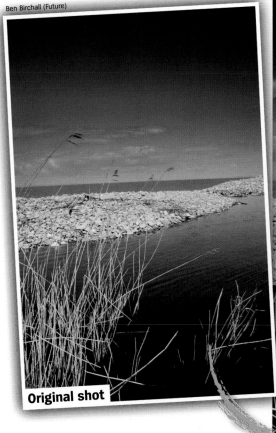

Ben Birchall (Future)

Original shot

How to...
Create a
two-tone landscape

On
the disc
Try it yourself!
Start image and
video on the DVD

Find out how to use Camera Raw's Split Toning tab to emphasise features
in a landscape, replacing the original colours with a striking split-tone effect

WHAT YOU'LL NEED *Photoshop CS3 or newer*
WHAT YOU'LL LEARN *How to increase contrast, how to use the Split Tone*
tab in ACR, how to fine-tune the tonal balance
IT ONLY TAKES *10 minutes*

**Well-composed landscape photos should feature a variety of different
tones and shapes that draw the eye in.** Take our unprocessed Raw
source file, for example. The foreground reeds at the left of the frame
lead your eye towards the narrow pebble beach, which in turn draws
your attention to the distant horizon. The shot has been framed to
create a balanced composition, with the horizon splitting the scene
into two halves – landscape and skyscape. This type of photo is perfect
for a creative split-tone makeover, because it already has a distinctive

contrasting tones and features. The warmly-lit reeds and pebbles
stand out against the cool blue sky and sea, presenting an attractive
mix of shapes and colours to enhance (rather than overpower) with a
split-tone effect.

In this tutorial we'll show you how to use the tools in Adobe Camera
Raw to increase the contrast between the land, sea and sky. You'll
then learn how to create a monochrome version of the image using the
powerful HSL/Grayscale tab controls. Once you've produced a striking
monochrome print, we'll show you how to use the Split Toning tab's
sliders to add separate washes of colour to the shot's highlights and
shadows. Although you can achieve this result in Photoshop/Elements
proper, Adobe Camera Raw enables you to produce this effect without
compromising your file's quality. Here's how it's done.

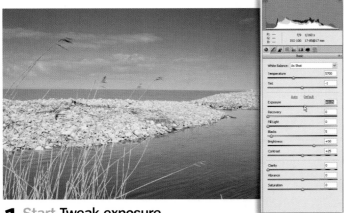

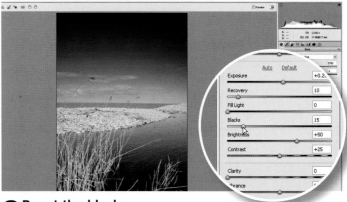

1 Start Tweak exposure

Open Raw_start.CR2 from the Mono Split folder on your DVD. Before changing the colours, you'll need to tweak the shot's tones and boost the contrast between its shadows and highlights. You can see from the histogram that the highlights could be stronger, so set the Exposure to +0.25 to brighten them up.

2 Boost the blacks

Move the Recovery slider to 10 to restore any highlights clipped in the last step. Now drag the Blacks slider to 17, making the shadows' darkest pixels darker without affecting the midtones or highlights. Our shot now has a distinctive contrast, which will give the Split Toning tools more to work with in the next step.

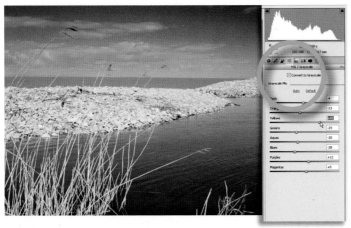

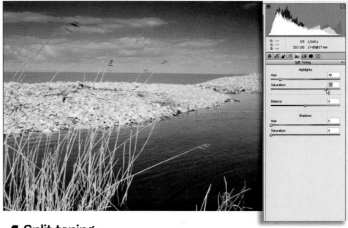

3 Make it mono

Now go to the HSL/Grayscale tab and click the Convert to Grayscale box to create a monochrome version of the landscape. Darken the blue sky and sea by dragging the Blues slider to –28. You can make the reds and pebbles stand out by dragging the Yellows slider to the right to +45.

4 Split toning

Now that you've brightened the pebbles and reeds, you can colorise the shadows and highlights separately to enhance different parts of the scene. Click the Split Toning tab, put the Highlights' Saturation up to 80 and drag the Hue slider to 48, turning the brightest pixels a warm sepia.

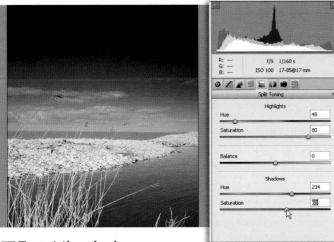

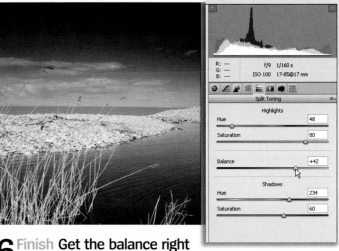

5 Target the shadows

Drag the Shadows Saturation slider up to 60 and tint the shot's shadows a rich dark blue by dragging the Shadows Hue slider to 234. This creates a pleasing contrast between the warm pebbles and reeds and the cold sea and sky. The colour and tonal contrast helps to emphasise the shapes in the scene.

6 Finish Get the balance right

The Balance slider helps you adjust the dominance of the two colours in the shot. The warm sepia landscape looks a little weak compared to the intensity of the brooding blue sky, so pull the Balance slider to the right to +42, spreading the sepia tones in the shot, and you're done – you now have an attractive split-tone landscape.

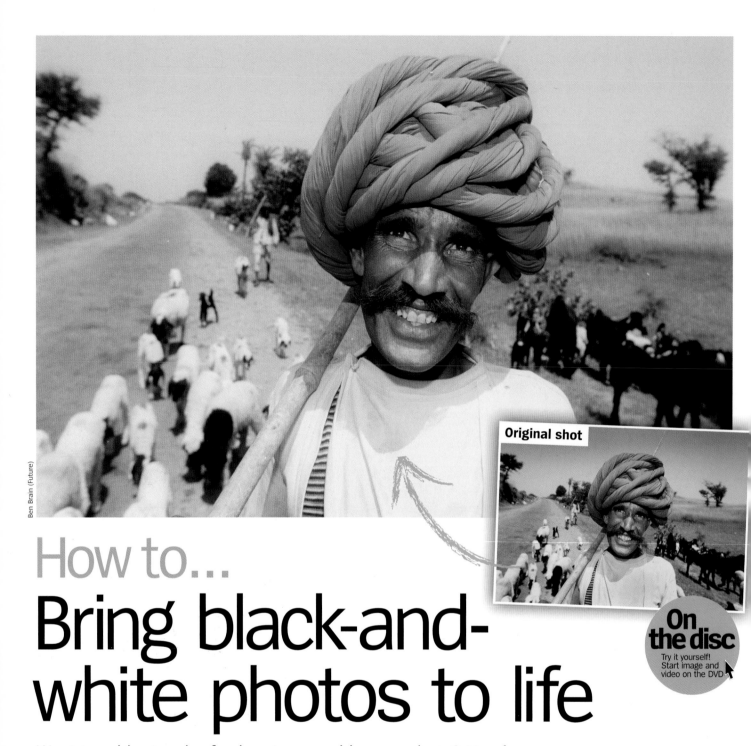

Original shot

Ben Brain (Future)

On the disc
Try it yourself!
Start image and
video on the DVD

How to...

Bring black-and-white photos to life

Want to add a touch of colour to your old mono shots? Here's an easy way to add a hand-tinted effect to a scan of an old black-and-white print

WHAT YOU'LL NEED *Elements 8 or newer, or any version of Photoshop*
WHAT YOU'LL LEARN *How to subtly hand-tint your black-and-white shots using Variations/Color Variations, blending modes, layers and brushes*
IT ONLY TAKES *30 minutes*

Got some dusty old black-and-white prints in your attic or even a mono digital photo that you want to breathe new life into? In this tutorial we'll show you how to replicate the effects of a hand-tinting. This traditional technique was widely used before the advent of colour photography. It was hugely popular among adventurous travelling

photographers in the late 1800s and early 1900s, who used tinted images to bring a taste of the exotic back home. It was also a rather laborious process that took skilled workers hours of painstaking toil to get right. Today, however, the technique can be more easily replicated in the digital darkroom using some simple techniques and tools, including brushes, blending modes and layers, as we'll show you here.

Inspired by the memorable images of the great travel photographer Burton Holmes, we dug out some black-and-white shots taken in India. After scanning the negatives, we set about giving the striking portrait shown above the hand-tinted treatment. Read on to find out how!

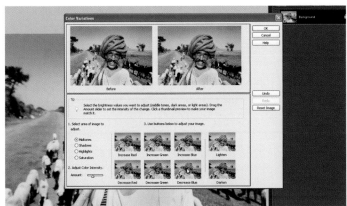

1 Start Turn it sepia

Open HandColour_Before.jpg from the Mono Hand folder on the DVD. First we'll give the shot a subtle sepia tone. To do this, go to Image > Adjustments > Variations in Photoshop, move the slider one notch towards Fine, and click More Red, then More Yellow. In Elements, go to Enhance > Color Variations, move the Adjust Color Intensity slider to the left (about a quarter of the way) and click Add Red and Decrease Blue.

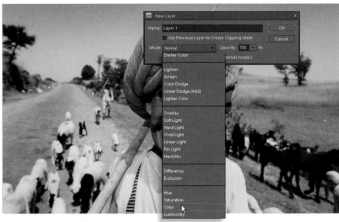

2 Set the blending mode

To add the first of your colours to the image, go to Layer > New > Layer (or Alt-click the Create a new layer button in the Layers dialog). Set the new layer's blending mode to Color using the menu in the dialog. This change is very important, because it will reveal the shapes and tones from the original layer in a way that's similar to hand-tinting inks.

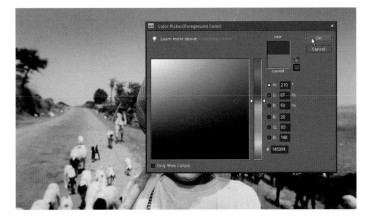

3 Configure your brush

Switch to the Brush Tool and set an appropriate sized brush for the area you want to colour. In this case, we're going to work on the large area of sky first, so choose a wide, soft-edged brush so you can colour the area quickly. Click the foreground colour swatch in the toolbox to open the Color Picker and set the foreground colour to a deep blue.

4 Start painting

Paint over the area of sky – tap the left or right square bracket key on your keyboard to make the brush smaller or bigger respectively to suit on the intricacy of the area you're painting (around the tree edges, for example). Don't worry about being too accurate – we're replicating a hand-tinted look, so it's okay if the edges are a bit rough.

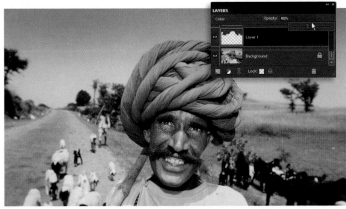

5 Reduce the opacity

Once you've applied the colour wash it can often still look a little too modern and garish. To calm the colour down a little, use the Opacity slider at the top of the Layers palette to reduce the opacity of the layer. Sometimes it's good to reduce it to as little as 10%. However, in most cases about 25% to 35% should be perfect.

6 Finish And repeat...

Repeat steps 2 to 5 with different colours for the other areas of the scene. It's good practice to keep and work on different colours and areas of the scene on separate layers, because the opacity required might be slightly different for each colour. Consequently, you can end up with lots of layers – at least 30 for a fully coloured scene. 📷

» HDR images

6

HDR is the hottest thing in photography right now. We'll show you several ways to create stunning HDR (or HDR-style) images and bring out more tonal detail than ever

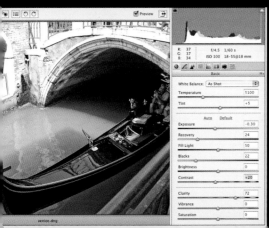

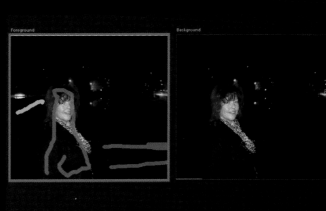

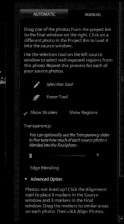

Get to know...
Dynamic range

On the disc
Try it yourself!
The start image is on the DVD

Film, cameras, monitors and printers can all re-create only a limited range of tones

If you remember shooting on film, you may know that colour film has a tonal range of about five stops (though high-contrast mono film can capture up to about nine stops). A modern digital camera has a range of around six to nine stops from darkest to brightest – digital SLRs with full-frame sensors fall near the top of this range, D-SLRs with smaller sensors deliver around half to one stop less, and compacts significantly less. The latest top-end digital SLRs boast an impressive 11 stops, but even this isn't enough to capture the full range of tones in a very high contrast scene like the sunny landscape below, where no camera could capture good detail in both the bright sky and the darkest shadows in a single shot. The idea of High Dynamic Range imaging is to take several differently exposed shots of the scene (at least two, but typically between three and five, up to a maximum of ten), each of which perfectly captures part of the tonal range, and then combine them into a single HDR image, which might contain over 23 stops of information. The shot below is the HDR image created by using Photoshop's Merge to HDR command to combine the three differently-exposed shots in the Garden folder on your DVD.

Stops and contrast ratio
We need to get technical for a moment...

It's not just cameras that have their own dynamic range, but also other imaging devices such as monitors and printers. In these cases dynamic range is typically expressed in terms of contrast ratio – that is, how much brighter the brightest tones are, compared to the darkest. In photography, dynamic range is measured in EV differences or stops. An increase of one EV or one stop is a doubling of the amount of light. Expressed the other way around, the contrast ratio equals 2 to the power of the EV difference. So if a typical LCD monitor can display a range of 9.5 stops, its contrast ratio is about 725 to 1. Photo prints have a much poorer contrast ratio of about 128:1, or around 7 stops of dynamic range.

Understanding...
Bit depth and tonal detail

It's not just the range from black to white, but the number of steps in between

As well as the range from darkest to lightest, tonal detail also depends on the subtlety of tones. Consider the black-and-white image here – not the one with shades of grey, but the one on the right with literally just black and white in it, not intermediate shades of grey. Clearly only two tones just aren't enough to render photographic tonal detail.

In both computers and monitors, the number of tones available depends on *bit depth* – the number of binary digits (bits) allocated to rendering each of the pixels ("picture elements") that make up the image. One bit can describe only black or white: the bit is either on (white) or off (black). Digital photos are normally at least 8-bit – see below for more.

Bit depth and tonal subtlety
Greater bit depth means more possible tones

If you have eight bits to describe one pixel, then the pixel can be any of 256 steps from black to white (shades of grey), because there are 256 possible permutations of a string of eight ones and zeroes. In colour photos, however, each pixel doesn't have just a greyscale brightness value; it has an intensity in *each* of the three colour channels (Red, Green and Blue) – R220,G15,B150, for example, is a rich pink.

By default, Photoshop and Elements assign eight bits to each colour channel, so each pixel can be any of 256x256x256 or 16.7 million colours. This is commonly known as 8-bits-per-channel colour, or simply 8-bit colour, or confusingly sometimes 24-bit colour (3 channels x 8 bits each).

If even more bits are allocated to describe each pixel, then an image can contain a subtler range of colours and finer gradations of tone from black to white. High Dynamic Range images have 32 bits per channel.

How to...
Options for HDR effects

There's more than one way to skin a high-contrast cat. Here's a guide to the options

How you produce your HDR effects depends on a range of factors: your camera, and what it can capture; which version of Photoshop or Elements or any third-party HDR software you're using; and whether you're shooting specifically with HDR effects in mind or decide you want to produce an HDR-style image from a single photo you've already taken. If you're using Photoshop CS2 or newer you can use the excellent built-in Merge to HDR command, and we'll look at the options for producing images for processing with this below. We'll look at some alternative options for both Elements and Photoshop users opposite.

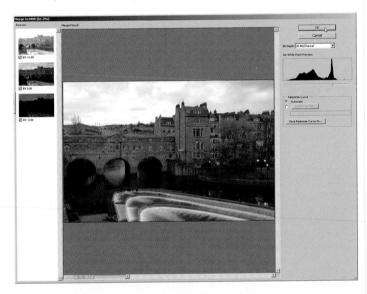

Merge to HDR options
There are several ways to use Photoshop's command

The first option is to shoot three or more exposures, using your camera's auto-bracketing feature if it has one, and combine them using Merge to HDR. You may get marginally better results from Raw files, which contain more tonal information to start with, but high-quality JPEGs will produce perfectly good results.

You can also produce two or more edits of a single Raw file, each optimised for a different part of the tonal range, and combine them with Merge to HDR. The command won't normally process multiple versions of the same Raw file, but we'll show you how to do it (see page 166).

If you wish, you could generate a 32-bit file using Merge to HDR, save it out, and then use specialist third-party software such as the excellent Photomatix Pro to perform the tone-mapping stage (see overleaf), taking advantage of its greater range of options to generate a variety of styles of image, from one with better detail in shadows and highlights through to the popular "hyper-real" finish.

Get to know...
More HDR options

On the disc
Try it yourself! HDR software is on the DVD

You don't need Photoshop to create HDR images – you can even emulate the effect

If you're using Elements, want more control over the process or just want to try other options, there are several specialist third-party applications you can try. One of the best is HDRSoft's Photomatix Pro. You'll find a trial version in the Software folder on your DVD – it's fully working, but will add a watermark to images produced via Tone Mapping, 48-bit Compression and four of the six combination modes. Find out more at www.hdrsoft.com.

You don't have to use HDR software at all to produce images of scenes that have a high contrast range. You can recover highlight and/or shadow detail using the sliders in ACR, or tools such as Levels and Shadows/Highlights in Photoshop and Elements. However, you'll be able to recover only a limited amount of tonal information before image quality starts to suffer, so if you're shooting a high-contrast scene you should wherever possible take two or more exposures to capture both highlight and shadow information, using a tripod or otherwise bracing the camera. If you can't produce the desired result by editing one of your shots, you can combine them using layers and masks – see below for more, and pages 158 and 160 for demonstrations of the technique.

HDR-style effects with layers
Combine different exposures manually using masks

If you've got only a single photo, you'll need to produce two or possibly three edits from it so that you have versions in which highlights, shadows and midtones are well exposed. If you've got several exposures, you can combine them as they are or tweak them first to enhance the areas that will be revealed in the composite image. You can then pick one of the images to be the "base" image in the composite – it doesn't matter which one you use, but if you have one image which is mostly well-exposed and just want to reveal small areas from other images, it make sense to use that one. Paste the other image(s) into your base image as new layers, then hide or reveal areas by editing the mask.

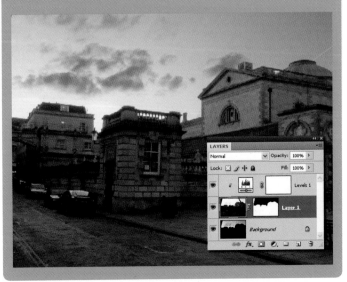

How to...
Converting HDR files

HDR images aren't much use in their pure 32-bit state – you can't even view them

Photoshop's Merge to HDR command and third-party tools such as Photomatix Pro enable you to merge a set of LDR (low dynamic range) exposures to produce a single 32-bit high dynamic range image. However, not all Photoshop's commands and tools can be used on 32-bit images. Elements can't even open them. It can open 16-bit images, but the range of options and commands available to use on these is still limited – notably, you won't be able to use layers or most filters. To use these, you'll need to convert to 8-bit, and doing this is irreversible. Printers and monitors are also 8-bit only (except for a few very expensive 10-bit "professional" monitors). This means that you won't actually be able to view or print a 32-bit true HDR image. If you combine exposures to produce a 32-bit image, it won't look at all pleasing on screen – the huge range of detail present simply can't be displayed. So before you can do anything much with your HDR images, you essentially need to turn them back into LDR (16-bit or 8-bit) images. The usual way to do this is using a process called tone-mapping, but there are several options available here, which can result in subtly or more strikingly different final images.

From HDR to LDR
There are several options for converting your HDR file

Photoshop can generate a 32-bit HDR file but can't do much with it. Its value is much like a Raw file's, as a kind of "negative" from which you can produce usable images (so it's smart to save it – as soon as Photoshop displays the merged file [not the preview], go to File > Save As and save it as a TIFF). To convert it, go to Image > Mode and pick the bit depth you want (16-bit or 8-bit). In the HDR Conversion dialog are four options for adjusting the dynamic range to a usable level. Exposure and Gamma enable you to manually adjust the image's brightness and contrast levels; Local Adaptation enables you to adjust local brightness regions throughout the image using Radius and Threshold sliders. The other two options, Highlight Compression and Equalize Histogram, are automatic.

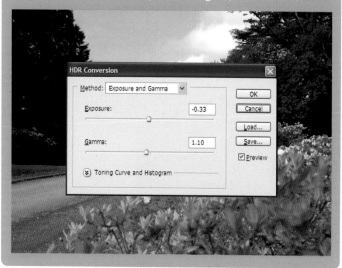

Understanding...
About tone mapping

Tone mapping is the process that turns an HDR file into a viewable, printable image

You might be wondering what the point of combining LDR images to produce an HDR image is, if you then have to convert the HDR image back into an LDR one. Well, imagine a dimly lit room with a bright sunny day on view through the windows. The contrast range will be way beyond the capabilities of a camera sensor, but if we take several different exposures we can record all of that range and then combine the exposures to contain the full range in an HDR image. When we tone-map this image back to LDR, we throw away lots of data, but we can keep information that would have appeared as burnt-out highlights or blocked shadows had the scene been captured with a single exposure. (For example, if you exposed the scene to capture the interior detail, exterior areas would be clipped to a brightness level of 255, or pure white, with no detail visible.) When we tone-map our HDR image, we discard some of the highlight data that can't be displayed, but keep enough to show detail that couldn't otherwise be captured. So at the end of the entire process the image you have is not a literal (32-bit) HDR image. That's one reason to consider other methods of producing HDR-style effects – the end result can often look just as good.

Tone mapping options
Control the conversion process in Photoshop

When you tone-map an HDR image, you not only have to reduce or compress the brightness range but also discard large numbers of the brightness stops to go from 32-bit to 16-bit or 8-bit. Photoshop and third-party programs such as Photomatix Pro give you a number of options for managing the process, effectively controlling how much information is discarded and how the remaining data is reorganised. You can simulate the dynamic range of the eye – allowing interior parts of a scene to fall a shade darker than exterior areas if the exterior areas look spot-on, for example – or create a more hyper-real, "painterly" effect, with maximum detail and texture shown both inside and outside. The latter, as below, is the kind of look that many people associate with the term HDR.

Get to know...
Cameras and file formats

Are you getting the very best from your camera? Not if it's giving you JPEGs...

As we've noted, most digital cameras capture about six to nine stops of dynamic range in a single shot. But within that range, most can record 12 bits of data per channel, which equates to 4,096 possible brightness levels in each colour channel. (Think of levels as tonal information: the more levels, the more tonal detail is available.) The JPEG file format, however, is 8-bit only, meaning it records only 256 levels per channel. So if you opt to save your shots as JPEGs, you're throwing away most of the image information captured by your camera – obviously not ideal if you want to create HDR images! One solution is to save your shots as Raw files if your camera gives you the option – all D-SLRs and many quality compacts do. Raw files contain the image information captured by the camera sensor, without any in-camera processing. This means they contain the full range of tones and colours that your camera is capable of recording (but see below). In terms of bit depth, some top-end cameras are capable of recording 14 bits of data per channel, so saving your shots as Raw files means you could be getting 16,384 possible brightness levels per channel. It's not full 32-bit HDR, but it's an awful lot more tonal detail to be starting with!

More about Raw files
Raw files offer a way to capture greater dynamic range

Raw files aren't strictly "HDR" (that is, 32-bit) images, but they do have a greater dynamic range than your monitor can display – at least in their unprocessed state. Some of this tonal information is lost when you apply edits in ACR – exactly how much depends on what you do, and the more contrast you apply the more is lost – but unless you go very hard on the contrast, you'll probably end up with around eight to nine stops of tonal range from a typical Raw file. The key point is that it contains enough tonal information that you can process it in different ways to bring out different parts of the range, save out multiple versions of the image and combine these using compositing techniques to create an effect very similar to the LDR tone-mapped version of a real HDR file – see page 160.

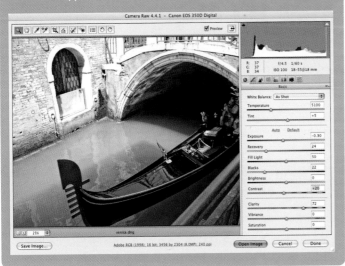

Understanding...
Working with Raw files

Raw files, like "digital negatives", must be processed before you can even view them

If you shoot Raw, you can't even open your Raw files directly in Photoshop/Elements; they first need to be processed in a Raw converter (though Merge to HDR can import unprocessed Raw files). Camera makers usually supply their own Raw software with their cameras, or you can use Adobe's Camera Raw plug-in, as updated from time to time to support new camera models; download the latest version from www.adobe.com/downloads/updates. You can make a wide range of adjustments and edits in ACR (see Part 4, page 112), and when you decide to save an image from ACR or open it in Photoshop/Elements for further work, you can choose to save it as a 16-bit or as an 8-bit file. (Note that you set this in the Workflow Options for ACR as a whole, not for each separate image. If you're running ACR under Photoshop, access these by clicking on the text summary of the current settings at the foot of the ACR interface, below the image preview window. Under Elements there's a pop-up Depth menu there.) For HDR, it makes sense to save as 16-bit in order to preserve as much tonal detail as possible, though as we've seen some tools and options in Photoshop and Elements can't be used on 16-bit images.

The non-destructive advantage
There are other important advantages to using Raw

Also like negatives, Raw files are never actually altered by editing in ACR. Instead, details of your edits are saved separately (either in the main Camera Raw database on your hard disk or in a "sidecar" .XMP file in the same folder as the original Raw file, depending on the setting in ACR's Preferences). These edits are re-applied to the Raw file if you reopen it in ACR (but because they're separate can always be modified or removed); if you save or open the image into Photoshop/Elements, the edits are applied to create a *copy* of the edited image. Your original Raw file remains unaltered throughout. So in a typical folder, you might find Name.CR2 (the unaltered Raw file), Name.xmp (ACR's record of your edits), and Name.jpg (the edited version opened in Photoshop/Elements and saved as a JPEG).

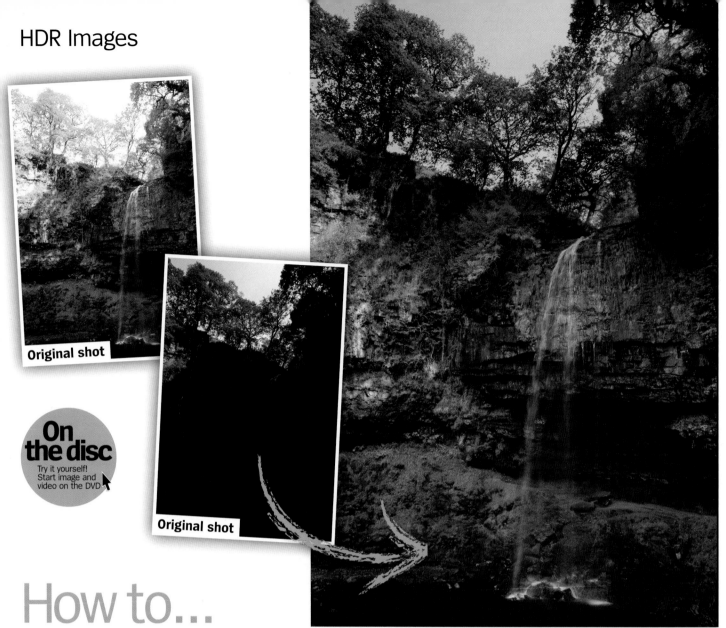

Original shot

Original shot

Paul Grogan (Future)

HDR Images

How to...
Combine two separate exposures

Banish blown highlights and impenetrable blacks by merging two versions of the same scene – even if you moved the camera between shots

WHAT YOU'LL NEED *Photoshop CS3 or newer*
WHAT YOU'LL LEARN *How to align two handheld shots accurately, how to combine separate exposures from two shots, how to make blue skies in your photos more vivid*
IT ONLY TAKES *10 minutes*

When you shoot a high-contrast scene such as an outdoor setting in bright sunlight, there's a danger of losing detail in the brightest highlights and the darkest shadows as the camera struggles to capture the full tonal range. You could try to address this as you take the shot. You might set Evaluative metering mode on your D-SLR, for example, which measures the scene's light levels as a whole and attempts to balance between over- or underexposing the contrasting

elements. This setting can lead to disappointing results, though. To make sure that we captured detail throughout the tonal range in this waterfall scene, taken at Sgwd Henrhyd in Powys, we took two shots. The first was set to capture the shaded waterfall, causing the sunlit trees and the sky to become overexposed, while the second was exposed to capture detail in the trees, plunging the shaded areas below into darkness. By combining the correctly exposed areas in Photoshop, we can create a shot with detail in both the shadows and the highlights.

The two shots we're using were captured using a handheld camera, which was inadvertently moved a fraction between exposures. We'll show you how to align the handheld shots automatically and then use layer masks to blend the best bits together. To finish, we'll also add a wash of blue to create a more vibrant sky.

1 Start Copy and paste

Open waterfall_start2.jpg from the Bracket folder on your DVD. Go to Select > All then Edit > Copy. Now open waterfall_start1.jpg. Go to Edit > Paste to paste the copied image as a new layer. In the Layers palette, double-click the Layer 1 label and rename the layer Highlight Exposure. Double-click the Background layer's thumbnail to unlock it, and rename this layer Shadow Exposure.

2 Analyse the alignment

You'll soon notice that the two handheld shots aren't perfectly aligned – the photographer even leaned forward between shots, so the scale and perspective don't match at all. It would be a nightmare to scale, rotate and move the layers to align them manually – but luckily, you can do it automatically. Hold down the Shift key and click both layer thumbnails to highlight them both. Now go Edit > Auto-Align Layers.

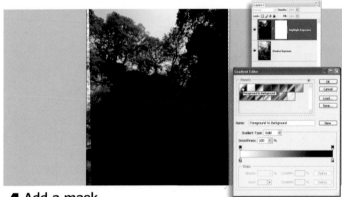

3 Align the layers

There are four options available in the Auto-Align layers dialog. For most jobs, try Reposition Only: this won't distort the layers. Because our shots show objects at slightly different sizes, however, they'll need to be scaled, rotated and panned, so Auto is the best option. Click OK, and Photoshop will align the layers so that their content overlaps precisely.

4 Add a mask

Target the top (Highlight Exposure) layer, then click the "Add layer mask" button in the Layers palette to add a mask to the layer. Now switch to the Gradient Tool. Click the Linear Gradient button in the tool options bar, then click the gradient preview to open the Gradient Editor and choose the Foreground to Background preset. Press D, then X if need be, to make the foreground colour white.

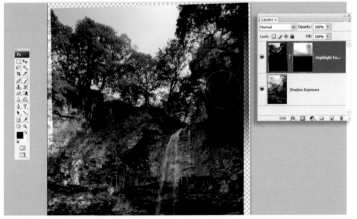

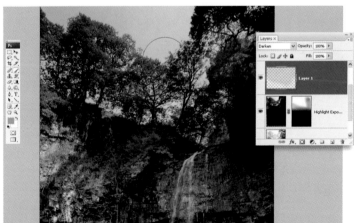

5 Apply a gradient

Click-and-drag from the top of the image to below the treeline to draw a gradient on the mask, revealing the top layer's well-exposed trees but hiding the dark waterfall, showing the well-exposed waterfall on the layer below. Switch to the Brush Tool, set hardness to 0 and opacity to 25%. Tap X to make the foreground colour black, and paint over the darker trees to reveal detail from the corresponding area below.

6 Finish Boost the blue

The overexposed sky has little colour. Add a new layer, and set the layer's blending mode to Darken. Click the foreground colour swatch in the toolbox and choose a sky blue. Using a brush with 33% opacity, paint gently over the sky to add a wash of colour to it. To finish, crop to remove the transparent edges caused by the auto-alignment process. ◘

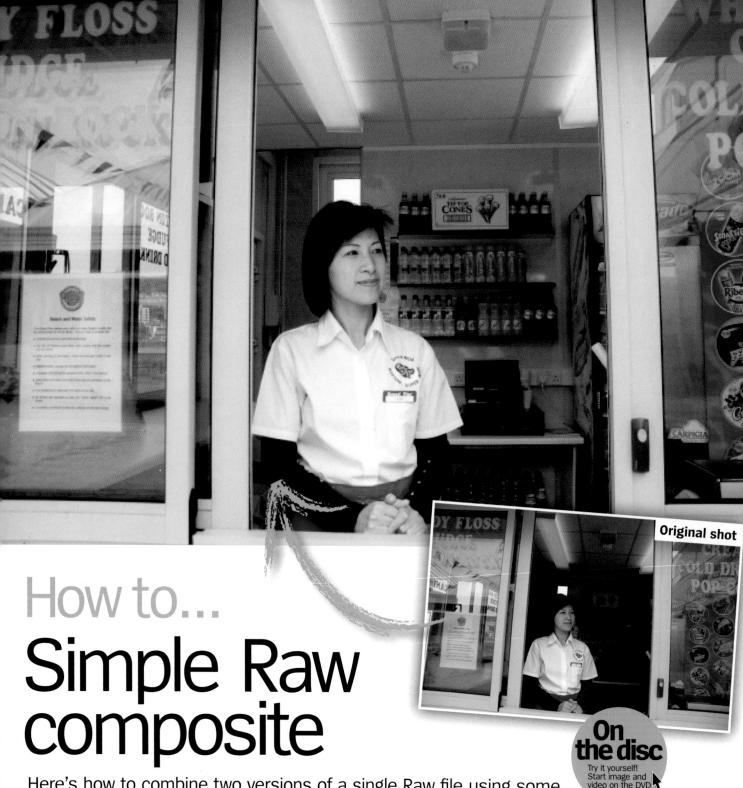

Original shot

How to...
Simple Raw composite

Here's how to combine two versions of a single Raw file using some different masking techniques to overcome tricky exposure problems

WHAT YOU'LL NEED *Any version of Photoshop or Elements*
WHAT YOU'LL LEARN *How to optimise exposure for different areas in ACR, how to combine two images using masks and compositing techniques, how to refine a mask using gradients and brushes*
IT ONLY TAKES *15 minutes*

As we've noted, Raw files have a greater dynamic range than JPEGs, and usually greater than your monitor can display, but they're still not quite "high dynamic range" images, in the sense that you won't be able to discern detail at both ends of the tonal range. Because they contain this greater dynamic range, however, it's often possible to process Raw files to bring out the detail in the shadows and then

again for the highlights. You can then blend these two versions of the image to reveal the correctly-exposed areas from both.

When it comes to combining the different versions of the image, you have a couple of options. The video tutorial in the Shop folder on your DVD will show you how to use Photoshop's Merge to HDR command to combine six different exposures created from this single Raw file, just as if you had taken six bracketed shots to start with. Here, though, we'll first show you a simpler but more manual approach: we'll create just two exposures from our Raw file (one for each of the main tonal zones in the scene, first the brightly-lit foreground area and then the dark shop interior), then combine these using masks and compositing techniques. We'll even show you a clever way to partially reveal areas.

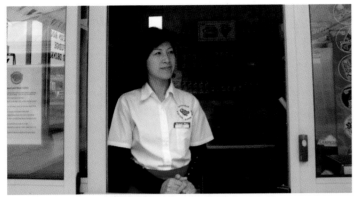

1 Start Assess the exposure

Open HDR_Before.NEF from the Shop folder on your DVD. It's a Raw file, so it will open in ACR. There's high contrast between the bright whites in the foreground (the window frames and the subject's shirt) and the deep shadows inside the kiosk. You could lighten the interior with ACR's Fill Light slider, but this could weaken the midtones in that area and elsewhere in the image.

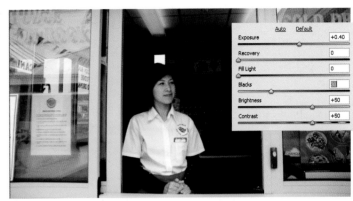

2 Adjust for the bright areas

We'll get much better results by combining two versions of the Raw file – one with the exposure optimised for the interior of the kiosk and the other optimised for the exterior. We'll start with the exterior. Increase Exposure to +0.40 and then, to improve contrast, increase Contrast to +50 and Blacks to +20. For the moment, just ignore the effect of these adjustments on the interior.

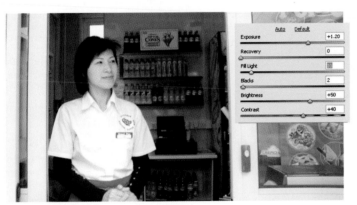

3 Adjust for the dark areas

Click Open Image to open the edited image in Photoshop/Elements. Now reopen the original Raw file again – if you're using Elements, you'll need to save the open image with a different name first; this is optional if you're using Photoshop. This time we'll make adjustments in ACR to lighten the interior, ignoring the effect on the foreground. Set Exposure to +1.20 and Fill Light to 10, and set Contrast to +40 and Blacks to 2 or 3.

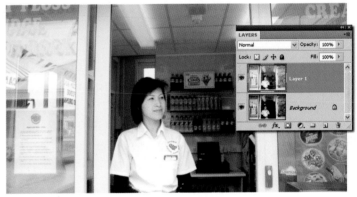

4 Combine using layers

Open this version of the image (and, if you've saved your first edited version out of ACR, open this too so both images are open). Go to the interior image and press Ctrl-A (Select > All) to select the entire canvas, then press Ctrl-C to Copy. Go to the exterior image and press Ctrl-V to Paste. The interior image will appear above the Background layer as a new layer.

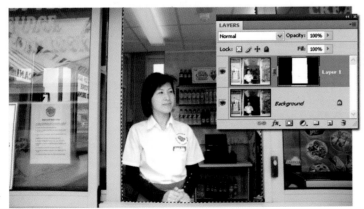

5 Add a mask

Add a mask to the top (interior) layer, then press Ctrl-I to invert the mask from white to black, so that the layer content is hidden. Now select the interior by drawing around the inside of the window frame with the Polygonal Lasso Tool as shown. Then, with this selection active, click the mask thumbnail and go to Edit > Fill (Fill Selection in Elements) and pick White to make the selected area white, revealing the lightened interior.

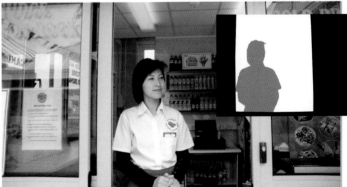

6 Finish Fine-tune the mask

Neither of our exposures is quite right for the subject: she's too light in the interior image and too dark in the exterior image, so the correct exposure is somewhere in-between. Switch to the Brush Tool, open the Swatches palette (Window > Swatches, or Color Swatches in Elements), click the 50% Gray swatch to make this grey the foreground colour, and carefully paint over the subject with a brush 100 pixels in diameter and set to around 90% hardness. ◘

How to...
Using Merge to HDR

Here's how to create an HDR image from two or more different exposures
with the automated Merge to HDR command in Photoshop CS2 and newer

WHAT YOU'LL NEED *Photoshop CS2 or newer*
WHAT YOU'LL LEARN *How to use Photoshop's Merge to HDR command
to combine several exposures into an HDR image, how to adjust the
Local Adaptation settings to get a better result*
IT ONLY TAKES *15 minutes*

**If you're using Photoshop CS2 or newer, you can use the dedicated
Merge to HDR command to generate true 32-bit HDR images by
combining several shots of the same scene taken at different
exposures.** It works best if you took the shots using a tripod (and if
there's nothing moving in-shot), but if they were taken handheld, the
Auto Alignment option will go some way towards minimising the blurring
and ghosting you invariably get if anything has moved between shots.

The process can take a little while, but even when it's generated an
HDR image that's not the end: you still need to create a viewable and
printable 16-bit image which has the final "look" you want. The HDR
Conversion dialog offers four options for converting the 32-bit HDR
image to 16-bit once your images have been merged. Of all these,
Local Adaptation is by far the most useful. Clicking the Toning and
Curve Histogram button reveals a tone curve that can be altered in a
similar way to the Curves dialog's. Your merged image will usually look
rather flat, so it's a good idea to start by bringing the black and white
points in towards the edge of the histogram to boost contrast. You'll
find that the Radius and Threshold sliders don't always alter things a
great deal; it's worth experimenting with them, but there are no hard
and fast rules, and it's worth noting that some settings can introduce
edge haloes, so don't push the sliders too hard. Here we'll take you
through the process from start to finish using the three images in the
Bridge folder on your DVD. (The JPEGs were produced from Raw files,
so you might see an alert when you run Merge to HDR – just OK this.)

Understanding the options
The HDR Conversion dialog offers four options

You can convert from 32-bit to 16-bit by choosing this in the Bit Depth menu within the Merge to HDR dialog (which you can do as soon as the preview has been generated) or at any time you open the 32-bit file by going to Image > Mode > 16 Bits/Channel. The HDR Conversion dialog will open, offering four conversion options.

The Local Adaptation conversion method, which we're using here, is the most useful. It uses a blurred version of the RGB channel as a mask to adjust tonality by calculating the amount of adjustment that's required for local brightness regions throughout the image. The Radius and Threshold sliders control this mask, though using them manually is tricky – see step 10 over the page for more.

The Exposure and Gamma option doesn't perform tone-mapping. The default settings produce an image identical to the one in the Merge to HDR preview, and simply show how your HDR data appears on an LDR output source without any form of compression. The sliders will perform as you'd expect, but the shadow and highlight detail contained in your HDR image won't be condensed as required. You could, however, use the sliders to adjust an HDR image that you've already brought into LDR line at the 32-bit stage by manual dodging and burning. See right for the other two options.

Automated tone-mapping
These two conversion options offer no control

The other two options in the HDR Conversion dialog give you less control than the Local Adaptation option we're using, which means that while they might produce an acceptable result in a particular instance, you can't do anything to improve things if they don't. The Highlight Compression option performs a crude form of tone-mapping, assigning the brightest pixels a value of 255 and converting the rest in a logarithmic manner. It's the method of choice if preserving highlight detail is the top priority, but rarely delivers decent overall results – images typically appear overly dark. If you go the semi-automated route with Local Adaptation, you can still ensure that all highlight detail is present.

Equalize Histogram is another automated tone-mapping option with no further controls. It works in a way vaguely similar to Photoshop's Auto Levels command, attempting to maximise visual contrast. It finds the peaks in the histogram and spreads these out locally, ensuring that the majority of pixels receive a contrast boost. The effect can be striking, with better midtone contrast than you get using Local Adaptation, but it tends to compress the tonal range at both the shadow and highlight ends of the range, producing heavy-looking shadows and weak highlights.

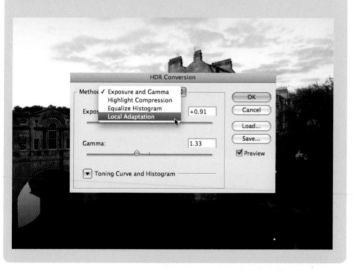

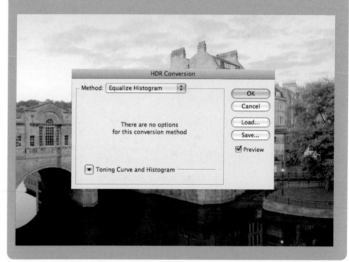

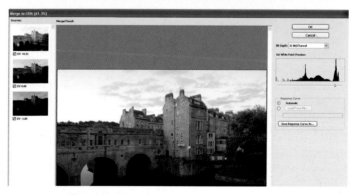

1 Start Launch Merge to HDR

The easiest way to launch Merge to HDR is to Ctrl-click to highlight all your exposures in Bridge, then go to Tools > Photoshop > Merge to HDR. Alternatively, in Photoshop go to File > Automate > Merge to HDR and use Browse to select your files (Ctrl-click on all three files in the dialog). Enable the Align option at the foot of the dialog (this is enabled by default if you take the Bridge route) and hit OK to merge the files.

2 Let Merge to HDR do its stuff

After a while, a preview of the merged image will appear, with the source images listed by exposure value on the left. You can move the White Point Preview slider all the way from left to right to check that you've captured the necessary detail in the shadows and highlights (but moving the slider has no effect on the appearance of the image when you open the HDR Conversion dialog in the next step). »

HDR Images

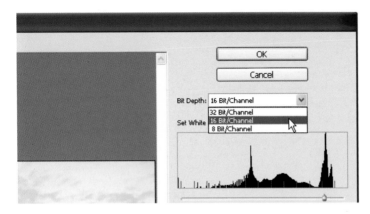

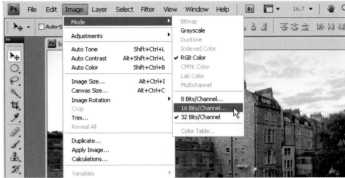

3 Proceed to conversion

If any tonal information is missing, you may have missed a file when loading your images, or you might want to shoot the scene again (if that's practicable) to capture the missing tones. If you're happy with the preview merge, you have three options. First, you can select 16-bit from the Bit Depth menu and click OK to open the HDR Conversion dialog.

4 Alternative steps

Alternatively, if Merge to HDR took a long time on your computer, click OK to open the image, then go to File > Save As and save the 32-bit file as a PSD or TIFF, so that if the conversion goes awry you can access the file without having to do the merging again. Now tone-map the file in Photomatix Pro (see page 155) or go to Image > Mode > 16 Bits/Channel to open the HDR Conversion dialog.

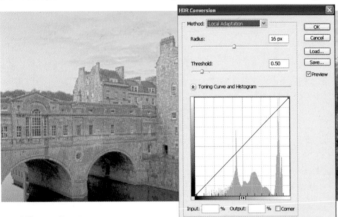

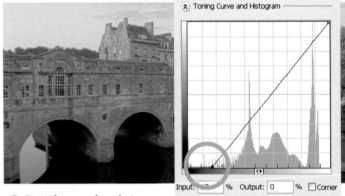

5 View the tone curve

In the HDR Conversion dialog, pick Local Adaptation in the Method menu, and click the button below the sliders to see the tone curve and histogram. If you're familiar with Curves in Photoshop, you'll know how to read a histogram and how Curves works. Unlike with regular Curves adjustments, however, you need to set the black and white points first...

6 Set the end points

In regular editing you'd generally use the Levels sliders to set the tonal end points before moving to Curves to fine-tune contrast and midtone brightness, but here it's all done with Curves. To set the black end point and define the darkest tones in the image, click the black point marker at the bottom-left (circled) and drag it to the right towards the edge of the histogram.

Expert tip: setting the end points
How you handle the tonal end points can be critical

Bear in mind that when you're setting the black and white end points on the tone curve, you don't have to drag the markers right to the edges of the histogram: if there were no pure black or pure white tones in the original scene, you don't need to create them. However, moving the markers close to the edges is generally desirable if you want to create strong contrast, as long as the effect suits the scene. If you drag the markers to the edges of the histogram, the darkest tones in the shot will become pure black, with an RGB value of or close to 0, and the brightest tones

will be pure white, with a value of or close to 255. If you drag the markers inwards past the edges of the histogram, you'll clip areas to pure black or white; you'll generally want to avoid doing this, though it's fine to clip small areas for creative effect (but note that clipped shadows are preferable to clipped highlights, because you expect to see detail and not just glare in brightly-lit areas). If histogram information is cut off at one or both ends of the graph, it means areas are already clipped; you can either re-shoot the scene with more exposures, or live with it.

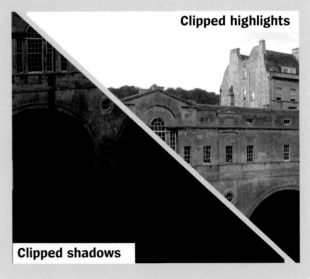

Clipped highlights

Clipped shadows

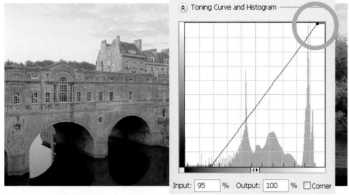

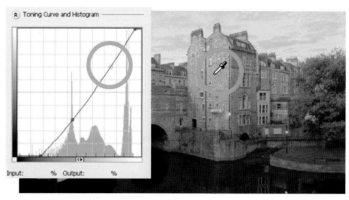

7 Set the white point

To set the white point, click the marker at the top-right (circled) and drag it to the left until it's close to, or directly in line with, the edge of the highlights information in the histogram. See the "Expert tip" box opposite for more about setting the black and white end points. When you're happy with the black and white points, you can work the curve in the usual way by adding and manipulating points.

8 Adjust different tones

Add a single point near the middle of the curve and pull it upwards to brighten the shot or downwards to darken it. Alternatively, you can place several points on the curve and pull down in the shadows and up in the highlights to boost contrast, or vice-versa to reduce contrast. You can click and drag within the image to see where particular areas lie on the tone curve, enabling you to target them precisely.

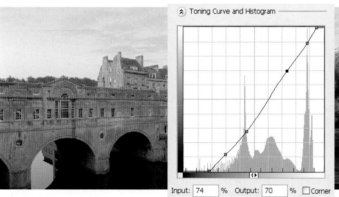

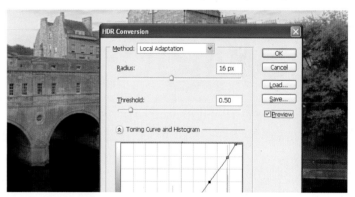

9 Tone options

Here we've created a simple S-curve to boost contrast, using two more points to anchor the shadows and highlights so they're not affected. You can produce more extreme effects than is possible in 16-bit mode. To create abrupt changes in tone, target a point and click the Corner box – the point will now be joined to adjacent points by a straight line rather than a curved one.

10 Using the sliders

The Radius and Threshold sliders are less intuitive tools, but they're worth trying out. The Local Adaptation method effectively splits the image up into "zones" of brightness; the Radius slider adjusts the size of these zones, while Threshold sets the minimum brightness difference there needs to be between pixels before Photoshop considers them to be in different "zones".

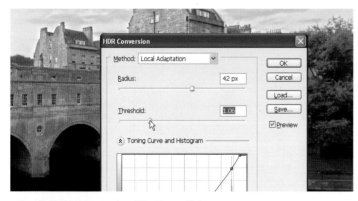

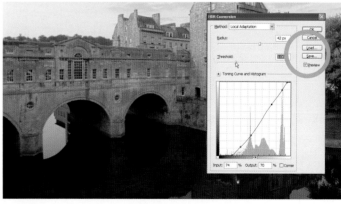

11 Experiment with the sliders

Generally, a high Radius value plus a high Threshold value will produce edge haloes, so this combination should be avoided. Increasing both values by smaller amounts will boost midtone contrast, but it's best to experiment image-by-image if you're so inclined. If you can't get the effect you want with the sliders, leave them at their defaults and tweak the final image's tone or contrast afterwards.

12 Finish Save settings and convert

If you're creating more than one HDR image of a scene, you can save your conversion settings by clicking the Save button. You can then apply these settings to the other images as a starting point by clicking the Load button. Once you're happy with your settings, click OK to convert the image to 16-bit mode and open it in Photoshop. ◘

Original shot

Rod Lawton

How to...
Merge to HDR with a single Raw file

On the disc
Try it yourself!
Start image and
video on the DVD

To use Merge to HDR with three versions of the same Raw file, you'll need to cheat a little, but the results can be spectacular

WHAT YOU'LL NEED *Photoshop CS2 or newer*
WHAT YOU'LL LEARN *How to produce three different "exposures" from a single Raw file, how to fool Merge to HDR into accepting them*
IT ONLY TAKES *10 minutes*

On page 160 we saw how to process a single Raw file multiple times to optimise different tonal areas and then combine these separate versions of the image manually to create an HDR-style image. You can't normally use the automated Merge to HDR command to blend such images, because it won't accept variants of one shot as different

"exposures". Here, however, we'll show you the way around this. (Take a look also at the video tutorial in the Shop folder on your DVD for a similar project using the image we used before.) This trick is possible because Raw files have greater dynamic range than JPEGs, and Adobe Camera Raw is particularly good at extracting the extra information. At best, though, it is able to recover only a couple of stops' worth of information, so it's still important to watch the exposure when you take a shot. Check your camera's histogram afterwards to make sure you've recorded sufficient detail in both the shadows and highlights, then try this technique to create a true HDR image from a single Raw file.

1 Start Open your Raw file
Normally you can't use Merge to HDR to combine multiple versions of the same Raw file which you've processed to different exposure values: this is because Photoshop analyses the images' EXIF data or metadata and can see that they're the same photo. There are, however, workarounds. Open HDR-before.dng from the Raw folder on your DVD.

2 Create your first "exposure"
We'll create the middle exposure first. The Camera Raw Default settings are a bit too dark, so set Exposure to +1. Now, if you're running ACR under CS4 or CS5, you just need to save each edited version of the Raw file as a TIFF. Under earlier versions, the process is a little more convoluted. Open the image into Photoshop, Select All, then Copy.

3 Paste into a new file

Go to File > New. One of Photoshop's New File presets is based on the clipboard size, and this is the one you want. Click OK to create the file, then Paste your copied image into the new file – it'll appear as Layer 1. (Depending on how your document presets are set up, there might be a Background layer below it.)

4 Save the new file

Right-click the layer thumbnail and choose Flatten Image from the foot of the contextual menu; Layer 1 will be renamed "Background". What you have now is an exact copy of your original image, but in a file that contains no EXIF data (it's just the image data that's pasted in). Save the image as a TIFF to maximise quality.

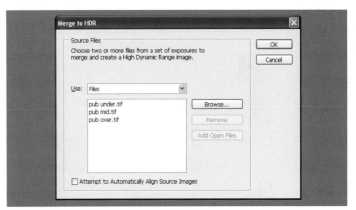

5 Repeat to create more "exposures"

Repeat these steps to create "overexposed" and "underexposed" versions of the shot, saving the images out of ACR in CS4/5, or creating and saving new documents in earlier versions. For the overexposed version, set Exposure to +3 to bring out the shadow detail, and for the underexposed version set Exposure to –1 to bring out highlight detail.

6 Launch Merge to HDR

Now launch Merge to HDR as we did in the previous tutorial, and load the three "exposures" you've created. Since you know that the composition of the three images is identical, you can save a bit of processing time by disabling the "Attempt to Automatically Align Source Images" option. Click OK to merge the images.

7 Manually set EV

For true different exposures, Photoshop calculates the exposure values based on the EXIF data. Because it doesn't have that data here, you'll be prompted to enter the values manually. You don't have to use the same exposure values you set in ACR; in fact, minus values can confuse Photoshop and produce odd results, so if you've set exposure values of –1, 1 and 3 in ACR, you can simply enter the *relative* exposure values – say, 2, 4 and 6 – and the images will be merged correctly.

8 Finish Process the merged image

Satisfied that the three images are different exposures, Merge to HDR will now process them; see the previous tutorial for more on converting an HDR image. The results won't be as good as if you'd shot three different exposures, because even in Raw mode the dynamic range of a camera's sensor is limited. However, it's a good compromise if you have only one Raw file to work with. ○

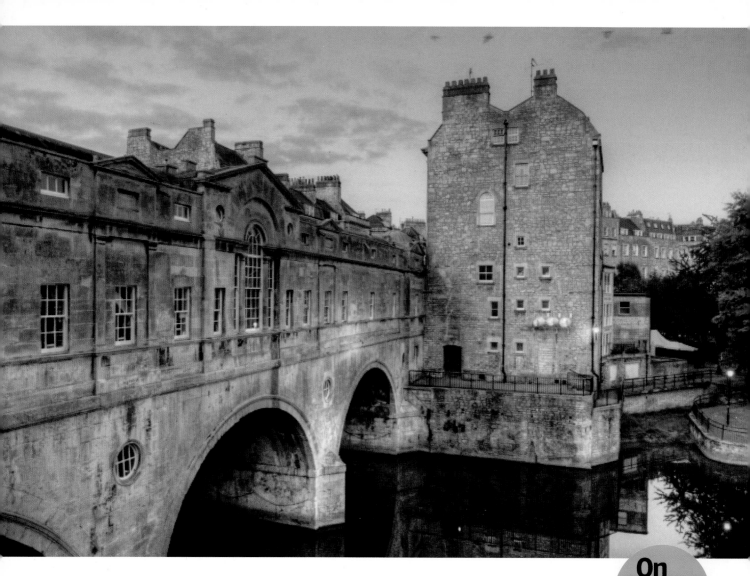

How to...
Restoring contrast

The tone compression inherent in converting an HDR image into something
viewable can reduce contrast – here are a couple of ways to boost it again

WHAT YOU'LL NEED *Any version of Photoshop or Elements*
WHAT YOU'LL LEARN *How to counter the midtone flatness typical in
HDR images, how to boost contrast using a range of techniques*
IT ONLY TAKES *5 minutes*

**To create a viewable image, all HDR involves compressing a very
wide brightness range into the much narrower range of the final
image, and this tonal compression inevitably reduces contrast.** You
can rectify this to some extent using the Local Adaptation conversion
options, but you're still likely to want to fine-tune the contrast after
converting the image. And while Photomatix Pro gives you more control
over the tone-mapping process, it doesn't include a conventional
contrast adjustment.

Some HDR techniques involve lightening shadows and darkening
highlights, as do tonal adjustment tools such as Shadows/Highlights

and the Fill Light slider in ACR; both compress tones to some degree.
And sometimes HDR images look "flat" simply because the highlight
and shadow areas now have a similar brightness level, so that the final
image ironically lacks any punch. Whatever the cause, weak contrast in
HDR images can ruin the effect, so here's how to restore contrast.

Too much contrast is just as bad as too little, though, so don't try to
create extreme contrast effects that don't suit an image. The three
shots used here were taken as the sun was going down, so we wouldn't
expect to see strong shadows or bright highlights – a subtle boost in the
darker and lighter midtones is enough to lift the image. After applying
your contrast adjustment, open the Histogram palette. Toggle the effect
on and off by showing and hiding the adjustment layer or duplicate layer,
or by clicking the Preview box in the adjustment dialog, and note how the
histogram changes. Watch out for gaps in the midtones where the tonal
information is being stretched, and for clipping at either end.

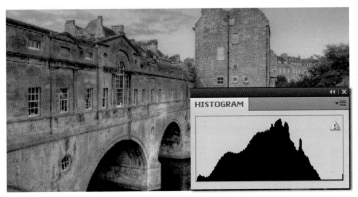

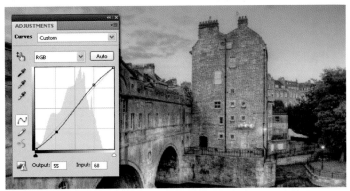

1 Start Examine the histogram

You can try these techniques on any HDR image – we've merged the three exposures from the Bridge 2 folder on your DVD using Photomatix Pro, and tone-mapped the image using the default Detail Enhancer settings. The resulting image has a good overall range of tones but it looks a little flat, and the histogram shows how the tonal information is bunched in the midtones.

2 Create an S-curve

If you're using Photoshop, add a Curves adjustment layer. To create a classic contrast-boosting S-curve, click to place a point on the shadows quarter-point (the top-right corner of the bottom-left square) and pull it downwards a little, then place a second point on the highlights quarter-point (the bottom-left corner of the top-right square) and drag it upwards a little.

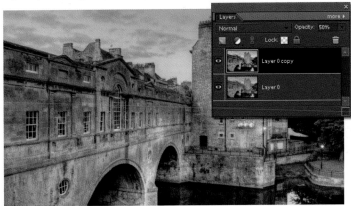

3 The Elements alternative

In Elements you can boost contrast with Adjust Color Curves. You can't, however, apply this as an adjustment layer, so to preserve the original image you'll need to create a duplicate layer. (You can't do this with 16-bit images, so go to Image > Mode and convert to 8-bit first.) Then go to Enhance > Adjust Color > Adjust Color Curves. One of the preset effects is "Increase Contrast", but its effect is a bit too strong.

4 Fine-tuning in Elements

You can tone-down the effect by pulling the Adjust Highlights slider to the right and the Adjust Shadows slider to the left. Alternatively, you can just OK the preset effect, then reduce the opacity of the duplicate layer (to around 50% in this case) for a more natural-looking contrast increase – that's one benefit of using a duplicate layer.

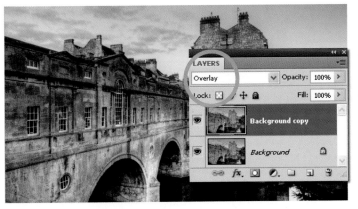

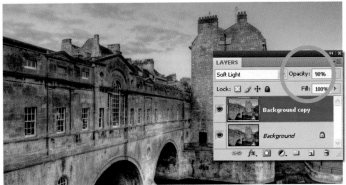

5 Blending mode method

Another way of boosting contrast is to add any adjustment layer (such as Levels) that doesn't instantly apply an adjustment, and set the new layer's blending mode to Overlay: this mode lightens highlight areas and darkens shadows but without affecting the end points, increasing contrast in the same way as a Curves adjustment.

6 Finish Fine-tuning

If the contrast boost isn't enough, duplicate the adjustment layer or duplicate layer; if it's too strong, you can change the blending mode from Overlay to Soft Light for a gentler contrast increase, or reduce the layer opacity. (If you're using Elements and want to localise the contrast boost, the adjustment layer option is your best bet, because it comes with a ready-made layer mask.) 📷

How to...
Boosting midtone contrast

Give any photo a boost using this trick to add contrast to midtone areas

In addition to boosting contrast overall, you can give almost any image more punch by applying a technique known as local contrast enhancement. This entails using the Unsharp Mask filter to boost the contrast within the midtones rather than between the lightest and darkest areas, which creates the impression of a broader dynamic range. When you dramatically increase the filter's Radius, it creates the effect of contrast between the areas that are bordered by the edges, rather than sharpness along the edges themselves. The effect is easy to apply, but you'll be amazed at how big a difference it makes. The Clarity slider in the Camera Raw editor's Basic tab also applies local contrast enhancement; however, the Unsharp Mask technique gives you more options for fine-tuning the effect.

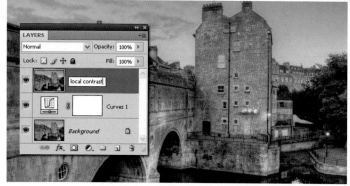

1 Start Create a merged layer for filters
We're using the Bridge 2 image we used in the previous tutorial. If, as is the case here, the image contains adjustment layers, you'll need to create a new merged layer at the top of the stack to which you can apply filters – to do this, click the top layer thumbnail and press Ctrl-Alt-Shift-E (Command-Option-Shift-E on a Mac). Go to Filter > Sharpen > Unsharp Mask in Photoshop, or Enhance > Unsharp Mask in Elements.

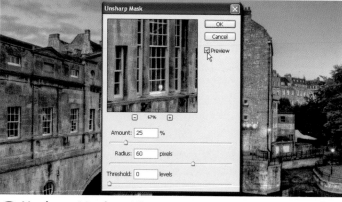

2 Unsharp Mask settings
For normal sharpening you'd keep the Radius value low, at around 0.5 or so, and the Amount high, up to around 250, but for this effect we do the reverse. Set Radius to somewhere between 50 and 100, and Amount to between 30 and 50 – the optimal settings will depend on the image. You don't need to touch the Threshold slider.

3 Find the optimal values
Here we've used an Amount of 25 and a Radius of 60, but you can use values that are quite a bit higher or lower without appreciably affecting the result. While we haven't lightened or darkened any parts of the shot noticeably, the colour and contrast boost in the midtones is striking – toggle the Preview option in the dialog on and off, or click-and-hold in the filter's preview window, to see the difference.

4 Finish Fine-tune and mask as needed
A good strategy is to overdo the Unsharp Mask settings a little and then reduce the layer opacity to suit. If you want to localise the effect, add a mask to the layer and paint with a black brush where you want to hide the effect or a grey brush to reduce it. Here we used a 50% grey brush to subdue the effect in the sky, where it made the clouds look too sharp, and in the water, where it exacerbated the colour noise. ○

How to...
Avoid HDR pitfalls

Here's how to avoid creating unreal or flawed images when merging to HDR

We've seen how it's possible to produce markedly different styles of HDR images, ranging from those that simply capture a wider tonal range to the "ultra-real", surreal and painterly. Which you choose to produce is largely a matter of taste, but it's a good idea to stop short of "overcooking" your HDR images. One of the appealing things about HDR images is their richness of colour and tone, but make sure you don't push the saturation or contrast too far. Apart from looking garish, overcooked shots may start to exhibit noise (particularly in shadow areas), missing detail, and posterisation or banding of colours. If you boost general contrast or local contrast, taking it too far can cause

haloes along contrast edges, as can oversharpening; if you opt to dodge and burn (lighten and darken) specific areas, use a large, soft brush so as to avoid leaving a hard edge between areas of differing tone, and take care not to go over the same area too much and create obvious light or dark patches. Here we'll reveal some of the most common flaws you're likely to find in your HDR images, so that you know what to watch for. Try creating an HDR image from the shots in the Flaws folder on your DVD and see if you can avoid them. We've included an example of ghosting (at the bottom-right of the merged image) in the Ghosting folder, in addition to the component images.

1 Movement from shot to shot
We can't overstress how vital it is to use a tripod when shooting images for merging to HDR. Even if your camera moves just a little between frames, the HDR image can be ruined. As we've seen, the Merge to HDR command has an option that will force Photoshop to align your frames, but it can't work miracles. If you haven't got a tripod, find a railing, tree or other solid support to brace your camera against.

2 Colour temperature
One reason to shoot your component images in Raw is that if your images have a colour temperature mismatch, it can be corrected for each one in ACR. When you first open the images in ACR, click on each and check the colour temperature readout at the right-hand side. Now click on the next image and check its readout and, if it's not the same, change it using the slider, save, and merge the edited versions.

3 Haloes along contrast edges
One of the most common flaws in HDR images is bright, surreal haloes around high-contrast edges, such as where buildings meet the sky. The culprit is heavy-handed use of the Radius and Threshold sliders when converting the image to 16-bit. Keep the Threshold value low – in fact, it's often best to start with both sliders set high and reduce both values until there's absolutely no sign of haloes.

4 Ghosted objects
If your component images include any moving objects, you can get a strange, ghostly effect. This can easily be fixed by cloning, though, which you should do as a matter of course at the end of your HDR workflow – do it on the 16-bit image after conversion. Use any of the cloning or healing tools, sampling a clean area near the offending object. Badly ghosted objects are best cloned away completely. ◘

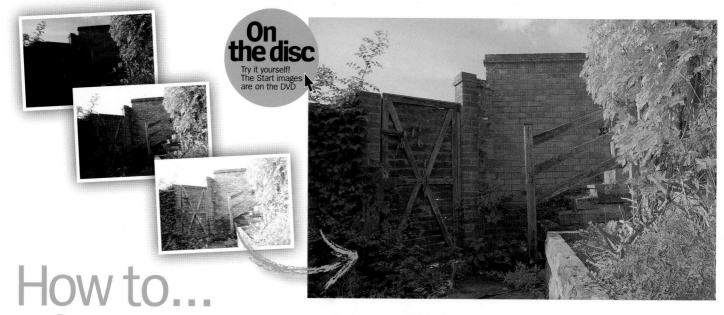

On the disc
Try it yourself!
The Start images
are on the DVD

How to...
Photomerge Exposure

Elements 8 introduced ingenious new tools that enable you
to create HDR-style effects by merging different exposures

WHAT YOU'LL NEED *Elements 8 or 9*
WHAT YOU'LL LEARN *How to use Photomerge Exposure to create*
HDR-style images by combining different exposures
IT ONLY TAKES *10 minutes*

**Elements doesn't have the Merge to HDR command, but if you're
using Elements you can use specialist third-party software such as
Photomatix Pro to generate HDR images.** Alternatively, Elements 8
introduced an "automated" tool that enables you to combine multiple
differently exposed shots of the same scene into one well-exposed
image with extended apparent dynamic range. Photomerge Exposure
doesn't produce the true HDR images that you get from Merge to HDR
and Photomatix Pro. However, the Automatic option works well with
three bracketed exposures if you just want to capture a high-contrast
scene without tone-mapping or other effects. It's very quick, and you
can of course enhance the merged image further with Elements' tools
to bring out shadow or highlight detail, among other things.

Here we'll introduce you to using Photomerge Exposure to blend
three different exposures of the same scene. Note that if you're
shooting Raw files you'll need to convert them to DNGs, otherwise
Photomerge will generate a preview of the merged image but won't
be able to generate the image. You may also find that Photomerge
struggles to align images precisely if you haven't used a tripod,
in which case you'll see "ghosting" or other artifacts in the merged
image. For HDR-style images, Automatic mode is the way to go; the
Manual mode is more useful for picking out a definable area in one
shot and blending into the background of another. Unless the contrast
is good, however, you'll find it's easy to select and transplant areas you
don't want with Manual mode, so you may need to undo and try again
a few times to get a perfect result. You can also use the Eraser Tool to
erase brush strokes in the Foreground window to remove those areas
from the Background image. Use the Transparency slider to blend
areas together, and the Alignment Tool to place markers on matching
points to align your shots if need be.

1 Start Open your source images
In Elements 8 or 9 you can blend two or more different exposures
of the same scene with Photomerge Exposure. It's a fairly basic tool,
but the Automatic option can do a good job of blending three or more
shots. (The Manual option is less useful – see opposite.) Go to File >
Open, and select the three shots in the Photomerge folder on your DVD.

2 Launch Photomerge
Go to File > New > Photomerge Exposure, or switch to Guided Edit
mode, go to the Photomerge options and choose Exposure. The default
option is Automatic – if the Manual options appear, click the Automatic
tab, and Elements will align and blend the three selected exposures. As
you can see here, the default merge isn't bad at all.

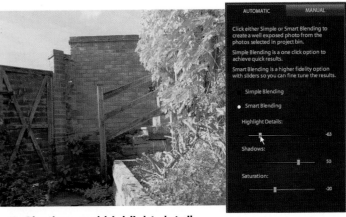

3 Customise the blend

If you switch between Simple Blending and Smart Blending, you'll get slightly different results; if you use the latter you can fine-tune the effect using sliders. At the default settings the image is oversaturated and the shadows are a bit dark, so pull Saturation to the left to around –20, and Shadows to the right to around 50 to lighten the shadows.

4 Shadow and highlight detail

If you drag the Highlights Detail slider to the left, the highlights are brightened, but if you go too far you'll clip areas to white, as here. If you drag it to the right, you'll pull back highlights that are close to clipping and restore detail and colour in those areas. Don't move it too far, though – you want to keep enough highlights to create contrast.

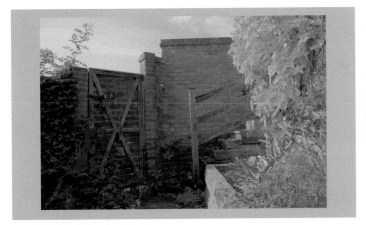

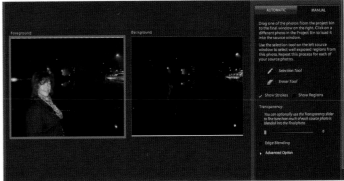

5 Finishing touches

In this case the default Highlights Detail setting of 50 is fine. Click Done to create the merged image. You can make further edits in Full Edit mode if needed – here we've cropped the image to get rid of the mismatched edges created by the alignment process.

6 Manual mode

The Manual option enables you to combine well-exposed areas from two or more photos by drawing over them to mark which areas you want to include; it's ideal for working with two night shots where one has been taken using flash and the other hasn't. Open the two shots from the Photomerge2 folder on your DVD, go to Photomerge as before but this time click the Manual tab.

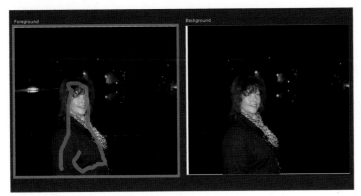

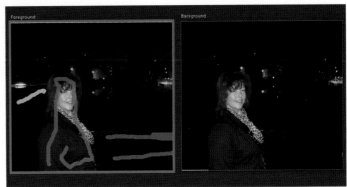

7 Define the areas you want

We'll add the flash-lit shot of our subject to the other image, in which she's underexposed but the background lighting looks more natural. Drag the shot in which the subject is dark onto the Background window, then click the flash-lit shot to display it in the foreground window. Click the pencil icon to activate the Selection Tool, and draw over the subject as shown (just roughly will do to start with).

8 Finish Fine-tune

Photomerge has done a pretty good job of transplanting our subject into the background image. However, while it's also selected the railings behind her, it hasn't selected those to the right, and it's also added part of the background behind her head. The results you get will depend on exactly where you draw with the Selection Tool, and you'll generally need to do some fine-tuning and erasing. ◙

Effects & Projects 7

To finish, here's a selection of enhancements and creative effects you can apply to transform your photos, plus a couple of ideas for using your shots in practical projects

Original shot

How to...
Add interest
to dull skies

On the disc
Try it yourself!
Start image and
video on the DVD

Give bland skies a makeover and lift your shots using Photoshop
to re-create the effect of a lens-mounted graduated filter

WHAT YOU'LL NEED *Any version of Photoshop or Elements*
WHAT YOU'LL LEARN *How to fake a graduated filter effect, how to
master Photoshop's Gradient Editor*
IT ONLY TAKES *15 minutes*

**When it comes to landscapes, a bland blue sky will look much more
interesting if it gradually changes colour towards the top of the
frame.** You can achieve this effect in-camera by placing a graduated
filter over the lens. This adds texture to the sky's previously uniform

swathe of colour and creates a more balanced composition. However,
once you've used a graduated filter on location, the sky's colour
gradient is permanently set. By reproducing this graduated filter effect
digitally in Photoshop instead, you give yourself much more freedom to
make the style and intensity of the gradient better suit the composition
of each shot you take.

In this tutorial we'll show you a simple way to configure Photoshop's
Gradient Tool and draw a gradient that transitions between the sky's
natural colour and a compatible darker blue.

George Cairns

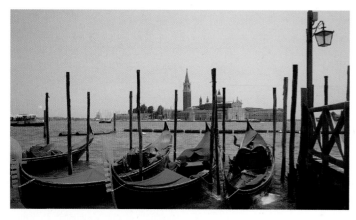

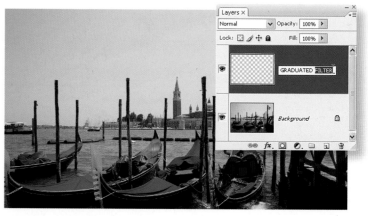

1 Start Open your image
First, open Graduated_start.jpg from the FX Grad folder on your
DVD. The cloudless blue sky in this Venetian seascape looks a bit bland
and desaturated compared to the bright foreground, but it's possible to
improve the composition by making the sky appear more dominant and
detailed, and thus make the whole scene more appealing.

2 Label a layer
Go to Window > Layers to open the Layers palette if need be, then
click the Create a new layer button. Double-click the name Layer 1 and
rename the layer "Graduated Filter". It's always good practice to label
layers as soon as you create them, because this helps you to identify
each layer later (especially if you're working on a multi-layered project).

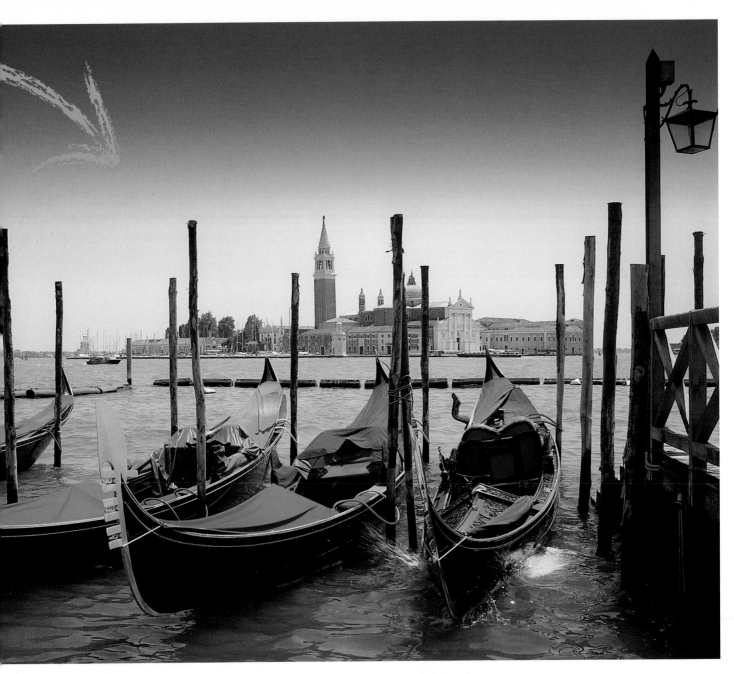

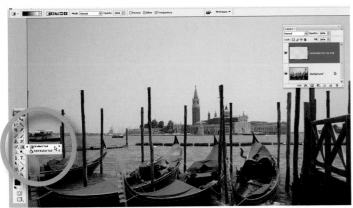

3 Grab the Gradient Tool

Switch to the Gradient Tool (or press the G key to activate it). The tool options bar at the top of the window will change to provide you with a variety of gradient-editing tools. The default gradient will transition between the black and white foreground to background colours, but you'll need to do some tinkering to create a graduated sky filter.

4 Edit the gradient

Click on the gradient preview at the left-hand end of the options bar to open the Gradient Editor. In this dialog, you'll see a collection of gradient presets, such as the default Foreground to Background. You can select any of these presets and then modify it to create your own custom graduated sky filter effect. »

5 Change the preset

Click the Foreground to Transparent gradient preset (the second one). The Gradient Tool will now draw a gradient that gently blends from the black foreground colour to 100% transparency, which makes it behave in a similar way to a lens-mounted graduated filter.

6 Edit the Color Stop

To replace the default black foreground with a more suitable blue colour, double-click on the colour part of the Color Stop (the box part, rather than the arrow) at the foot of the gradient preview bar. A Color Picker will pop open, in which you can set the new colour.

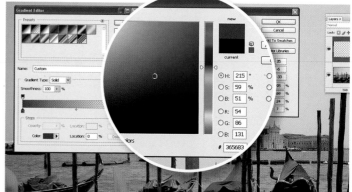

7 Sample the sky

To choose a natural sky blue, move your mouse pointer over the sky. It will turn into an eyedropper, and you can now simply click to sample the sky colour. This will become the new foreground colour, but you'll also see lighter and darker versions of this colour in the large colour field at the left-hand side of the Color Picker.

8 Darken the colour

Click inside the colour field to pick a darker shade of the shot's blue sky. Alternatively, to use the same dark blue colour we chose, you can type precise values into the boxes to define a colour – try typing 54, 86 and 131 into the R, G and B boxes respectively. Click OK to close the Color Picker, and again to close the Gradient Editor.

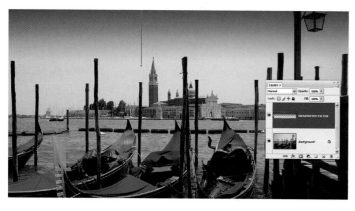

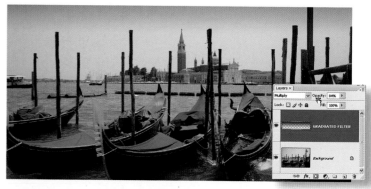

9 Draw a gradient

Ensure that the Linear Gradient type is selected in the tool options bar, then click on your Graduated Filter layer's thumbnail in the Layers palette to target it. Click-and-drag to draw a linear gradient from the top of the image to just above the mooring posts. To create a perfectly straight gradient, hold down the Shift key as you draw.

10 Finish Better blends

You'll notice that the graduated sky obscures the top of the lamppost. To fix this, change the Graduated Filter layer's blending mode to Multiply. This reveals the colours and tones of the lamppost and also blends the gradient's darker blue with the sky's original colour to create a more realistic blend. Finally, reduce the layer's opacity to about 85% for a more subtle effect. 📷

On the disc
Try it yourself!
Start image and
video on the DVD

Original shot

How to...
Get smart
with filters

Using Photoshop's Smart Filters, you can get more creative with
artistic effects without destroying your original photo. Here's how!

WHAT YOU'LL NEED *Photoshop CS3 or newer*
WHAT YOU'LL LEARN *How to add special effects in a non-destructive way,
when and how to use Smart Filters in Photoshop, how to use blending
modes to increase your filter options*
IT ONLY TAKES *20 minutes*

**As we've already noted, there's often more than one way to do
something in Photoshop, but where you have the option it is always
a good idea to try to use the method that will let you go back and
change what you have done later.** Such "non-destructive" editing is at
the heart of good Photoshop working practice. If you try to avoid altering
your photo's original pixels, using features such as adjustment layers and
layer masks instead of applying adjustments directly or erasing, you can
re-do or tweak an effect later on, or remove it if you change your mind.

Unfortunately, there are effects that most versions of Photoshop will
not allow you to apply in a non-destructive manner. Filters are the best
example. In Elements and all versions of Photoshop before CS3, you
have to apply a filter to an image layer. And even if you applied a filter to
a copy of the image layer (for the sake of good practice), you still couldn't
go back and tweak the setting you used later that day, or in years to
come, when you wished you had used a different effect.

But with the arrival of CS3 a new type of layer was introduced
which enables you to apply filters in a non-destructive fashion so
that your settings can be altered at any point in the editing process
(or in months or years to come, provided you saved the image in
Photoshop's own .psd file format). Using these Smart Filters is not
just good working practice, it also encourages you to get more
inventive with artistic effects, so read on.

1 Start Use the Smart option
Open Smart_start.jpg from the FX Smart folder on your DVD in Photoshop CS3 or newer. First you'll need to convert the Background layer so that it can be used for Smart Filters. To do this, go to Filters > Convert For Smart Filters. If you get an alert that the image will be turned into a Smart Object, that's what you want, so just click OK.

2 Check the Layers palette
To check that the image is now ready for Smart Filters, look at the Layers palette (go to Window > Layers if this is not already visible). The Background layer will have been renamed Layer 0, and the thumbnail for this layer will have a small symbol in the bottom right corner indicating that it is now a Smart Object.

3 Get out the art tools
Next, we'll add a filter that makes the image look like a sketch or painting. To do this, go to Filter > Artistic and a wide range of options will appear. All of these filters use the same interface, so it doesn't matter which you choose, because you can swap the selection later. However, let's choose the Rough Pastels option for now.

4 Set the strokes and texture
The Rough Pastels filter provides a wide range of options, which allow you to choose the strength and length of your electronic pastel strokes, plus the texture and lighting of your digital canvas. We set the Stroke Length to 9, the Stroke Detail to 8, the texture to Canvas, left Scaling at 100%, Relief 9 and Light Direction at Bottom. Click OK.

5 Seeing Smart Filters
Back in the Layers palette, you'll notice a new Smart Filters sub-layer, complete with its own white ("reveal all") layer mask attached to it. Below this is the Rough Pastels layer. To revisit the filter settings and alter them if you wish, simply double-click on the words Rough Pastels to reopen the Filter Gallery interface.

6 Tweak the Pastel effects
You can now change the settings you made back in step 4, or apply a different filter if you wish simply by choosing another from the drop-down menu at the top of the interface. For this exercise, we're going to move the Stroke Detail slider to the left, to set a new value of 3. Now click OK (or simply press the Return key).

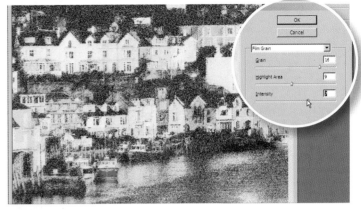

7 Apply a second filter effect

Another benefit of Smart Filters is that several effects can be applied to the same image, but each will remain independently editable. Click on the Layer 0 icon in the Layers palette, then go to Filters > Artistic > Film Grain to apply the next filter effect.

8 Add some grain

Use the sliders to adjust the size and contrast of the grain added to the image. For this image, set the Grain slider to 16, and move the Highlight Area and Intensity sliders to 10 and 7 respectively. Because this is a Smart Filter, you can go back and change these values later.

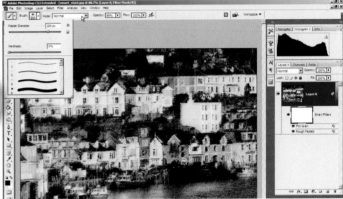

9 Blending and opacity

Click OK, and a new Smart Filter layer will appear in the Layers palette. You'll notice that alongside the name of each filter there is a small icon (two horizontal lines and two arrows). Double-click this and the blending mode and opacity options for that filter will appear. You can lower the opacity to soften the effect, or change the mode from Normal to Soft Light to increase the contrast.

10 Finish Make use of the mask

Click on the white layer mask next to the words Smart Filters in the Layers palette. By painting on this with black or grey, you can hide or reduce the effect of all the Smart Filters in the image. Here, paint over the fishing boats with a soft black brush set to an opacity of around 70% to add detail back into this focal point area and restrict the filter effects mainly to the foreground and background. ◘

Get to know... Smart Filters
Master the Smart Filters controls and improve the way you work

① Smart Object symbol
The symbol in the bottom-right corner of the layer thumbnail tells you that the layer has been converted to a Smart Object, so it can have Smart Filters applied to it.

② Smart Filter eye icon
Clicking on this visibility eye icon (so that it disappears) hides all the Smart Filter effects you have applied to that layer.

③ Individual eye icons
Clicking here hides the individual filter effect. The effect re-renders every time you do this, so can take some time if the file size is large (or if your computer is slow).

④ Smart Filter "layers"
Smart Filters are listed under the layer they are applied to. Double-click the name of one to alter its settings or replace it with another filter. Drag filters up or down the list to change their stacking order.

⑤ Blending Options
Double-click this to change the Blending Mode or opacity of the individual filter.

⑥ Mask
Click this and paint on the image using a black brush to mask the effect of all the Smart Filters applied to the layer (but note that you can't mask them individually).

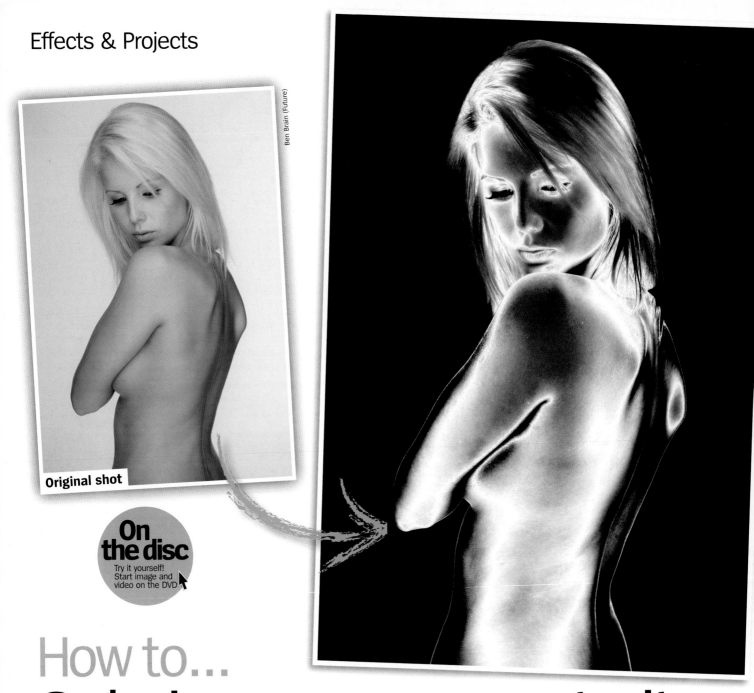

Ben Brain (Future)

Original shot

On the disc
Try it yourself!
Start image and
video on the DVD

How to...
Solarise a mono portrait

Looking for fresh new ways to edit your mono shots? Utilise Photoshop's
powerful Curves command to re-create a traditional darkroom technique

WHAT YOU'LL NEED *Photoshop CS or newer*
WHAT YOU'LL LEARN *How to alter tone using Curves, how to invert
specific tones, how to lighten dark tones using layer masks*
IT ONLY TAKES *10 minutes*

**There are many different ways you can edit your colour images to
produce striking black-and-white prints (see Part 5, page 128), but
here we'll show you how to give your monochrome images a creative
spin.** In this project we'll show you how to transform a portrait by
emulating the solarisation technique made famous by surrealist
photographers such as Man Ray as far back as the 1920s.

At first glance a solarised photo may look like a negative version of
the mono image. However, in a negative all the shadows and highlights
are reversed so that blacks become white and vice-versa. Solarised

images, on the other hand, feature a wide range of contrasting tones,
only some of which are reversed. Another distinctive property of a
solarised photo is the sharp white line that appears around high-contrast
areas. This makes the textures in the photo look shiny, which, as in the
image above, enhances and emphasises the soft contours of a human
subject's skin.

The solarisation effect was discovered by accident and is tricky to
produce in the traditional darkroom, but thanks to the tools packed into
Photoshop's digital darkroom you can create a solarised image with
ease. On the opposite page we'll show you how to discard a shot's
colour information and use the Curves command to create a classic
solarised effect. You'll also use Curves in a more traditional way to boost
the contrast between the highlights and shadows, and fine-tune the
results with a bit of old-school dodging and burning.

1 Start Desaturate the colour shot

Open Solarise_start.jpg from the FX Solar folder on your DVD. To quickly convert the shot to black-and-white, go to Image > Adjustments > Desaturate (or press Ctrl-Shift-U). As we've seen, this isn't an ideal way to convert to mono: you'll see that the desaturated image looks a little washed out, reducing the impact that the photo had in colour.

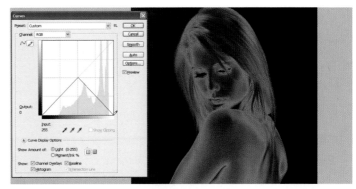

2 Solarise with Curves

To create the distinctive solarised effect, go to Image > Adjustments > Curves. Click the pencil button to draw a curve by hand instead of just modifying one. Hold down the Shift key and click in the bottom left-hand corner (where Output and Input both read 0). Still holding Shift, place a second point in the middle of the curve (at Output 128, Input 128), then a third at the bottom right (Output 0, Input 255). Click OK.

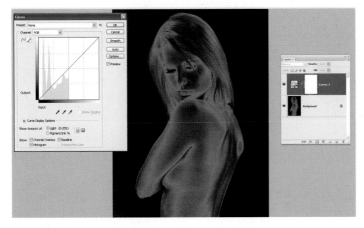

3 Adjust the tones

In step 2, the curve we drew follows the normal curve up to the midpoint, so it inverts the highlights but leaves midtones and shadows untouched, and the subject's eyelashes, for example, are still black. The shot still looks washed-out, so now add a Curves adjustment layer.

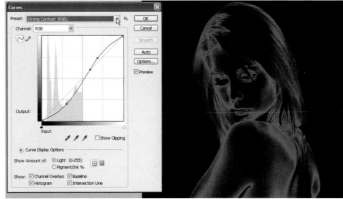

4 Try a contrast preset

You could try to boost the image's contrast by going to the Curves dialog's Preset menu and choosing the Strong Contrast (RGB) curve. This automatically places points on the curve, darkening the shadows and midtones and brightening highlights. There's still not enough contrast, though, because there are no pure whites in the image.

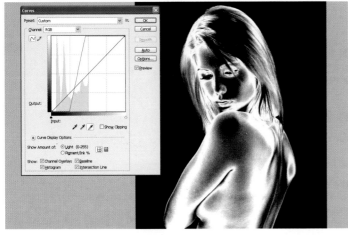

5 Try a manual adjustment

Click the left-hand eyedropper in the dialog, and click with it on an area of the image that should be jet black (such as the bottom-left corner of the image). This will darken the shadows. Now click the right-hand eyedropper and click on one of the brightest points on the model's skin to brighten the highlights. Click OK when you're finished.

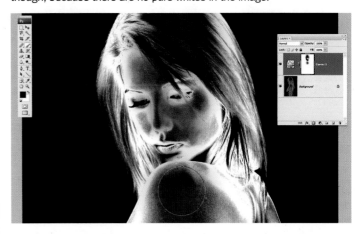

6 Finish Dodge the shadows

Finally, switch to the Brush Tool and click the brush preview in the options bar to open the Preset picker. Choose a soft brush tip, and set the Radius to 600, Opacity to 21% and Flow to 25%. Now click the Curves adjustment layer's mask thumbnail to target the mask and brush over the dark shadows on the face and shoulder – the effect in this case will be to "dodge" (lighten) those areas. ◻

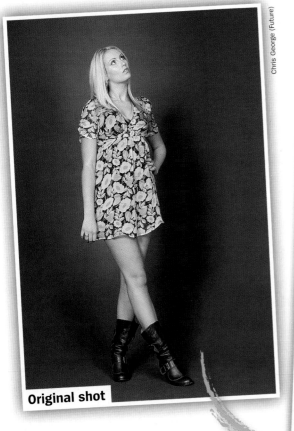

Original shot

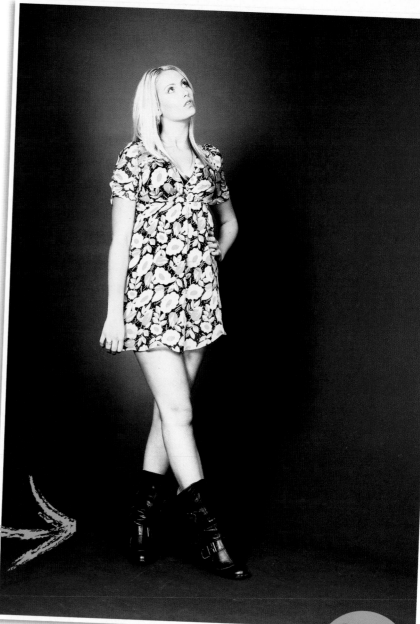

Chris George (Future)

On the disc
Try it yourself!
Start image and
video on the DVD

How to...
Give portraits a cross-processed look

Fashion photographers used to develop film in the wrong chemicals on purpose to create striking colour effects. Here's how to achieve the look in Photoshop

WHAT YOU'LL NEED *Photoshop CS or newer*
WHAT YOU'LL LEARN *How to use the Cross Process preset in the Curves dialog, how to adjust Curves manually to get exactly the colours you want*
IT ONLY TAKES *10 minutes*

Cross-processing is one of those effects, created in the traditional photographic darkroom, that refuses to die. The slightly psychedelic effect that it produces looks like a throwback to the days of flower power, but the mismatched colours are still much loved by the style press, and the effect can be seen in practically every fashion or music magazine you pick up.

To create the effect in the traditional darkroom, you need to shoot using a roll of colour print film, then, when developing the film, you deliberately work with the wrong chemicals: instead of using the correct print film solution, you use chemicals designed for slide film. The result is a high-contrast image with strange colour casts, featuring purple-pink skin and green-blue shadows.

These days, you can re-create the same effect using Curves in Photoshop. The secret is to use the three colour channels within the Curves dialog, using a different S-shaped curve for the Red, Green and Blue channels to get the strange mis-processed look. Best of all, it's easy to control the effect, so the results are much less hit-and-miss than the chemical counterpart. Read on to find out how it's done!

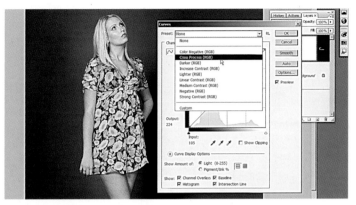

1 Start The simple solution

Open Cross_start.jpg from the FX Cross folder on your DVD, then add a Curves adjustment layer. Next, click on the dialog's Preset menu (it reads "None" by default) and choose Cross Process (RGB) from the drop-down menu that appears. This preset makes a good start at creating the effect we're after.

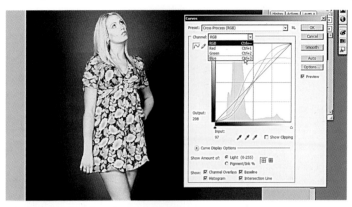

2 Make the background blue

The automated effect gives our shot a green background, but you can tweak this if you like. Choose Blue from the dialog's Channel menu. Click on the second anchor point from the top of the S-shaped blue line and push it up to the top and to the left. Next click on the bottom anchor point and drag it down slightly. The backdrop will now appear blue.

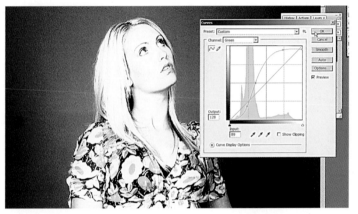

3 Seeing green

Next, choose Green from the dialog's Channel menu. You'll see that the curve has five anchor points – one point at each end and three creating an S-shaped curve in the centre. Move the top two anchor points up a little. This will give the skin tones (the light areas in the image) a slight green tinge.

4 In the pink

Next, choose Red from the dialog's Channel menu. Once again, you'll see an S-shaped curve with five anchor points in the Curves window. Click on the fourth anchor point up and push this upwards as far as it will go. Again, this will target the light skin tones in the image, which will now take on a purple-pink colour.

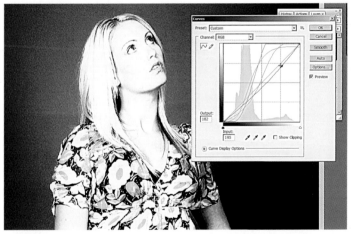

5 Reduce the brightness

The previous steps have increased the contrast in the image and skewed the colours, but the shot now looks too bright overall. To fix this problem, choose RGB from the dialog's Channel menu. Now click on a point about three-quarters of the way up the straight black line and drag it downwards slightly.

6 Finish Brush over the face

Click OK in the Curves dialog. The result so far is good, but you'll see that some detail has been lost in the face. Click the Curves layer's mask thumbnail, then switch to the Brush Tool. Set the brush colour to black, Opacity 30%, Width 175 pixels and Hardness 0. Now carefully paint over the model's face and hair. This will restore detail, reduce brightness and make the face more pink. ◘

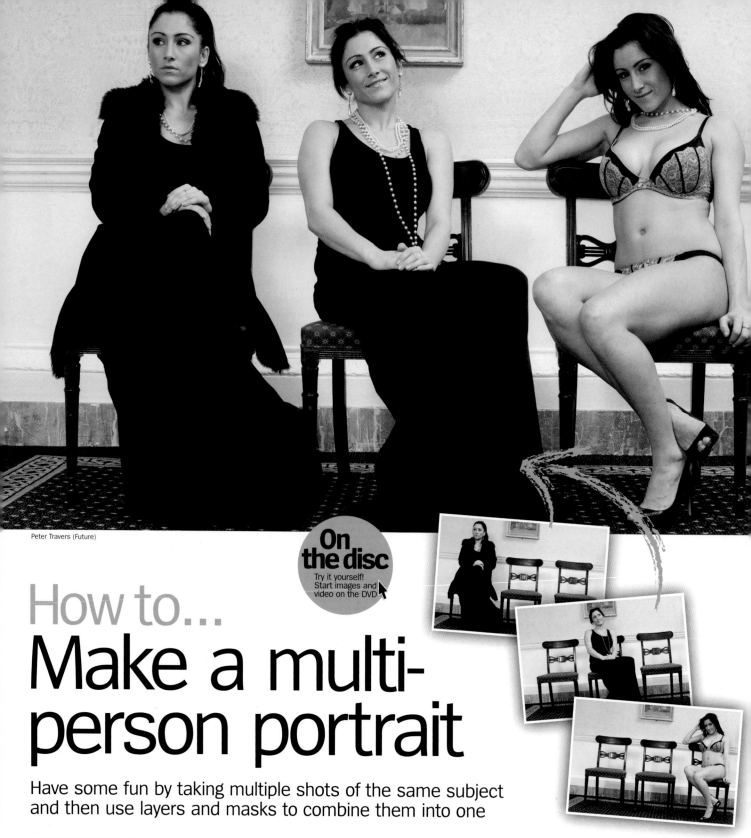

Peter Travers (Future)

How to...
Make a multi-person portrait

Have some fun by taking multiple shots of the same subject and then use layers and masks to combine them into one

WHAT YOU'LL NEED *Elements 9 or Photoshop CS and newer*
WHAT YOU'LL LEARN *How to stack several shots of the same scene using layers, how to reveal different areas using layer masks*
IT ONLY TAKES *15 minutes*

We've already seen how to combine different shots of the same scene in one file and then use layer masks to conceal and reveal different areas of each layer (see page 96). Here we'll use the same techniques to reveal the subject in three different shots to create a "multi-person" portrait. We shot our start images by setting up our camera on a tripod, used off-camera flash light, and fixed our exposure in Manual mode to 1/50 sec at f/9 and ISO 800; this ensured that our subject was always

sharp in the frame and the lighting was consistent across the frame. We directed our model to pose in a variety of outfits and sit on different chairs in order to tell the story, and also made sure her positions didn't overlap as we took each shot. You could use as many frames as you like, depending on your subject, scene and personal preference.

In Elements 8 and older, there's no "Add layer mask" button in the Layers palette, but it is possible to add a mask to an image layer. Add an adjustment layer such as Levels that doesn't apply an instant effect, OK it without touching its settings, then drag this layer beneath the layer you want to mask. Alt-click on the line between the two layers in the stack, and the Levels layer's mask will act as a mask for the image layer. Repeat this for each layer you want to mask. Otherwise, just follow our steps...

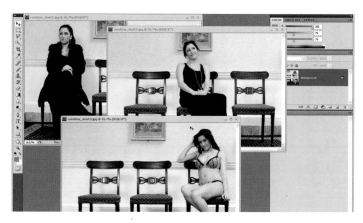

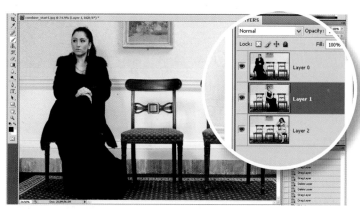

1 Start Select the start images

Open the three images from the Composite folder on your DVD. To place them on separate layers top of each other, simply switch to the Move Tool, hold down the Shift key, then drag and drop combine_start2 .jpg and combine_start3.jpg on top of combine_start1.jpg. (Holding down Shift just ensures that they'll be aligned with one another.)

2 Stack up the layers

Close combine_start2 and combine_start3.jpg. You'll now see three layers in the Layers palette (go to Window > Layers to open it if it isn't visible): Layer 1, Layer 2 and the Background layer. Double-click the Background layer thumbnail to unlock it; the name Layer 0 will do. Drag Layer 0 to the top of the stack, and if need be drag Layer 1 (the shot with the model sitting on the middle chair) up to the middle of the stack.

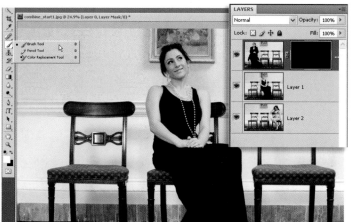

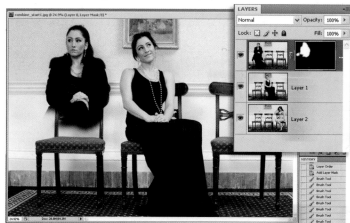

3 Add a layer mask

Highlight Layer 0, hold down the Alt key, and click on the Add layer mask button in the Layers palette to add a black "hide all" mask to this layer. Switch to the Brush Tool, and in the options bar set the brush size to around 300 pixels, Mode to Normal, and Opacity and Flow to 100%. Tap D, then X if necessary, to set the foreground colour to white.

4 All will be revealed

Now simply paint the area over the left-hand chair to reveal the model in that position on Layer 0. Paint slowly and carefully so you don't paint over the model in the middle and reveal the empty chair in Layer 1 beneath. It helps to get in closer, so zoom in (hold down Ctrl and tap the + key) to 50% or a larger magnification to paint more accurately.

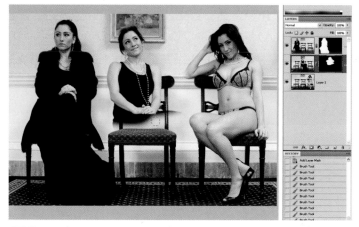

5 Reveal some more

Now click the Layer 1 thumbnail to highlight this layer, and Alt-click the Add layer mask button to add a black mask to this layer, concealing its content. Target the mask as before and paint with a white brush, this time carefully painting over the middle chair to reveal the model on this layer, so you can see all three portraits in one image.

6 Finish Made a mistake?

Don't panic if you accidentally paint over the wrong area; simply tap the X key to swap your brush colour to black and then paint that area of the mask back in. Tap X again to return the brush colour to white to continue painting and reveal areas on the currently highlighted layer. You can touch-up the mask on any layer at any time – just make sure you've clicked the correct mask thumbnail to target the layer you want. ◘

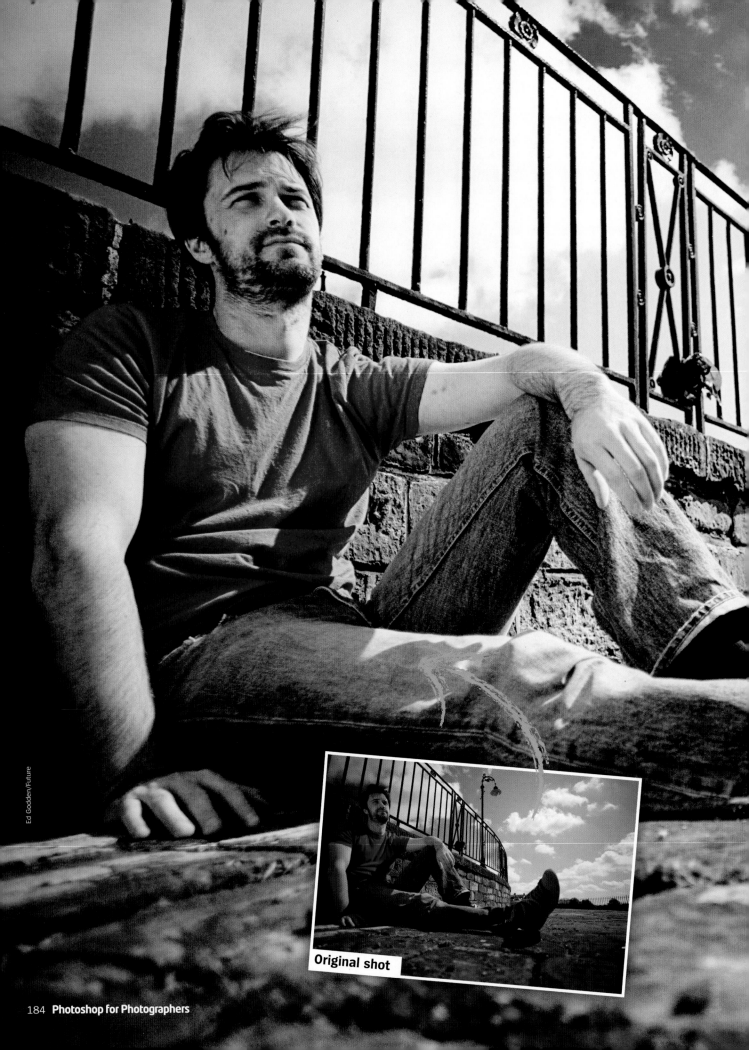

Original shot

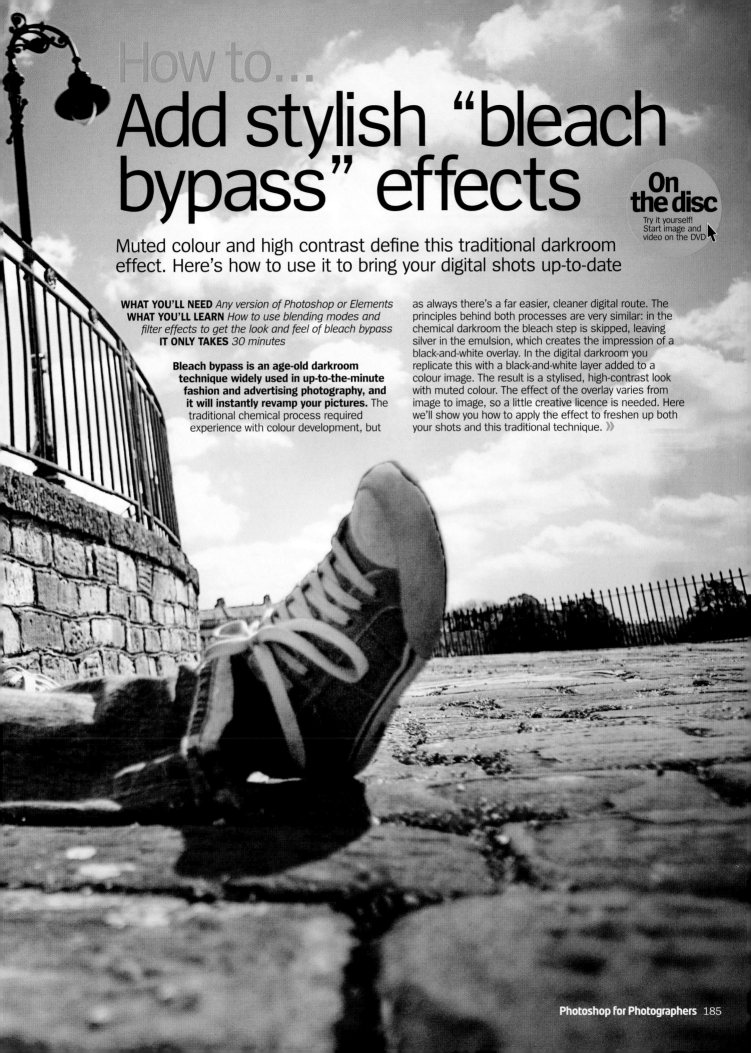

How to...
Add stylish "bleach bypass" effects

Muted colour and high contrast define this traditional darkroom effect. Here's how to use it to bring your digital shots up-to-date

WHAT YOU'LL NEED *Any version of Photoshop or Elements*
WHAT YOU'LL LEARN *How to use blending modes and filter effects to get the look and feel of bleach bypass*
IT ONLY TAKES *30 minutes*

Bleach bypass is an age-old darkroom technique widely used in up-to-the-minute fashion and advertising photography, and it will instantly revamp your pictures. The traditional chemical process required experience with colour development, but

as always there's a far easier, cleaner digital route. The principles behind both processes are very similar: in the chemical darkroom the bleach step is skipped, leaving silver in the emulsion, which creates the impression of a black-and-white overlay. In the digital darkroom you replicate this with a black-and-white layer added to a colour image. The result is a stylised, high-contrast look with muted colour. The effect of the overlay varies from image to image, so a little creative licence is needed. Here we'll show you how to apply the effect to freshen up both your shots and this traditional technique. »

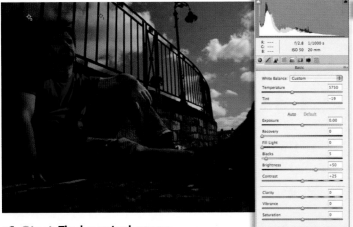

1 Start Find neutral areas

Open Bleach_Before.tif from the FX Bleach folder on your DVD. To begin, we need to correct the shot's colour by setting the white balance. Using the Color Sampler Tool, click on several neutral points of the image – points whose R, G and B values (displayed just beneath the histogram) are the same or very close.

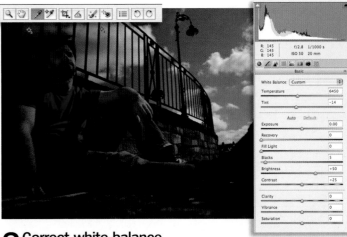

2 Correct white balance

Switch to the White Balance Tool and click on one of the points made with the Color Sampler Tool. Setting the white balance isn't an exact science, so click around the points to find which one produces a result that looks right. Once done, switch to the Hand Tool to avoid resetting the balance.

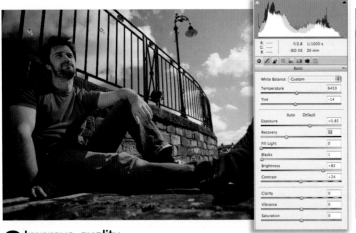

3 Improve quality

We can now look at the overall image quality and make adjustments using the sliders under the Basic tab. Start by switching on the clipping warnings (tap U for the shadows and O for highlights). Now use the sliders to adjust the image to improve the histogram. When you're happy, click Open Image.

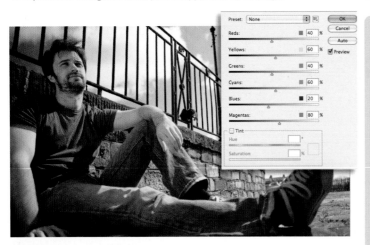

4 Duplicate layers

In Photoshop proper, we want to start by creating a mono layer to overlay the colour image, analogous to the silver that remains in the chemical process. Go to the Layers palette and start by duplicating the Background layer twice, then change the blending mode of the top layer to Screen.

5 Blend colour layers

The image should suddenly lighten. Making sure you still have the top layer targeted, press Ctrl-E to merge it down into the layer below. We now want to make our high-contrast Black & White layer. Click the "Create adjustment layer" button in the Layers palette and select Black & White from the list.

Elements workaround
Convert to mono

If you're using Elements, you don't have the luxury of a Black & White adjustment layer. Instead click on Enhance > Convert to Black and White. You'll be able to get a very similar effect using the selection of conversion presets on the left of the dialog.

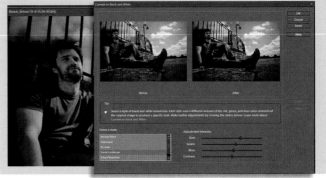

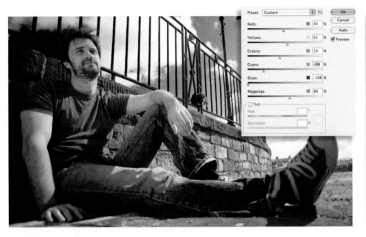

6 Fine-tune the mono conversion

Move your mouse pointer over the image (in CS4/5, click the eyedropper icon) and you'll see the pointer change to an eyedropper. Click onto one of the tones in the image and drag to the left or right – you'll see the tones lighten or darken. Adjust the image to increase the contrast.

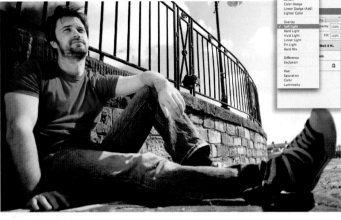

7 Clip to one layer

We want the black-and-white effect to apply only to the present top layer. Hold down Alt and click on the line between the adjustment and image layers: this creates a clipping group, so the adjustment affects only that layer. Now change the layer's blending mode to Soft Light.

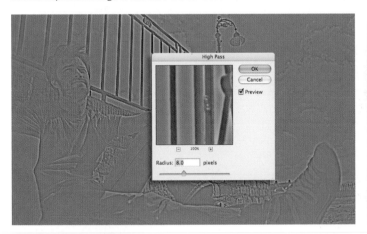

8 High Pass Filter

Click back on the Background layer and create another duplicate of it, then drag this new copy right to the top of the stack. Now go to Filter > Other > High Pass and set the value to about 8 – or with an image of your own, adjust this so that you get something that looks like an embossed imprint, and click OK.

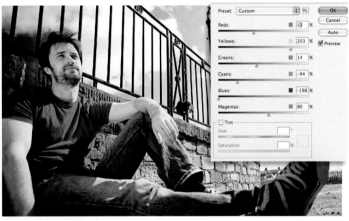

9 Mute colours

Now change the blending mode of the High Pass layer to Overlay, and we're almost done. To make subtle adjustments to the tones, you can double-click on the Black & White adjustment thumbnail in the Layers palette and use the eyedropper as before to lighten and darken areas as required.

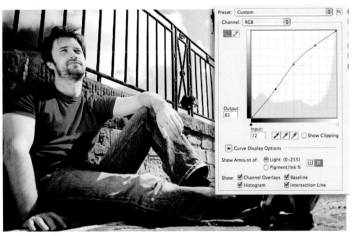

10 Increase the contrast

To really take control over the tones and increase contrast in the exact areas of the image that we want, we need to use Curves. Add a new Curves adjustment layer, anchor the midpoint, then pull the highlights up and the shadows down to create an S-shaped curve and boost the contrast.

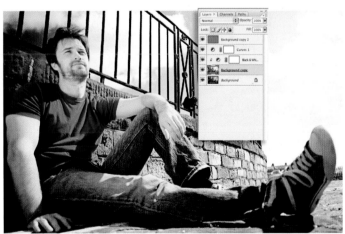

11 Finish Finishing touches

To complete the effect, switch to the Burn Tool, select Shadows in the Range menu and set the Exposure to 5%. Brush lightly to burn in the shadows, then switch to the Dodge Tool, set Range to Highlights, and lighten the highlights where necessary to create a suitably ultra-high-contrast look. 📷

Original shots

Ben Brain & Ali Jennings (Future)

How to...
Cook up a classic cyanotype

For a distinctive finish, replicate the cool blue look of the classic photographic printing process using a few simple adjustment layers – and no messy chemicals!

WHAT YOU'LL NEED *Any version of Photoshop or Elements*
WHAT YOU'LL LEARN *How to re-create a classic cyanotype*
IT ONLY TAKES *20 minutes*

Classic cyanotypes – the original "blueprints" – were instantly recognisable by their Prussian blue colouring. Unfortunately, creating them meant using several very nasty chemicals (the first part of the name comes from "cyanide") and a lot of mess. They were also reliant on enough sun (UV light) to expose the image – a problem in rainy

England! So here's a technique that you can use to produce the effect in the digital instead of the chemical darkroom.

Cyanotypes are great for printing and look particularly good on rag paper. They're pretty flexible when it comes to style, but are more commonly associated with close-ups of flowers, such as the one we're using, and architectural images. The key to creating digital cyanotypes is using layers and layer blending modes, as well as gradients. Use our guide to transform your photos into classic-style cyanotypes which will look impressive enough to display on any wall.

1 Start Convert to black-and-white

Open Flowers_Before.jpg from the FX Cyan folder on your DVD, and start by duplicating the Background layer. Then add a Black & White adjustment layer and set the percentages as follows: Red 102%, Yellow 102%, Green 134%, Cyan −56%, Blue 20% and Magenta 80%. OK this, then merge the adjustment layer down onto the flower layer.

2 Add colour tone

Change the layer's blending mode to Screen. Next, add a Gradient Map adjustment layer. Click in the Gradient preview to open the Gradient Editor. Double-click on the Color Stop at the left-hand end to open the Color Picker and set its colour to a cyan-blue by typing 004E84 in the Hex colour field at the foot of the dialog. OK this, then click the other Color Stop and change it to white.

3 Improve tone with Levels

To improve the colour and draw out the detail of the flower, add a Levels adjustment layer and darken the tones to get a rich, dark Prussian blue background. If you find that detail on the flowers is being lost, add a layer mask and remove or reduce the effect where needed.

4 Add a grain effect

Now add a new empty layer at the top of the stack, go to Edit > Fill (Fill Layer in Elements) and choose 50% Gray in the dialog's Use menu, then click OK. Now go to Filter > Noise > Add Noise. Set Amount to 20% and click both Gaussian and Monochromatic, then click OK. This will add tone and texture to the final cyanotype print.

5 Finish Add a border

Go to File > Place and load the image Border01.jpg. Resize the border image to fit by dragging its corner or side handles, and move it into position. When done, OK this, then right-click the layer's name in the Layers palette and choose Rasterize Layer (or in Elements, Simplify Layer). Change the layer blending mode to Screen, then press Ctrl-I to invert the border layer's colours and your cyanotype is ready. 📷

Try this on...
Portraits and close-ups

Using the cyanotype effect is a great way to transform your pictures and will quickly add impact to a wide variety of different subjects. Close-ups, portraits and architectural shots all really benefit from the effect, giving them a unique, eye-catching look. Give it a try!

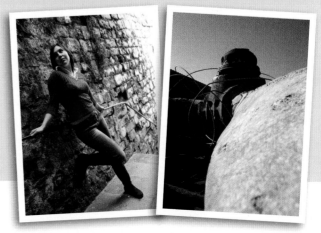

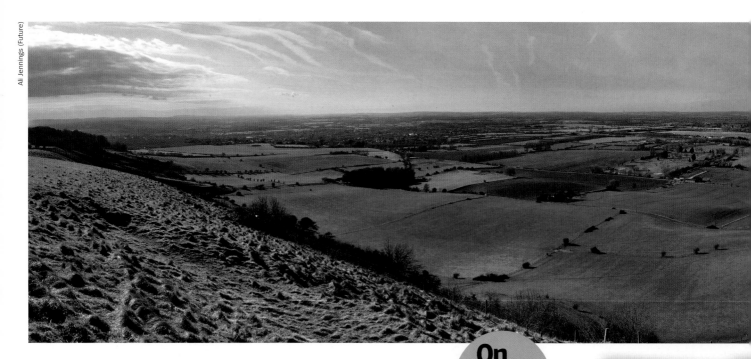

Ali Jennings (Future)

How to...
Capture the perfect panorama

Get the big picture! Here's how even handheld shots can be stitched into a flawless panorama using Photoshop's powerful Photomerge feature

On the disc
Try it yourself!
Start images and
video on the DVD

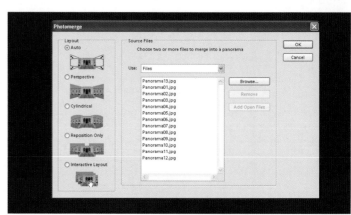

WHAT YOU'LL NEED *Any version of Photoshop or Elements*
WHAT YOU'LL LEARN *How to stitch multiple shots of parts of a scene together into a single panorama*
IT ONLY TAKES *25 minutes*

Photoshop's clever Photomerge feature makes creating huge panoramic images from multiple shots incredibly easy. There's a vast array of specialist equipment you can buy, designed to help you get an accurate sequence of shots perfectly levelled and aligned. But as you'd expect, this kit is expensive, and for most panoramic scenes it's difficult, if not impossible, to see any difference between a shot taken with pro kit and one that was taken handheld. Photoshop's Photomerge feature is powerful enough to do a great job of stitching together your handheld image sequences, correcting and compensating for any wonky horizons and changes in exposure. However, it's still important to try to get the best quality sequence you can. The images used here were shot handheld with a 50mm lens, and have an overlap of 20% to 50% to ensure the most seamless blend.

Here we'll show you how to stitch together the 13 source files you'll find in the Panorama folder on your DVD.

1 Start Load the files into Photomerge
In Photoshop, go to File > Automate > Photomerge; in Elements, go to File > New > Photomerge Panorama. When the Photomerge window appears you will see a series of layout options on the left. Make sure you have Auto selected, then in the source files area click Browse and locate the source images on your DVD. Click OK to start the process.

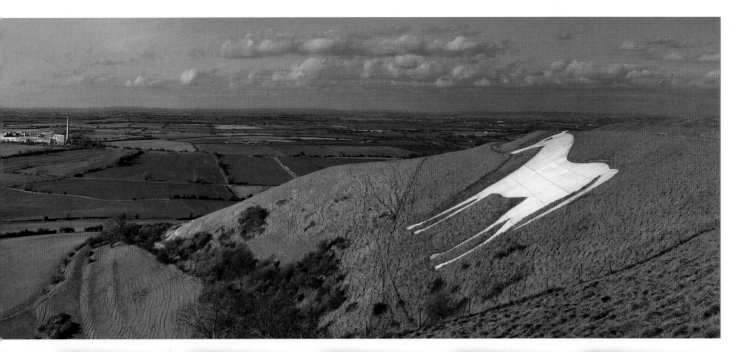

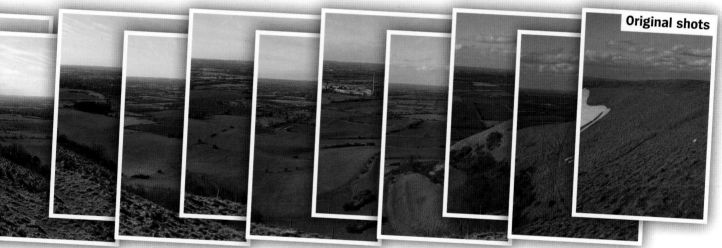

Original shots

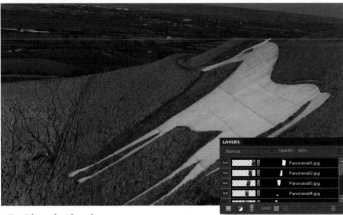

2 Check the image

Press Ctrl and + to zoom in, then hold down the spacebar and drag to move around the image and check how well Photomerge has blended the images together. You may see faint white lines at some zoom ratios; these show where the images have been blended and will disappear when the file is flattened.

3 Flatten and correct the image

To merge the blended layers together, go to Layer > Merge Visible. Zoom right out so that the panoramic image fills the screen (Ctrl-0). At the moment the horizon is bowed, but this is easy to correct. Go to Filter > Correct Camera Distortion in Elements or Filter > Distort > Lens Correction in Photoshop. Push the Remove Distortion slider to +20 – any further and you'll start to see the image fold in on itself. »

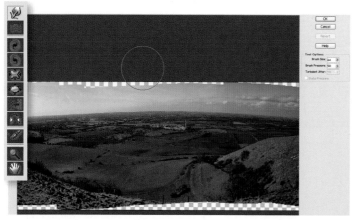

4 Further adjustments

Click OK to apply the change. Although the filter has gone some way to correcting the distortion, there's still a defined bow on the horizon. To fix this, go to the Liquify filter (in the Filter > Distort sub-menu in Elements). Choose the Warp tool – the first tool in the filter's toolbox – and increase the Brush Size to 62. Set Pressure to 50.

5 Straighten the horizon

Starting in the centre of the image, move the brush so that it meets the horizon. Now, in small movements, click and move the horizon down a touch, release the mouse and repeat a little further along the horizon until you have manually reduced the bowing. Check the horizon for any further bumps and use the same action to reduce them.

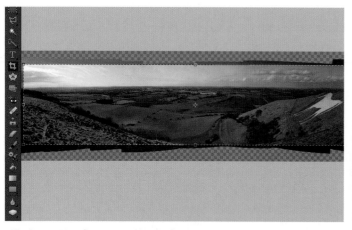

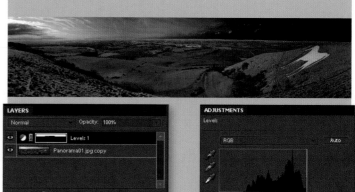

6 Crop to clean up the edges

Switch to the Crop tool and start by clicking-and-dragging from right outside the image edges to draw a marquee around the entire image. Now pull any of the handles around the edge of the crop box inwards so that any areas around the edge of the image showing transparent pixels are cropped out. Press Return to apply the crop.

7 Enhance the sky

Use the Magic Wand Tool to carefully select the sky, then go to Refine Edge and Feather the selection by 5 pixels. Add a Levels adjustment layer, and move the Black Point slider inwards to 45 and the midtones slider to 0.35. Switch to the Brush Tool, take a large black brush, and set the brush opacity to 20% and size to 1,000px.

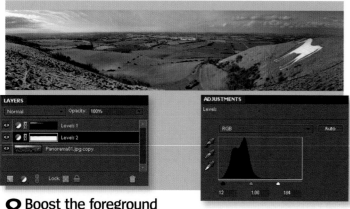

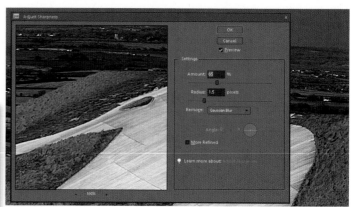

8 Boost the foreground

Click the Levels layer's mask thumbnail, then paint in large sweeping movements across the right-hand side of the sky to even out the exposure. Click the Background layer thumbnail and select the sky again. Press Ctrl-Shift-I to invert the selection, then refine the edge as before. With this selection active, add another Levels adjustment layer and pull the Black Point slider in to about 12 and White Point to 184.

9 Finish Finishing touches

To boost the colours, click the top layer thumbnail and add a Hue/Saturation layer. Increase the Master Saturation to 10. Click the layer mask and paint with a black brush to help smooth any uneven blending. Finally, flatten the image, then sharpen using Smart Sharpen or Adjust Sharpness with Amount 65 and Radius 1.5, and you're finished. ◘

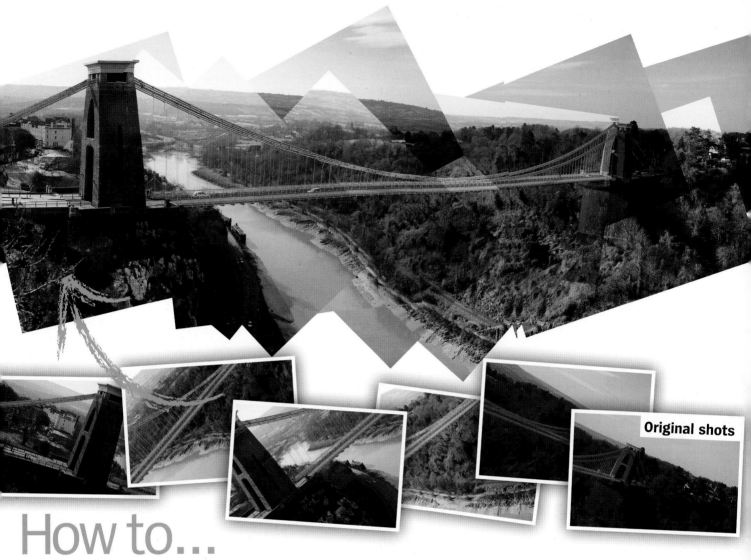

Original shots

How to...
Create an artistic photo joiner

Multi-layered composites? Go one better! Position, transform and overlap multiple shots to create an unusual Hockney-inspired photo collage

WHAT YOU'LL NEED *Any version of Photoshop or Elements*
WHAT YOU'LL LEARN *How to add multiple photographs to a single Photoshop document; how to reposition, transform and align layer content; how to change layer opacity quickly*
IT ONLY TAKES *20 minutes*

Back in the 1970s and 80s, artist David Hockney would photograph a location from multiple angles (and even at different times). He would then combine the separate shots into a single collage to evoke an impression of time and place. These striking photo collages are often referred to as "photo joiners", and they enable you to display a standard landscape shot in a unique and creative way.

When you stitch a series of shots together in Photoshop, you're normally concerned with blending them carefully together to create a seamless panoramic image (see page 200). However, joiner collages embrace the fact that multiple shots have been used, so there's no need to spend time disguising overlapping edges or attempting to make exposure, colour or perspective match between the disparate shots.

To shoot the components for your joiner, leave your camera on Auto. The difference in lighting between each shot will add texture and variety to your collage. Zoom in to get close-ups of your location and then pan the camera to capture the scene in a series of shots. Feel free to rotate the camera at creative angles, too, because this will add irregular edges to your collage and draw attention to its individual components.

Over the next couple of pages we'll show you how to assemble your joiner in Photoshop or Elements using the 12 source files on your DVD. »

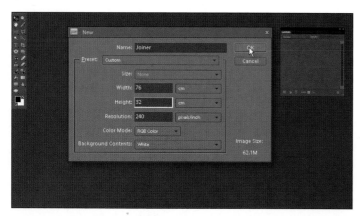

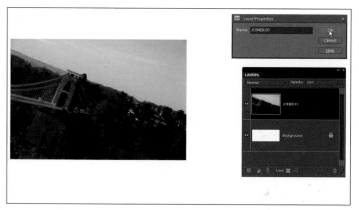

1 Start **Create a canvas**
To begin, go to File > New (and on to Blank File in Elements). Name your new document "Joiner". To accommodate the 12 full-size digital photos in a single canvas, you'll need to set Width to 76cm, Height to 32cm and Resolution to 240. Next, set Background Contents to White using the drop-down menu, then click OK.

2 **Open the first file**
Go to File > Open, then browse to the source file Joiner_001.jpg in the Joiner folder on your DVD and open it. Go to Select > All, then Edit > Copy. Return to your white canvas document and go to Edit > Paste. This will add the photo as Layer 1. Rename the layer "Joiner 01". You can now close the original Joiner_001 document to keep things tidy.

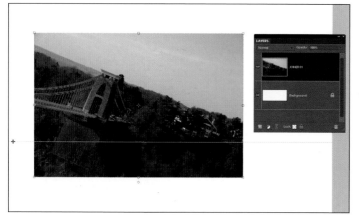

3 **Add a guide**
You'll see that the bridge is tilted at different angles in every shot. To get the tilted bridge to run horizontally, you'll need a little help. Go to View > Rulers. Click inside the top ruler and drag downwards to add a horizontal guide to the canvas. Position the guide midway down the document at about 16cm, as shown above.

4 **Rotate and position**
Go to Image > Transform > Free Transform (Ctrl-T). A bounding box will appear around the edges of the shot. Position your pointer outside the box and a rotate icon will appear. Click-and-drag to rotate the shot so that the bridge runs parallel with the guide. Drag inside the box to position the photo at the right of the canvas, then hit Return.

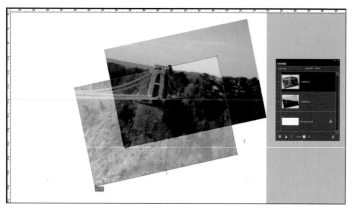

5 **Align the second shot**
Open the image named Joiner_002.jpg. Copy and paste it into the main document as before. Label the layer Joiner02 and set its layer opacity to 50%. Use Free Transform (Ctrl-T) to rotate and position the shot so that the bridge aligns with the details on the Joiner01 layer. Hit Return when you're happy and return the layer's opacity to 100%.

Expert tip
Change layer opacity with one keystroke
To align the shots you need to reduce each layer's opacity to 50%, then restore it to 100%. You can do this using the Layers palette's Opacity slider. However, a faster way to set a layer's opacity to 50% is to highlight the layer, then simply tap the 5 key. When done, tap the 0 (zero) key to restore the layer to 100% opacity.

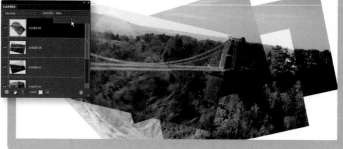

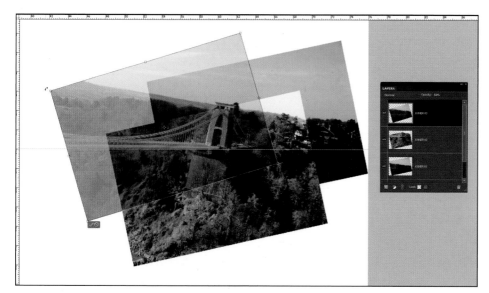

6 Rough and ready

Add the image named Joiner_003.jpg to the canvas. Rotate and position it over the previous layers so that the features are roughly aligned, but this time don't worry if things don't align perfectly – these imperfections give the joiner image its distinctive photo collage look and draw attention to its individual photo components.

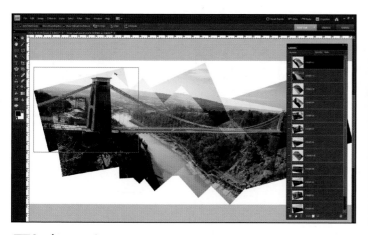

7 And repeat...

Repeat steps 2 to 4 to add all 12 source photos to the document. Once done, switch to the Move Tool and enable the Auto Select Layer option in the options bar. You can now just click on a shot to make it the active layer. To fine-tune the active layer's position, tap the arrow keys on your keyboard to nudge it a few pixels in any direction.

8 Tweak the Levels

Different layers have different tones, which adds interesting texture and variety. However, some layers look a bit too dark. To fix this, click the layer thumbnail (Joiner06 here), then go to Levels (under Image > Adjustments in Photoshop or Enhance > Adjust Lighting in Elements). Drag the grey Midtone slider to 1.23 to lighten that shot's midtones a little. Click OK. You can now do the same with Joiner09.

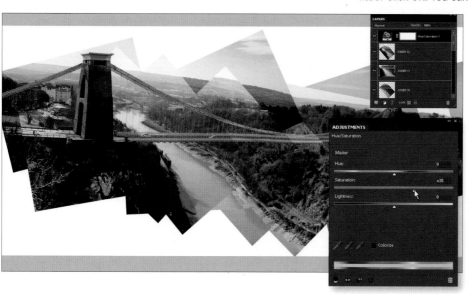

9 Finish Adjust the colour

To adjust the entire image, you can add adjustments at the top of the layer stack. You'll notice that the colours in all the source photos are a little muted. To improve this, add a Hue/Saturation adjustment layer at the very top of the layer stack. Set Master Saturation to +35, OK this, and you're done. ◘

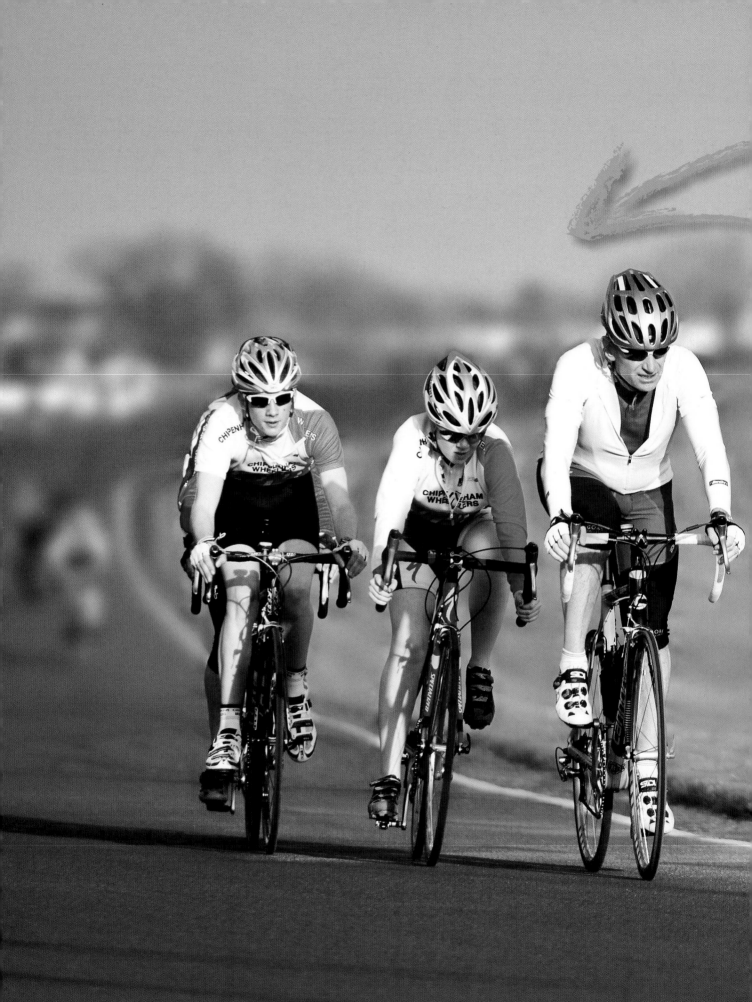

Paul Grogan (Future)

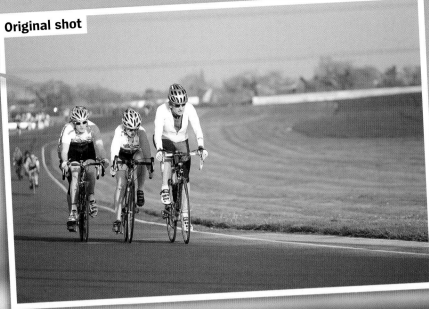

Original shot

How to...
Create classic
action photos

On the disc
Try it yourself!
Start image and
video on the DVD

A pin-sharp sports shot can seem to freeze the fastest-moving subjects, so restore
a sense of dynamism by mimicking shallow depth of field in Photoshop. Here's how!

WHAT YOU'LL NEED *Photoshop CS2 or newer*
WHAT YOU'LL LEARN *How to blur a background to mimic shallow depth
of field or panning blur, how to sharpen selected areas again by picking
them out with brushes on a layer mask*
IT ONLY TAKES *30 minutes*

**Shooting sports or other fast-moving action always presents a
challenge.** Apart from the difficulties of focusing accurately on a
moving target, you need to use high shutter speeds to ensure sharp
shots of moving subjects, which means you sometimes end up with a
result like our original image here that captures the subject perfectly
but freezes the action, giving little sense of the dynamism of the
scene. For our photo, we ventured to Castle Combe Circuit in Wiltshire
(www.castlecombecircuit.co.uk) to capture the Chippenham Wheelers
in action, but this picture doesn't convey the speed and excitement at
all. So we'll show you how to restore the feeling of movement by
mimicking shallow depth of field in Photoshop to make your subject
leap off the page. Plus, we'll reveal how to give flat, colourless skies a
boost and how to remove power-lines and other unwanted blemishes
from your final images. So turn the page and let's get started! »

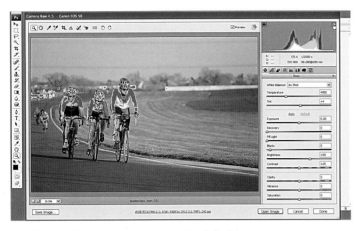

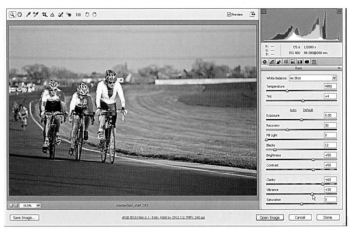

1 Start Check for clipped highlights

Open 6_masterclass_start.cr2 from the Action folder on your DVD. It's a Raw file, so it will open in the Adobe Camera Raw (ACR) editor. Click the white triangle at the top-right of the histogram (or tap O) to activate the highlight clipping warning. The red overlay will indicate blown-out areas of the shot that contain little or no detail.

2 Recover the blown-out areas

To recover some of the detail in these blown-out areas, drag the Recovery slider to about 30. To boost the contrast and colour, drag the Blacks slider to 10, the Contrast slider to 50 and the Clarity and Vibrance sliders to 60 and 30 respectively.

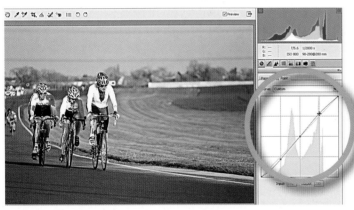

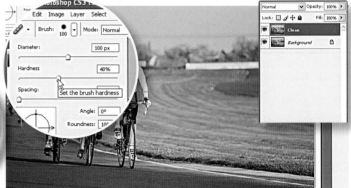

3 Boost contrast

Next, click on the Tone Curve tab (available only if you're running ACR under Photoshop), select the Point tab and then choose Medium Contrast from the drop-down menu. To boost the contrast a little further, drag the point nearest the top-right corner up to about 200.

4 Remove the power lines

Click Open Image to open the image in Photoshop/Elements. Duplicate the Background layer and rename this new layer "Clean". To clone out the obtrusive power lines in the sky, switch to the Spot Healing brush and set the brush's Diameter to 100 pixels, Hardness to 40% and Spacing to 1%.

5 Clean up the scene

Carefully paint along both power lines, taking particular care not to stray into the trees on the horizon. Now switch to the Clone Stamp Tool, set the brush Size to around 100 pixels and then work your way around the image, Alt-clicking to sample a clear source point and then clicking on the image to clone out the dust spots in the sky or tarmac.

6 Selective blur

To make the riders stand out more, you can blur the background and foreground while keeping the subjects sharp. To do this, first create a duplicate layer and rename the layer "Blur". Next, go to Filter > Blur > Gaussian Blur and, in the dialog that appears, set the filter to a Radius of around 20 pixels. Click OK.

7 Draw a gradient

Add a mask to the Blur layer, then switch to the Gradient Tool. Tap D, plus X if necessary, to make the foreground colour black and the background colour white. Pick the default Foreground To Background gradient in the options bar, and click the Reflected Gradient button (the fourth of the group of five). Make sure the mask is targeted, and draw a gradient from the top to the bottom of the lead rider's front wheel.

8 Reveal the riders

To make all the riders sharp again, we need to mask more of the Blur layer. To do this, switch to the Brush Tool and set Radius to 149, Opacity to 100% and Flow to 80%. Ensure that the foreground colour is black and the mask is targeted, then zoom in to 50% and paint over each of the riders, masking out any haloes around their edges.

9 Add a gradient layer

To deepen the blue of the sky without adding unwanted noise, go to Layer > New Fill Layer > Gradient. Click OK, then click the Reverse box in the dialog that appears. Click in the Gradient preview to open the Gradient Editor, then double-click the colour part of the Color Stop at the bottom left of the gradient slider (circled).

10 Make the gradient blue

In the Colour Picker that appears, type 165, 190 and 242 into the R, G and B boxes, and click OK. Now, in the Gradient Editor, drag the top-right pointer above the gradient ramp two-thirds of the way to the left. Drag the bottom-left Stop so it lines up with the top pointer. Click OK in both dialogs, and then change the gradient layer's blending mode to Multiply and drag its Opacity slider to 40%.

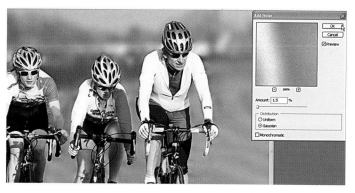

11 Sharpen the riders

You can now apply some sharpening. If you sharpen the whole image, though, you'll also sharpen the background, causing artifacts. To sharpen just the riders, target the Clean layer and go to Filter > Sharpen > Unsharp Mask. Set Amount to 150%, Radius to 1.0 and Threshold to 5% to reduce unwanted noise.

12 Finish Make some noise

Because the original image was shot at a relatively high ISO (800), the "grain" around the outlines of the riders is now quite visible, but the grain in the background has been smoothed out by the blurring in step 6. To ensure that the background blends with the grain around the riders, target the Blur layer and go to Filter > Noise > Add Noise. Set Amount to 1.5, click Gaussian Distribution, and click OK to end. ◘

How to...
Make a personal Christmas card

'Tis the season to be creative and send truly personal greetings cards incorporating your own photographs

WHAT YOU'LL NEED *Photoshop CS or newer; Elements has equivalent features, but some work a little differently*
WHAT YOU'LL LEARN *How to create a custom-shaped frame and paste a photo inside it, how to add and customise your own text*
IT ONLY TAKES *20 minutes*

On the disc Try it yourself! Start images are on the DVD

Season's Greetings

Let's face it, if you want to send a heartfelt personal message to friends or loved ones at Christmas, how personal is it going to seem on a store-bought, mass-produced card? Even if you're sending a card to one of those less intimate acquaintances you might contact only once or twice a year, why should you showcase somebody else's photography, especially when you could do better yourself? Christmas cards are the perfect occasion to show off your own photography and create something personal into the bargain.

If you're using Elements, you might have tried producing your own greetings cards under the Create tab. If you have, though, you'll have discovered that Elements limits you to using its own built-in templates. You can customise the results to some extent by changing the background colours and patterns, but you're stuck with the program's basic layouts and designs. What's more, there's nothing comparable in Photoshop anyway. So here we'll show you how to use various tools not often used in photo-editing, including Shape and Text layers, to create a truly personal card in Photoshop. We've included some seasonal images on your DVD to get you started. You can try this technique in Elements too, though some features (such as Paste Inside) work a little differently.

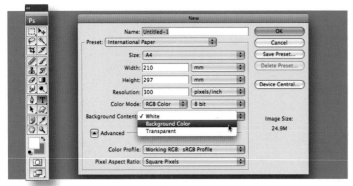

1 Start Create a new document
First click the background colour swatch in the toolbox and choose a suitably festive colour in the Color Picker (or alternatively Ctrl-click a swatch in the Swatches palette to make that the background colour). Then go to File > New. In the Preset menu, choose your paper size – we'll be printing on standard A4 card, so we chose International Paper, then A4. Leave Resolution set to 300ppi for top-quality printing, and for Background Contents choose Background Color, then click OK.

2 Add a frame for your picture
We'll be making a portrait-format card, so go to Image > Rotate Canvas > 90° CW to turn the document on its side. Now go to View > New Guide, click Horizontal and type in 148.5mm (don't forget the "mm") to mark where the card will be folded. Next, switch to the Rounded Rectangle Tool (U) and draw a frame in the area that will be the front of the card (to the right of the guide we've just added).

3 Custom Shapes

Now switch to the Custom Shape Tool (in the same toolbox compartment, or press U four times). In the options bar, make sure the tool is configured to create Shape layers (the first button at the left), then click the Shape preview to open the Custom Shape picker. Click the small button at the top-right of this to see the palette menu, and choose the Nature set. (You can append this set or replace the default set and then restore it at any time by choosing Reset Shapes in the same menu.) Double-click the Snowflake 3 shape in this set.

4 Add your snowflakes

Click the third of the group of six buttons to the right of the Shape preview, so that the tool now works in "Subtract from shape area" mode. Hold down Shift to constrain the proportions of the shape, and click-and-drag to draw a snowflake shape that overlaps the frame area, roughly as shown. Add some more snowflakes if you wish, of different sizes, and try using "Exclude overlapping shape areas" mode for an interesting variation.

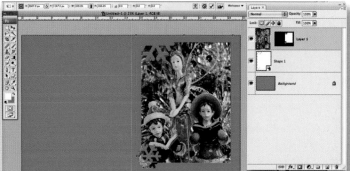

5 Select the inside of the frame

When you're happy with the effect, right-click on the name of the shape layer (the words "Shape 1") in the Layers palette and choose Convert to Smart Object in the contextual menu (this will give you the option to reshape the layer later if you want to). Now switch to the Magic Wand Tool, make sure the Contiguous option is *not* enabled, and click once in an area of white to select all the white areas.

6 Add your photo

Now open one of the images in the Christmas folder on your DVD, Select All and Copy. Return to your card, make sure the selection is still active, and go to Edit > Paste Into. The image will appear within the frame. Press Ctrl-T to initiate Free Transform, and reposition and resize the image as you wish (holding down Shift to constrain its proportions) – it will remain masked within the frame shape. Hit Return when done.

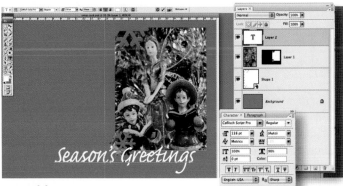

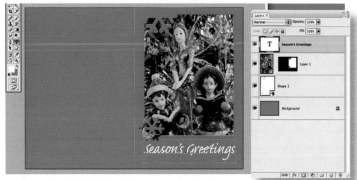

7 Add some text

Now to add a personal message. Switch to the Horizontal Type Tool, choose a suitable font in the options bar, click anywhere on the canvas and start typing. You can change the font, text colour, size and other characteristics in the options bar, or click the right-most of the main group of buttons in the options bar to open the Character and Paragraph palettes, which offer complete control. (Remember to select the text first if you want to change text you've already typed in.)

5 Finish Finalise the text and print

For faster text adjustments, click-and-drag on the symbol next to each of the fields in the Character or Paragraph palette – drag to the left next to the Size field, for instance, to make the selected text smaller. Hold down Ctrl to move the block of text where you want it, then click the tick button at the right of the tool options bar to OK all your text. Save as a PSD to preserve your layers, or flatten and print on a suitable weight of card. ◘

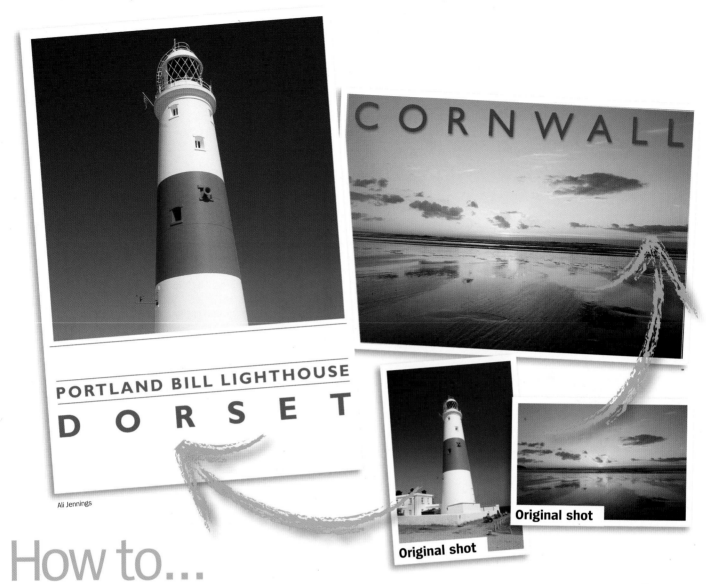

PORTLAND BILL LIGHTHOUSE
D O R S E T

Ali Jennings

CORNWALL

Original shot

Original shot

How to...
Create greetings cards and postcards

Take the next step and find out how to turn your photos into cold hard cash by making greetings cards and postcards good enough to sell

WHAT YOU'LL NEED *Photoshop CS2 or newer*
WHAT YOU'LL LEARN *How to place images as Smart Objects, how to modify placed Smart Objects, how to add keylines or simple borders using Layer Styles, and how to add text or other elements*
IT ONLY TAKES *30 minutes*

There are many reasons people take photographs – just as a hobby, to produce keepsakes or mementoes of special occasions, or as a more serious pastime or even a profession. Wherever you usually fall on the scale, you might want to do more with your photos at some point. Even if you've never been asked to photograph a friend or

relative's wedding for payment, let alone considered making a living from photography, you might one day like the thought of turning your photos into something commercial. Here we'll look at how you can create saleable cards and postcards from your images using some techniques slightly different from the ones in our previous tutorial.

Sizing images to a particular paper or card size can be tricky with the Image Size dialog, so we'll use Smart Objects, which enable sizing and resizing of an image in an easier, non-destructive way. We'll also show you how to add a subtle keyline and a little text to your print. Of course, for images to be saleable they need to be flawless and pin-sharp, so we'll also cover a little cosmetic retouching. Read on and cash in!

1 Start **Place Smart Objects**
First copy the Greetings folder from the DVD to your hard disk. Now create a new document the exact dimensions of the front face of your card at 300ppi. Go to File > Place, locate cardstart.jpg and click OK to place the image on a new layer as a Smart Object. Hit Return to OK.

2 **Crop the image**
To edit the original image, double-click the Smart Object layer. Switch to the Crop Tool, hold down the Shift key and drag a square crop frame over the image. Drag inside the crop frame to reposition it. When you're happy with it, hit Return or double-click within the crop box.

3 **Scale the Smart Object**
Close the file, saving the changes to update the Smart Object. To scale the image to the card, go to Edit > Transform > Scale. Hold Shift while dragging on a corner handle to scale the shot, and then move it into position by dragging within the bounding box. Hit Return to OK.

4 **Add a keyline**
Switch to the Rectangle Tool and click the Shape layers button in the options bar. Hold down the Shift key and drag a square around the outside of the image. In the Layers palette, set the Fill slider to 0%, then click the FX button at the base of the palette and choose Stroke.

5 **Colour and scale**
Click the Stroke Color swatch and choose a colour from the image by clicking in it. Set the Stroke Width via the slider and choose Inside for Position. Click OK to apply the stroke. To adjust the size of the key line square at any time, simply go to Edit > Transform > Scale.

6 Finish **Type and lines**
Next, you can add some text with the Type Tool and draw a couple of fine lines with the Line Tool; hold Shift as you draw a line to ensure that it's level. Finally, you need to centre-align all the layers: Shift-click all their thumbnails to highlight them all, then go to Layer > Align > Horizontal Centers. Turn the page for another card project. »

Effects & Projects

1 Start Smart Object place and scale

Create a new document measuring 5x3.5 inches at 300ppi. Go to File > Place. Locate the image you want to use and click Place to add it as a separate Smart Object layer. Go to Edit > Transform > Scale. Hold Shift and drag a corner handle, scaling the image to cover the canvas.

2 Image clean-up

Reposition the image by simply dragging within the bounding box. When you're happy with the scale and position, hit Return to OK it. To clone away any imperfections and dust spots, double-click the Smart Object layer thumbnail to edit the placed image.

3 Edit and update

Now use the Clone Stamp Tool to clone out any imperfections. While editing the original image, you can also make tonal adjustments using Image > Adjustments > Curves. When you've made all your edits, close this file, saving the changes to update the Smart Object.

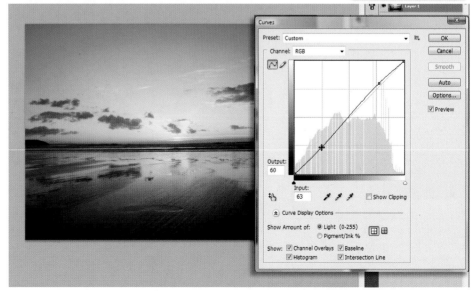

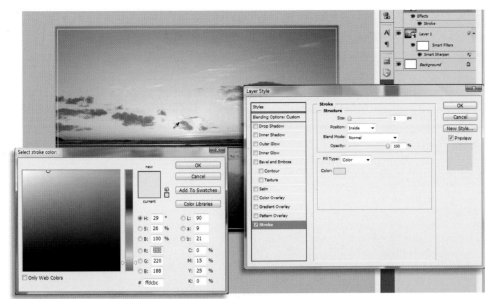

4 Simple border
You can add a keyline around the outer edges by using the Rectangle Tool. After drawing the rectangle, go to the Layers palette and set the Fill to 0%. Click the FX button at the foot of the palette and add a Stroke Layer Style to create an outline around the rectangle.

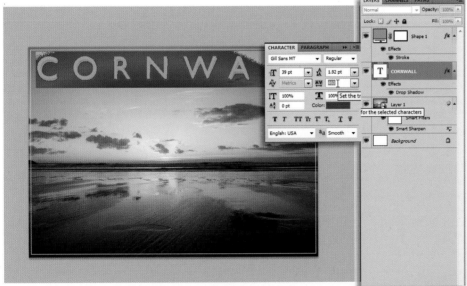

5 Finish Add and edit type
Click with the Type Tool to add type, choosing Centre Text from the options bar. To add space between the letters, highlight your type and adjust the Tracking in the Character palette; click the Text Color swatch below and then click on the image to make the text that colour. 📷

Expert tip
Change the Stroke colour
Once you've added the stroke to the Rectangle Shape layer, you can change the stroke colour by double-clicking on the word Stroke in the list linked to the Shape layer in the Layers palette to open the Layer Style dialog. Click the Color swatch and either choose a new colour from the picker or click on a colour within your image.

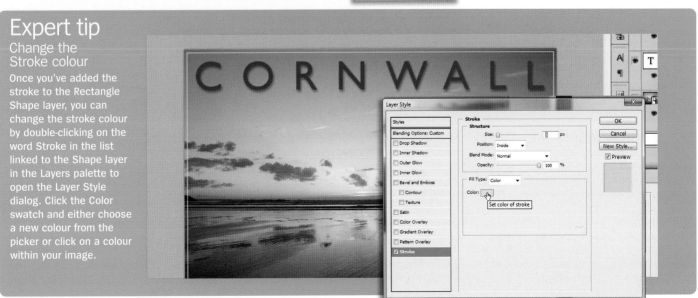

Glossary

Glossary

We've tried to minimise the jargon, but if you're flummoxed by feathering or muddled about marquees, our quick reference guide is here to help

A

Adjustment layer
A layer containing an image adjustment or effect instead of image content. Like a red Cellophane overlay on a print, an adjustment layer will alter the appearance of layers below it but not actually alter their content, making adjustment layers a cornerstone of reversible, "non-destructive" editing. The adjustment can be altered, hidden or removed at any point. When you add an adjustment layer, a mask is also automatically created, so that the effect can be applied to a lesser extent (or not at all) in particular areas.

Adobe Camera Raw
A free plug-in used by Photoshop or Elements to process and edit Raw files. Adobe Camera Raw is frequently updated to support the newest camera models.

Anti-aliasing
A method of smoothing diagonal or curved lines in digital images to avoid a "staircase" or "stepped" appearance caused by the fact that the pixels making up the image are discrete blocks of colour.

Artifacts
Flaws in an image caused by limitations in the recording or manipulation process. Examples include colour and tonal banding, random "blotches" or a mottled, grainy appearance.

Aspect ratio
The relationship between the width and height of a picture, describing the proportions of an image format or a photograph. The aspect ratio of most D-SLRs is 3:2, while on most other digital cameras it is 4:3.

B

Backup
A copy of a digital file, kept in case of damage to, or loss of, the original digital image.

Blending mode
Blending modes determine how the pixels in a layer interact with underlying pixels on other layers instead of simply covering them. Some blending modes are much more useful in

photo-editing than others. Multiply is handy to darken an image, and Screen to lighten it; Overlay and Soft Light will boost contrast.

Burn Tool
Can be used to darken parts of the image selectively during digital image manipulation. The tool gets its name (and its hand-shaped icon) from a traditional darkroom process, where parts of a print could be made darker by holding your hands under the enlarger in such a way that some parts of the print were exposed to more light than others. See Dodge.

C

Canvas
A Photoshop term for the overall dimensions of the image file that you are using. Like the canvas used for a painting, the Canvas may be the same size as the actual size of the picture or it may be larger.

Canvas Size
The Canvas Size control enables you to increase the size of the canvas without affecting the pixels that make up the image itself. It can be used to add a border to a shot, for example, or to add a blank area into which more sky can be cloned.

Catchlight
A white highlight in the eye of the subject, which is a reflection of the light source. The shape, size and intensity of the highlight will vary depending on the lighting set-up.

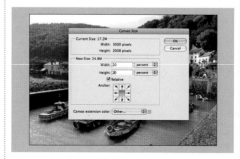

Canvas Size: add extra space all the way around an image, or on any side you choose.

Chromatic aberration
A lens fault, common in telephoto lenses, where different colours of white light are focused at slightly different distances, creating ugly coloured haloes around the edges of a photographic subject.

Clipping
When the dark parts of an image become pure black or the light parts become pure white, so that image detail is lost in these areas. On a histogram a clipped shadow or highlight is indicated by the graph being "cut off" at the left (shadows) or right (highlights) side.

Clone Stamp
An image-editing tool that enables you to replace an area of the image with pixels taken from elsewhere in the image (or even another image). Used for removing blemishes and unwanted objects from a picture.

CMYK
Cyan, Magenta, Yellow and Black (or Key). The four primary inks used in commercial printing. Elements doesn't support CMYK colour mode.

Colour channels
Every colour you see on-screen is created by a specific mix of red, green and blue light, and every printed colour by a specific "formula" of ink colours. In Photoshop, the component colours can be represented and viewed as separate colour channels – RGB for most digital photos.

Colour profile
Description of how a camera, printer, monitor or other device displays or records colour. It provides a universal way in which different devices can produce similar-looking results. This is sometimes known as an ICC profile, because the standards are set down by the ICC (International Color Consortium).

Colour space
Theoretical definition of the range of colours that can be displayed by a device.

Colour temperature
All light sources have a characteristic colour temperature: artificial (Tungsten-filament) lights are warmer (more orange) than daylight, which is warm near dawn, turns cooler (more blue)

during the day, then warms again at nightfall. Our eyes adjust for colour temperature much of the time without us realising it, so that colours look pretty consistent. Digital cameras can make electronic adjustments using a "white balance" system to neutralise colours, but when they get it wrong (or you use the wrong White Balance setting on your camera for the conditions), a colour cast results.

Curves

A powerful tool that enables you to adjust the exposure and contrast of an image. By altering the shape of the curve, different areas of tone can be lightened or darkened by varying amounts. By altering the curves for each of the different colour channels, the colour balance of the image can also be altered – to create special effects, or simply to correct for unwanted colour casts. Elements' version, Adjust Colour Curves, is more limited than Photoshop's Curves dialog.

D

DNG (Digital Negative)

A Raw file format invented by Adobe, and used by some camera manufacturers. An advantage is that, unlike other Raw formats, it is not specific to just one manufacturer or camera model, and it's not just a read-only format – you can save your files in DNG format too. A free DNG Converter application available from Adobe will convert any Raw file into DNG (www.adobe.com/products/dng).

Dialog

A window that pops open when you select certain commands, usually to give you the opportunity to configure settings or enter further preferences. In Photoshop/Elements, menu commands that will open a dialog for further instructions before applying their effect are usually indicated by an ellipsis (...) after their name, like File > Save As...; those without this, like File > Save, will work immediately.

Dodge Tool

A way of lightening selected areas of the image during digital manipulation. Gets its name (and its spoon-shaped icon) from a traditional darkroom technique, where parts of a print could be made darker by holding a handmade tool under the enlarger in such a way that some parts of the print received less light than others. See also Burn.

DPI

Dots per inch. Strictly speaking, a measure of the density of dots of ink that a printer lays down on paper. Compare image resolution (density of pixels) of a print or on-screen image at a certain size, measured in *pixels* per inch.

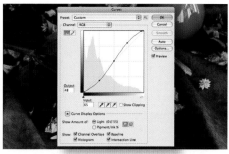

Curves: a hugely powerful tool for precise tonal adjustments and special effects.

Dynamic range

Term used to describe the range between the lightest and darkest points in a photograph. The range that can be recorded by a digital camera is relatively small compared to the range that the human eye can perceive.

E

EXIF (Exchangeable Image File)

Camera settings recorded by many digital cameras as part of the image file. This data automatically notes a wide range of information about the picture, including the date and time it was recorded, aperture, shutter speed, model of camera, whether flash was used, number of pixels used, metering mode, exposure mode, Exposure Compensation used and zoom setting. The information can then subsequently be read by suitable software. To access this information in Photoshop/Elements, go to File > File Info.

Eyedropper

Used to sample the colour of an area, typically changing the foreground colour to the same shade. Can also be used in some adjustment tools for setting exposure or colour balance by clicking on a particular area of tone as a reference point.

F

Feathering

A way of "softening" the edge of an area that you have selected to work on; adds a transition zone of transparent pixels which allows any background to partially show through (like the edges of a feather). Used so that the join between manipulated and non-manipulated areas is not obvious.

File format

The way in which a digital image is stored. When you've finished editing your images, you usually get a choice of formats to use while saving. Common file types include JPEG, TIFF, and PSD (Photoshop Document).

Filter

A general term used within Photoshop for a wide range of artistic effects and other utilities. Many are special effects, such as those that add grain and texture to an image; others, such as the sharpening filters, are more utilitarian.

G

Gamut

The range of colours that can be printed or displayed by a particular device.

GIF (Graphic Interchange Format)

A digital file format sometimes used for compressing graphics and images for web use.

Gradient Tool

Fills the image or selection with a colour that fades from into another colour (or none). It is particularly useful for creating masks with seamless edges, but can also be used to add colour to a drab sky.

H

Hand Tool

A tool for moving your image around when you are zoomed in and can't see all the image at once, by clicking and dragging on the image. Press the H key, or hold down the spacebar, to switch to this tool quickly.

HDR (high dynamic range)

A digital imaging technique where a series of identical pictures of a scene are taken at different exposure brightnesses and then combined into the one image. This brings out detail in shadow and highlight areas that usually cannot be captured in a single exposure, and is particularly useful for high-contrast subjects, such as brightly-lit landscapes, interiors and night scenes.

Healing Brush

A retouching tool that lays down copied pixels like the Clone Stamp but then in addition will analyse nearby colour and tone and attempt to blend the cloned pixels in with the surrounding area. Sometimes produces better results than the Clone Stamp, but sometimes doesn't, because its blending effect will tend to blur detail. For seamless cloning, it is often a good option to use both tools.

High key

An image in which bright, white tones dominate.

Highlight

The brightest (whitest) areas of an image. »

Glossary

Histogram
A graph that provides an instant guide to the contrast and exposure of your picture. It maps the distribution of tones, from the darkest at the left to the brightest at the right. The scale runs from 0 (solid black) to 255 (pure white), and the height of the graph at any point represents the relative number of pixels in the image (or layer or selection) with that brightness level. The overall shape of the histogram gives you an at-a-glance indication of the tonal range of the image and the presence of any clipping. You can use tools such as Levels, or the main sliders in Adobe Camera Raw, to adjust the shape of the histogram and thereby improve the contrast and exposure of the image.

Hue
Another term for colour; technically it tells you where a colour lies on the colour wheel without telling you how bright or dark the colour is.

J

JPEG (Joint Photographic Experts Group)
A file format used widely for digital images. A variable amount of compression can be used to vary the amount of detail stored and the resulting file size. It is the standard format used by digital cameras (although Raw or TIFF formats may also be provided as options).

K

Kelvin (K)
Unit used in measuring colour temperature, named after William Thomson, first Lord Kelvin, the 19th-century physicist who identified the phenomenon. Average midday daylight has a colour temperature of around 5500K.

L

Lasso
A pencil-like tool that you can use to select an area you want to work on simply by drawing around it.

Layer
The digital counterpart of the cut-out pieces of paper in a collage or decoupage. Layers containing cut-out objects can be stacked on top of your original image or Background layer in order to create a composite image; adjustments and effects can also be applied in the form of adjustment layers, enabling you to alter the exposure, colour, and so on, without actually altering the original. Layers can be opaque, semi-transparent, or merged with layers in the stack below in a number of ways.

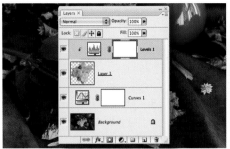

Layers: an invaluable tool for adjustments and effects as well as creating composites.

Layers palette
Enables you to manage and organise the layers in a multi-layered image, add new layers or adjustment layers, and change the way in which layers interact with each other (such as their opacity and blending mode).

Levels
A tool used in digital image manipulation to adjust exposure, contrast and colour balance. Histograms are used as a guide to the corrections that need to be made.

Lossless compression
A process whereby the size of a digital image file is made smaller without losing information. Raw files use this technique.

Lossy compression
A process in which information is lost from a digital image file in order to make the file size smaller. JPEGs are the most common file format that uses lossy compression.

Low key
An image that is dominated by dark tones.

M

Magic Wand Tool
A tool that selects pixels on the basis of their colour: click on a pixel, and more pixels of a similar colour or tone will be selected. The Tolerance setting will dictate just how close in colour other pixels must be in order to be included in the selection.

Marquee
The Marquee Tools enable you to make regular-shaped selections such as ellipses or rectangles. The term marquee is also used to refer to the animated dotted outline that indicates the border of a selection, often referred to as "marching ants".

Midtones
All areas of the image that are not shadows or highlights. Areas of brightness which, if the image were converted to black and white, would be a shade of grey rather than black or white. In a histogram, they correspond with the main central parts of the histogram graph.

Move Tool
Used for aligning a layer or selection, by moving it around the canvas.

N

Noise
Unwanted interference in an electrical signal. Seen as a grain-like pattern in dark areas of a digital image. Noise increases in digital photos when a higher ISO setting is used.

P

Paint Bucket
Tool that fills a complete area with a particular colour. As with the Magic Wand, you can adjust the Tolerance to change the effect. Can be useful for creating masks.

Palette Bin / Panel Bin
Area at the right of the interface for keeping various dialogs and information displays in Photoshop/Elements. CS4, Elements 8 and newer tend to use the term "panel" instead of "palette". Can be minimised to buttons or hidden completely if required.

Photomerge
A group of "automated" features designed for combining a number of similar or related shots together, including Photomerge Panorama for combining an overlapping sequence to create a panoramic view. Elements includes additional Photomerge tools not included in Photoshop, such as Photomerge Group Shot (for combining the best features from a series of near identical group portraits).

Pixels
Every digital photograph is made up of millions of coloured, square-shaped dots called pixels (the term derives from "picture elements"). Each is a distinct colour, but like the tiles in a mosaic they blend together optically to create a "photo-realistic" image. Zooming into your images using the Zoom Tool in Photoshop/Elements enables you to see, and then edit, each of these building blocks if you choose.

Plug-in
A piece of software that adds functionality to an existing computer program. Plug-ins are available for many digital image manipulation programs, including Photoshop/Elements, providing an increased range of effects and transformations.

PPI
Pixels per inch. A measure of the resolution (density of pixels) in a print or on-screen image.

PSD
Photoshop's (and Elements') own file format, which preserves components such as layers and transparency which are not supported by some formats (including JPEG). It's worth saving an edited photo as a PSD if you might want the option to revisit layers or adjustment layers at a later time.

R

Raw
A file format option provided by digital SLRs and some other top-end digital cameras. Image data is stored in a semi-processed state and needs to be fully processed on a computer. Raw files enable exposure compensation, image contrast, colour balance and other settings to be altered after the initial exposure, while still retaining maximum image quality. Raw images also offer a greater tonal range than the alternative JPEG recording quality options. Raw is not an abbreviation, or even a single file type like JPEG; the format varies from manufacturer to manufacturer, and sometimes from camera to camera. Most current Canon models use .CR2, and Nikon models use .NEF.

Red-eye
An effect often caused by flash in which light reflects from the retina of a subject's eye, producing a bright red pupil in the image.

Resolution
A measure of the density of pixels in a printed or on-screen image, usually expressed in terms of pixels per inch (ppi). A resolution of 300ppi is widely regarded as the optimum for professional-quality printing. Monitors typically display images at between 72 and 96ppi, though this can vary with monitor size and other factors. Changing a photo's resolution in the Image Size dialog won't change how big it looks on-screen, only in print.

RGB
Stands for Red, Green and Blue. These are the three primary colours used by your digital camera to record a picture. Some digital editing tools can access and edit each of the three colour channels separately.

S

Saturation
The strength of a colour or hue. An increase in saturation gives a more intense colour. Too much saturation and the image will look fake. An image with no saturation whatsoever will appear in black-and-white.

Scratch disk
Hard disk space used by Photoshop while processing an image to store information temporarily. Used, for example, to store the "history states" that are essential for using the History / Undo History palette.

Sharpening
Sharpening boosts the contrast around the edges of objects to increase definition, which helps counter the inherent softening effect of digital capture. Inkjet printing has a further softening effect, so if you're going to print your image, it will need more sharpening than for on-screen viewing.

Solarisation
A traditional darkroom effect where an image is processed so that it is partly a normal positive image and partly a negative. This effect is easily re-created using Photoshop/Elements. This special effect looks best when applied to a black-and-white image.

T

Thumbnail
A small, low-resolution version of an image, often used in image-management applications such as Adobe Bridge or Organizer to make it easier and faster to search through and preview your photo collection. The small representations of each layer in the Layers palette are also called thumbnails.

TIFF (Tagged Image File Format)
Digital image format used to record files with maximum available detail. Files can be large, although this can be reduced using lossless compression.

Tungsten lighting
A type of bulb lighting that has a warm colour temperature between 2600 and 3500K.

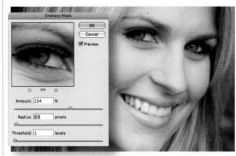

Unsharp Mask: adding localised contrast makes your digital images look sharper

U

Unsharp Mask (USM)
One of the most popular Photoshop tools for increasing sharpness in a digital image. It gets its curious name from a traditional print process, where a soft-focus negative is sandwiched with the original in order to increase edge contrast.

V

Vibrance
A slider available in Adobe Camera Raw and Photoshop that enables you to increase the saturation of colours, but not universally – it concentrates the increase in saturation on colours that are not saturated already, with less effect on already-intense colours. This often leads to a more visually pleasing result.

XYZ

XMP
Abbreviation for Extensible Metadata Platform. A labelling technology used by a number of Adobe programs, including the Photoshop family. It records useful information about a file, and it is usually embedded within the file itself. With Raw files, the XMP information is recorded separately, keeping a record of adjustments made with Adobe Camera Raw without affecting the original Raw file.

On your DVD-ROM

Here's how to get the most from your packed disc
and learn from experts one-to-one at your own pace

On the disc
Try it yourself!
Start image and
video on the DVD

Important
About copyright

Please note that all the images on your DVD
are copyright. **They are not "royalty-free" or
"library" images.** They are supplied solely for
your own private use, so you can work along
with our tutorials. They must not be sold on,
redistributed in any form (whether as-supplied or
edited), made available on any server or website,
or used for any commercial purpose.

How to... Use the disc interface

1 Welcome to the disc
After the disc interface launches and you've accepted the terms of use, you'll see this Welcome screen. To access the content on the disc, simply click the appropriate chapter link in the bar below the title. The link at the foot of the screen will take you to information about Future's entire portfolio of superlative photography magazines and details of how you can subscribe. This button will work only if you have an active internet connection.

2 Images and Videos
Go to any chapter, and you'll see a list of its contents in the same order in which they appear in the printed pages. Click on any of these, then on "Open Folder" in the next screen (see step 3) and the folder containing the resources for that project – start image, plus video tutorial if any – will open on your Desktop. (Note that this might be behind the disc interface window.) Click on "Home" at any time to return to the screen shown in step 1.

3 Accessing the images
Drag any image files to your own hard disk to open them in Photoshop or Elements. You can simply double-click the video files to view them in Apple's QuickTime Player (download the latest version free of charge from **www.quicktime.com**) or compatible player software. You might experience better performance if you copy the video files to your own hard disk and view them from there rather than direct from the disc.

Your free DVD-ROM includes over nine hours of expert video tutorials, plus all the "start" images you'll need to complete the step-by-step projects in this book, and even the HDR enthusiast's third-party software of choice, Photomatix Pro, to try out. You'll find our little "On the disc" sticker on the page to confirm that there's disc content accompanying the page you're reading. Note that not all the tutorials in this book will be accompanied by source images: some don't require you to work along with a project.

To access the files on this disc, first insert the DVD into your computer's disc drive. Whether you're using a Windows PC or a Mac, the disc should work equally well.

Getting started
The first item that should appear on your screen is the disclaimer window; here you'll need to click on "I agree". Please remember that this disc has been scanned and tested at all stages of production, but – as with all new software – we recommend that you run a virus checker before use. We also recommend that you have an up-to-date backup of your hard disk before using this disc. Consult your network administrator before installing software on a networked PC.

Once the DVD is running you'll see a home page, with links to different sections within the book. Click on a link to access the chapter you want, then on the specific tutorial you're interested in (see above for a guide to finding your way around the disc). You'll find the video tutorial and source image for each project in their own sub-folders.

Our video tutorials are in QuickTime or MPEG-4 format, and we recommend that you install the latest version of Apple's QuickTime player, available to download free of charge at **www.quicktime.com**. (Other video playback software is available.)

Questions and queries
If you have a query about using your disc's interface or its content, please visit our reader support website at **www.futurenet.com/ support**, where you can find solutions to many common problems.

Expert tip
Starting the disc interface manually
If the disc interface doesn't load automatically when you insert the disc, here's what to do.
PC users: Click on the Windows Start button and click Run. Now click Browse and go to the CD/DVD directory in My Computer. Look for a file called CBZ.exe and double-click on it. Click OK in the Run dialog, and the interface should open.
Mac users: Double-click the disc icon to view its contents, then double-click "CBZ.osx" to launch the interface.

Index

More Great Books From Fox Chapel Publishing

Black & White Digital Photography
The All-In-One Guide to Taking Quality Photos and Editing Successfully Using Photoshop
By Editors of PhotoPlus Magazine

This book explores the evocative world of black and white photography and looks at exhilarating new ways to approach the mono medium.

ISBN: 978-1-56523-718-6
$27.95 • 224 Pages

The Complete Digital SLR Handbook
Mastering Your Camera to Take Pictures Like a Pro
By Editors of PhotoPlus Magazine

This book shows how to stop wasting shots and make every shot a winner, with expert advice on settings, sharpness, and exposure.

ISBN: 978-1-56523-717-9
$27.95 • 192 Pages

How ___ Pain___
*Profe___
Practical Draw___ ___echniques*
By Editors of ImagineFX Magazine

Art students, professional illustrato___ and creative amateurs alike will f___ inspiration and encouragement t___ their core skills and embrace in___ digital techniques.

ISBN: 978-1-5652___
$27.95 • 112 Pages

___fficial Vampire ___andbook
___wn Patterns ___ad

The Art of Steampunk
Extraordinary Devices and Ingenious Contraptions from the Leading Artists of the Steampunk Movement
By Art Donovan

Dive into the world of Steampunk where machines are functional pieces of art and the design is only as limited as the artist's imagination.

ISBN: 978-1-56523-573-1
$19.95 • 128 Pages

___mple to Stylish Projects from the Experts at American Woodworker
Edited by Randy Johnson

Add a special touch to cherished photos or artwork with hand-made picture frames from the experts at American Woodworker.

ISBN: 978-1-56523-459-8
$19.95 • 120 Pages

Labeling America: Popular Culture on Cigar Box Labels
The Story of George Schlegel Lithographers, 1849-1971
By John Grossman

Discover the beauty of cigar box labels and bands from the 19th and 20th centuries, printed by George Schlegel Lithographers and collected by John Grossman; currently housed at the Winterthur Museum in Delaware.

ISBN: 978-1-56523-545-8
$39.95 • 320 Pages

Handmade Music Factory
The Ultimate Guide to Making Foot-Stompin Good Instruments
By Mike Orr

With a little creativity and some salvaged parts, you can create your own arsenal of instruments that look good, sound great, and deliver some foot stompin' fun!

ISBN: 978-1-56523-559-5
$22.95 • 160 Pages